mark galer philip andrews

Focal Press is an imprint of Elsevier Linacre House, Jordan Hill, Oxford OX2 8DP, UK 30 Corporate Drive, Suite 400, Burlington, MA 01803, USA

First published 2007

Copyright © 2007, Mark Galer and Philip Andrews. Published by Elsevier Ltd. All rights reserved

The rights of Mark Galer and Philip Andrews to be identified as the authors of this work has been asserted in accordance with the Copyright, Designs and Patents Act 1988

No part of this publication may be reproduced, stored in a retrieval system or transmitted in any form or by any means electronic, mechanical, photocopying, recording or otherwise without the prior written permission of the publisher

Permissions may be sought directly from Elsevier's Science & Technology Rights
Department in Oxford, UK: phone (+44) (0) 1865 843830; fax (+44) (0) 1865 853333;
email: permissions@elsevier.com. Alternatively you can submit your request online by
visiting the Elsevier web site at http://elsevier.com/locate/permissions, and selecting
Obtaining permission to use Elsevier material

Notice

No responsibility is assumed by the publisher for any injury and/or damage to persons or property as a matter of products liability, negligence or otherwise, or from any use or operation of any methods, products, instructions or ideas contained in the material herein. Because of rapid advances in the medical sciences, in particular, independent verification of diagnoses and drug dosages should be made

British Library Cataloguing in Publication Data

A catalogue record for this book is available from the British Library

Library of Congress Cataloging-in-Publication Data

A catalog record for this book is available from the Library of Congress

ISBN: 978-0-240-52064-3

For more information on all Focal Press publications visit our website at: www.focalpress.com

Printed and bound in Canada

07 08 09 10 11 11 10 9 8 7 6 5 4 3 2 1

Working together to grow libraries in developing countries

www.elsevier.com | www.bookaid.org | www.sabre.org

ELSEVIER

BOOK AID

Sabre Foundation

Acknowledgements

To our families:

Dorothy, Matthew and Teagan and Karen, Adrian and Ellena

for their love, support and understanding.

We would like to pay special thanks to Mark Lewis and Bryan O'Neil Hughes for their advice and editorial input and to Stephanie Barrett and Margaret Denley at Focal Press for all their hard work in getting this book to press.

Picture credits

Paul Allister; Magdalena Bors; Andrew Boyle: Dorothy Connop; Catherine Dorsen; Samantha Everton; Serena Galante; Shari Gleeson; John Hay; Paulina Hryniewiecka; Jeff Ko; Anitra Keogh; Seok-Jin Lee; Anica Meehan; Chris Mollison; Chris Neylon; Serap Osman; Rod Owen; Craig Shell; Daniel Stainsby; Jennifer Stephens; Akane Utsunomiya; Victoria Verdon Roe.

Also our thanks go to www.iStockphoto.com for supporting this venture by supplying various tutorial images.

All other images and illustrations by the authors.

foundation module

Introduction	×ii
A structured learning approach	xiii
Supporting DVD	xiii
Research and resources	xiii
Essential information	xiv
The Digital Darkroom	- 1
Digital setup	2
Monitor settings	3
Choosing a working space	5
Getting started with Photoshop	5
Settings and preferences	8
Navigation and viewing modes	10
Rulers and guides	13
Digital Basics	15
Introduction	16
Channels and modes	17
Levels	18
Hue, Saturation and Brightness	19
Color and light overview	21
Bit depth and mode	23
File size	24
File formats	25
Image compression	28
Resolution	30
Image size	34
Interpolation	37
Bridge	41
Introduction	42
Bridge turns 2.0!	43
Setting up Bridge	44
Using Bridge	48
Using Bridge to access the project resources	53

Capture and Enhance	55
Introduction	56
Advantages and disadvantages of 16-bit editing	57
Foundations project 1	58
Image capture – Step 1	58
Cropping an image – Step 2	59
Tonal adjustments – Step 3	61
Color adjustments – Step 4	66
Cleaning an image – Step 5	68
Sharpening an image – Step 6	69
Saving a modified file – Step 7	70
Adobe Camera Raw	75
Introduction	76
Processing Raw data	77
Processing projects – images on supporting DVD	77
Straighten, crop and size – Step 1	78
Color space – Step 2	79
Choosing a bit depth – Step 3	80
White balance – Step 4	81
Tonal adjustments – Step 5	82
Saturation and vibrance – Step 6	84
Noise reduction and sharpening – Step 7	85
Digital exposure	86
Adjusting exposure in ACR	87
Dust on the sensor – batch removal	93
Archiving Raw files as digital negatives	94
Digital Printing	97
Introduction	98
Monitor calibration and working color space	100
Pre-flight checklist	101
Preparing a test print	102
Printer manages color	103
Photoshop manages color	105
Analyzing the test print	107
Maximizing shadow and highlight detail	108
Creating a 'ringaround'	109
In conclusion	109
Printing using a professional laboratory	110
Printing monochromes	112
Multi-black printers	113

advanced skills module

Layers and Channels	115
Introduction	116
Layers overview	117
Layer types	121
Channels	124
Adjustment and filter layers and editing quality	126
Layer masks and editing adjustments	127
Selections	129
Introduction	130
Selection Tools overview	130
Shape-based selections with the Marquee Tools	130
Drawn selections using the Lasso Tools	131
Customizing your selections	133
Refining selections	135
Saving and loading selections	136
Feather and anti-alias	137
Defringe and Matting	138
A magic workflow	139
Quick Mask or Refine Edge	141
'Color Range'	143
Channel masking	145
Selections from paths	147

Layer Blends	153
Introduction	154
The 'Darken' group	156
The 'Lighten' group	159
The 'Overlay' group	162
Blend modes for tinting and toning	164
Luminosity	166
Difference and Exclusion	167
Creating a simple blend	168
Filters	171
Filtering in Photoshop	172
Smart Filters in CS3	173
The Filter Gallery	175
Fade Filter command	176
Improving filter performance	176
Installing and using third party filters	177
Filtering a shape or text (vector) layer	177
The great filter round-up	177
Extract filter	178
Liquify filter	180
Vanishing Point	182
Artistic filters	186
Brush Strokes filters	187
Blur filters	188
Distort filters	190
Noise filters	192
Pixelate filters	195
Render filters	195
Sharpen filters	196
Stylize filters	197
Sketch filters	198
Texture filters	199
Video filters	200
Other filters	200
Filter DIY	201

imaging projects module

Retouching Projects	203
Correcting perspective – Project 1	204
Adjustment layers – Project 2	214
Shadow/Highlight – Project 3	226
Clone and stamp – Project 4	231
Advanced sharpening techniques – Project 5	240
Advanced Retouching	249
Black and white – Project 1	250
Gradient maps – Project 2	259
Creative depth of field – Project 3	269
Smart Objects – Project 4	273
The smooth tone technique – Project 5	281
Time of day – Project 6	287

Montage Projects	297
Layer masks – Project 1	298
Creating a simple blend – Project 2	308
Paths and selections – Project 3	314
Extracting hair – Project 4	319
Replacing a sky – Project 5	326
Shadows and blur – Project 6	332
High dynamic range – Project 7	342
Displace and Liquify – Project 8	351
Composite lighting – Project 9	359
Creating a panorama – Project 10	365
Special Effects	375
Posterization – Project 1	376
Digital diffusion – Project 2	381
Digital Polaroid transfer effect – Project 3	387
Lith printing – Project 4	392
Portrait makeovers – Project 5	396
Advanced blending – Project 6	401
Glossary	407
Keyboard Shortcuts	417
Web Links	419
Index	420

Contents DVD

The DVD is a veritable treasure trove of supporting files for the projects in this book as well as a resource for your own creative projects. The images and movies on the DVD are divided into their respective chapters and can be accessed via Bridge (see *Bridge* > page 53). Most of the images in the Foundation and Advanced Skills modules of the book can be found on the DVD together with all of the images from the Imaging Projects module. The movies are an invaluable resource, allowing you to start, stop and rewind so that the skills can be quickly and easily acquired at your own pace. The DVD also contains multi-layered image files (PSDs) of the completed projects, uncompressed TIFF files with saved selections, RAW files and high-quality 16 Bits/Channel files. Loadable Actions and Presets are also available to enhance your software, together with a rich stock library of royalty-free images.

THE DVD PROVIDES EXTENSIVE SUPPORT IN THE FORM OF:

Over eight hours of movie tutorials to guide you through all of the projects in this book. You may need to install the QuickTime movie player from the supporting DVD to watch the movies.

- High-resolution, high-quality JPEG images to support all of the imaging projects.
- Full-resolution TIFF images with 'saved selections' for users interested in completing the projects in the least amount of time whilst achieving maximum quality.
- Camera RAW and 16 Bits/Channel files.
- High-resolution images courtesty of iStockphoto.com.
- Multi-layered Photoshop documents (PSD files) of completed projects.
- A stock library of 100 high-resolution, royalty-free images for creative montage work.
- Adobe presets (Layer Styles, Custom Shapes and Gradients) to enhance the performance capabilities of your Adobe Photoshop Elements software.
- Photoshop Action files to fast-track your workflows and editing tasks.
- Printable PDF file of keyboard shortcuts to act as a quick and handy reference guide to speed up your image-editing tasks.
- Receive a 10% discount on additional images purchased from iStockphoto.com by quoting the code that is available on the supporting DVD.

Introduction

Photoshop has helped revolutionize how photographers capture, edit and prepare their images for viewing. Most of what we now see in print has been edited and prepared using the Adobe software. The image-editing process extends from basic retouching and sizing of images, to the highly manipulated and preconceived photographic montages that are commonly used by the advertising industry. This book is intended for photographers and designers who wish to use the 'digital darkroom' rather than the traditional darkroom for creative photographic illustration. The information, activities and assignments contained in this book provide the essential skills necessary for competent and creative image editing. The subject guides offer a comprehensive and highly structured learning approach, giving comprehensive support to guide Photoshop users through each editing process. An emphasis on useful (essential) practical advice and activities maximizes the opportunities for creative image production.

Anitra Keogh

Acquisition of skills

The first section of this book is a foundation module designed to help the user establish an effective working environment and act as a guide for successful navigation through the image-editing process from capture to print. Emphasis is placed on the essential techniques and skills whilst the terminology is kept as simple as possible using only those terms in common usage.

Application of skills

The subsequent modules extend and build on the basic skills to provide the user with the essential techniques to enable creative and skilful image editing. The guides explore creative applications including advanced retouching, photomontage, vector graphics, special effects and preparing images for the web. Creative practical tasks, using a fully illustrated and simple step-by-step approach, are undertaken in each of the guides to allow the user to explore the creative possibilities and potential for each of the skills being offered.

A structured learning approach

The study guides contained in this book offer a structured learning approach and an independent learning resource that will give the user a framework for the techniques of digital imaging as well as the essential skills for personal creativity and communication.

The skills

To acquire the essential skills to communicate effectively and creatively takes time and motivation. Those skills should be practised repeatedly so that they become practical working knowledge rather than just basic understanding. Become familiar with the skills introduced in one study guide and apply them to each of the following guides wherever appropriate.

The DVD has images and movies available to support and guide the learning process

Supporting DVD

A supporting DVD and dedicated web log (blog) has been set up to enable users to access current information. The address for the blog site is: www.photoshopessentialskills.com. The supporting files can be accessed through the Bridge interface (Computer > CS3_DVD).

Research and resources

You will only realize your full creative potential by looking at a variety of images from different sources. Artists and designers find inspiration in many different ways, but most find that they are influenced by other work they have seen and admired.

Essential information

The basic equipment required to complete this course is access to a computer with Adobe Photoshop CS3 (CS2 would suffice for many of the projects contained in the book). The photographic and design industries have traditionally used Apple Macintosh computers but many people now choose 'Windows'-based PCs as a more cost-effective alternative. When Photoshop is open there are minor differences in the interface, but all of the features and tools are identical. It is possible to use this book with either Windows-based or Apple Macintosh computers.

Storage

Due to the large file sizes involved with digital imaging it is advisable that you have a high-capacity, removable storage device attached to the computer or use a CD or DVD writer to archive your images.

Commands

Computer commands which allow the user to modify digital files can be accessed via menus and submenus. The commands used in the study guides are listed as a hierarchy, with the main menu indicated first and the submenu or command second, e.g. Main menu > Command or Submenu > Command. For example, the command for opening the Image Size dialog box would be indicated as follows: Edit > Image Adjustments > Image Size.

Keyboard shortcuts

Many commands that can be accessed via the menus and submenus can also be accessed via keyboard 'shortcuts'. A shortcut is the action of pressing two or more keys on the keyboard to carry out a command (rather than clicking a command or option in a menu). Shortcuts speed up digital image processing enormously and it is worth learning the examples given in the study guides. If in doubt use the menu (the shortcut will be indicated next to the command) until you become more familiar with the key combinations.

Note > The keyboard shortcuts indicate both the Mac and PC equivalents.

Example: The shortcut for pasting objects and text in most applications uses the key combination Command/Ctrl + V. The Macintosh requires the Command key (next to the spacebar) and the V key to be pressed in sequence whilst a PC requires the Control key (Ctrl) and the V key to be pressed.

the digital darkroom

shop photoshop photoshop photoshop photoshop phot

shop photoshop photoshop photoshop photoshop photoshop

essential skills

- Set up the computer, monitor and software preferences for effective digital image editing.
- ~ Gain familiarity with the Photoshop interface.
- Review Photoshop's basic tools and commands for navigating images on screen.

Digital setup

Photoshop is the professional's choice for digital image editing. Photoshop affords precise control over images that are destined to be viewed on screen and in print. In order to maximize this control it is necessary to spend some time setting up the software and hardware involved in the imaging process in order to create a predictable and efficient workflow.

This chapter will act as a pre-flight checklist so that the user can create the best possible working environment for creative digital image editing. The degree of sophistication that Photoshop offers can appear daunting for the novice digital image-maker, but the time required setting up the software and hardware in the initial stages will pay huge dividends in the amount of time saved and the quality of the images produced.

Commands and shortcuts

This chapter will guide you to select various options from a list of menus on your computer. If a command or dialog box is to be found in a submenu, which in turn is to be found in a main menu, it will appear as follows: 'Main menu > Submenu > Command'. Many of the commands can be executed by pressing one or more of the keyboard keys (known as 'keyboard shortcuts').

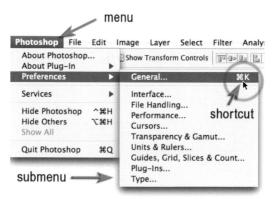

Keyboards: Mac and PC keyboards have different layouts. The 'Alt' key on a PC is the 'Option' key on a Mac. The functions assigned to the 'Control' key on a PC are assigned to the 'Command' key on a Mac (the key next to the Spacebar with the apple on it). When the text lists a keyboard command such as 'Ctrl/Command + Spacebar' the PC user will press the Control key and the Spacebar while the Mac user should press only the Command key together with the Spacebar.

Monitor settings

Resolution and colors

Set the monitor resolution to ' 1024×768 ' pixels or greater and the monitor colors to 'Millions'. Monitor resolutions less than 1024×768 will result in excessively large palettes and a lack of 'screen real estate' or monitor space in which to display the image you are working on.

Note > If the 'Refresh Rate' is too low on a CRT monitor the monitor will appear to flicker. The best CRT monitors will enable a high resolution with a flicker-free or stable image.

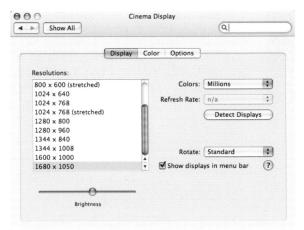

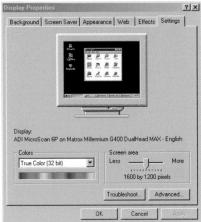

Monitor color temperature - selecting a white point

The default 'color temperature' of a new monitor is most likely to be too bright and too blue for digital printing purposes (9300). Reset the 'Target White Point' (sometimes referred to as 'Hardware White Point' or 'Color Temperature') of your monitor to 'D65' or '6500', which is equivalent to daylight (the same light you will use to view your prints). Setting the white point is part of the 'calibration' process that ensures color accuracy and consistency.

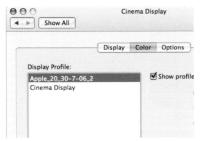

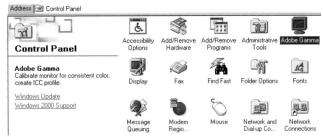

Calibration and profiling

With the default settings, every monitor displays color differently, even monitors of the same model and make. Calibration attempts to set the monitor to a 'standard' color display. This will help to prevent your images from looking radically different from monitor to monitor. If a monitor calibration device cannot be used you should attempt to calibrate your monitor using the software 'Monitor Calibrator' (Mac) or 'Adobe Gamma' (PC).

Older style CRT monitors should be warmed up before starting the calibration process. Switch on the monitor and allow the image to stabilize for at least half an hour. Then set the brightness, contrast, gamma and color temperature of the monitor using the calibration software. This will ensure that the appearance of an image on your screen will be the same on any other calibrated screen. Monitor calibration will also help to ensure that your prints appear very similar to your screen image, especially if you have an accurate profile of your printer.

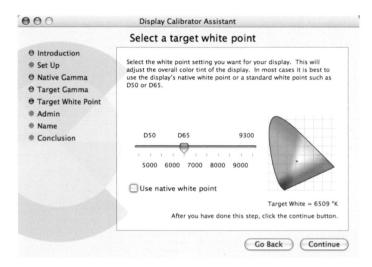

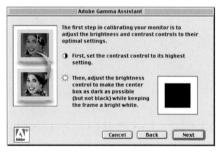

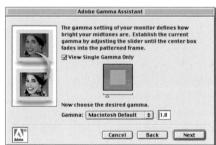

Software calibration

When using Macintosh OSX go to 'System Preferences > Displays > Color > Calibrate'. When using the Windows operating system open the software 'Adobe Gamma' (found in the 'control panel'). This will launch the monitor calibrator software. Choose '6500' as the 'Target White Point' or the 'Hardware White Point' and 'Adjusted White Point' if using Adobe Gamma. The software will also guide the user to set the contrast, brightness and 'gamma' of the monitor (when using an LCD screen ignore the advice in Adobe Gamma to raise the contrast setting to maximum). On completion of the calibration process you must save the newly calibrated monitor settings by giving it a profile name. It is advised that when you name this profile you include the date that you carried out the calibration. It is usual to check the calibration of a monitor every 6 months.

Note > When you choose 6500 as your target white point your monitor will initially appear dull and a little yellow compared to what you are used to seeing.

Choose a working space

It is important to select the correct Color Settings for your workflow in your Adobe software before you start to work with any images. If you are running the Adobe Creative Suite the color settings can be synchronized across the suite of applications in Adobe Bridge (Edit > Creative Suite Color Settings). If setting the 'working space' in Photoshop CS3 go to Edit > Color Settings.

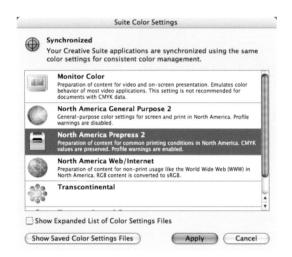

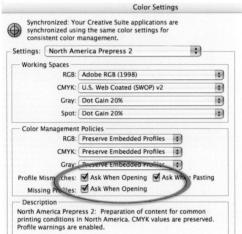

If preparing images for the web or a print service provider using the sRGB profile, select sRGB in the RGB working space or North America Web/Internet in the Settings menu. If preparing images for inkjet printing or for commercial prepress (CMYK) choose Adobe RGB (1998) in the RGB working space menu or North America Prepress 2 in the settings menu. Check the Profile Mismatches and Missing Profiles boxes so that you will be warned of mismatches or missing profiles when opening or pasting images.

Note > If you are preparing your color settings for a print workflow consult your print service provider or prepress operator to ensure that you are working with the optimum settings for the intended workflow.

Getting started with Photoshop

The new interface of Photoshop CS3 is highly organized and presents the user with an effective interface offering maximum control over the process of image editing. If all of the information and control relating to a single image were on display there would be no room left on a standard monitor for the image itself. Most of the features of the editing software therefore are hidden from view but can be quickly accessed once the user starts to understand how the software is organized. The Photoshop interface consists of the:

Menu, Tools, Options bar, Image window and Palettes

Note > The user interface (UI) is the same irrespective of the computer platform you are working with (Mac or PC). In practical terms the main difference between the two systems is that Windows and Macintosh use different key stroke combinations for shortcuts.

The menu

The menu at the top of the screen gives you access to the main commands. Each menu is subdivided into major categories. Clicking on each menu category gives you access to the commands in the section. A command may have a submenu for selecting different options or for launching various 'dialog boxes'. Many of the commands can be accessed without using the menu at all by simply pressing a key combination on the keyboard called a 'shortcut'. Menu items can now be modified (hidden or color coded) by going to the Edit menu and selecting Menus. This is a useful way of rationalizing the menus or highlighting the key commands if you are a newcomer to Photoshop.

The Tools palette

To select a tool to work on your image you simply click on it in the Tools palette. If you leave your mouse cursor over the tool Photoshop will indicate the name of the tool and the keyboard shortcut to access the tool. Some of the tools are stacked in groups of tools. A small black arrow in the bottom right corner of the tool indicates additional tools are stacked behind. To access any of the tools in this stack click and hold down the mouse button on the uppermost tool for a second.

The Options bar

The 'Options' bar gives you access to the controls or specifications that affect the behavior of the tool selected. The options available vary according to the type of tool selected.

The image window

The file name, magnification, color mode and document size are all indicated by the image window in 'Standard Screen Mode'. If the image is larger than the open window the scroll bars can control the section of the image that is visible.

The palettes

The palettes provide essential information and control over the image-editing process. They can be arranged in stacks and moved around the screen and collapsed to icon view. Icons at the base of each palette provide access to frequently used commands while additional options are available from the palette fly-out menu. Clicking the palette tabs or title bars will collapse the palettes to save additional screen real estate. Pressing the 'Tab' key will temporarily hide the palettes. If you want to access the Tools or palettes that are hidden just move your cursor to the edge of the screen for them to reappear.

Note > Pressing the 'Tab' key will hide the palettes and toolbox from view. Pressing the Tab key again returns the palettes and Tools. Holding down the Shift key while pressing the Tab key will hide all the palettes but keep the Tools on the screen. Palettes can be accessed from the Window menu if they are not already open.

Docking palettes

Palettes can be dragged to the edge of the screen to dock them. Clicking on the two-triangle icon at the top of the dock will expand the palettes.

Settings and preferences

Before you start working with an image in Photoshop it is important to select the 'Color Settings' and 'Preferences' in Photoshop. This will not only optimize Photoshop for your individual computer but also ensure that you optimize images to meet the requirements of your intended output device (monitor or print). These settings are accessed through either the 'Photoshop' menu or 'Edit' menu from the main menu at the top of the screen.

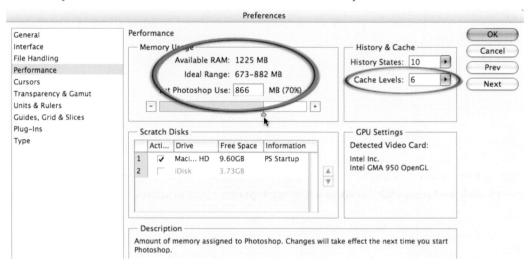

Memory (the need for speed)

If you have a plentiful supply of RAM (512 MB RAM or greater) you have to give permission for Photoshop to tap into these RAM reserves to a greater or lesser extent. Seventy-five percent of the available RAM will automatically be assigned to Photoshop. The best advice is to close all non-essential software when you are using Photoshop and allocate more RAM from the 'Performance' preferences (70% is a good starting point). You will need to restart Photoshop for the software to take advantage of the new memory allocation.

Cache levels

The cache levels setting is used to control the performance of the screen redraw (how long it takes an image to reappear on the screen after an adjustment is made) and histogram speed. If you are working with very-high-resolution images and you notice the redraw is becoming very slow you can increase the redraw speed by increasing the cache levels (it can be raised from the default setting of 6 up to 8 depending on the speed required). The drawback of lowering this setting is that the redraw is less accurate on screen images that are not displayed at 100%.

Allocation of RAM:

Remember that the computer's operating system requires a proportion of the available RAM on your computer. Photoshop CS3 supports a maximum of 4 gigabytes of RAM.

Scratch disks

As well as using RAM, Photoshop also requires a plentiful amount of free memory on the hard drive to use as its 'scratch disk' (a secondary memory resource). To avoid memory problems when using Photoshop it is best to avoid eating into the last few gigabytes of your hard drive space. As soon as you see the space dwindling it should be the signal for you to back up your work to free up additional hard drive capacity, consider the installation of a second hard drive or choose an external hard drive as your scratch disk. If you have a second hard drive installed or you have access to an external drive you can select this as your 'Second Scratch Disk' by going to 'Preferences > Plug-ins and Scratch Disks'.

	Acti	Drive	Free Space	Information	
1	1	Maci HD	9.60GB	PS Startup	
2		iDisk	3.73GB		A

Note > If you are intending to work on a very large image file it is recommended that the scratch disk and image file location are using separate disks or drives.

Efficient use of memory

When you have set up your memory specifications you can check how efficiently Photoshop is working as you are editing an image. Clicking to the right of the document size information (at the base of the image window) will reveal that additional information is available. Choosing the 'Scratch Sizes' option will display how much RAM and how much memory from the scratch disk are being used to process the image.

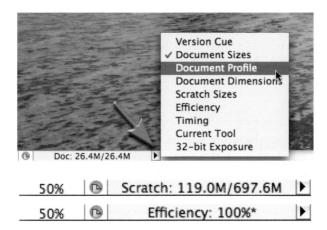

Choosing 'Efficiency' will display whether Photoshop is using the scratch disk to perform the image-editing tasks. Values less than 100% indicate that if more RAM were made available to Photoshop the operations would be faster. Simply closing software or images not being used can often increase efficiency.

Default settings

It is possible to reset all of the software preferences to their default settings as the software is launching by pressing and holding Alt + Control + Shift keys (Windows) or Command + Option + Shift keys (Mac). A screen prompt will invite you to delete the Adobe Photoshop Settings File. This is useful when using a shared computer so that each tool behaves as you would expect it to. Return the working space to its default setting when the application is already open by going to 'Workspace' in the options bar.

Page Setup

Select the paper size and orientation (vertical or horizontal) by going to File > Page Setup. When you have chosen the paper size you can quickly gain an idea of how large your image will be printed by clicking on the information tab at the base of the image window. The window that springs open shows the relationship between the paper and the image (represented by a rectangle with a large cross).

Note > A shaded area around the edge of the paper indicates the portion of the paper that cannot be printed (many older style printers).

Navigation and viewing modes

When viewing a high-resolution image suitable for printing it is usual to zoom in to check the image quality and gain more control over the editing process. There are numerous ways to move around an image and each user has their preferred methods to speed up the navigation process.

The Navigator palette

The Navigator palette is simple and effective to use. You can use it to both zoom in and out of the image and move quickly to new locations within the enlarged image. The rectangle that appears when you are zoomed in shows the area being displayed in the main image window. This rectangle can be dragged to a new location within the image. Using the slider directly underneath the preview window or clicking on the icons either side of the slider controls magnification.

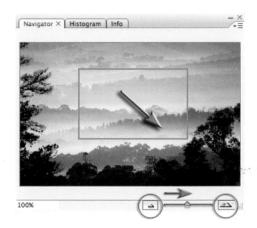

The 'Zoom' and 'Hand' Tools

These tools offer some advantages over the Navigator palette. They can be selected from within the toolbox or can be accessed via keyboard shortcuts. Clicking on the image with the Zoom Tool selected zooms into the image around the point that was clicked. The Zoom Tool options can be selected from the Options bar beneath the main menu. Dragging the Zoom Tool over an area of the image zooms into that area with just the one action (there is no need to click repeatedly).

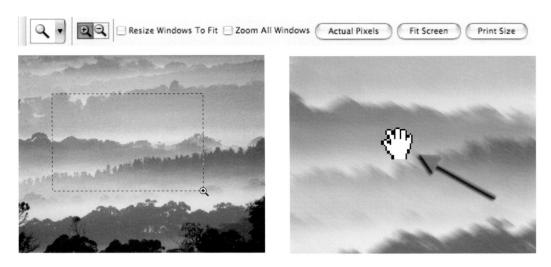

When you are zoomed into an area you can move the view with the 'Hand' Tool. Dragging the image with the Hand Tool selected moves the image within the image window (a little like using the scroll bars). The real advantage of these tools is that they can be selected via shortcuts. The Spacebar temporarily accesses the Hand Tool no matter what other tool is selected at the time (no need to return the cursor to the toolbox). The Zoom Tool can be accessed by pressing the Control/Command + Spacebar to zoom in or the Alt/Option + Spacebar to zoom out.

Note > When you are making image adjustments and a dialog box is open, the keyboard shortcuts are the only way of accessing the zoom and move features (you may need to click inside the adjustment dialog box first before using a keyboard shortcut when using a PC).

Additional shortcuts

Going to the View menu in the main menu will reveal the keyboard shortcuts for zooming in and out. You will also find the more useful shortcuts for 'Fit on Screen' and 'Actual Pixels' (100% magnification). These very useful commands can also be accessed via the Tools palette by either double-clicking on the Hand Tool (Fit on Screen) or double-clicking the Zoom Tool (Actual Pixels).

Screen modes

The screen can begin to look very cluttered in Standard Screen Mode when several applications or windows are open at the same time. A quick way to simplify the view is to switch to 'Maximized Screen Mode' or 'Full Screen Mode With Menu Bar'.

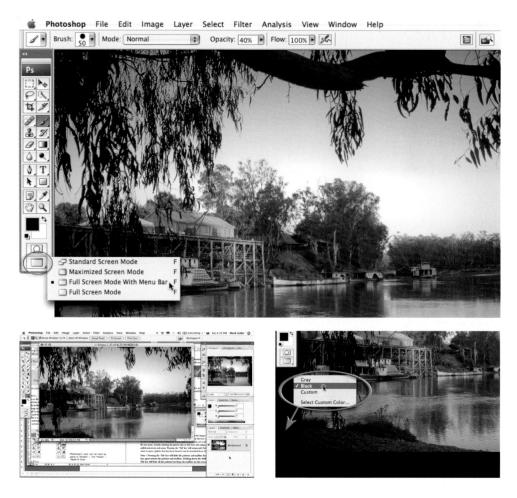

Click the icon located in the Tools palette or click and hold to access the menu, or press the letter 'F' on the keyboard to access the other screen modes. This will temporarily hide all other windows. The open image will be centered on the screen and surrounded with a neutral tone of gray. Continuing to press the F key will cycle through the screen modes and return you to the 'Standard Screen Mode'. Change the color of the background in Full Screen Mode With Menu Bar by Ctrl-clicking (Mac) or right-clicking (PC) on the background color (the background color may not be visible depending on the image size and your current zoom level).

Note > The screen can be further simplified by pressing the 'Tab' key. This hides the palettes and Tools from view. Pressing the Tab key again returns the palettes and Tools. Holding down the Shift key while pressing the Tab key will hide all the palettes but keep the Tools on the screen.

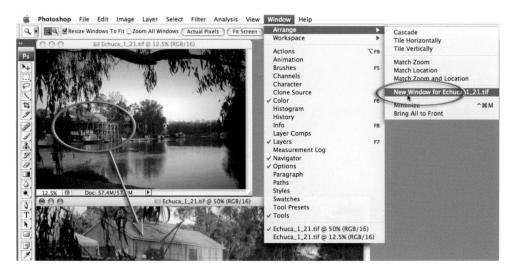

New Window

It is possible to have the same image open in two windows. This allows the user to zoom in to work on detail in one window and see the overall impact of these changes without having to constantly zoom in and out. Any changes made in one window will automatically appear in the other window.

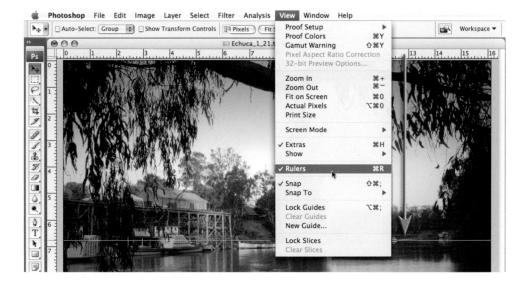

Rulers and guides

Guides can help you to align horizontals and verticals within the image area. Select 'Rulers' from the 'View' menu and then click on either the horizontal or vertical ruler and drag the guide into the image area. Guides can be temporarily hidden from view by selecting 'Extras' from the 'View' menu. Drag a guide back to the ruler using the Move Tool to delete it or remove all the guides by selecting 'Clear Guides' from the 'View' menu.

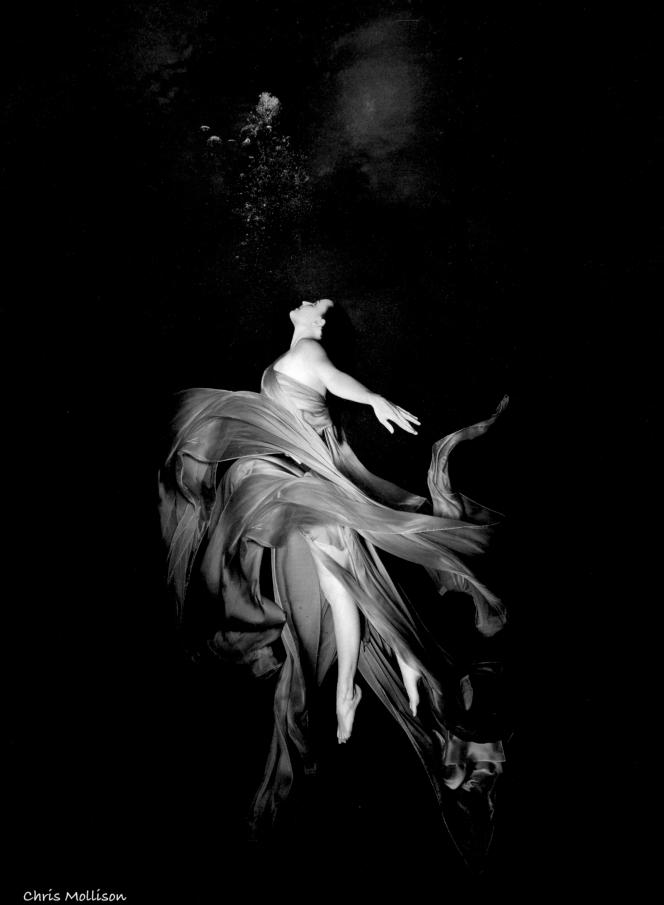

digital basics

hop photoshop photoshop photoshop photoshop photos

nop photoshop photoshop photoshop photoshop photos

essential skills

- ~ Gain a working knowledge of digital image structure.
- ~ Understand file size, bit depth, image modes, channels, file format and resolution.
- ~ Understand color theory and color perception.

Introduction

Digital imaging is now revolutionizing not only the process of photography but also the way we view photography as a visual communications medium. This new photographic medium affords the individual greater scope for creative expression, image enhancement and manipulation. Before we rush into making changes to our digital files in order to create great art, or turn a warty old frog into a handsome prince, it makes sense to slow down and take time out to understand the structure of the digital image file. In this way the technical terms used to identify, quantify and specify the digital file as a whole, or the component parts of the digital file, serve to clarify rather than bamboozle our overloaded gray matter.

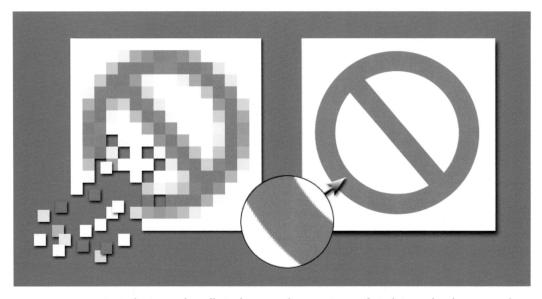

Anti-aliasing and small pixels ensure that a staircase of pixels is rendered as a smooth arc

Pixels

The basic building block of the digital image is the humble pixel (picture element). Pixels for digital imaging are square and positioned in rows horizontally and vertically to form a grid or mosaic. Each pixel in the grid is the same size and is uniform in color and brightness, i.e. the color does not vary from one side of the pixel to the other. If we fully zoom in on the pixels of a digital image, using image-editing software, we will see how smooth flowing shapes can be convincingly constructed out of rectangular building blocks (with not a curved pixel in sight). There are two processes used to create the illusion of curved lines in our photographs. The first is a process called anti-aliasing, where some of the edge pixels adopt a transitional (in-between) color to help create a smoother join between two different adjacent colors or tones. This process helps camouflage noticeable 'staircase' or 'shark's teeth' pixels. The most convincing way to render a smooth flowing line, however, is to simply display the pixels so small that we cannot make them out to be square using the naked eye.

Channels and modes

All the colors of the rainbow when mixed together create white light (a prism is often used to split white light into its component colors to demonstrate the connection between light and color). All the colors of the rainbow can be created by mixing just three of these colors – **Red**, **Green** and **Blue** light (called the **primary** colors of light) – in differing amounts. Using these simple scientific principles all the variations of color in our multicolored world can be captured and stored in three separate component parts of our digital image file. These component parts are called the Red, Green and Blue '**Channels**'. An image that uses this process to store the color data is called an RGB image. RGB is the most common type of '**Image Mode**'.

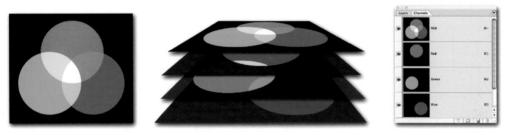

The primary colors of light (stored in three separate channels) create the secondary colors when mixed

In Adobe Photoshop the colored RGB channels are the powerful backbone of Photoshop, working behind the scenes to create multicolored images by providing three sets of information regarding color, i.e. the amount of red, green and blue present in each pixel location. When the color from only one channel is present, a primary color is created in the image window. When information from two channels is present a secondary color is displayed. These secondary colors (created by mixing two primaries) are called Cyan, Magenta and Yellow (CMY). When there is an absence of any color from the three RGB channels the pixel location appears black (no illumination). Mixing all three RGB channels together creates white light or gray if the brightness value from each of the three channels is lowered (see 'Levels'). Color information about the image can also be stored using the secondary colors (mixing two secondary colors creates a primary) plus black (K). Images using this system or **Mode** are called **CMYK** images. Photoshop users can view the information stored in the component channels by clicking on the Channels palette tab.

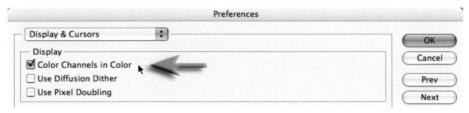

Note > You can view the information in each channel with or without color (Edit/ Photoshop > Preferences > Display & Cursors). It is usually beneficial to view the information in the channels without color when conducting advanced post-production editing but for the purposes of understanding what is actually happening, color is a distinct advantage.

Levels

We have seen how mixing primary colors of light can create the secondary colors. In the previous illustration, where three colored circles were overlapped, the color in each of the three channels is either 'on' or 'off'. In this way six colors are created from three RGB channels. The three channels can, however, house a greater range of information about color than simply 'yes' (fully on) or 'no' (fully off) in any one pixel location. Capture devices are capable of measuring 'how much' color is present in any one given location. In a standard RGB image, 256 different levels of color can be assigned to each pixel location. The channels operate very much like a mixing desk, mixing varying amounts of color from each of the three color channels to create the full color spectrum.

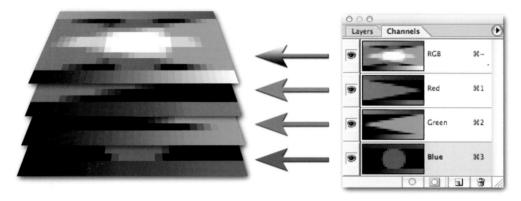

If the three channels are mixed in equal proportions what we see is a series of tonal steps from black (0 in all three channels) to white (255 in all channels).

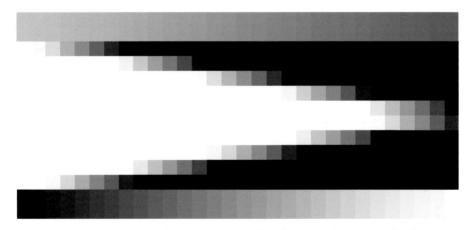

256 levels of tone are reduced to 30 so the steps can be clearly seen

256 separate tones are sufficient to create a smooth transition from dark to light with no visible steps. If the pixels are sufficiently small when printed out, the viewer of the image cannot see either the individual pixels or the steps in tone, and the illusion of 'continuous tone' or 'photographic quality' is achieved.

Hue, Saturation and Brightness

Equally high levels in each of the three color channels creates not only a bright or light toned pixel but may also indicate a bright level of illumination in the scene that has been captured. This can be attributed to the pixel being a record of a bright light, or the reflected light off a brightly illuminated subject, but it may alternatively be due to possible overexposure during the capture process, i.e. the sensor being exposed to the light source for too long.

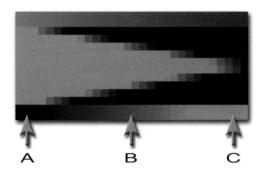

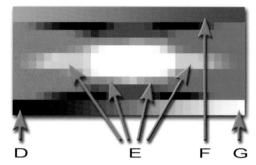

The illustration above shows the enormous variety of tones that can be achieved by combining 256 levels of information from the three color channels. Given that each channel can vary its level of information, independently of the other two, it is possible to create a single pixel with one of a possible 16.7 million different values $(256 \times 256 \times 256)$. To describe the nature of a particular color value without resorting to numbers, Adobe has adopted a system where the characteristics of the color can be described in three ways. These descriptive categories are:

Hue – as dictated by the dominant primary or secondary color, e.g. red, yellow, blue, etc. **Saturation** – the strength of the color, e.g. when one or two of the channels registers 0 the resulting color is fully saturated, i.e. no level of gray or white is weakening the purity of the color.

Brightness – from 0 (black – all channels 0) to 255 (at least one channel registering 255).

Using a common language of Hue, Saturation and Brightness (HSB) we can identify the colors indicated by letters in the illustration above, in terms that can be readily understood by the broader community that are neither mathematicians nor Photoshop nerds.

A to C are levels of brightness from black to fully saturated bright red. The levels from the other two RGB channels are not influencing the overall color or brightness of any of the pixels (all Green and Blue values are set to level 0).

D and G are levels of brightness from black to white. When all RGB channels read the same level the resulting tones are fully desaturated.

E indicates fully saturated secondary colors created by mixing two primary RGB channels at level 255.

F indicates colors of lower saturation as information from the three RGB channels is unequal (therefore creating a gray component to the color's characteristic).

Color Picker

As we have discussed previously it is essential when describing and analyzing color in the digital domain to use the appropriate terminology. A greater understanding of the characteristics of Hue, Saturation and Brightness (HSB) can be gained by viewing colors in the Adobe Color Picker.

To open the Color Picker, click on the foreground swatch in the Tools palette.

Hue – Click on any color in the vertical color bar (in the center of the Color Picker) to view the range of colors associated with that particular hue. Note the number in the top field next to the 'H' radio button. Each of the six primary and secondary colors are positioned 60° apart, e.g. Red at 0°, Yellow at 60°, Green at 120°, etc. Each hue is assigned a number or 'degree' between 0° and 360°. Saturation and Brightness values are not effected by changes in this bar.

Saturation and Brightness – Click in the large square box to the left of the bar to choose a Saturation and Brightness value for the selected Hue. Saturation increases when the selection circle is moved to the right side of the box and decreases when moved to the left. Brightness increases towards the top of the box and decreases towards the bottom of the box. Hue is not affected by these changes.

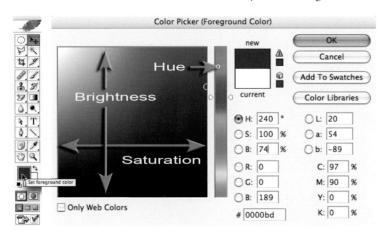

The 'foreground swatch' and 'Color Picker'

Creating and sampling color from an image

If the mouse cursor is moved out of the Color Picker dialog box and into the image window the mouse cursor icon turns into the Eyedropper icon, regardless of what tool was selected in the Tools palette when the Color Picker was opened.

- 1. With the Color Picker open and an image open behind the picker, press the Caps Lock key on the keyboard to turn this icon into a target for precise selection of a color or tone.
- 2. Click in an area of the image window to sample the color and reveal its characteristics in the Color Picker dialog box.
- 3. Change the sample size from a single pixel to a '3 by 3 Average' or '5 by 5 Average' by right-clicking (PC) or Control-clicking (Mac) in the image window to reveal the context menu for the Eyedropper Tool.

Color and light overview

Additive color

The additive primary colors of light are Red, Green and Blue or RGB. Mixing any two of these primary colors creates one of the three secondary colors Magenta, Cyan or Yellow.

Note > Mixing all three primary colors of light in equal proportions creates white light.

Subtractive color

The three subtractive secondary colors are Cyan, Magenta and Yellow or CMY. Mixing any two of these secondary colors creates one of the three primary colors Red, Green or Blue. Mixing all three secondary colors in equal proportions in a CMYK file creates black or an absence of light.

Activity 1- Channels and Info

- 1. Open the files 'RGB' and 'CMY' from the supporting DVD. When opening these files choose 'Leave as is (don't color manage)' in the Missing Profile dialog box.
- 2. Open the Channels palette to see how these six colors plus white and black were created using information from three (RGB) or four (CMYK) channels. Use the Eyedropper Tool and the Info palette (Window > Info) to measure the color values.

Hue, Saturation and Brightness

Although most of the digital images are captured in RGB it is sometimes a difficult or awkward color model for some aspects of color editing. Photoshop allows the color information of a digital image to be edited using the HSB model.

Hue, Saturation and Brightness or HSB is an alternative model for image editing which allows the user to edit either the Hue, Saturation or Brightness independently of the other two.

Activity 2 - Color Picker

- 1. Open the HSB image from the supporting DVD.
- 2. Click on the foreground color swatch in the Tools palette to open the Color Picker.
- 3. Move the cursor into the image window and click on each color in turn to review the HSB color values.

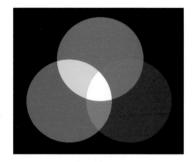

RGB – additive color

CMY – subtractive color

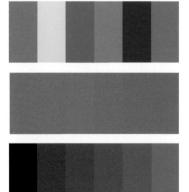

HSB – Hue, Saturation and Brightness

Color perception

Our perception of color changes and is dependent on many factors. We perceive color differently when viewing conditions change. Depending on the tones that surround the tone we are assessing, we may see it darker or lighter. Our perception of a particular hue is also dependent on both the lighting conditions and the colors or tones that are adjacent to the color we are assessing.

Activity 3

Evaluate the tones and colors in the image opposite. Describe the gray squares at the top of the image in terms of tonality. Describe the red bars at the bottom of the image in terms of hue, saturation and brightness. Measure the actual values. If they are the same why do they appear different?

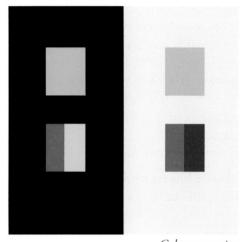

Color perception

Color gamut

Color gamut (or range) varies, depending on the quality of paper and colorants used (inks, toners and dyes, etc.). Printed images have a smaller color gamut than transparency film or monitors and this needs to be considered when printing. In the image opposite the out of gamut colors are masked by a gray tone. These colors are not able to be printed using the default Photoshop CMYK ink values.

Color management issues

The issue of obtaining consistent color – from original, to its display on a monitor, through to its reproduction in print – is considerable. The variety of devices and materials used to capture, display and reproduce color in print all have a profound effect on the end result.

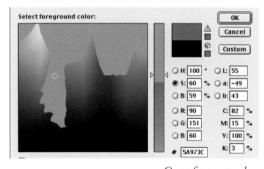

Out of gamut colors

Color management ensures consistent colors

Bit depth and mode

As discussed earlier in 'Levels' each pixel in a single channel of a standard RGB image is described in one of a possible 256 tones or levels. The computer memory required to calculate and store this color data is '8 bits', a bit (binary digit) being the basic unit of the computer's memory. The amount of bits dedicated to describing and recording tonal or color variations is called the 'bit depth'. If only tonal information is required (no color) a single channel 8-bit image is sufficient to create a good quality black and white image, reproducing all of the tonal variations needed to produce 'continuous tone'. An 8-bit image that handles only tonal variations is more commonly referred to as a **Grayscale** image.

When 8 bits are needed for each of the three channels of an RGB image this results in what is often referred to as a 24-bit image (3 × 8). Photoshop, however, does not refer to an RGB image as a 24-bit image but rather as an RGB Color and lists the bit depth of each channel rather than the entire image, e.g. 8 Bits/Channel. Images with a higher 'bit depth' have a greater potential for color or tonal accuracy although this sometimes cannot be viewed because of the limitations of the output device. Images with a higher bit depth, however, require more data or memory to be stored in the image file (Grayscale images are a third of the size of RGB images with the same pixel dimensions and print size). Photoshop offers support for 16 Bits/Channel and 32 Bits/Channel images.

RGB image, 256 levels per channel (24-bit)

256 levels (8-bit)

Capturing and editing at bit depths exceeding 8 bits per channel Sophisticated 'prosumer' (point and shoot) digital cameras and digital SLRs (DSLRs) are able to export files in the 'RAW' format in bit depths higher than 8 bits per channel to the computer. Higher quality scanners are able to scan and export files at 16 bits per channel (48-bit). In Photoshop it is possible to edit an image using 32, 16 or 8 bits per channel. The size of the file (megabytes rather than pixel dimensions) doubles each time the bit depth is doubled. 16 and 32 Bits/Channel image editing is used by professionals for high-quality or specialized image editing. When extensive tonal or color corrections are required it is recommended to work in 16 bits per channel whenever possible. It is, however, important to note that not all of the Adobe editing tools function in 16-bit mode (even less in 32 Bits/Channel).

File size

Digital images are data hungry (this data being required to record the extensive variations in color and/or tone of the original image or subject). The simple binary language of computers and the visual complexities of a photographic image lead to large 'file sizes'. This data can require large amounts of computer memory to display, print or store the image. The text file for this entire book would only be a small fraction of the memory required for the cover image (10 megabytes).

Units of memory		
8 bits	=	1 byte
1024 bytes	=	1 kilobyte
1024 kilobytes	=	1 megabyte
1024 megabytes	=	1 gigabyte
Storage capacity	of disks	and drives
Flash/USB pen	=	64 megabytes-2 gigabyte
CD	=	700-800 megabytes
DVD	=	4–9 gigabytes
iPod	=	512 megabytes to 80 gigabyte

Fortunately files can be '**compressed**' (reduced in memory size) when closing the file for storage or uploading over the Internet. Portable hard drives (such as Apple's 'iPod' or the smaller 'USB' or 'Flash' drives) are now commonly used for storing and transferring large image files conveniently and quickly. A 10-megapixel digital image can be saved as a 15-megabyte RAW file or a 1-megabyte JPEG file using a high-quality compression setting. The same file opens up to a 27.2-megabyte file in Photoshop. When talking about file size it helps to know whether you are talking about an open or closed file and whether any image compression has been used.

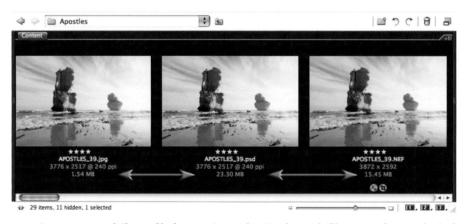

Same image – different file formats (viewed in Bridge with file size preference checked)

Note > If you are using Bridge (see the following chapter) it is possible to gain information about image size (megabytes) and pixel dimensions from files that have not been opened, either directly underneath the image thumbnail or in the 'Metadata' tab. When an image that has been compressed is opened in Photoshop the file size in megabytes will be larger but the pixel dimensions will remain the same.

File formats

When an image is captured by a camera or scanning device it has to be 'saved' or memorized in a 'file format'. If the binary information is seen as the communication, the file format can be likened to the language or vehicle for this communication. The information can only be read and understood if the software recognizes the format. Images can be stored in numerous different formats. The four dominant formats in most common usage are:

- Raw (.dng) Camera Raw and Digital Negative
- JPEG (.jpg, jpf and jpx) Joint Photographic Experts Group
- TIFF (.tif) Tagged Image File Format
- Photoshop (.psd) Photoshop Document

Camera RAW and Digital Negatives – Unlike the other file formats, RAW is not an acronym for a much longer name. Selecting the RAW format in the camera instead of JPEG or TIFF stops the camera from processing the color data collected from the sensor. The RAW data is what the sensor 'saw' before the camera processes the image, and many photographers have started to refer to this file as the 'digital negative'. The unprocessed RAW has to be converted into a usable image file format using image-editing software supplied by the camera manufacturer or built into software packages such as Adobe Photoshop and can be compressed and archived as a 'Digital Negative'.

A close-up detail of an image file that has been compressed using maximum image quality in the IPEG options box

A close-up detail of an image that has been compressed using low image quality in the JPEG options box.

Notice the artifacts that appear as blocks

JPEG (Joint Photographic Experts Group) – Industry standard for compressing continuous tone photographic images destined for the World Wide Web (www) or for storage when space is limited. JPEG compression uses a 'lossy compression' (image data and quality are sacrificed for smaller file sizes when the image files are closed). The user is able to control the amount of compression. A high level of compression leads to a lower quality image and a smaller file size. A low level of compression results in a higher quality image but a larger file size.

Note > It is recommended that you only use the JPEG file format after you have completed your image editing and always keep a master Photoshop document for archival purposes.

Format	Compression	Color modes	Layers	Transparency	Uses
RAW	No	Unprocessed	No	No	Master file
JPEG	Yes	RGB, CMYK, Grayscale	No	No	Internet and camera format (compressed)
JPEG2000	Yes	RGB, CMYK, Grayscale	No	No	Internet and archival
Photoshop	No	RGB, CMYK, Grayscale, Indexed color	Yes	Yes	Master file (modified)
TIFF	Yes	RGB, CMYK, Grayscale	Yes	Yes	Commercial printing and generic camera format (lossless)
GIF	Yes	Indexed color	No	Yes	Internet graphics and animations
DNG	Yes	Unprocessed	No	No	Archival format for storing original RAW and metadata

JPEG2000 – This version of the JPEG format supports 16 Bits/Channel and alpha channels and produces less image artifacts than the standard JPEG compression but uses a more complex list of saving options than the standard JPEG format. Photoshop CS3 supports the file format but it is not available as part of the 'Save for Web' options.

PSD (**Photoshop Document**) – This is the default format used by the Adobe image-editing software. A Photoshop document is usually kept as the master file from which all other files are produced depending on the requirements of the output device. The PSB format is another version of PSD and is designed specifically for creating documents larger than 2GB.

TIFF (**Tagged Image File Format**) — This has been the industry standard for images destined for publishing (magazines and books, etc.). TIFF uses a 'lossless' compression (no loss of image data or quality) called '**LZW compression**'. Although preserving the quality of the image, LZW compression is only capable of compressing images by a small amount. TIFF files now support layers and transparency that can be read by other Adobe software products such as InDesign.

GIF (**Graphics Interchange Format**) – This format is used for logos and images with a small number of colors and is very popular with web professionals. It is capable of storing up to 256 colors, animation and areas of transparency. It is not generally used for photographic images.

DNG (**Digital Negative Format**) – The DNG format is a new archival file format that stores both the RAW picture data as well as the metadata saved by the camera at the time of shooting.

TOP TIPS for cross-platform saving

Many work and education environments contain a mix of Windows and Macintosh machines. Though both systems are far better at reading each other's files than they used to be, there are still occasions when you will have trouble when sharing files between the two platforms. Use these tips to ensure that work that you save is available for use in both environments.

1. Make sure that you always append your file names.

This means add the three-letter abbreviation of the file format you are using after the name. So if you were saving a file named 'Image1' as a TIFF the saved file would be 'Image1.tif', a JPEG version would be 'Image1.jpg' and a Photoshop file would be 'Image1.psd'. Macintosh Photoshop users can force the program to 'Always Append' by selecting this option in the 'Saving Files' section of Preferences.

2. Save TIFF files in the IBM version.

When saving TIFF files you are prompted to choose which platform you prefer to work with; choose IBM if you want to share files. Macintosh machines can generally read IBM (Windows) TIFFs, but the same is not true the other way around.

3. Macintosh users save images to be shared on Windows formatted disks. If you are sharing images on a portable storage disk such as a Zip drive always use media that are formatted for Windows. Macintosh drives can usually read the Windows disks but Windows machines can't read the Macintosh versions.

4. Try to keep file names to eight characters or less and don't use spaces.

Older Windows machines and some web servers have difficulty reading file names longer than eight characters. So just in case you happen to be trying to share with a cantankerous old machine get into the habit of using short names – and always appended of course. Use a hyphen or underscore instead of a space and use lower case characters only (no capitals) if the images are destined for a web server that likes to say 'no'.

Image compression

Imaging files are huge. This is especially noticeable when you compare them with other digital files such as those used for word processing. A text document that is 100 pages long can easily be less than 1% the size of a file that contains a single 8×10 inch digital photograph. With files this large it soon became obvious to the industry that some form of compression was needed to help alleviate the need for us photographers to be continuously buying bigger and bigger hard drives.

What emerged was two different ways to compress pictures. Each enables you to squeeze large image files into smaller spaces but one system does this with no loss of picture quality – lossless compression – whereas the other enables greater space savings with the price of losing some of your image's detail – lossy compression.

What is compression?

All digital picture files store information about the color, brightness and position of the pixels that make up the image. Compression systems reorder and rationalize the way in which this information is stored. The result is a file that is optimized and therefore reduced in size. Large space savings can be made by identifying patterns of color, texture and brightness within images and storing these patterns once, and then simply referencing them for the rest of the image. This pattern recognition and file optimization is known as compression.

The compression and decompression process, or CODEC, contains three stages:

- 1. The original image is compressed using an algorithm to optimize the file.
- 2. This version of the file becomes the one that is stored on your hard drive or web site.
- 3. The compressed file is decompressed ready for viewing or editing.

If the decompressed file is exactly the same as the original after decompression, then the process is called 'lossless'. If some image information is lost along the way then it is said to be 'lossy'. Lossless systems typically can reduce files to about 60% of their original size, whereas lossy compression can reduce images to less than 1%.

There is no doubt that if you want to save space and maintain the absolute quality of the image then the only choice is the lossless system. A good example of this would be photographers, or illustrators, archiving original pictures. The integrity of the image in this circumstance is more important than the extra space it takes to store it.

On the other hand (no matter how much it goes against the grain), sometimes the circumstances dictate the need for smaller file sizes even if some image quality is lost along the way. Initially you might think that any system that degrades the image is not worth using, and in most circumstances, I would have to agree with you. But sometimes the image quality and the file size have to be balanced. In the case of images on the web they need to be incredibly small so that they can be transmitted quickly over slow telephone lines. Here some loss in quality is preferable to images that take 4 or 5 minutes to appear on the page. This said, I always store images in a lossless format on my own computer and only use a lossy format when it is absolutely crucial to do so.

Format	Compression amount	Original file size	Compressed file size	Lossy/ Lossless
JPEG	Minimum		0.14MB	Lossy
JPEG	Maximum	20.0MB (PSD file)	2.86MB	Lossy
JPEG2000	Minimum		0.07MB	Lossy
JPEG2000	Maximum		2.54MB	Lossy
JPEG2000			5.40MB	Lossless
TIFF	LZW		10.30MB	Lossless
TIFF	Zip		10.10MB	Lossless
TIFF	None		27.30MB	Lossless
PSD			20.00MB	Lossless

Comparing the compression abilities of different file types and settings using the same 20MB base file

How lossy is lossy?

The term lossy means that some of the image's quality is lost in the compression process. The amount and type of compression used determines the look of the end result. Standard JPEG and JPEG2000 display different types of 'artifacts' or areas where compression is apparent. The level of acceptable artifacts and practical file sizes will depend on the required outcome for the picture.

To help ensure that you have the best balance of file size and image quality make sure that you:

- Use the Save for Web or Save As > JPEG2000 features both contain a post-compression preview option.
- Always examine the compressed image at a magnification of 100% or greater so that unacceptable artifacts will be obvious.

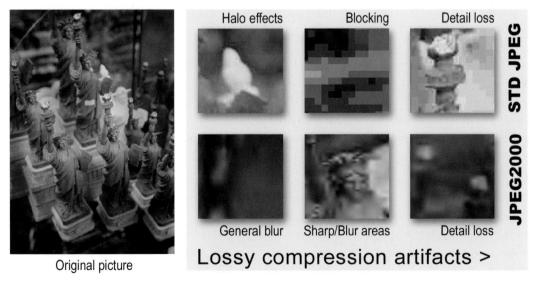

Typical artifacts resulting from applying too much compression to a photo

Resolution

Resolution is a term that is used to specify the size of a pixel, a dot of colored light on a monitor or a dot of ink on the printed page. There are usually two resolutions at play at any one time — the resolution of the digital file and that of the output device. We can talk about capture size, image resolution, monitor resolution and printer resolution. They are all different, but they all come into play when handling a single digital image that is to be printed. Various resolutions can be quoted as we move through the chain of processes involved in creating a digital print (in the example below the total number of pixels remains constant throughout the chain of events).

Summary

An image captured at a resolution greater than 3000ppi is displayed at 100ppi on a high-resolution monitor. Using Photoshop, the image resolution is lowered to 256ppi (the pixel dimensions remain the same). The image is then printed using an inkjet printer with a printer resolution of 1440dpi (dots per inch). The different resolutions associated with this chain of events are:

Capture size > Display resolution > Image resolution > Output device resolution

Image sensor

The sensor to the right creates an image file with 5 million pixels or 5 megapixels (2560×1920 pixels). The resolution assigned to the image file by the capture device may be a print or monitor resolution. Either way it has no bearing on the file size, which is determined by the total number of pixels.

The monitor resolution (the size of its display pixels, e.g. 1024×768) is defined by its resolution setting (approximately 100 pixels for every linear inch or 10,000 pixels for every square inch in a high definition TFT display). The image pixels (different than the display pixels) can be viewed in a variety of sizes by zooming in and out of the image using image-editing software.

Digital file adjusted in Photoshop

The resolution of the digital file is adjusted to 256 pixels per inch (ppi). Each pixel is allocated a size of 1/256th of an inch. Because the digital file is 2560 pixels wide this will create a print that is 10 inches wide if printed ($256 \times 10 = 2560$).

Note > Increasing the document size further will start to lower the resolution below an acceptable level (the pixels will become large enough to see with the naked eye).

The image is printed

The image is printed on an inkjet printer using a printing resolution of 1440 dots per inch. Many colored dots of ink are used to render a single image pixel (see 'Dpi and ppi').

Understanding resolution

Resolution is perhaps the most important, and the most confusing, subject in digital imaging. It is important because it is linked to quality. It is confusing because the term 'resolution' is used to describe at what quality the image is captured, displayed or output through various devices.

10 pixels per inch

20 pixels per inch

40 pixels per inch

Resolution determines image quality and size

Increasing the total number of pixels in an image at the capture or scanning stage increases both the quality of the image and its file size. It is 'resolution' that determines how large or small the pixels appear in the final printed image. The greater the image resolution the smaller the pixels, and the greater the apparent sharpness of the final image. Resolution is stated in 'pixels per inch' or 'ppi'.

Note > With the USA dominating digital photography, measurements in inches rather than centimeters are commonly used -1 inch equals exactly 2.54 centimeters.

The images to the right have the same pixel dimensions (300×300) but different resolutions. The large image has a resolution half that of the small one. A digital image can be made to appear bigger or smaller without changing the total number of pixels, e.g. a small print or a big poster. This is because a pixel has no fixed size. The pixel size can be modified by the image-editing software to change the document size. Increasing the resolution of the image file decreases the size of the pixels and therefore the output size of the file.

Note > When talking about the 'size' of a digital image it is important to clarify whether it is the pixel dimensions or the document size (measured in inches or centimeters) that are being referred to.

Dpi and ppi

If manufacturers of software and hardware were to agree that dots were round and pixels were square it might help users differentiate between the various resolutions that are often quoted. If this was the case the resolution of a digital image file would always be quoted in 'pixels per inch', but this is not the case.

At the scanning stage some manufacturers use the term dpi instead of 'ppi'. When scanning, 'ppi' and 'dpi' are essentially the same and the terms are interchangeable, e.g. if you scan at 300dpi you get an image that is 300ppi.

When working in Photoshop image resolution is always stated in ppi. You will usually only encounter dpi again when discussing the monitor or printer resolution. The resolutions used to capture, display or print the image are usually different to the image resolution itself.

Note > Just in case you thought this differentiation between ppi and dpi is entirely logical – it isn't. The industry uses the two terms to describe resolution, 'pixels per inch' (ppi) and 'dots per inch' (dpi), indiscriminately. Sometimes even the manufacturers of the software and hardware can't make up their minds which of the two they should be using, e.g. Adobe refer to image resolution as ppi in Photoshop and dpi in InDesign – such is the non-standardized nomenclature that remains in digital imaging.

File size and resolution

When we use the measurement 'ppi' or 'pixels per inch' we are referring to a linear inch, not a square inch (ignore the surface area and look at the length).

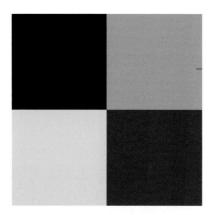

2 inch × 2inch file @ 1ppi = 4 pixels

2 inch × 2 inch file @ 2ppi = 16 pixels

File size, however, is directly linked to the **total** number of pixels covering the entire surface area of the digital image. Doubling the image output dimensions or image resolution quadruples the total number of pixels and the associated file size in kilobytes or megabytes.

Note > Handling files with excessive pixel dimensions for your output needs will slow down every stage of your digital image process, including scanning, saving, opening, editing and printing. Extra pixels above and beyond what your output device needs will not lead to extra quality. Quality is limited or 'capped' by the capability of the output device.

Calculating a suitable file size and scanning resolution

Scanning resolution is rarely the same as the resolution you require to print out your image. If you are going to create a print larger than the original you are scanning, the scanning resolution will be greater than the output resolution, e.g. a 35mm negative would have to be scanned at 1200ppi if a 6×4 inch commercial print is required. If the print you require is smaller than the original, the scanning resolution will be smaller than the output resolution.

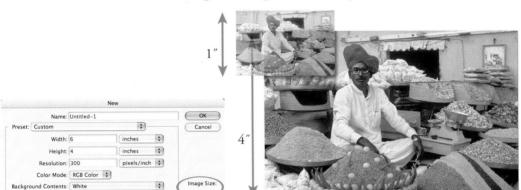

The smaller the original the higher the scanning resolution.

Magnification \times output resolution = scanning resolution scanning resolution = 4×300 ppi = 1200ppi

To calculate the correct file size and scanning resolution for the job in hand you can:

Either: Go to 'File > New' in Photoshop, type in the document size, resolution and mode you require and then make a note of the number of megabytes you require from the scanning process. Then adjust the scanning software resolution until the required number of megabytes is captured.

Or: Multiply the magnification factor (original size to output size) by the output resolution (as dictated by the output device) to find the scanning resolution (not so difficult as it sounds!).

Size and mode	Output device resolution				
	100ppi screen	240ppi inkjet	300ppi commercial		
8 × 10 RGB	2.29MB	13.20MB 4.39MB	20.60MB 6.87MB		
8 × 10 Grayscale	781K	4.3910115		size	
$5 \times 7 \text{ RGB}$	1.00MB	5.77MB	9.01MB	S	
5 × 7 Grayscale	342K	1.92MB	3.00MB	File	
4 × 6 RGB	703K	3.96MB	6.18MB	H	
4 × 6 Grayscale	234K	1.32MB	2.06MB		

Image size

Before you adjust the size of the image you have to know how to determine the size you need. Six- and eight-megapixel digital cameras are currently the affordable 'end' of professional digital capture. The image resolution produced by these digital cameras is not directly comparable to 35mm film capture but the images produced can satisfy most of the requirements associated with professional 35mm image capture. DSLRs using full frame sensors can match medium format film cameras for quality.

Six megapixel cameras capture images with pixel dimensions of around 3000×2000 (6 million pixels or 6 'megapixels'). The resulting file size of around 17MB (1 megapixel translates to nearly 3 megabytes of data) is suitable for an image in a commercial magazine that would nearly fill the page. Ten-megapixel cameras are capable of producing files that can be used to illustrate double-page spreads in magazines with just a small amount of resampling (see Interpolation).

Useful specifications to remember

- Typical standard-resolution monitor: 1024 × 768 pixels
- Typical full-page magazine illustration: 3400×2500 (8.5 million pixels)
- High-resolution TFT monitor: 100ppi
- High quality inkjet print: 240ppi
- Magazine quality printing requirements: 300ppi
- Full-screen image: $2.25MB (1024 \times 768)$
- Postcard-sized inkjet print: 4MB
- 10×8 inch inkjet print: 13.2MB
- Full-page magazine image at commercial resolution: 20MB

Note > Remember to double the above file sizes if you intend to edit in 16-bit per channel mode.

A 20MB file will usually suffice if you are not sure of the intended use of the digital file. Thirty-five-millimeter film scanned with a scanning resolution of **2300** will produce a 20.3MB file (2173 pixels \times 3260 pixels).

Pixel dimensions, document size and resolution

Before retouching and enhancement takes place, determine if the '**image size**' needs to be scaled for the intended output (the capture resolution will probably require changing to output resolution). This will ensure that optimum image quality and computer operating speed are maintained. To control image size go to '**Image > Image Size**' in Photoshop.

Image size is described in three ways:

- Pixel dimensions (the number of pixels determines the file size in terms of kilobytes).
- Print size (output dimensions in inches or centimeters).
- Resolution (measured in pixels per inch or ppi).

If one is altered it will affect or impact on one or both of the others, e.g. increasing the print size must either lower the resolution or increase the pixel dimensions and file size. The image size is usually changed for the following reasons:

- Resolution is changed to match the requirements of the print output device.
- Print output dimensions are changed to match display requirements.

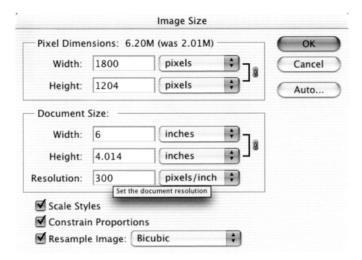

Image size options

When changing an image's size a decision can be made to retain the proportions of the image and/or the pixel dimensions. These are controlled by the following:

- If 'Constrain Proportions' is selected the proportional dimensions between image width
 and image height are linked. If either one is altered the other is adjusted automatically and
 proportionally. If this is not selected the width or height can be adjusted independently of
 the other and may lead to a distorted image.
- If 'Resample Image' is selected (use with caution, see 'Resampling') adjusting the dimensions or resolution of the image will allow the file size to be increased or decreased to accommodate the changes. Pixels are either removed or added. If deselected the print size and resolution are linked to prevent resampling. Changing width, height or resolution will change the other two. Pixel dimensions and file size remain constant.

Resampling

An image is 'resampled' when its pixel dimensions (and resulting file size) are changed. It is possible to change the output size or resolution without affecting the pixel dimensions (see 'Understanding resolution'). Resampling usually takes place when the pixel dimensions of the original capture or scan do not precisely match the requirements for output (size and resolution). Downsampling decreases the number of pixels and information is deleted from the image. Increasing the total number of pixels or resampling up requires new pixels to be added to the file. The new pixels use information based on color values of the existing pixels in the image file.

Image scanned at correct resolution

Effects of excessive resampling up

Excessive resampling up can result in poor image quality (the image will start to appear blurry). Avoid the need for resampling to enlarge the file size, if at all possible, by capturing at a high enough resolution or by limiting the output size. If you have to resample due to the limitations of your capture device (not enough megapixels) then files that resample best are those that have been captured from a digital camera using a low ISO setting and have not previously been sharpened.

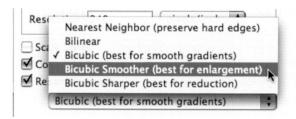

When resampling up an image to create a larger file, choose the 'Bicubic Smoother' from the Interpolation options in the Image Size dialog box. Use 'Bicubic Sharper' when decreasing the size of the file. Bilinear and Nearest Neighbor are used for hard-edged graphics and are rarely used for the interpolation of photographs. If you have already sharpened your image prior to resampling (best avoided) you will need to reapply the Unsharp Mask or Smart Sharpen to regain the sharp quality of the image.

Interpolation

Well it seems that in recent years a small revolution in refinement has been happening in the area of interpolation technologies. The algorithms and processes used to apply them have been continuously increasing in quality until now they are at such a point that the old adages such as

Sensor dimension/output resolution = maximum print size

don't always apply. Using either software or hardware versions of the latest algorithms it is now possible to take comparatively small files and produce truly large prints of good quality.

Resampling techniques

Bicubic – All resampling techniques in Photoshop use the best interpolation settings of Bicubic, Bicubic Sharper or Bicubic Smoother in conjunction with the Image > Image Size feature. The standard approach uses a 4×4 sampling scheme of the original pixels as a way of generating new image data. With the Resample and Constrain Properties options selected, the new picture dimensions are entered into the 'width' and 'height' areas of the dialog. Clicking OK will then increase the number of pixels in the original.

Use the Smart Sharpen or Unsharp Mask filter after resampling rather than before and restrict the amount of resampling that is performed on a single image. If the software allows the user to crop, resize and rotate the image at the same time, this function should be utilized whenever possible.

Bicubic via LAB – In this technique the mode of the picture is changed from RGB to LAB first using the Image > Mode > Lab command. The two color channels (A and B) are then hidden in the channels palette and the bicubic interpolation is applied to just the lightness (L) channel. The color channels are then switched back on. The theory behind this approach is that by only interpolating the lightness channel the enlarged image will suffer less deterioration overall.

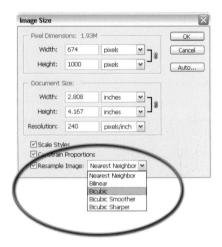

Stair interpolation – There is a growing school of thought that states that increasing the size of an image by several smaller steps will produce a sharper, more detailed result than making the upscale enlargement in a single jump. Most professionals who use this approach increase the size of their images by 10% each time until they reach the desired pixel dimensions.

The advances in the algorithms and procedures used to create large images have dramatically improved over the last few years. I still cringe saying it, but it is now possible to break the 'I must never interpolate my images rule' in order to produce more print area for the pixels I have available.

Resampling guidelines:

When resampling keep in mind the following guidelines for ensuring the best results:

- 1. Images captured with the correct number of pixels for the required print job will always produce better results than those that have been interpolated.
- 2. The softening effect that results from high levels of interpolation is less noticeable in general, landscape or portrait images and more apparent in images with sharp-edged elements.
- 3. The more detail and pixels in the original file the better the interpolated results will be.
- 4. A well-exposed, sharply focused original file that is saved in a lossless format such as TIFF is the best candidate image for upsizing.

What is interpolation anyway?

Interpolation is a process by which extra pixels are generated in a low-resolution image so that it can be printed at a larger size than its original dimensions would normally allow. Interpolation, or as it is sometimes called, upsizing, can be implemented via software products such as the Image Size > Resample option in Photoshop or by using the resize options in the printer's hardware.

Both approaches work by sampling a group of pixels (a 4×4 matrix in the case of bicubic interpolation) and using this information together with a special algorithm as a basis for generating the values for newly created pixels that will be added to the image. The sophistication of the algorithm and the size of the sampling set determine the quality of the interpolated results.

Printer-based resampling

An alternative approach to using Photoshop to resample your picture is to make use of the 'scaling' options in your printer driver dialog. Most desktop and high-end laboratory digital printers are capable of the interpolation necessary to produce big prints.

When outsourcing to a professional printer the file is kept to its original pixel dimensions and the resolution is reduced so that the print size

will equal the required print dimensions. The digital printer is then instructed to interpolate the file as it was printing to its optimum resolution of the machine. On the desktop a similar process is used with the digital photographer selecting a scale value, or an option to match the image size to the paper dimensions, in the print or print driver dialog. Letting the output device perform the interpolation of the image has the following advantages: the process does not require the photographer to change the original file in any way and it removes an extra processing step from the file preparation process.

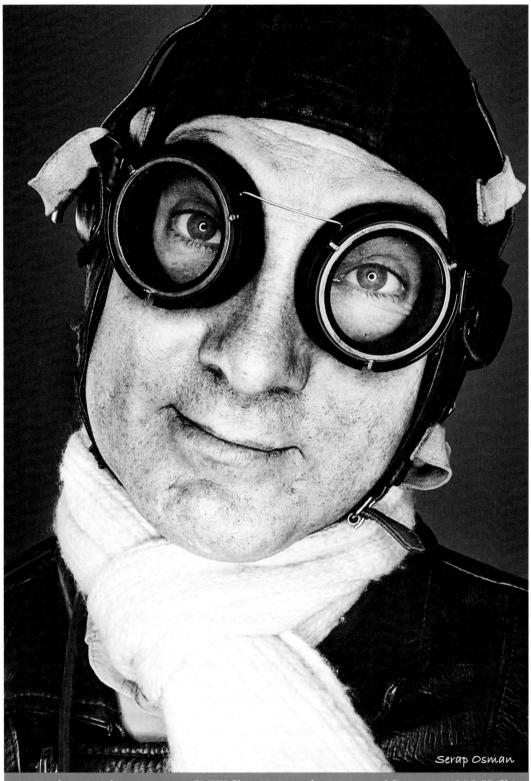

5.5 inches x 8 inches @ 300ppi – CMYK file – 15.1 megabytes (converted from an 11.3M RGB file)

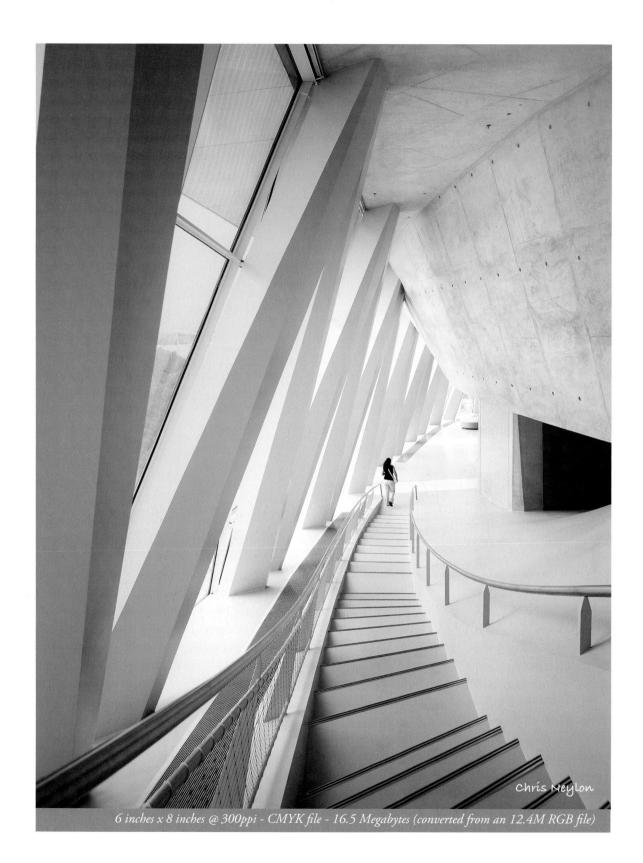

hop photoshop ph

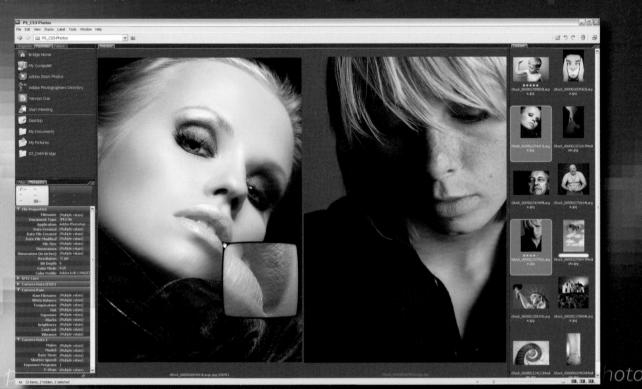

Images courtesy of www.iStockphoto.com

essential skills

- ~ Gain a working knowledge of Bridge.
- ~ Understand how to change the contents and appearance or the workspace.
- ~ Download, sort, add keywords and process files from Bridge.

Introduction

For most photographers the world of digital has heralded a new era in picture taking. The apparent lack of cost (no film or processing charges) involved in the recording of each frame means that most of us are shooting more freely and more often than ever before. More pictures not only means more time processing, enhancing and printing them but also more time sorting, searching, naming, tagging and storing. In fact, recent studies of how photographers spend their time have shown that many spend 10–15% of their working day involved in just these sort of management activities. For this reason many use specialized Digital Asset Management (DAM) systems or software to aid with this work. Though for many image workers asset management is the least stimulating part of their job, it is a key area where building skills will free up more time for those parts of the process that you enjoy the most – taking and processing pictures.

Bridge - the center for asset management

Over the last few revisions of Photoshop, Adobe has become increasingly more involved in including image management tools for the working photographer as part of the editing program.

Initially this meant the inclusion of a File Browser which could be opened from inside Photoshop but more recently a totally separate program called Bridge has replaced the standard file browser option. The application can be opened by itself via the program menu, or from within Photoshop with the File > Browse command or button on the Options bar.

Bridge has now developed into a tool that is much more suitable for managing your image assets

The fastest way to open a file from your picture library is to search for, and select, the file from within Bridge and then press Ctrl/Cmd + O or, if Photoshop is not the default program used for opening the file, select File > Open With > Photoshop. Multi-selected files in the browser can also be opened in this way.

Keep in mind that Bridge is a separate stand-alone application from Photoshop, has its own memory management system and can be opened and used to organize and manage your photo files without needing to have Photoshop running at the same time.

Bridge can be opened in a variety of different ways: individually via the Start menu (left) or from inside Photoshop using the dedicated button on the Options bar (middle) or the File > Browse command (right)

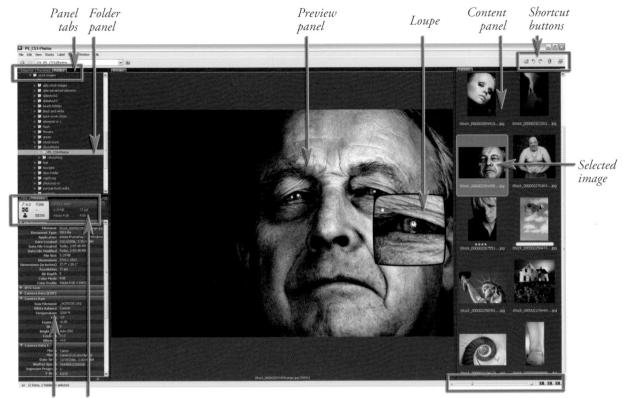

Metadata Capture panel details ('metadata placard') Bridge 2.0 has a new interface, three panel areas, sideby-side preview options, a Filter feature for fast searches, a dedicated download manager and a Loupe Tool. This view has been changed from the default view; there is a discussion of how to do this in this chapter Thumbnail size slider and workspace shortcut buttons

Bridge turns 2.0!

First introduced in Photoshop CS2, Bridge has quickly become an important part of most photographers' daily workflow. Rather than just being a file browser, Bridge also enables photographers to organize, navigate image assets, add metadata and labels and even process Raw files. The interface has changed from the first release of the program. Now Bridge has a three-panel area setup which makes the most of the wide screen arrangements that many image makers are now using. A variety of panels can be displayed in any of the areas. These include:

- Folders panel displays a folder-based view of your computer.
- Favorites panel provides quick access to regularly used folders you select.
- Metadata panel shows metadata information for the select file.
- Keywords panel use for adding new or existing keywords to single or multiple photos.
- Filter panel provides sorting options for the files displayed in the content panel.
- Preview panel shows a preview of selected files or files. Includes the loupe option.
- Inspector panel displays a variety of custom details controlled by options in the preferences.
- Content panel this panel displays the thumbnail version of your assets.

Setting up Bridge

Viewing options

One of the real bonuses of Bridge is the multitude of ways that the panels can be viewed in the workspace. Essentially two different controls alter the way that Bridge appears – Workspace and View.

Workspace controls the overall look of the Bridge window and is centered around the Window > Workspace menu. Panels can be opened, resized, swap positions, be grouped together and pushed and pulled around so that you create a work environment that really suits your needs and specific screen arrangements. It is even possible to stretch Bridge over two screens so that you can use one screen for previewing and the other for displaying metadata, favorites or content. Once you are happy with the layout of the workspace use the Window > Workspace > Save Workspace option to store your design. Alternatively you can select from a number of preset workspace designs located in the Window > Workspace menu.

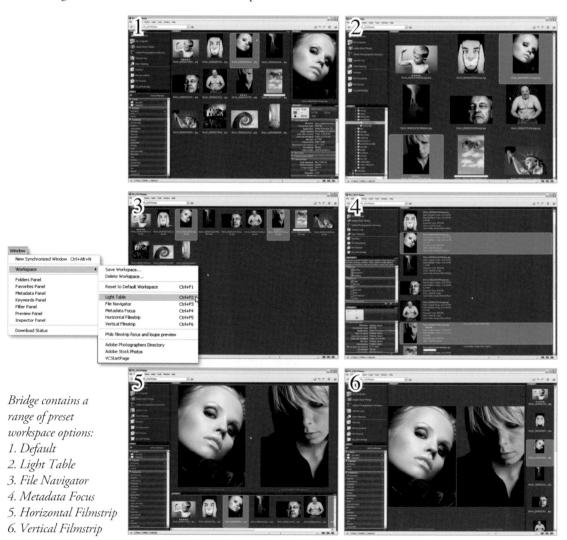

Most View options are grouped under the View menu and essentially alter the way that Content area data or thumbnails are presented. Here you can choose to show the thumbnails by themselves with no other data (View > Show Thumbnail only) or with metadata details included (View > As Details).

There is also an option to display the content thumbnails as an impromptu slideshow. With no images selected choose View > Slideshow to include all pictures in the content panel in the show. To display a few photos, multi-select the pictures first, and then pick the Slideshow command. The overall slideshow options such as duration, transitions and caption content can be altered via the option settings (View > Slideshow Options).

In addition, Bridge 2.0 also contains two new viewing features. The first is the ability to display multiple pictures in the preview panel in a side-by-side manner. Simply multi-select several items in the content area to display them in the preview panel in this new compare mode. The second feature is the new Loupe Tool, which acts like an interactive magnifier. The loupe size changes with the size of the displayed preview image and works best with a large preview image. To use, click the cursor on an area in the preview picture. A 100% preview of this picture part is then displayed. Click and drag the cursor to move the loupe around the photo.

The way that picture content is displayed can also be adjusted in a variety of ways in Bridge:

- 1. Preview with a single image selected.
- 2. Preview with multiple thumbnails selected
- 3. Impromptu slideshow generated from inside Bridge
- 4. The loupe view of a preview image

Custom panel display

Some panels also contain custom options that govern the type and way that the information is displayed within the panel itself. For both the Keyword and Metadata panels these options are located in the fly-out menu accessed at the top right of the panel. You can add folders to the Favorites panel by right-clicking on them in the Folder panel and then choosing the Add to Favorites entry from the menu that appears. To remove listed folders right-click the entry and choose the Remove from Favorites option. The Inspector panel display and the types of data shown with thumbnails in the Content panel are controlled by settings in Preferences (Edit > Preferences).

The content of some panels and the way that this information is displayed can be adjusted using either the flyout menus at the top right of the panels, right-click menu options for panel items or Bridge preference settings. Fly-out menu for the Metadata panel (left) and right-click menu for Favorite panel entries (right) are shown

Speedy thumbnail generation

One of the reasons why this version of Bridge works more quickly than the previous one is that now you get to control how the program builds the thumbnails that are displayed in the content area. Rather than build the same level of thumbnail quality for all pictures, the program creates lower quality, but fast to generate and display, thumbnails by default. In the General section of the Preferences you can select between the creation of these Quick Thumbnails, High Quality Thumbnails or even an option that instructs the program to convert the thumbnails to high quality when first previewed. Bridge is set to Quick Thumbnails by default so fast display of content is the order of the day, but for those who are willing to wait a little longer for higher quality thumbnails it is great to know that we have this option as well.

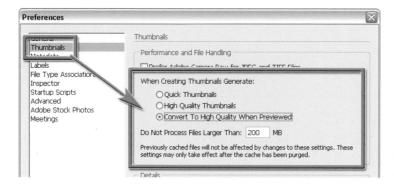

The Thumbnail section of the Preferences dialog contains three different options for the way that thumbnails are created in the Content panel

Caching decisions

The cache is an allocated space on your hard drive that is used to store thumbnail and metadata information (Labels and Ratings) for the images displayed in the Content panel. Bridge uses this cache to speed up the display of thumbnails. The information in the cache is generally built the first time the contents of a specific folder are displayed. This process can take some time, especially if the folder contains many pictures. For this reason, there is also an option to build the cache of selected folders in the background whilst you continue other work. Select the directory to be cached in the Folder panel and then choose Tools > Cache > Build Cache for Subfolders. If for any reason you want to remove a previously created cache from a specific directory, then select the folder and choose the Tools > Cache > Purge Cache for Folder option.

You can speed up the display of images by pre-caching the folders they are saved in using the Build Cache for Subfolders option in the Edit > Cache menu

The location of the cache impacts indirectly on performance for two reasons:

- 1. Cache files can become quite large and so it is important to ensure that the drive selected to house the cache has enough space to be able to adequately store the file.
- 2. When image files are copied to another drive or location a new cache has to be constructed when the folder is first viewed unless the cache is copied along with the picture files.

The settings contained in the Advanced section of the Preferences dialog provide the option to select the place where the central cache is stored. Use this setting to ensure that the cache file is located on a drive with sufficient space. Also included here is a new option for exporting cache files to folders whenever possible. Use this setting to employ a distributed cache system (rather than a centralized one), which enables image and cache files to be stored together in the same folder. If this folder is then moved, copied or written to a new location the cache will not have to be rebuilt for the photos to be displayed in Bridge. In situations where the image folder is stored on a CD, DVD or other location that is locked, the cache is written to the central location.

The location of centralized cache files as well as the ability to store the cache in the same folder as the images is controlled by settings in the Advanced section of the Preferences dialog

Removing unwanted Cache files:

- To delete the cache for all image files on the computer select the Purge Cache button in the Advanced section of the Edit > Preferences dialog.
- To remove the cache files for a single directory select the directory in Folder view and then choose Tools > Cache > Purge Cache for Folder.

Using Bridge

Bridge is a key component in the photographer's workflow. From the time that the photos are downloaded from the camera, through the editing and processing stages and then onto archiving and locating specific pictures, the application plays a pivotal role in all image management activities. Let's look a little closer at each of these areas.

Downloading pictures

New for Bridge 2.0 and borrowed from Photoshop's little brother, Photoshop Elements, is the Adobe Photo Downloader (APD) utility. The downloader manages the transfer of files from camera or card reader to your computer. In doing so the transfer utility can also change file names, convert to DNG on the fly, apply pre-saved metadata templates and even save copies of the files to a backup drive. This feature alone saves loads of time and effort for the working photographer over performing these tasks manually.

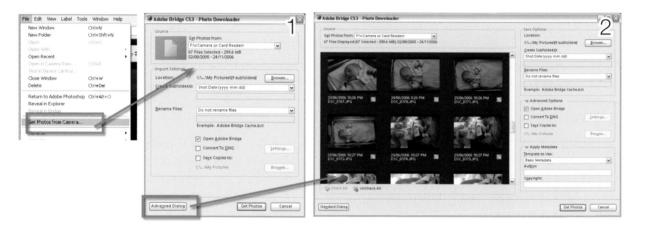

Bridge now ships with the Adobe Photo Downloader utility designed to simplify the transfer of image files from camera or card reader to computer. When working with the Downloader you have a choice of two modes – Standard (1) and Advanced (2)

Transferring with the Adobe Photo Downloader

Step 1: Select the Get Photos from Camera option from the File menu inside Bridge. Next you will see the new Adobe Photo Downloader dialog. The utility contains the option of either Standard or Advanced modes. The Advanced option not only provides thumbnail previews of the images stored on the camera or card, but the dialog also contains several new features for sorting and managing files as they are downloaded. But let's start simply, with the options in the Standard dialog.

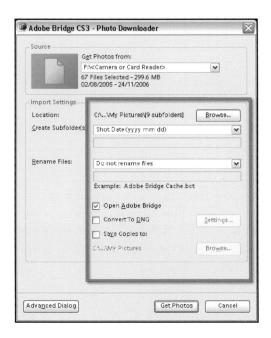

Step 2 Standard mode: To start you need to select the source of the pictures (the location of the card reader or camera). In the Standard mode all pictures on the card will be selected ready for downloading. Next set the Import Settings. Browse for the folder where you want the photographs to be stored and if you want to use a subfolder select the way that this folder will be named from the Create Subfolder dropdown menu. To help with finding your pictures later it may be helpful to add a meaningful name, not the labels that are attached by the camera, to the beginning of each of the images. You can do this by selecting an option from the Rename File drop-down menu and adding any custom text needed. There are also options to open Bridge after the transfer is complete and convert to DNG or save copies of the photos on

the fly (great for backing up images). Clicking the Get Photos button will transfer your pictures to your hard drive – you can then organize the pictures in the Bridge workspace. For more choices during the download process you will need to switch to the Advanced mode.

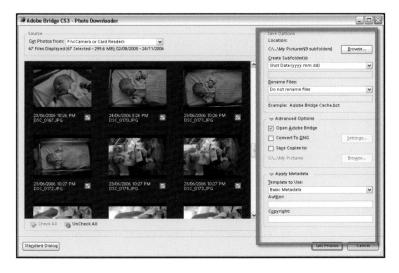

Step 3 Advanced mode:

Selecting the Advanced Dialog button at the bottom left of the Standard mode window will display a larger Photo Downloader dialog with more options and a preview area showing a complete set of thumbnails of the photos stored on the camera or memory card. If for some reason you do not want to

download all the images, then you will need to deselect the files to remain, by unchecking the tick box at the bottom right-hand of the thumbnail. This version of the Photo Downloader has the same location for saving transferred files, rename, convert to DNG and copy files options that are in the Standard dialog. In addition, this mode also contains the ability to add metadata to the photos during the downloading process. You can select a predefined metadata template from the drop-down menu or manually add in author and copyright details. Pressing the Get Photos button will start the download process.

Locating files

Files can be located by selecting the folder in which they are contained using either the Favorites or Folders panel or the Look In menu (top of the dialog). Alternatively, the Edit > Find command can be used to search for pictures based on filename, file size, keywords, date, rating, label, metadata or comment.

Locate specific pictures or create collections of photos using the sophisticated Find options in Bridge

Filtering the files displayed

In Bridge 2.0 Adobe introduces a new interactive way to find specific photos amongst the thousands of files that sit on photographers' hard drives. The new feature is called Filters and is housed in a panel of its own which displays a list of file attributes such as file type, orientation, date of creation or capture, rating, labels, keywords and even aspect ratio. Clicking on a heading activates the filter and alters the Content display to

The Filter panel contains a selection of file attributes that can be selected as ready made search criteria in order to quickly create a subset of photos. 1) Menu of Sort choices

show only those files that possess the selected attribute. Selecting a second Filter entry reduces the displayed content further. Using this approach, it is possible to reduce thousands of photos to a select few with several well-placed clicks in the Filter panel. To remove all filters and view all items in a folder click the folder icon in the top left of the panel.

Stacking alike photos

One way to help organize pictures in your collection is to group photos of similar content together. Bridge contains a stacking option design just for this purpose. After multi-selecting the pictures to include from those displayed in the content area select Stacks > Group as Stack. All images will be collated under a single front photo like a stack of cards. The number of images included in the stack is indicated in the top left of the stack thumbnail. Stacks can be expanded or collapsed by clicking on this number (stacks expand downwards in workspaces where the thumbnails are arranged vertically). Options for ungrouping the photos in a stack or changing the picture used as the front image can be located in the Stacks menu.

Expand image stacks by clicking on the circled number in the top left of the thumbnail of the stacked photos (1). Collapse image stacks by clicking on the same circled number positioned on the first thumbnail in the series (2)

Labelling pictures

As you are probably now realizing Bridge is more than just a file browser; it is also a utility that can be used for sorting and categorizing your photos. Using the options listed under the Label menu, individual or groups of photos can be rated (with a star rating) or labelled (with a colored label). These tags can be used as a way to sort and display the best images from those taken at a large photoshoot or grouped together in a folder. Labels and ratings are applied by selecting (or multi-selecting) the thumbnail in the Bridge workspace and then choosing the tag from the Label menu. Shortcut keys can also be used to quickly attach tags to individually selected files one at a time.

Adding keywords

Along with labelling and rating photos for easy editing and display options it is also possible to assign specific keywords that help describe the content of your images. The keywords are stored in the metadata of the photo and are used extensively not only by Bridge as a way of locating specific photos but also by photo libraries worldwide for cataloging. Most keyword activity is centered around the Keyword panel in Bridge. Here you can create and apply keywords to images or groups of images. Keywords are grouped into Keyword Sets. To apply a keyword to a photo, select the

Labels or ratings are often used as a way of indicating the best images in a group of pictures taken in a single session. The photos displayed in the Content panel can be sorted according to their Label or Rating using the settings in the Filter panel

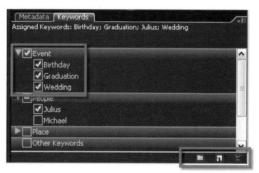

Keywords are words that summarize the content of the photo. They are used extensively by photo libraries for cataloging multiple photos. Keywords can be created and applied in Bridge using the Keywords panel

image first and then click on the checkbox next to the Keyword or Keyword Set to add. Click on the checkbox again to remove a keyword. A summary of all the Assigned Keywords for a specific photo is displayed at the top of the panel. New keywords or keyword sets are created, and existing ones deleted, using the buttons at the bottom right of the panel.

Tools used in Bridge

Although no real editing or enhancement options are available in the Bridge feature it is possible to use the browser as a starting point for many of the operations normally carried out in Photoshop. For instance, photos selected in the workspace can be batch renamed, printed online, used to create a Photomerge panorama, compiled into a contact sheet or combined into a PDF-based presentation,

Bridge is a great starting place for many of the tools contained in the File > Automate menu in Photoshop as you can select the images to include before starting the feature from the Tools > Photoshop menu

all via options under the Tools menu. Some of these choices will open Photoshop before completing the requested task whereas others are completed without leaving the browser workspace.

Processing RAW inside Bridge

One of the real bonuses of Bridge is the ability to open, edit and save RAW files from inside the browser workspace. Now there is no need to open the files to process via Photoshop. The conversions to DNG, TIFF, JPEG or PSD files can be handled directly from the browsing workspace by selecting (or multi-selecting) the files and then choosing File > Open in Camera Raw. All Raw processing is handled by the latest version of Adobe Camera Raw (ACR) which ships with Photoshop CS3 and for the first time both TIFF and JPEG files can also be processed with the feature.

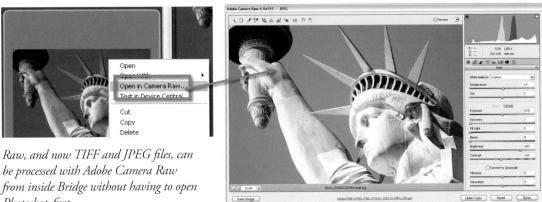

Photoshop first

Processing in Photoshop

It is a simple matter to transfer photos from the Bridge workspace into Photoshop. You can either double-click a thumbnail or select the image and then choose Open With > Photoshop CS3 from the right-click menu. By default double-clicking Raw images will open them into the Adobe Camera Raw utility inside Photoshop, but this behavior can be changed to process the file inside Bridge by selecting the Double-Click Edits Camera Raw Settings in Bridge option in the General Preferences for Bridge.

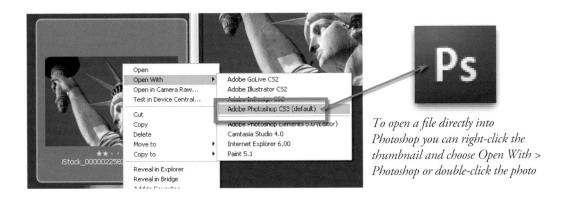

Using Bridge to access the project resources

Use Bridge to access the project resources that are available on the supporting DVD. Access the DVD from the Favorites panel in Bridge. Double-click the Photoshop_CS3 DVD icon to access the chapter folders. Images can be opened directly from Bridge or alternatively a folder of images can be dragged from the Content panel in Bridge to a location on your hard drive if required.

Inside each chapter folder the resources are divided into the different file formats. The same images can be accessed as JPEG, TIFF or Raw files (.dng). The JPEG images are compressed versions (lower quality) but take up little hard drive space. The TIFF files are uncompressed and may contain saved selections that can be used to speed up the editing process in some projects.

Most of the images are available as Raw files. These are required for many projects in the Advanced Retouching and Montage chapters, where some of the editing process is performed in the Adobe Camera Raw workspace (see Adobe Camera Raw). Each project in the 'Imaging Projects' module (last four chapters) is also supported by a movie. Movies can be watched in Bridge or can be opened directly in the QuickTime player (when installed) by double-clicking the movie file icon in the Content panel.

capture and enhance

hoto

Sam Everton

essential skills

- ~ Capture high-quality digital images for image editing.
- ~ Gain control over the color, tonality and sharpness of a digital image.
- Duplicate, optimize and save image files for print and for web.

Introduction

Every digital image that has been captured can be enhanced further so that it may be viewed in its optimum state for the intended output device. Whether images are destined to be viewed in print or via a monitor screen, the image usually needs to be resized, cropped, retouched, color-corrected, sharpened and saved in an appropriate file format. The original capture will usually possess pixel dimensions that do not exactly match the requirements of the output device. In order for this to be corrected the user must address the issues of 'Image Size', 'Resampling' and 'Cropping'.

To end up with high quality output you must start with the optimum levels of information that the capture device is capable of providing. The factors that greatly enhance final quality are:

- A 'subject brightness range' that does not exceed the exposure latitude of the capture device (the contrast is not too high for the image sensor).
- Using a low ISO setting to capture the original image.
- The availability of 16 bits per channel scanning or the camera Raw file format.

Optimizing image quality

This chapter focuses its attentions on the standard adjustments made to all images when optimum quality is required without using any advanced techniques. Standard image adjustments usually include the process of optimizing the color, tonality and sharpness of the image. With the exception of dust or blemish removal, these adjustments are applied globally (to all the pixels). Most of the adjustments in this chapter are 'objective' rather than 'subjective' adjustments and are tackled as a logical progression of tasks. Automated features are available for some of these tasks but these do not ensure optimum quality is achieved for all images. The chapter uses a 'hands-on' project to guide you through the steps required to achieve optimum quality.

Save, save and save

Good working habits will prevent the frustration and the heartache that are often associated with the inevitable 'crash' (all computers crash or 'freeze' periodically). As you work on an image file you should get into the habit of saving the work in progress and not wait until the image editing is complete. It is recommended that you use the 'Save As' command and continually rename the file as an updated version. Unless computer storage space is an issue the Photoshop (PSD) file format should be used for work in progress. Before the computer is shut down, the files should be saved to a removable storage device or burnt to a CD/DVD. In short, save often, save different versions and save backups.

Stepping back

Digital image editing allows the user to make mistakes. There are several ways of undoing a mistake before resorting to the 'Revert' command from the File menu or opening a previously saved version. Photoshop allows the user to jump to the previous state via the Edit > Undo command (Command/Ctrl + Z) while 'Histories' allows access to any previous state in the History palette without going through a linear sequence of undos. Alternatively the user can 'Step Backward' by using the keyboard shortcut Ctrl + Alt + Z (PC) or Command + Option + Z (Mac).

Advantages and disadvantages of 16-bit editing

When the highest quality images are required there are major advantages to be gained by starting off the editing process in '16 Bits/Channel' mode. In 16 bits per channel there are trillions, instead of millions, of possible values for each pixel. Spikes or comb lines, that are quick to occur while editing in 8 bits per channel, rarely occur when editing in 16 bits per channel mode. The disadvantages of editing in 16 bits per channel are:

- Not all digital cameras are capable of saving in the RAW format.
- The size of file is doubled when compared to an 8 bits per channel image of the same output size and resolution.
- Some editing features (including many filters) do not work in 16 bits per channel mode.
- Only a small selection of file formats support the use of 16 bits per channel.

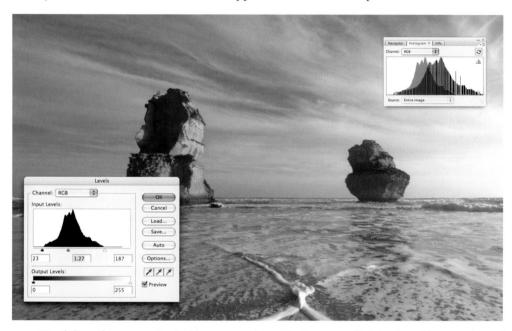

Comb lines that appear in the histogram will usually disappear if editing in 16 bits per channel

Choosing your bit depth

It is still preferable to make major changes in tonality or color in 16-bit mode before converting the file to 8-bit mode. Images can be converted from 8-bit (Image > Mode > 16 Bits/Channel) or captured in 16-bit (the preferred choice). Most of the better scanners that are now available (flatbed and film) now support 16 bits per channel image capture. Many scanners refer to 16 bits per channel scanning as 48-bit RGB scanning. Some scanners offer 14 bits per channel scanning but deliver a 48-bit image to Photoshop. Remember, you need twice as many megabytes as the equivalent 8-bit image, e.g. if you typically capture 13.2 megabytes for an 8×10 @ 240ppi you will require 26.4 megabytes when scanning in 16 bits per channel.

Note > Photoshop also supports 32 Bits/Channel editing which is primarily used for editing images with a high dynamic range (see Montage Projects – High Dynamic Range).

Foundations project 1

Follow the seven steps over the following pages in order to learn how to create one image optimized for print and one image optimized for web viewing from the same image file.

Image capture - Step 1

Capture a vertical portrait image using soft lighting (low-contrast diffused sunlight or window lighting would be ideal). The image selected should have detail in both the highlights and shadows and should have a range of colors and tones. An image with high contrast and missing detail in the highlights or shadows is not suitable for testing the effectiveness of the capture or output device.

Digital capture via a digital camera

Images can be transferred directly to the computer from a digital camera or from a card reader if the card has been removed from the camera. Images are usually saved on the camera's storage media as JPEG or RAW files. If using the JPEG file format to capture images you should choose the high or maximum quality setting whenever possible. If using the JPEG file format, it is important to select low levels of image sharpening, saturation and contrast in the camera's settings to ensure optimum quality and editing flexibility in the image-editing software. If the camera has the option to choose Adobe RGB instead of sRGB as the color space this should also be selected if one of the final images is destined for print.

Digital capture via a scanning device

Ensure the medium to be scanned is free from dust and grease marks. A smooth paper surface (rather than a textured surface) offers the best medium for flatbed scanning. The scanning device can usually be accessed directly from the Adobe software via the 'Import' command. Ensure that you scan the image at an appropriate resolution for your image-editing needs (see 'Digital Basics > Calculating file size and scanning resolution').

Cropping an image - Step 2

After opening the captured image in Photoshop, click on the Crop Tool icon in the Tools palette. In the Options bar type '4in' in the Width field and '6in' in the Height field. Type in '240' in the Resolution field and set the resolution units to 'pixels/inch'. When sizing an image for the intended output it is important to select the width and height in pixels for screen or web viewing and in centimeters or inches for printing. Typing in 'px', 'in' or 'cm' after each measurement will tell Photoshop to crop using these units. If no measurement is entered in the field then Adobe will choose the default unit measurement entered in the Preferences (Preferences > Units & Rulers). The preference can be quickly changed by Control-double-clicking on either ruler (select View > Rulers if they are not currently selected).

Note > The Image Size dialog box can also change the size of an image but it cannot crop an image to the a different 'format' or shape, e.g. you cannot change an oblong image to a square image unless you crop or remove a portion of the image using the Crop Tool.

Additional information

The action of entering measurements and resolution at the time of cropping ensures that the image is sized and cropped or 'shaped' as one action. Entering the size at the time of cropping ensures the format of the final image will match the printing paper, photo frame or screen where the image will finally be output. To quickly delete all of the existing units that may already be entered in the fields from a previous crop, select the 'Clear' option. To quickly enter the current actual measurements of a selected image, click on the 'Front Image' button. This option is useful when you are matching the size of one or more new images to an existing one that has already been prepared.

Note > If both a width and a height measurement are entered into the fields the proportions of the final crop will be locked and may prevent you from selecting parts of the image if the capture and output formats are different, e.g. if you have entered the same measurement in both the width and height fields the final crop proportions are constrained to a square.

Perfecting the crop

Click and drag to place the cropping marquee on the image; you can resize the marquee with the corner handles. The marquee can be click-dragged to reposition or use the keyboard arrow keys to fine-tune the positioning. If the image is crooked you can rotate the cropping marquee by moving the mouse cursor to a position just outside a corner handle of the cropping marquee. A curved arrow should appear, allowing you to drag the image straight.

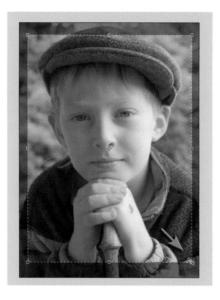

Before completing the crop, you should check the entire image edge to see if there are any remaining border pixels that are not part of the image. Click on the 'Change Screen Mode' icon at the bottom of the Tools palette to change the screen mode to 'Maximized Screen Mode' or 'Full Screen Mode'. Alternatively you could drag the corner of the image window to extend the size of the window. You may need to select View > Fit on Screen to see all edges or if you must zoom in to see details, you can quickly move the window view by using the Hand Tool (press the Spacebar). Press the 'Return/Enter' key on the keyboard to complete the cropping action. Alternatively press the 'Esc' key on the keyboard to cancel the crop.

The marquee tool is programmed to snap to the edges of the document as if they were magnetized. This can make it difficult to remove a narrow border of unwanted pixels. To overcome this problem you will need to go to the 'View' menu and switch off the 'Snap To > Document Bounds' option.

Note > See 'Retouching – Project 1' for more information on cropping images.

Tonal adjustments - Step 3

The starting point to adjust the tonal qualities of EVERY image is the 'Levels' dialog box (go to 'Image > Adjustments > Levels'). Do not use the 'Brightness/Contrast' adjustment feature in older versions of Photoshop. The horizontal axis of the histogram in the Levels dialog box displays the brightness values from left (darkest) to right (lightest). The vertical axis of the histogram shows how much of the image is found at any particular brightness level. If the subject contrast or 'brightness range' exceeds the latitude of the capture device or the exposure is either too high or too low, then tonality will be 'clipped' (shadow or highlight detail will be lost and no amount of adjustment will recover it).

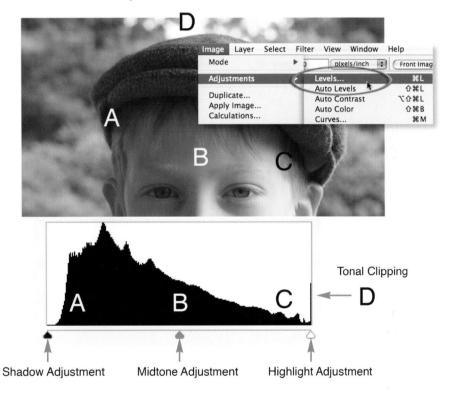

Histograms

During the capture stage it is often possible to check how the capture device is handling or interpreting the tonality and color of the subject. This useful information can often be displayed as a 'histogram' on the LCD screen of high quality digital cameras or in the scanning software during the scanning process. The histogram displayed shows the brightness range of the subject in relation to the latitude or 'dynamic range' of your capture device's image sensor. Most digital camera sensors have a dynamic range similar to color transparency film (around five stops) when capturing in JPEG or TIFF. This may be expanded beyond seven stops when the RAW data is processed manually.

Note > You should attempt to modify the brightness, contrast and color balance at the capture stage to obtain the best possible histogram before editing begins in the software.

Optimizing tonality

In a good histogram, one where a broad tonal range with full detail in the shadows and highlights is present, the information will extend all the way from the left to the right side of the histogram. The histogram on the left (below) indicates missing information in the highlights (right side of histogram). The histogram on the right indicates a small amount of 'clipping' or loss of information in the shadows (left side of histogram).

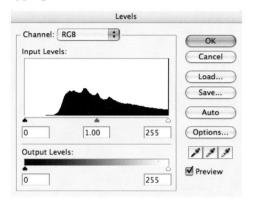

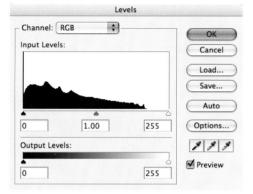

Histograms indicating image is either too light or too dark

Brightness

If the digital file is too light a tall peak will be seen to rise on the right side (level 255) of the histogram. If the digital file is too dark a tall peak will be seen to rise on the left side (level 0) of the histogram.

Solution: Decrease or increase the exposure/brightness in the capture device.

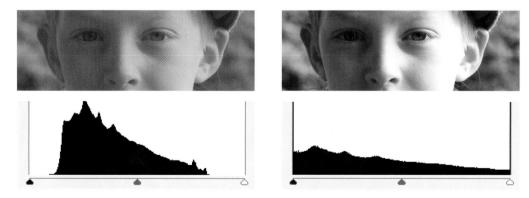

Histograms indicating image either has too much contrast or not enough

Contrast

If the contrast is too low the histogram will not extend to meet the sliders at either end. If the contrast is too high a tall peak will be evident at both extremes of the histogram.

Solution: Increase or decrease the contrast of the light source used to light the subject or the contrast setting of the capture device. Using diffused lighting rather than direct sunlight or using fill-flash and/or reflectors will ensure that you start with an image with full detail.

Optimizing a histogram after capture

The final histogram should show that pixels have been allocated to most, if not all, of the 256 levels. If the histogram indicates large gaps between the ends of the histogram and the sliders (indicating either a low-contrast scan or low-contrast subject photographed in flat lighting) the subject or original image should usually be recaptured a second time.

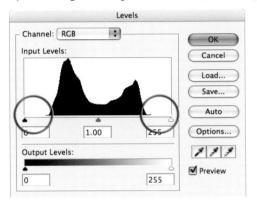

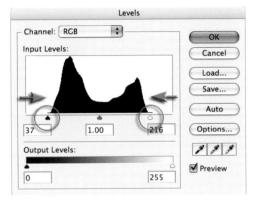

Small gaps at either end of the histogram can, however, be corrected by dragging the sliders to the start of the tonal information. Holding down the Alt/Option key when dragging these sliders will indicate what, if any, information is being clipped. Note how the sliders have been moved beyond the short thin horizontal line at either end of the histogram. These low levels of pixel data are often not representative of the broader areas of shadows and highlights within the image and can usually be clipped (moved to 0 or 255).

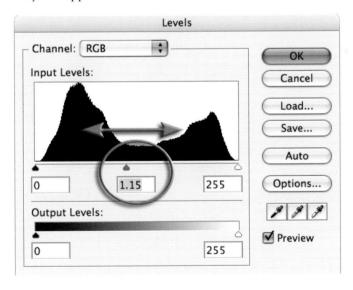

Moving the 'Gamma' slider can modify the brightness of the midtones. After correcting the tonal range using the sliders, click 'OK' in the top right-hand corner of the Levels dialog box.

Note > Use the Levels for all initial brightness and contrast adjustments. The Brightness/ Contrast adjustment feature in Photoshop CS and CS2 should be avoided as this will upset the work performed using Levels and can result in a loss of information.

Shadows and highlights

When the tonality has been optimized using the Levels dialog box the shadow and highlight values may require further work. One of the limitations of the Levels adjustment feature is that it cannot focus its attention on only the shadows or the highlights, e.g. when the slider is moved to the left both the highlights and the shadows are made brighter.

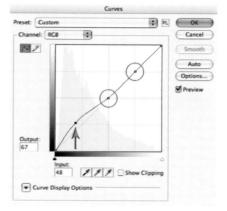

Targeted adjustments can be achieved using the Curves adjustment feature (Image > Adjustments > Curves). Curves allows the user to target tones within the image and move them independently of other tones within the image, e.g. the user can decide to make only the darker tones lighter while preserving the value of both the midtones and the highlights. It is also possible with a powerful editing feature such as Curves to move the shadows in one direction and the highlights in another. In this way the contrast of the image could be increased without losing valuable detail in either the shadows or the highlights. See 'Advanced Retouching – Projects 1 and 2' for more information on Curves.

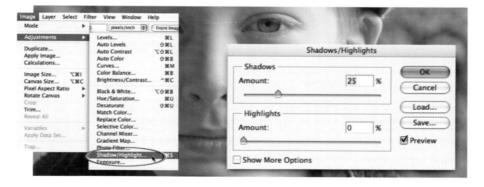

The Shadow/Highlight adjustment feature (Image > Adjustments > Shadow/Highlight) offers an alternative. This targets and adjusts tonality in a non-destructive way and in many ways offers superior control than the Curves adjustment feature (midtone contrast) in a user-friendly interface. The disadvantage is that the adjustment is not available as an adjustment layer. See 'Advanced Retouching' for more information.

Note > See 'Retouching Projects – Project 3' for more information on shadow and highlight control.

Target values – using the eyedroppers

Note > The following procedure is recommended for quick corrections only. The procedure is useful for a semi-automated approach to target the important shadow and highlight tones.

To ensure highlights do not 'blow out' and the shadows do not print too dark it is possible to target, or set specific tonal values, for the highlight and shadow tones within the image using the eyedroppers (found in the Levels and Curves dialog boxes). The tones that should be targeted are the lightest and darkest areas in the image with detail. The default settings of these eyedroppers are set to 0 (black) and 255 (white). These settings are only useful for targeting the white paper or black film edge. After establishing the darkest and lightest tones that will print using a step wedge (see 'Digital Printing') these target levels can be assigned to the eyedroppers.

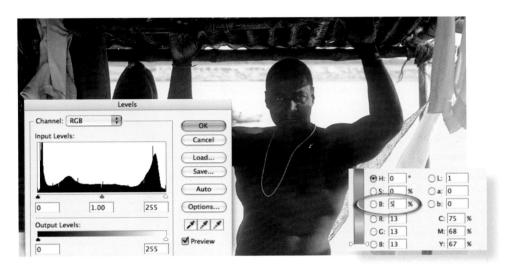

Setting a target value

- Double-click the black or white eyedropper tool in the Levels dialog box to display the Color Picker (now called the 'Select target shadow color' or 'Select target highlight color' dialog box).
- 2. Enter a value in the 'Brightness' field (part of the Hue, Saturation and Brightness or 'HSB' controls) and select OK. A value between 4 and 8 would be considered 'normal' for shadow target tones while values between 92 and 99 could be considered for target highlight tones.
- 3. Carefully view the image to locate the brightest highlight or shadow with detail. Be careful to select representative tones, e.g. for the target highlight do not select a specular highlight such as a light source or a reflection of the light source which should register a value of 255.
- 4. Using the black and white eyedropper tools, with the altered values, click on the appropriate image detail to assign their target values.

Note > When setting the target values of a color image it is important to select neutral highlight or shadow tones, otherwise a color cast may be introduced into the image. If a color cast is introduced using this technique the color can be corrected by using the center eyedropper 'Sample in image to set gray point' and then clicking on a neutral tone within the image.

Color adjustments - Step 4

Neutral tones in the image should appear desaturated on the monitor. If a color cast is present try to remove it at the time of capture or scanning if at all possible.

Solution: Control color casts by using either the white balance on the camera (digital), shoot using the RAW file format or by using an 80A or 80B color conversion filter when using tungsten light with daylight film. Use the available color controls on the scanning device to correct the color cast and/or saturation.

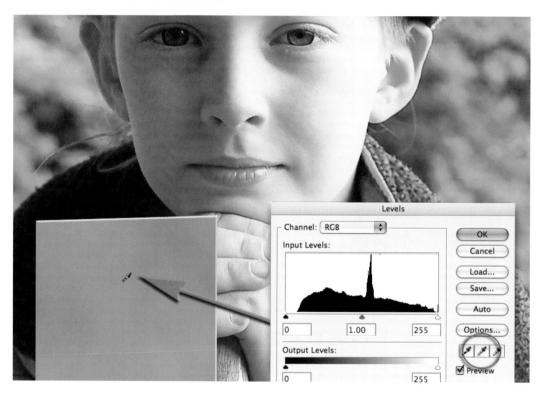

Color correction using Levels

If you select a Red, Green or Blue channel (from the channel's pull-down menu) prior to moving the Gamma slider (middle slider) you can remove a color cast present in the image. For those unfamiliar with color correction, the adjustment feature 'Variations' in Photoshop or 'Color Variations' in Photoshop Elements gives a quick and easy solution to the problem.

Setting a gray point

Click on the 'Sample in image to set gray point' eyedropper in the Levels dialog box and then click on any neutral tone present in the image to remove a color cast. Introducing a near white card or gray card into the first image of a shoot can aid in subsequent color corrections for all images shot using the same light source.

Note > See 'Retouching Projects - Project 2' for more information.

Variations (not available when editing 16-bit files)

The 'Variations' command allows the adjustment of color balance, contrast and saturation to the whole image or just those pixels that are part of a selection. For individuals that find correcting color by using the more professional color correction adjustment features intimidating, Variations offers a comparatively user-friendly interface. By simply clicking on the alternative thumbnail that looks better the changes are applied automatically. The adjustments can be concentrated on the highlights, midtones or shadows by checking the appropriate box. The degree of change can be controlled by the Fine/Coarse slider.

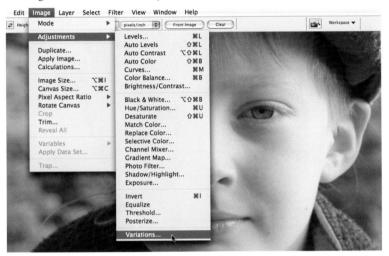

Variations can be accessed from the Adjustments submenu in the Image menu. Start by selecting the 'Midtones' radio button and then adjust the Fine/Coarse slider until you can see a thumbnail that looks about right, and then click on the one you like. Then click 'OK'.

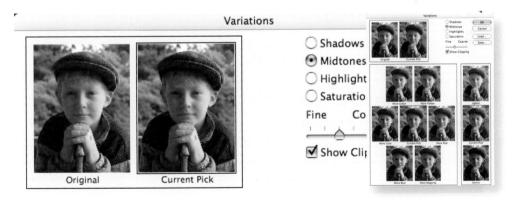

Note > Clicking on a thumbnail more than once will result in repeated, and increasing, intensity of the chosen correction. Editing with the highlights, shadows or saturation button checked can lead to a loss of information in one or more of the channels. If the 'Show Clipping' is checked, a neon warning shows areas in the image that have been adjusted to 255 or 0. Clipping does not, however, occur when the adjustment is restricted to the midtones only.

Cleaning an image - Step 5

The primary tools for removing blemishes, dust and scratches are the 'Clone Stamp Tool', the 'Healing Brush Tool' and the 'Spot Healing Brush Tool'. The Clone Stamp is able to paint with pixels selected or 'sampled' from another part of the image. The Healing Brush is a sophisticated version of the Clone Stamp Tool that not only paints with the sampled pixels but then 'sucks in' the color and tonal characteristics of the pixels surrounding the damage. The Spot Healing Brush Tool requires no prior sampling and is usually the first port of call for most repairs. The following procedures should be taken when working with the Spot Healing Brush Tool or Healing Brush Tool.

- 1. Select the Spot Healing Brush Tool from the Tools palette.
- 2. Zoom in to take a close look at the damage that needs to be repaired.
- 3. Choose an appropriate size, soft-edged brush from the brushes palette that just covers the width of the blemish, dust or scratch to be repaired.
- 4. Move the mouse cursor to the area of damage.
- 5. Click and drag the tool over the area that requires repair.
- 6. Increase the hardness of the brush if the repair area becomes contaminated with adjacent tones, colors or detail that does not match the repair area.
- 7. For areas proving difficult for the Spot Healing Brush to repair switch to the Healing Brush Tool or the Clone Stamp Tool. Select a sampling point by pressing the Alt/Option key and then clicking on an undamaged area of the image (similar in tone and color to the damaged area). Click and drag the tool over the area to paint with the sampled pixels to conceal the damaged area (a cross-hair marks the sampling point and will move as you paint).

Note > If a large area is to be repaired with the Clone Stamp Tool it is advisable to take samples from a number of different points with a reduced opacity brush to prevent the repairs becoming obvious.

Sharpening an image - Step 6

Sharpening the image is the last step of the editing process. Many images benefit from some sharpening even if they were captured with sharp focus. The 'Unsharp Mask' and the 'Smart Sharpen' filters from the 'Sharpen' group of filters are the most sophisticated and controllable of the sharpening filters. They are used to sharpen the edges by increasing the contrast where different tones meet.

The pixels along the edge on the lighter side are made lighter and the pixels along the edge on the darker side are made darker. Before you use the Unsharp Mask go to 'View > Actual Pixels' to adjust the screen view to 100%. To access the Unsharp Mask (the slightly simpler of the two sophisticated sharpening filters) go to 'Filter > Sharpen > Unsharp Mask'. Start with an average setting of 100% for 'Amount', a 1- to 1.5-pixel 'Radius' and a 'Threshold' of 3. The effects of the Unsharp Mask filter are more noticeable on-screen than in print. For final evaluation always check the final print and adjust if necessary by returning to a previously saved version or by going back one step in the History palette. The three sliders control:

Amount – This controls how much darker or lighter the pixels are adjusted. Eighty to 180% is normal.

Radius – Controls the width of the adjustment occurring at the edges. There is usually no need to exceed 1 pixel if the image is to be printed no larger than A4/US letter. A rule of thumb is to divide the image resolution by 200 to determine the radius amount, e.g. $200ppi \div 200 = 1.00$.

Threshold – Controls where the effect takes place. A zero threshold affects all pixels whereas a high threshold affects only edges with a high tonal difference. The threshold is usually kept very low (0 to 2) for images from digital cameras and medium or large format film. The threshold is usually set at 3 for images from 35mm. Threshold is increased to avoid accentuating noise, especially in skin tones.

Note > See 'Retouching Projects - Project 5' for more information on sharpening images.

Saving a modified file - Step 7

Go to the 'File' menu and select 'Save As'. Name the file, select 'TIFF' or 'Photoshop' as the file format and select the destination 'Where' the file is being saved. Check the 'Embed Color Profile' box and click 'Save'. Keep the file name short using only the standard characters from the alphabet. Use a dash or underscore to separate words rather than leaving a space and always add or 'append' your file name after a full stop with the appropriate three- or four-letter file extension (.psd or .tif). This will ensure your files can be read by all and can be safely uploaded to web servers if required. Always keep a backup of your work on a remote storage device if possible.

Resize for screen viewing

Duplicate your file by going to 'Image > Duplicate Image'. Rename the file and select OK. Go to 'Image > Image Size'. Check the 'Constrain Proportions' and 'Resample Image' boxes. Type in 600 pixels in the 'Height' box (anything larger may not fully display in a browser window of a monitor set to 1024×768 pixels without the viewer having to use the scroll or navigation bars). Use the Bicubic Sharper option when reducing the file size for optimum quality.

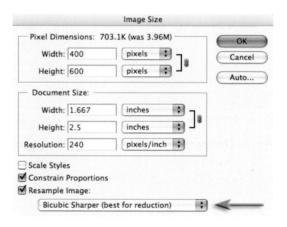

Using the Crop Tool (typing in the dimensions in pixels, e.g. 600px and 400px) will also resize the image quickly and effectively. This technique does not, however, make use of Bicubic Sharper and images may require sharpening a second time using the Smart Sharpen or Unsharp Mask filter.

Note > Internet browsers do not respect the resolution and document size assigned to the image by image-editing software – image size is dictated by the resolution of the individual viewer's monitor. Two images that have the same pixel dimensions but different resolutions will appear the same size when displayed in a web browser. A typical screen resolution is often stated as being 72ppi but actual monitor resolutions vary enormously.

JPEG format options

After resizing the duplicate image you should set the image size on screen to 100% or 'Actual Pixels' from the View menu (this is the size of the image as it will appear in a web browser on a monitor of the same resolution). Go to 'File' menu and select 'Save As'. Select JPEG from the Format menu. Label the file with a short name with no gaps or punctuation marks (use an underscore if you have to separate two words) and finally ensure the file carries the extension .jpg (e.g. portrait_one.jpg). Click 'OK' and select a compression/quality setting from the 'JPEG Options' dialog box. With the Preview box checked you can check to see if there is excessive or minimal loss of quality at different compression/quality settings in the main image window.

Note > Double-clicking the Zoom Tool in the Tools palette will set the image to actual pixels or 100% magnification.

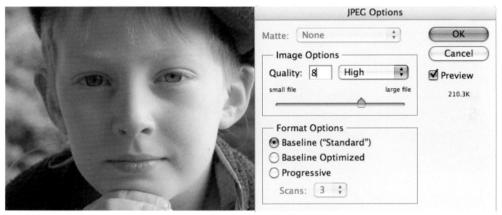

Choose a compression setting that will balance quality with file size (download time). High compression (low quality) leads to image artifacts, lowering the overall quality of the image. There is usually no need to zoom in to see the image artifacts as most browsers and screen presentation software do not allow this option.

Image Options: The quality difference on screen at 100% between the High and Maximum quality settings may not be easily discernible. The savings in file size can, however, be enormous, thereby enabling much faster uploading and downloading via the Internet.

Format Options: Selecting the 'Progressive' option from the Format Options enables the image to be displayed in increasing degrees of sharpness as it is downloading to a web page, rather than waiting to be fully downloaded before being displayed by the web browser.

Size: The open file size is not changed by saving the file in the JPEG file format as this is dictated by the total number of pixels in the file. The closed file size is of interest when using the JPEG Options dialog box as it is this size that dictates the speed at which the file can be uploaded and downloaded via the Internet. The quality and size of the file is a balancing act if speed is an issue due to slow modem speeds.

Save for Web & Devices

The Save for Web & Devices command from the File menu offers the user an alternative, all-in-one, option for resizing, optimizing and previewing the image prior to saving the file in the JPEG format. Access the Save for Web & Devices feature from the File menu. Click on the 2-up tab to see a before and after version of your image. Click on the second image and, from the 'Preview Menu', choose either the Mac or Windows options. This will enable you to anticipate how your image may be viewed in software that cannot read the ICC profile that Photoshop normally embeds as part of the color management process, e.g. most web browsers.

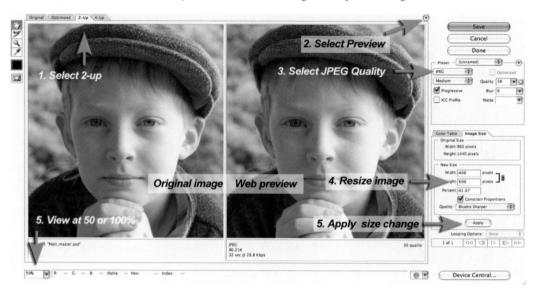

To adjust the color or tone prior to saving as a JPEG exit the Save for Web feature and go to View > Proof Setup and then choose either Macintosh RGB or Windows RGB depending on the intended monitor that the image will be viewed on. With the Proof Setup switched on, adjustments may be required to both image brightness and saturation in order to return the appearance of the image to 'normal'. Brightness should be controlled via the 'Gamma' slider in the 'Levels' adjustment feature and color saturation via the 'Hue/Saturation' adjustment feature.

Capture and enhance overview

- 1. Capture an image with sufficient pixels for the intended output device.
- 2. Resize and crop the image to the intended output size.
- 3. Optimize the histogram using the Levels dialog box.
- 4. Adjust the tonality and color.
- 5. Clean the image using the Spot Healing Brush Tool.
- 6. Apply the Unsharp Mask or Smart Sharpen filter.
- 7. Save the adjusted image as a Photoshop file (PSD).
- 8. Duplicate the file and resize for uploading to the web if required.
- 9. Save the file as a JPEG with a suitable compression/quality setting.

6 inches x 9 inches @ 240ppi – 3:2 format image cropped from an original 4:3 format digital sensor

adobe camera raw photoshop photoshop

vanessa Montgomery by Victoria Verdon Roe

essential skills

10p

- Capture high-quality digital images as camera Raw files.
- Process a camera Raw file to optimize color, tonality and sharpness.
- Use camera Raw settings to batch process images for print and web viewing.
- Convert Raw files to digital negatives for archival storage.

Introduction

One of the big topics of conversation since the release of Photoshop CS has been the subject of 'Raw' files and 'digital negatives'. This chapter guides you through the advantages of choosing the Raw format and the steps you need to take to process a Raw file from your camera in order to optimize it for final editing in Photoshop CS3.

All digital cameras capture in Raw but only Digital SLRs and the medium- to high-end 'Prosumer' cameras offer the user the option of saving the images in this Raw format. Selecting the Raw format in the camera instead of JPEG or TIFF stops the camera from processing the color data collected from the sensor. Digital cameras typically process the data collected by the sensor by applying the white balance, sharpening and contrast settings set by the user in the camera's menus. The camera then compresses the bit depth of the color data from 12 to 8 bits per channel before saving the file as a JPEG or TIFF file. Selecting the Raw format prevents this image processing taking place. The Raw data is what the sensor 'saw' before the camera processes the image, and many photographers have started to refer to this file as the 'digital negative'. The term 'digital negative' is also used by Adobe for their archival format (.dng) for Raw files.

The sceptical among us would now start to juggle with the concept of paying for a 'state-of-the-art' camera to collect and process the data from the image sensor, only to stop the high-tech image processor from completing its 'raison d'être'. If you have to process the data some time to create a digital image why not do it in the camera? The idea of delaying certain decisions until they can be handled in the image-editing software is appealing to many photographers, but the real reason for choosing to shoot in camera Raw is QUALITY.

Processing Raw data

The unprocessed Raw data can be converted into a usable image file format by Adobe Camera Raw (ACR). Variables such as bit depth, white balance, exposure, brightness, contrast, saturation, sharpness, noise reduction and even the crop can all be assigned as part of the conversion process. Performing these image-editing tasks on the full high-bit Raw data (rather than making these changes after the file has been processed by the camera) enables the user to achieve a higher quality end-result. Double-clicking a Raw file, or selecting 'Open in Camera Raw' in Bridge, opens the Adobe Camera Raw (ACR) dialog box, where the user can prepare and optimize the file for final processing in the main Photoshop editing interface. If the user selects 16 Bits/Channel in the Workflow Options, the 12 bits per channel data from the image sensor is rounded up - each channel is now capable of supporting 32,769 levels instead of the 256 levels we are used to working with in the 8 bits per channel option. Choosing the 16 Bits/ Channel option enables even more manipulation in the main Photoshop editing space without the risk of degrading the image quality. When the file is opened into the image-editing workspace of your Photoshop software, the Raw file closes. Any changes you make to the appearance of the image in the ACR dialog box will be applied to the image that is opened in Photoshop's main editing space but won't alter the original image data of the Raw file. The adjustments you make in the ACR dialog box are instead saved as either a sidecar file (.xmp) or in the computer's Camera Raw database.

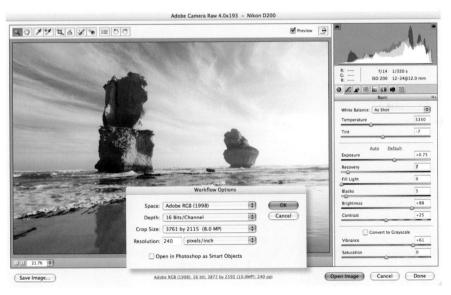

Processing projects - images on supporting DVD

Although the ACR dialog box appears a little daunting at first sight, it is reasonably intuitive and easy to master, and then Raw image processing is a quick and relatively painless procedure. The dialog box has been cleverly organized by Adobe so the user starts with the top slider and works their way down to the bottom control slider. If the image you are processing is one of a group of images shot in the same location, and with the same lighting, the settings used can be applied to the rest of the images as an automated procedure.

Straighten, crop and size - Step 1

Select the Straighten Tool on the top left-hand side of the ACR dialog box. Click on one end of an imaginary horizontal or vertical line within the image and drag to the other end of the line and then let go of the mouse clicker to automatically straighten the image. Cropping in ACR does not delete pixels but merely hides them and these pixels can be recovered if necessary.

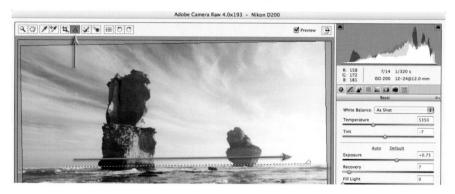

Crop the image to the correct aspect ratio or shape using the Crop Tool. Select one of the existing aspect ratios or create your own using the 'Custom' command found in the Crop menu. The aspect ratio of the bounding box will change when a new format is selected. Click and drag on any corner handle to alter the composition or framing of the image. Use the keyboard shortcut Command/Ctrl + Z to undo any action that you are not happy with.

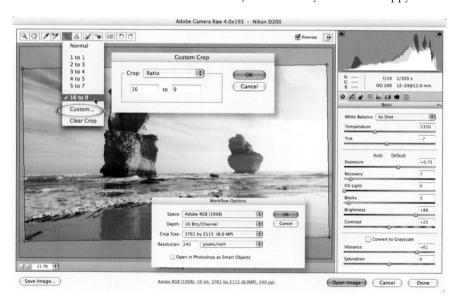

The Crop Size (pixel dimensions) and Resolution can also be set in ACR. If your target output is specified in inches or cms you will need to perform some calculations to ascertain the optimum crop size (divide the dimensions of the document needed by the optimum image resolution required by the output device). As crop sizes are only approximate in ACR you should choose a size that is slightly larger than the actual dimensions required.

Color space - Step 2

There are four choices of color space in the ACR dialog box and it is important to select the most appropriate one for your workflow before you start to assign color values to the image in ACR (using the controls on the right side of the dialog box). ColorMatch RGB is rarely used these days (it was a space commonly used before color management came of age back at the end of the last decade) so the choice is now limited to just three. The main difference between the three major spaces is the size of the color gamut (the range of colors that each space supports). There is not much point in working with a color space larger than necessary as the colors outside of the monitor space will not be visible and they cannot be reproduced by an output device with a limited gamut range. The three color spaces are as follows:

sRGB – This is the smallest (with a range of colors similar to a typical monitor) of the three common color spaces and should be selected if your images are destined for screen viewing or are destined to be printed by a print service provider using the sRGB color space.

Adobe RGB (1998) – This space is larger than the sRGB space and is the most common color space used in the commercial industry, where the final image is to appear in print. It is a good compromise between the gamut of a color monitor and the gamut of an average CMYK printing press. It is also a space that is suitable for some Print Service Providers and standard quality inkjet prints, e.g. a budget inkjet printer using matte or semi-gloss paper.

The wide gamut ProPhoto space (white) compared to the Adobe RGB 1998 space (color)

ProPhoto RGB – This is the largest color space and can be selected if you have access to a print output device with a broad color gamut (larger than most CMYK devices are capable of offering). When working in ProPhoto the user must stay in 16 Bits/Channel for the entire editing process. Converting to smaller color spaces in Photoshop's main editing space usually results in loss of data in the channels regardless of the rendering intent selected in the conversion process. This loss of data may not be immediately obvious if you do not check the histogram after the conversion process. The data loss is most apparent in bright saturated colors where texture and fine detail may be missing as the color information in the individual channels has become clipped in the conversion process.

Choosing a bit depth - Step 3

Select the 'Depth' in the Workflow Options (click on the blue text at the base of the ACR dialog box). If the user selects the 16 Bits/Channel option, the 12 bits per channel data from the image sensor is rounded up — each channel is now capable of supporting 32,769 levels. In order to produce the best quality digital image, it is essential to preserve as much information about the tonality and color of the subject as possible. If the digital image has been corrected sufficiently in ACR for the requirements of the output device, the file can be opened in Photoshop's main editing space in 8 bits channel mode. However, if the digital image has further corrections applied in the 8 bits per channel mode, the final quality will be compromised. Sixteen-bit editing is invaluable if maximum quality is required from an original image file that requires further or localized editing of tonality and color in Photoshop after leaving the camera Raw dialog box. If you have assigned the ProPhoto RGB color space in ACR you must use the 16 Bits/Channel color space in Photoshop to avoid color banding or posterization.

The problem with 8-bit editing

As an image file is edited extensively in 8 Bits/Channel mode (24-bit RGB) the histogram starts to 'break up', or become weaker. 'Spikes' or 'comb lines' may become evident in the resulting histogram after the file has been flattened.

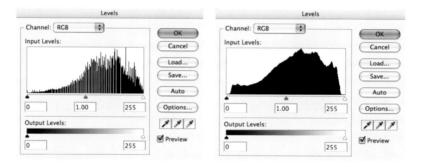

Final histograms after editing the same image in 8 and 16 bits per channel modes

This is due to the fact that there are only 256 levels or tones per channel to describe the full color range of the image. This is usually sufficient if the color space is not huge (as is the case with ProPhoto RGB) and the amount of editing required is limited. If many gaps start to appear in the histogram as a result of extensive adjustment of pixel values this can result in 'banding'. The smooth change between dark and light, or one color and another, may no longer be possible with the data supplied from a weak histogram. The result is a transition between color or tone that is visible as a series of steps in the final image (see Shadow management).

A 'Smart' solution

By opening a Raw file as a smart object (Open Object – hold down the Shift key if this option is not visible) the user can open a Raw file in 8 Bits/Channel but keep the integrity of the histogram by returning to the ACR dialog box to make any large changes to hue, saturation or brightness (luminosity) values.

White balance - Step 4

The first step in optimizing the color and tonal values for the color space we have chosen to work in is to set the white balance by choosing one of the presets from the drop-down menu. If a white balance was performed in the camera, the 'As Shot' option can be selected. If none of the presets adjust the color to your satisfaction you can manually adjust the 'Temperature' and 'Tint' sliders to remove any color cast present in the image. The 'Temperature' slider controls the blue/yellow color balance while the 'Tint' slider controls the green/magenta balance. Moving both the sliders in the same direction controls the red/cyan balance.

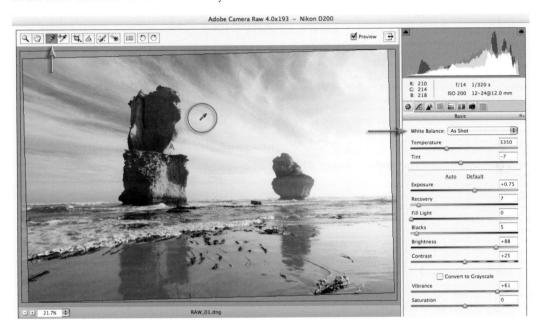

Alternatively you can simply click on the 'White Balance' eyedropper in the small tools palette (top left-hand corner of the dialog box) and then click on any neutral tone you can find in the image.

Note > Although it is a 'White Balance' you actually need to click on a tone that is not too bright. Clicking on a light or mid gray is preferable.

A photographer looking to save time may introduce a 'gray card' in the first frame of a shoot to simplify the task. If precise white balance is extremely critical the photographer can shoot a GretagMacbeth ColorChecker Chart that uses a range of color and gray patches. The user can then target the Red, Green and Blue patches and fine-tune the white balance using the Calibrate controls in ACR. Precise measurements for the colors can be found on the website www.brucelindbloom.com

81,66,52	160,138,116	94,102,134	74.86,56	118,111,154	128,168,157
164,117,48	79,75,140	143,84,80	68,51,83	144,168,74	184,155,61
59,48,126	85,123,67	122,58,46	200,188,68	142,83,123	76,108,145
241,241,241	190,190,190	145,145,145	104,104,104	67,67,67	37,37,37

A GretagMacbeth ColorChecker Chart

Tonal adjustments – Step 5

Directly beneath the White Balance sliders are the tonal controls. Careful adjustment of these sliders will allow you to get the best out of the dynamic range of your imaging sensor, thereby creating a tonally rich image with full detail. Set the brightest points within the image using the 'Exposure' slider and darkest points using the 'Blacks' slider. Both of these sliders behave like the input sliders in the 'Levels' dialog box and will set the white and black points within the image. The 'Brightness' and 'Contrast' sliders can be used to fine-tune the midtone values. The new 'Recovery' slider is designed to rescue highlight tones that may otherwise clip and also the new 'Fill Light' slider will lighten the very dark shadow tones that may not print with any texture or detail (think of recovery and fill light as non-destructive variants of the shadow/highlight adjustment feature). Tall peaks appearing at either end of the histogram indicate you will lose shadow, highlight or color detail when you export the file to the main Photoshop editing software. If the image becomes too dark because you are dragging the Exposure slider to the left in order to protect highlight detail, instead use the Recovery slider to darken the highlight detail without darkening the midtone values. Check the Shadows and Highlights buttons at the top of the ACR dialog box for a quick indication of clipping in the histogram.

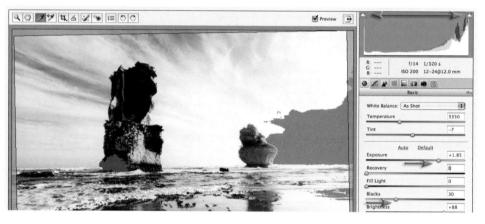

Raising the Exposure and Blacks sliders has clipped the highlights (red) and blacks (blue)

Advanced clipping information

Hold down the 'Alt/Option' key when adjusting either the 'Exposure' or 'Blacks' slider for an indication in the image window of the channel, or channels, where clipping is occurring. Excessive color saturation for the color space selected, as well as overly dark shadows and overly bright highlights, will also influence the amount of clipping that occurs. Clipping in a single channel (indicated by the red, green or blue warning colors) will not always lead to a loss of detail in the final image. However, when the secondary colors appear (cyan, magenta and yellow), you will need to take note, as loss of information in two channels starts to get a little more serious. Loss of information in all three channels (indicated by black when adjusting the shadows and white when adjusting the exposure) should be avoided.

Note > Large adjustments to the 'Brightness', 'Contrast' or 'Saturation' sliders may necessitate further 'tweaking' of the Exposure, Recovery, Fill Light or Blacks sliders.

Adjusting tonality in Raw using the Tone Curve

It is possible to fine-tune the tonality in camera Raw using the 'Tone Curve' editor. The user can choose to edit the tone curve using four sliders underneath the curve in the 'Parametric' tab or in a similar way to the Curves adjustment feature in the main editing space of Photoshop by using the tone curve in the Point tab. In the 'Point' tab the user is able to choose one of the presets from the Tone Curve menu or choose 'Linear' from this menu and then place their own adjustment points on the curve. To place an adjustment point on the curve simply click on the line and then drag the adjustment point to a new position.

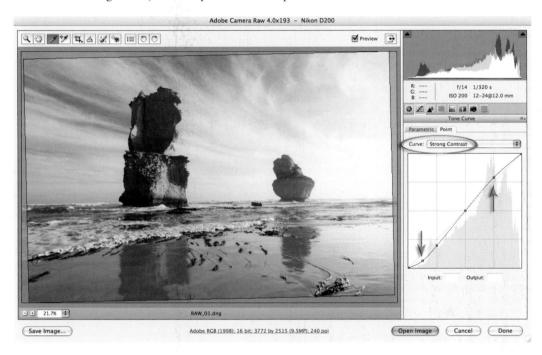

Selecting adjustment points from the image

In the Point tab, it is possible to create an adjustment point by sampling a tone from the preview image. To select an adjustment point in this manner move the mouse cursor into the preview window. Hold down the Ctrl key (PC) or Command key (Mac) to access the sample tool. Note the small ring that appears on the tone curve in the relative position to the tone being sampled. Click the mouse while sampling a highlight tone, a midtone and a shadow tone to add adjustment points. Click on an adjustment point on the tone curve to make it the active adjustment point. Either drag the adjustment point to make the selected tonal range darker or lighter or enter a new value in the output field just below the tone curve. You can use the keyboard arrow keys to fine-tune adjustment point placement. See 'Advanced Retouching' for more information on adjustment curves.

Note > The keyboard shortcut for cycling through the adjustment points (to make a different adjustment point active) is to hold down the Ctrl key and then press the Tab key (PC and Mac). Remove adjustment points by selecting an adjustment point and then pressing the Backspace key (PC) or Delete key (Mac).

Saturation and vibrance – Step 6

Increasing saturation in ACR can lead to clipping in the color channels. Clipping saturated colors can lead to a loss of fine detail and texture. Saturation clipping is especially noticeable when you have selected the smaller sRGB color space and have captured an image with highly saturated colors. As a landscape image is not the best image to illustrate saturation and vibrance we will use a more colorful image to illustrate these issues. The Vibrance slider that has been introduced with CS3 applies a non-linear increase in saturation (targeting pixels of lower saturation). It is also designed to protect skin tones in order to prevent faces from getting too red. It should create less clipping problems when compared to the Saturation control.

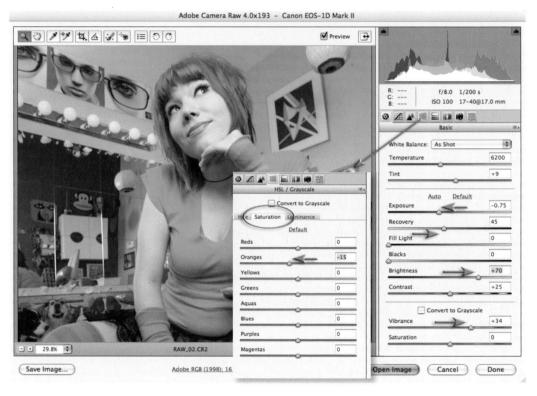

High levels of saturation clipping present in this file were corrected with the help of the Saturation controls in the HSL tab – saturation could then be increased reasonably non-destructively using the Vibrance slider Image of Melissa Zappa by Victoria Verdon Roe

In images where some colors readily clip due to their natural vibrance (especially when using a smaller gamut such as sRGB), lowering the global saturation in order to protect the clipping of a single color can result in a lifeless image. In these instances the user can turn to the HSL tab to edit the saturation of colors independently.

Note > Choosing a larger color space such as ProPhoto RGB, where the colors rarely clip, is only a short-term solution. The color gamut must eventually be reduced to fit the gamut of the output device. ACR is currently the best place in CS3 to massage these colors into the destination space.

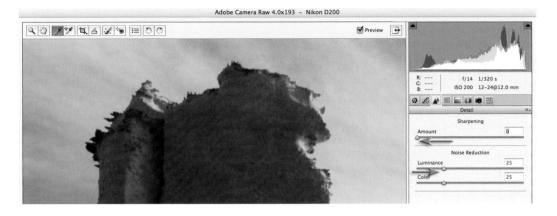

Noise reduction and sharpening – Step 7

Set the image to 200% and click on the Detail tab to access the sharpness and noise reduction controls. The Luminance and Color sliders (designed to tackle the camera noise that occurs when the image sensors' ISO is high) should only be raised from 0 if you notice image artifacts such as noise appearing in the image window.

Note > Zoom image to 200% to determine levels of noise present in the image.

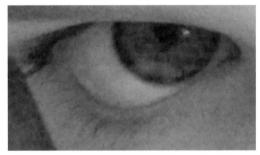

In the image above the sensor was set to 400 ISO on a budget DSLR. Both luminance noise (left) and color noise (right) are evident when the image is set to 200%. When using more expensive DSLR cameras that are set to 100 ISO, it may be possible to leave the Luminance and Color noise sliders set to 0.

It is recommended that you only perform a gentle amount of sharpening in the Raw dialog box (less than 25). By default, sharpening only affects the image preview as viewed in Bridge and not the image opened in the Photoshop editing space. Sharpening can be changed to affect all images by changing the default Camera Raw preferences.

Warning > The Luminance and Color sliders can remove subtle detail and color information that may go unnoticed if the photographer is not careful to pay attention to the effects of these sliders. Zoom in to take a closer look, and unless you can see either the little white speckles or the color artifacts set these sliders to 0.

Digital exposure

Most digital imaging sensors capture images using 12 bits of memory dedicated to each of the three RGB color channels, resulting in 4096 tones between black and white. Most of the imaging sensors in digital cameras record a subject brightness range of approximately five to eight stops (five to eight f-stops between the brightest highlights with detail and the deepest shadow tones with detail).

Tonal distribution in 12-bit capture

Distribution of levels

One would think that with all of this extra data the problem of banding or image posterization due to insufficient levels of data (a common problem with 8-bit image editing) would be consigned to history. Although this is the case with midtones and highlights, shadows can still be subject to this problem. The reason for this is that the distribution of levels assigned to recording the range of tones in the image is far from equitable. The brightest tones of the image (the highlights) use the lion's share of the 4096 levels available while the shadows are comparatively starved of information.

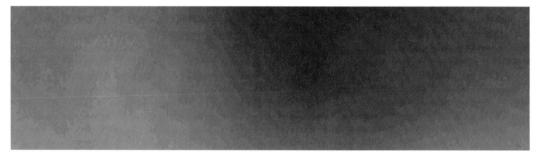

An example of posterization or banding

Shadow management

CCD and CMOS chips are, however, linear devices. This linear process means that when the amount of light is halved, the electrical stimulation to each photoreceptor on the sensor is also halved. Each f-stop reduction in light intensity halves the amount of light that falls onto the receptors compared to the previous f-stop. Fewer levels are allocated by this linear process to recording the darker tones. Shadows are 'level starved' in comparison to the highlights that have a wealth of information dedicated to the brighter end of the tonal spectrum. So rather than an equal amount of tonal values distributed evenly across the dynamic range, we actually have the effect as shown above. The deepest shadows rendered within the scene often have fewer than 128 allocated levels, and when these tones are manipulated in post-production Photoshop editing there is still the possibility of banding or posterization.

Adjusting exposure in ACR

For those digital photographers interested in the dark side, an old SLR loaded with a fine-grain black and white film is a hard act to follow. The liquid smooth transitions and black velvet-like quality of dark low-key prints of yesteryear is something that digital capture is hard pressed to match. The sad reality of digital capture is that underexposure in low light produces an abundance of noise and banding (steps rather than smooth transitions of tone). The answer, however, is surprisingly simple for those who have access to a DSLR and have selected the Raw format from the Quality menu settings in their camera. Simply be generous with your exposure to the point of clipping or overexposing your highlights and only attempt to lower the exposure of the shadows in Adobe Camera Raw.

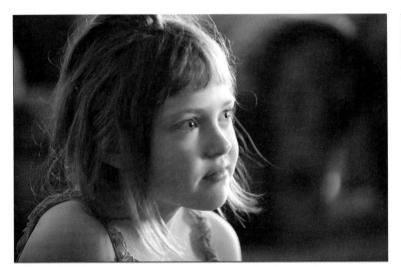

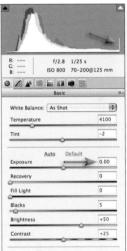

1. The first step is the most difficult to master for those who are used to using Auto or Program camera exposure modes. Although the final outcome may require deep shadow tones, the aim in digital low-key camera exposure is to first get the shadow tones away from the left-hand wall of the histogram by increasing and NOT decreasing the exposure. It is vitally important, however, not to increase the exposure so far that you lose or clip highlight detail. The original exposure of the image used in this project reveals that the shadow tones (visible as the highest peaks in the histogram) have had a generous exposure in-camera so that noise and banding have been avoided (the tones have moved well to the right in the histogram). The highlights, however, look as though they have become clipped or overexposed. The feedback from the histogram on the camera's LCD would have confirmed the clipping at the time of exposure (the tall peak on the extreme right-hand side of the histogram) and if you had your camera set to warn you of overexposure, the highlights would have been merrily flashing at you to ridicule you of your sad attempts to expose this image. The typical DSLR camera is, however, a pessimist when it comes to clipped highlights and ignorant of what is possible in Adobe Camera Raw. Adobe Camera Raw can recover at least one stop of extra highlight information when the Exposure slider is dragged to the left (so long as the photographer has used a DSLR camera that has a broader dynamic range than your typical fixed lens compact digicam).

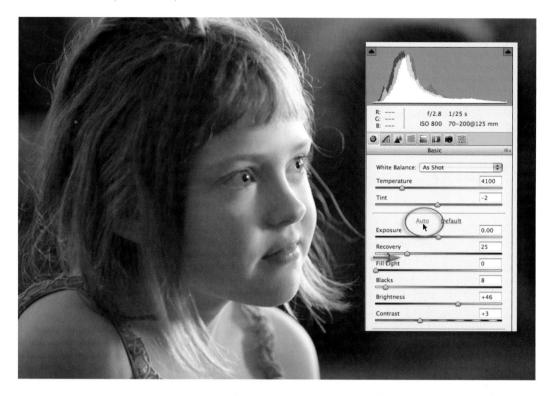

Adobe Camera Raw rescues the highlights – sometimes automatically

'Exposing right'

When the Auto checkbox in the Exposure slider is checked, Adobe Camera Raw often attempts to rescue overexposed highlights automatically. With a little knowledge and some attention to the camera's histogram during the capture stage, you can master the art of pushing your highlights to the edge. So if your model is not in a hurry (mine is watching a half-hour TV show) you can take an initial exposure on Auto and then check your camera for overexposure. Increase the exposure using the exposure compensation dial on the camera until you see the flashing highlights. When the flashing highlights start to appear you can still add around one extra stop to the exposure before the highlights can no longer be recovered in Adobe Camera Raw. The popular term for this peculiar behavior is called 'exposing right'.

PERFORMANCE TIP

If the highlights are merrily flashing and the shadows are still banked up against the left-hand wall of the histogram, the solution is to increase the amount of fill light, i.e. reduce the difference in brightness between the main light source and the fill light. If you are using flash as the source of your fill light, it would be important to drop the power of the flash by at least two stops and choose the 'Slow-Sync' setting (a camera flash setting that balances both the ambient light exposure and flash exposure) so that the flash light does not overpower the main light source positioned behind your subject. The harsh light from the on-camera flash can also be diffused using a diffusion device.

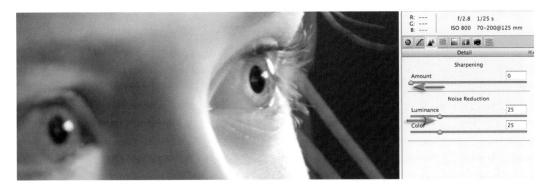

2. Before we massage the tones to create our low-key image we must first check that our tones are smooth and free from color and luminance noise. Zoom in to 100% magnification for an accurate preview and look for any problems in the smooth dark-toned areas. Setting both the Luminance Smoothing and Color Noise Reduction sliders to 25 (found in the Detail tab) removes the noise in this image. I would also recommend that the Sharpness slider be set to 0 at this point. Rather than committing to global sharpening using the Adobe Camera Raw dialog box, selective sharpening in the main Photoshop editing space may help to keep the tones as smooth as possible.

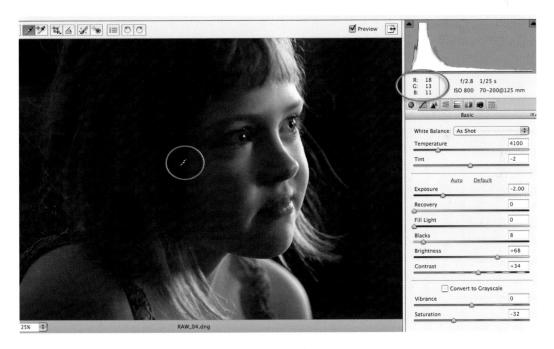

3. Create the low-key look by moving the Exposure and/or the Brightness sliders to the left in the Basic tab. You can continue to drop these sliders until the highlights start to move away from the right-hand wall of the histogram. Select the 'White Balance Tool' and move your mouse cursor over the deeper shadows – this will give you an idea of the RGB values you are likely to get when this image is opened into the editing space. Once you approach an average of 15 to 20 in all three channels the low-key look should have been achieved.

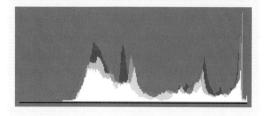

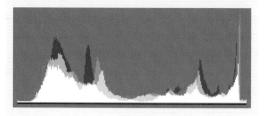

Expose right and adjust left

'Expose right' and multiple exposures

This inequitable distribution of levels has given rise to the idea of 'exposing right'. This work practice encourages the user seeking maximum quality to increase the camera exposure of the shadows (without clipping the highlights) so that more levels are afforded to the shadow tones. This approach to making the shadows 'information rich' involves increasing the amount of fill light (actual light rather than the ACR's fill light) or lighting with less contrast in a studio environment. If the camera Raw file is then opened in the camera Raw dialog box the shadow values can then be reassigned their darker values to expand the contrast before opening it as a 16 Bits/Channel file. When the resulting shadow tones are edited and printed, the risk of visible banding in the shadow tones is greatly reduced.

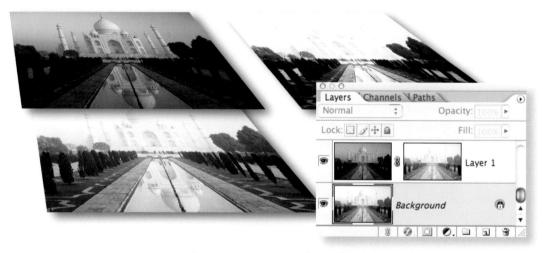

Separate exposures can be combined during the image-editing process

This approach is not possible when working with a subject with a fixed subject brightness range, e.g. a landscape, but in these instances there is often the option of bracketing the exposure and merging the highlights of one digital file with the shadows of a second. Choose 'Merge to HDR' (high dynamic range) from the File > Automate menu or use the manual approach outlined in 'Advanced Retouching'. The example above shows the use of a layer mask to hide the darker shadows in order to access the bit-rich shadows of the underlying layer and regain the full tonal range of the scene.

Images by kind permission of Sovereign Hill Outdoor Museum, Ballarat, Victoria

Processing multiple Raw files

It is possible to open more than one image into the camera Raw dialog box. Opening the files in Bridge (Ctrl + R or Command + R) instead of Photoshop (Ctrl + O or Command + O) will allow you to process a batch of files in Bridge while working on another image in Photoshop.

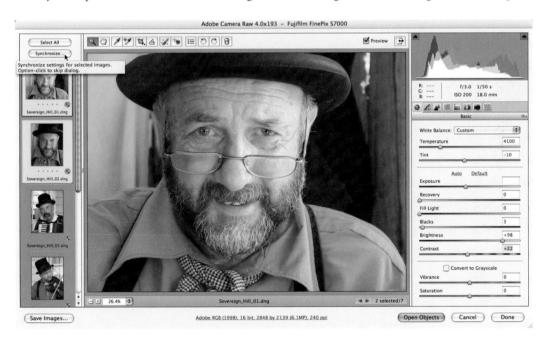

When images share the same lighting it is possible to synchronize the Raw settings. Images taken with a camera using the Auto White Balance setting will often display minor color variations which would benefit from being standardized in camera Raw.

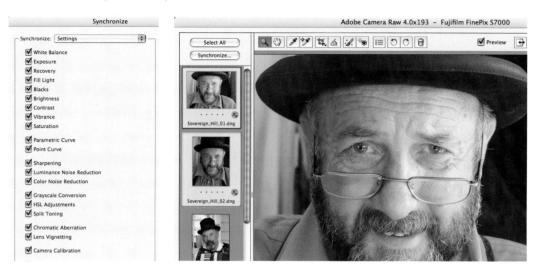

Start the synchronize procedure by optimizing one image and then select the rest of the images that share the same lighting. Clicking on the Synchronize button allows you to choose the precise Raw settings you would like to synchronize. The ability to synchronize selected settings allows you to standardize some components, such as color and tonality, while leaving other settings, such as crop and sharpness, specific to an individual image.

Note > Cropping an image in Camera Raw does not delete the pixels but merely hides them from view in the Bridge previews. The crop can be removed or altered at any time.

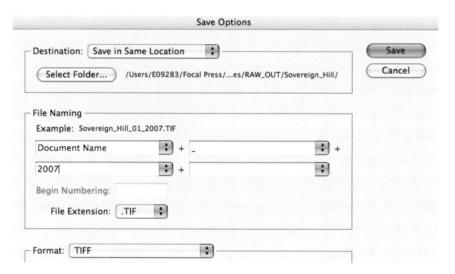

Select Done in the camera Raw dialog box to apply the changes or select 'Save' to process the files (convert them to PSD, TIFF or JPEG files with the settings applied). Saving multiple files can take a while but you can work in Photoshop on another image whilst this process is taking place (so long as the Raw files were opened in Bridge rather than in Photoshop).

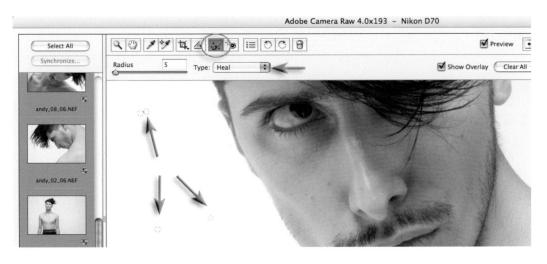

Dust on the sensor – batch removal

A significant problem arises for many digital cameras when dust is allowed to accumulate on the sensor. This becomes most noticeable in smooth areas of light tone such as sky or white studio backdrops as dark spots. Use the Retouch tool and click on a spot in the image. Photoshop will automatically choose an area of the image to heal this spot. The Radius can be changed by raising the Radius slider or dragging the red circle bigger. The source for the heal area (the green circle) can be dragged to an alternate location if required. Fortunately the dust is in the same place in each and every image and so after spotting one image you can choose 'Select All' and 'Synchronize' to remove the dust from all images you have open in the ACR dialog box. Be sure to check the Spot Removal option in the Synchronize dialog box before selecting OK.

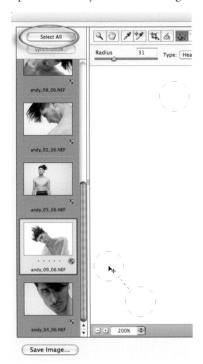

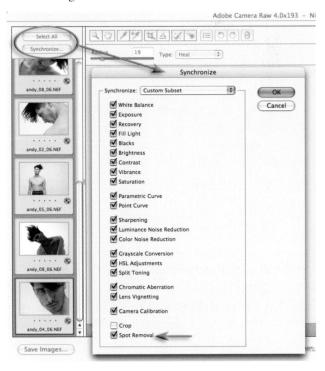

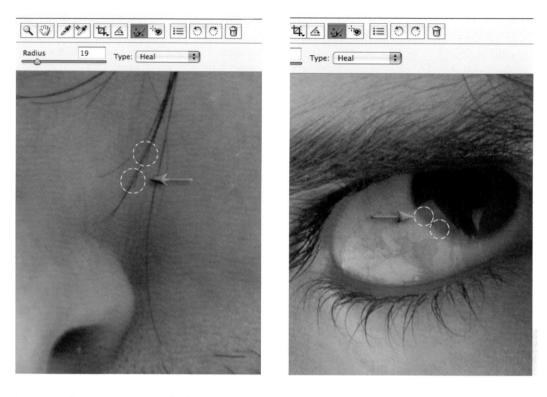

In areas of continuous tone the heal area that is selected automatically by Photoshop is usually OK. In areas of fine detail the healing area may need to be relocated to ensure lines do not appear disjointed.

Archiving Raw files as digital negatives

Working with camera Raw files is going to create some extra strain on the storage capacity found on a typical computer's hard drive. What to do with all of the extra gigabytes of Raw data is a subject that people are divided about. You can burn them to CD or DVD disks – but are the disks truly archival? You can back them up to a remote FireWire drive – but what if the hard drive fails? Some believe that digital tape offers the best track record

for longevity and security. Why archive at all you may ask? Who can really tell what the image-editing software of the future will be capable of – who can say what information is locked up in the Raw data that future editions of the Raw editors will be able to access. Adobe has now created a universal Raw file format called DNG (Digital Negative) in an attempt to ensure that all camera Raw files (whichever camera they originate from) will be accessible in the future. The Digital Negative format also includes lossless compression to reduce the size of the Raw files. The Adobe DNG converter is available from the Adobe website or from the supporting DVD. The converter will ensure that your files are archived in a format that will be understood in the future. Expect to see future models of many digital cameras using this DNG format as standard. One thing *is* for sure – Raw files are a valuable source of the rich visual data that many of us value and so the format will be around for many years to come.

Low-key image created in Camera RAW by reducing exposure – image by Mark Galer

digital printing shop

Magdalena Bors

phot

essential skills

- Control the color accuracy between monitor preview and print.
- Understand the procedures involved with producing a digital print.
- Print a color-managed digital image using a desktop inkjet printer.
- Compensate for visual differences between the monitor preview and print.

Introduction

Creating high-quality prints using desktop inkjet printers can be a mystifying, infuriating and costly experience. You can really only hope to get close to the quality of traditional photographic prints if you follow a color-managed workflow and print on digital 'Photo Paper' using a '6-ink' (minimum) rather than a '4-ink' inkjet printer. Using high quality photo papers ensures that the images you print will appear sharp and with richly saturated colors. Matching the colors of the print to those that appear on your monitor is, however, a mystifying experience for many. A little understanding of the issues involved will help you find a personal path to perfect prints.

The Epson Stylus Photo R800 is capable of printing a rich color gamut due to additional primary red and blue inks. A tiny droplet size makes the need for light cyan and light magenta inks superfluous

If you choose to print using a budget priced 4-ink inkjet printer, the lower quality is most noticeable in the highlights of the image. The addition of light cyan and light magenta inks or a high-quality printer that is capable of printing a very small dot ensures smooth photographic quality highlights (the ink dots are hard to see without a magnifying glass). Epson 6 and 8-ink printers retail under the 'Epson Stylus Photo' name, whilst Canon's 6 and 8-ink models are often referred to as 'bubble-jet' printers.

Color conversions

Color on a computer's monitor is created by mixing red, green and blue light (RGB) whilst the reflected light from cyan, magenta, yellow and black inks (CMYK) creates color on the printed page. A perfect match is therefore very difficult to achieve, as the range or 'gamut' of colors capable of being reproduced by each of the two display mediums is similar, but different. The colors present in a digital image file have to be translated or converted to fit the gamut or 'color space' of each output device or printer. Once you have achieved an accurate translation, however (a good looking print that resembles what you have pictured on your monitor), just changing the brand of printing paper can upset the apple cart if the translation process is not adjusted accordingly.

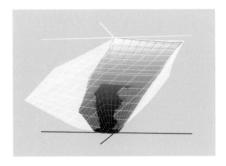

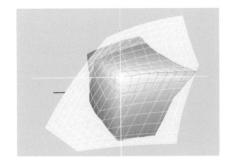

The range or 'gamut' of colors that each output device is capable of displaying can vary enormously. In the illustrations a CMYK printing space (shown in color) is contained by the much larger RGB monitor space (shown in white)

Profiles

The accuracy of color translation is made possible by the use of 'ICC profiles' such as 'sRGB' and 'Adobe RGB'. Profiles are tagged onto image files by digital cameras, scanners and image-editing programs as a way of recording not only the color numbers (the numerical values taken from the levels in each of the channels) but how the colors actually appear in terms of their relative hue, saturation and brightness. In a 'color-managed' workflow it is a 'color management engine' (such as Adobe's 'ACE' built into Photoshop) that will massage the numbers of the colors captured so that the actual appearance of the color is the same on your calibrated and profiled monitor. Your monitor has a distinctly different set of color characteristics to the capture device, and so the color management engine uses your monitor's profile to perform the task of color matching. Color accuracy is only possible, however, if you have calibrated and profiled your monitor.

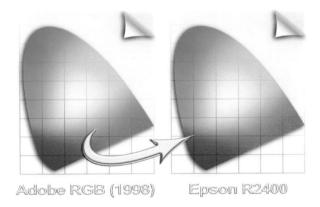

Color profiles help to ensure that what you see is what you get

The completion of this color management process is where the colors we see on our monitor are then translated accurately into the colors that we can see reproduced by our chosen output device. With this final step there are however choices, as the computer's operating system, the Adobe software and the printer are all capable of managing this final step – and these choices typically lead to the confusion that often surrounds the printing procedure. Get the mix of choices wrong and the final result can look like the proverbial dog's dinner. Find the right route through the maze of options and color consistency is yours.

Monitor calibration and working color space

To ensure the level of visual consistency outlined earlier we must first check that our monitor's contrast, brightness and color are fairly standard, i.e. not on a 60s trip to the world of weird. Each monitor requires its own custom profile (not the canned one considerately installed by the factory). Standardizing the monitor's display is called 'monitor calibration'. When the monitor is calibrated we can save a profile for the monitor. In this way the precise colors captured by the camera can be interpreted by Photoshop and tweaked using the monitor profile so that the image can be displayed accurately on your unique screen (a case of 'what-you-see-is-really-what-you-get'). Reset the 'Target White Point' (sometimes referred to as 'Adjusted White Point') of the monitor to D65 or 6500, which is equivalent to daylight (the same light you will use to view your prints), using 'Adobe Gamma' (from the 'Control Panel/s' in Windows) or 'Display Calibrator' (from the 'Utilities' folder in Mac OSX).

Tristimuli Values
 ⊕ Target White Point
 □ Conclusion
 □ D50 Warm yellowish lighting – standard for graphic arts work.
 □ D65 Cooler – equivalent to midday sunlight.
 □ 9300 Coolest – the default white point of most displays and televisions.

Note > See 'The Digital Darkroom' for extended information on this important subject.

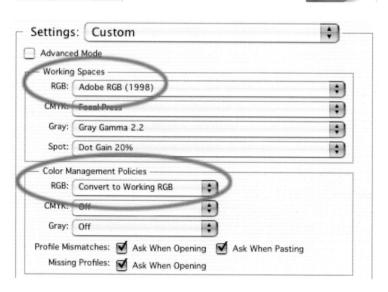

Select an appropriate color setting for the software

To create an on-screen preview of the image that will be eventually output by your printer, it is important to select a 'working space' for Photoshop that is sympathetic to the range of colors that can be achieved by your inkjet printer using good quality 'photo paper'. The most suitable working space currently available is called 'Adobe RGB (1998)'. To implement this working space choose 'Color Settings' in Photoshop and set the workspace to 'Adobe RGB (1998)' from the RGB pull-down menu. In the 'Color Management Policies' section, select 'Convert to Working RGB' from the 'RGB' pull-down menu and check the 'Ask When Opening' boxes.

Pre-flight check list

In an attempt to make the first time not too memorable, for all the wrong reasons, check that your ink cartridges are not about to run out of ink and that you have a plentiful supply of good quality paper (same surface and same make). It is also worth starting to print when there are several hours of daylight left, as window light (without direct sun) is the best light to judge the color accuracy of the prints. If you are restricted to printing in the evening it may be worthwhile checking out 'daylight' globes that offer a more 'neutral' light source than tungsten globes or fluorescent tubes. It is also important to position the computer's monitor so that it is not reflecting any light source in the room (including the direct illumination from windows and skylights). If your monitor is reflecting a brightly colored wall or window then consider shifting your furniture.

Note > Refilling your ink cartridges and using cheap paper is not recommended for absolute quality and consistency.

Keeping a record

The settings of the translation process (all the buttons and options that will be outlined next), the choice of paper, the choice of ink and the lighting conditions used to view the print will all have enormous implications for the color that you see on the printed page. The objective when you have achieved a color match is to maintain consistency over the process and materials so that it can be repeated with each successive print. It is therefore important to keep a track of the settings and materials used.

Project	Portrait	Sept 22/04
Image File	TIFF	220 ppi
Paper	Epson	Matte HW
Inks	Epson	AUG 04
Colour Management	Adobe	Printer
Profiles	N/A	Same As Source
Printer Settings	Matte HW	Best Photo
Colour Controls	Photo-realistic	+4 Saturation

There is only one thing more infuriating than not being able to achieve accuracy, and that is achieving it once and not being sure of how you did it. Some words of advice – WRITE IT DOWN!

Note > A template for the print record sheet is available on the supporting DVD.

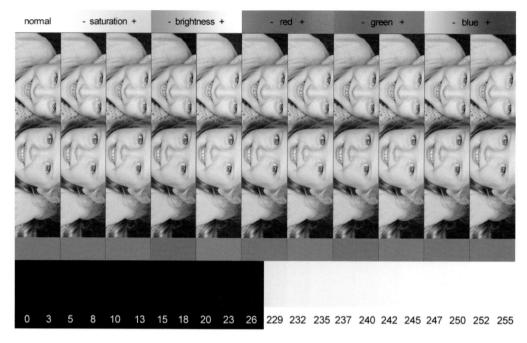

Use the test file to help you target the perfect color balance quickly and efficiently

Preparing a test print

Start the printing process by selecting 'Print' from the 'File' menu. As discussed previously there are several methods of printing. There is no one road. In order to discover a workflow that suits your own setup it is recommended that you use a test file that has a broad range of colors of varying saturations. Use a test file that incorporates a range of saturated colors, neutral grays and skin tones. If this file prints perfectly you can be confident that subsequent prints using the same media and settings will follow true to form. The test print file in the illustration above is available on the supporting DVD. It will help you target your optimum shadow and highlight points and stop you from chasing what initially appears to be a color cast and in the end turns out to be a blocked ink jet.

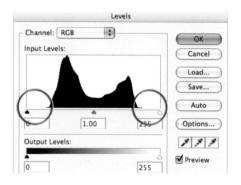

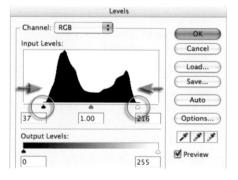

Note > There is an old saying, 'quality in – quality out'. Each image you print must be checked that it has been optimized for printing. The file's histogram should be optimized and any obvious color cast removed. See 'Capture and Enhance'.

Printer manages color

The first path uses the Photoshop default settings in the 'Print' dialog box. This path allows the printer to manage the colors. Although Adobe has the industry standard color management engine it is only as effective as the profiles it is handed for the conversion job. The printer profiles shipped with the printer are again canned and may, or may not, bear any resemblance to the color characteristics of the actual printer you are using.

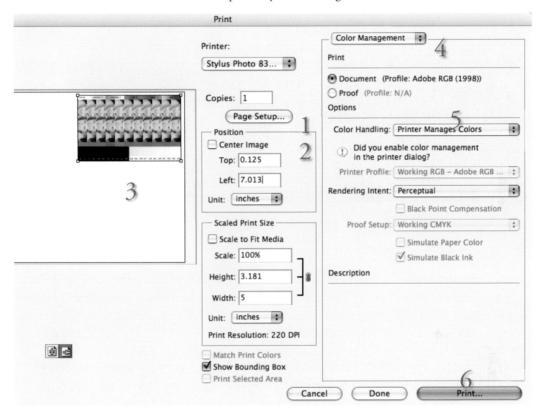

- Click on 'Page Setup' to select the paper size and orientation (horizontal or vertical).
 If you only need to change orientation click on the icon below the preview window.
- 2. Deselect the 'Center Image' check box.
- 3. Drag the image preview to a corner of the page to save printing paper.
- 4. Choose 'Color Management' from the options menu.
- 5. Select the 'Printer Manages Colors' option in the Color Management section (use the 'Photoshop Manages Colors' option if you have a custom profile for your printer).
- 6. Select Print.

Note > The default settings in the Adobe Print dialog box use a setting called 'Printer Manages Colors', which you can only see if you click on the 'More Options' button. This setting instructs the Adobe software to hand over the image to the printer without making any changes to the color numbers. When you click on the Print button in the Print dialog box you will be transported to the printer driver dialog box.

Printer driver

Look for the following options in your printer dialog box:

- 1. Select the paper you are using from the 'Media Type' menu.
- 2. Select the 'Advanced' option (usually found in the 'Custom' menu on a PC).
- 3. Select the maximum dpi from the 'Print Quality' menu or any option that indicates the 'Best Photo' quality option has been selected.
- 4. Select 'Color Controls' from the 'Color Management' menu (you should see the Magenta, Cyan and Yellow color sliders).
- 5. Select 'Print'.

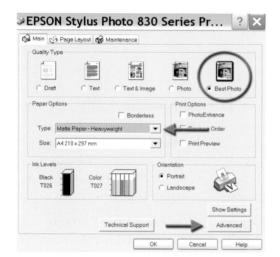

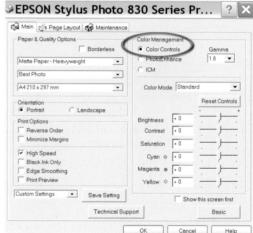

The options for 'Printer Color Management' in an Epson printer driver for a PC

The printer is now handling the color management. Once the test file has been printed you can make an assessment of what changes need to be made before printing a modified or 'tweaked' version. Be sure to let the test print dry for at least 10 to 15 minutes before making an assessment of the color and tonal values as these may change quite dramatically. Subtle changes can continue to occur for several hours during the drying process. See 'Analyzing the test print' when assessing whether any changes need to be made to the first test print. To speed up and simplify the procedure for subsequent prints a 'custom setting' or 'preset' can be resaved in the printer driver once you have achieved accuracy by fine-tuning the color sliders. Name the custom setting incorporating the paper surface, e.g. Matte HW-PCM (printer color management).

Note > The precise wording of the options in the printer drivers may vary between different manufacturers and models of printer.

Photoshop manages color

The secret to success when using Adobe's color management is to select 'No Color Adjustment' from the 'Color Management' or ICC controls in the printer driver software (if using a Canon printer go to 'Color > Color Control > None').

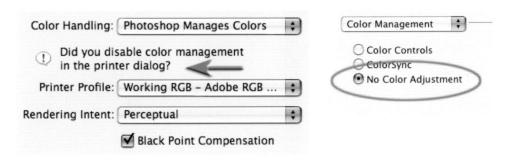

Select 'No Color Adjustment' in the printer driver when using Adobe to color-manage your printing

From the Color Management section of the print dialog box choose the 'Photoshop Manages Colors' option and choose the printer profile. Choose 'Relative Colorimetric' or 'Perceptual' as the rendering intent and check the 'Black Point Compensation' check box. When you select print and the printer driver opens it is now essential to cancel the printer's color management.

Note > You may have to hunt (sometimes in vain) for the 'No Color Adjustment' option in your own printer driver as this is not the most common printing method used by non-professionals. The bargain basement inkjet printers are designed to take the reins of the color management procedure as not all image-editing software is capable of handling the color management, Adobe being the exception to the rule.

Warning > The worst colors imaginable are produced by instructing Adobe to manage the color translation, and then NOT disabling the color management in the printer driver software. If in doubt follow the printer color management approach.

Photoshop color management workflow

Select the 'Media Type' and quality settings as in the previous path and then click 'Print'. The Adobe color management workflow is as follows:

- 1. Select 'Color Management' in the Print dialog box.
- 2. Select the profile for the printer and media type (if available) from the 'Print Space' menu.
- 3. The 'Source Space' indicates the current profile of the image you are about to print.
- 4. Choose 'Perceptual' or 'Relative Colorimetric' as the 'Intent'.
- 5. Choose the media type and highest dpi or 'Best Photo' print quality.
- 6. In the Color Management section choose 'No Color Management'.
- 7. Select 'Print'.

Soft proofing

Although the image that appears on your monitor has been standardized (after the calibration process and the implementation of the Adobe RGB working space), the printed image from this standardized view would appear different if printed through a variety of different inkjet printers onto different paper surfaces or 'media types'. In Photoshop it is possible to further alter the visual appearance of the image on your monitor so that it more closely resembles how it will actually appear when printed by your specific make and model of inkjet printer on a particular paper surface. This process is called 'soft proofing'.

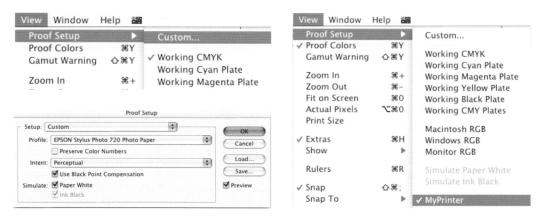

To set up the soft proof view go to View > Proof Setup > Custom. From the Profile menu select the profile of your printer and paper or 'media type'. Choose 'Perceptual' from the 'Intent' menu and check the 'Use Black Point Compensation' and 'Paper White' boxes. Save these settings so they can be accessed quickly the next time you need to soft proof to the same printer and media type.

When you view your image with the soft proof preview the color and tonality will be modified to more closely resemble the output characteristics of your printer and choice of media. The image should now be edited with the soft proof preview on, to achieve the desired tonality and color that you would like to see in print. It is recommended that you edit in 'Full Screen Mode' to remove distracting colors on your desktop and use adjustment layers to modify and fine-tune the image on screen.

Analyzing the test print

View the print using soft window light (not direct sunlight) when the print is dry, and try to ascertain any differences between the print and the screen image in terms of hue (color), saturation and brightness. Any differences may be attributed to inaccuracies in your initial monitor calibration and/or the profile that was shipped with your printer (Photoshop color management only).

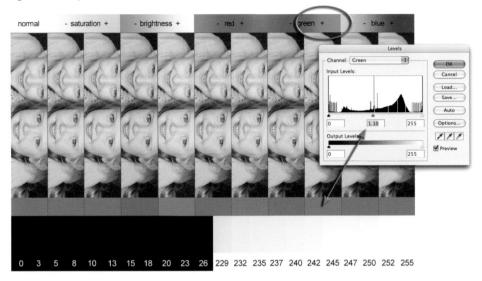

- Check that the color swatches at the top of the image are saturated and printing without tracking marks or banding (there should be a gradual transition of color). If there is a problem with missing colors, tracking lines or saturation, clean the printer heads using the printer guidelines.
- 2. View the skin tones to assess the appropriate level of saturation. The lower and higher saturation swatches have a -20 and +20 adjustment applied using Photoshop's Hue/Saturation adjustment.
- 3. View the gray tones directly beneath the images of the children to determine if there is a color cast present in the image. The five tones on the extreme left are desaturated in the image file. If these print as gray then no color correction is required. If, however, one of the gray tones to the right (which have color adjustments applied) appears to be gray then a color cast is present.
- 4. Find the tone that appears to be desaturated (the color cast corresponds with the color swatches at the top of the test file). Apply this color correction to the next print. For example, if the plus green strip appears to print with no color cast then a 1.1 gamma adjustment in the green channel is required (when using the Photoshop color management) for the next test print. A minus value will need to be entered in the Magenta slider in the 'Color Controls' when using 'Printer Color Management'.

Note > Each of the color strips in the test image has the same gamma adjustment applied using the RGB channels. The correction necessary can be made using the Levels dialog box by sliding the Gamma slider to 0.9 or 1.1 in the corresponding color channel when using Photoshop color management.

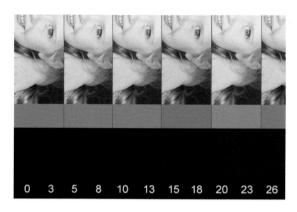

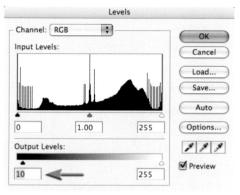

Maximizing shadow and highlight detail

Examine the base of the test strip to establish the optimum highlight and shadow levels that can be printed with the medium you have chosen to use. If the shadow tones between level 10 and level 20 are printing as black then you should establish a Levels adjustment layer to resolve the problem in your Adobe software. The bottom left-hand slider should be moved to the right to reduce the level of black ink being printed. This should allow dark shadow detail to be visible in the second print. A less common problem is highlight values around 245 not registering on the media. However, if this is a problem, the highlight slider can be moved to the left to encourage the printer to apply more ink.

Note > It is important to apply these output level adjustments to an adjustment layer only as these specific adjustments apply to only the output device you are currently testing.

Printing overview

Materials

Start by using the printer manufacturer's recommended ink and paper.

Use premium grade 'Photo Paper' for maximum quality.

Monitor

Position your monitor so that it is clear of reflections.

Select a target white point or color temperature of 6500.

Set contrast, brightness and 'Gamma' using 'Adobe Gamma' or 'Monitor Calibrator'.

Adobe

Set the Color Settings of the Adobe software.

Select 'Same As Source' (Path One) or the profile of the 'Destination Space' (Path Two).

Printer

Use a 6-ink inkjet printer for maximum quality.

Select the 'Media Type' in the printer software dialog box.

Select highest dpi or 'Best Photo' quality setting.

Proofing

Allow print to dry and use daylight to assess color accuracy of print.

Creating a 'ringaround'

It is advisable to limit the variables once color consistency has been achieved. When changing an ink cartridge it is recommended that you run a test from the same image used to initiate the color consistency and then modify any settings if required.

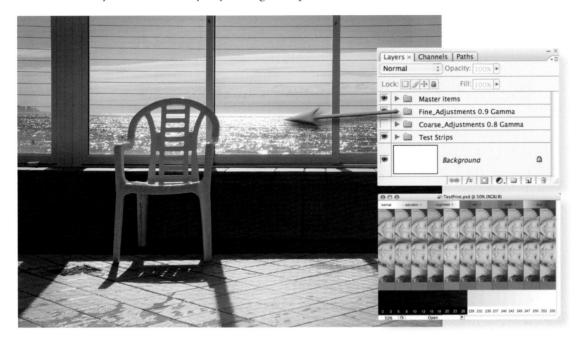

It is possible to use the adjustment layers used to create the 'ringaround' in the test print to monitor variations in color and saturation in additional images. This involves opening the test print PSD file on the supporting DVD and dragging the layer group (the folder above the background layer in the Layers palette) into your image window. Use the Free Transform command from the Edit menu to resize the adjustment layers to fit your own image. If one of the adjustments hits the target, switch off all of the other adjustment layers in the group and remove the layer mask of the correct adjustment layer (drag it to the trash can in the Layers palette or click the layer mask thumbnail whilst holding down the Shift key) and then proceed to print.

In conclusion

Although daunting at first, obtaining a color-managed workflow is reasonably quick and easy to use once the settings have been saved in the printer driver dialog box. It is probably worth mentioning that you should print out another test strip each time you change paper or inks just to ensure the print accuracy has not been upset by the change. It is also worth printing out a test strip if the printer has been idle for a number of weeks to ensure all the inks are printing as they should. This is not the entire color story but one of the two paths outlined in this tutorial should get you out of the maze that you may have found yourself in.

Printing using a professional laboratory

Professional photographic laboratory services are now expanding into the production of large and very large prints using the latest inkjet and piezo technology. Many are also capable of printing your digital files directly onto color photographic paper. In fact, outputting to color print paper via machines like the Durst Lambda and Fuji Frontier has quickly become the 'norm' for a lot of professional photographers. Adjustment of image files that print well on desktop inkjets so that they cater for the idiosyncrasies of these RA4 and large inkjet machines is an additional output skill that is really worth learning.

With improved quality, speed and competition in the area, the big players like Epson, Kodak, Durst, Fuji and Hewlett Packard are manufacturing units that are capable of producing images that are not only visually stunning, but also very, very big. Pictures up to 54 inches wide can

be made on some of the latest machines, with larger images possible by splicing two or more panels together. A photographer can now walk into a bureau with a CD containing a favorite image and walk out the same day with a spliced polyester poster printed with fade-resistant, all-weather inks the size of a billboard. In addition to these dedicated bureau services, some professionals, whose day-to-day business revolves around the production of large prints, are actually investing in their own wide format piezojet or inkjet machines. The increased quality of pigment-based dye systems together with the choice of different media, or substrates as they are referred to in the business, provides them with more imaging and texture choices than are available via the RA4 route.

Before you start

Getting the setup right is even more critical with large format printing than when you are outputting to a desktop machine. A small mistake here can cause serious problems to both your 48×36 inch masterpiece as well as your wallet, so before you even turn on your computer, talk to a few professionals. Most output bureaus are happy to help prospective customers with advice and usually supply a series of guidelines that will help you set up your images to suit their printers. These instructions may be contained in a pack available with a calibration swatch over the counter, or might be downloadable from the company's website.

Some of the directions will be general and might seem a little obvious, others can be very specific and might require you to change the CMYK settings of your image-editing program so that your final files will match the ink and media response of the printer. Some companies will check that your image meets their requirements before printing, others will dump the unopened file directly to the printer's RIP assuming that all is well. So make sure that you are aware of the way the bureau works before making your first print.

General guidelines

The following guidelines have been compiled from the suggestions of several output bureaus. They constitute a good overview but cannot be seen as a substitute for talking to your own lab directly.

- Ensure that the image is orientated correctly. Some printers are set up to work with a portrait or vertical image by default; trying to print a landscape picture on these devices will result in areas of white space above and below the picture and the edges being cropped.
- Make sure the image is the same proportion as the paper stock. This is best achieved by making an image with the canvas the exact size required and then pasting your picture into this space.
- Don't use crop marks. Most printers will automatically mark where the print is to be cropped. Some bureaus will charge to remove your marks before printing.
- 4. Convert text to line or raster before submission. Some imaging and layout programs need the font files to be supplied together with the image at the time of printing. If the font is missing then the printer will automatically substitute a default typeface, which in most cases will not be a close match for the original. To avoid failing to supply a font needed, convert the type to line or raster before sending the image to the bureau.
- 5. Use the resolution suggested by the lab. Most output devices work best with an optimal resolution; large format inkjet printers are no different. The lab technician will be able to give you details of the best resolution to supply your images in. Using a higher or lower setting than this will alter the size that your file prints so stick to what is recommended.
- 6. Keep file sizes under the RIP maximum. The bigger the file the longer it takes to print. Most bureaus base their costings on a maximum file size. You will need to pay extra if your image is bigger than this value.
- 7. Use the color management system recommended by the lab. In setting up you should ensure that you use the same color settings as the bureau. This may mean that you need to manually input set values for CMYK or use an ICC profile downloaded from the company's website.

Set orientation >>

Set paper size >>

Set correct resolution >>

Convert to or Assign ICC profile >>

Printing monochromes

To the eyes of experienced darkroom workers the difficulties of printing black and white photographs with a color printer are immediately apparent. Most photo quality inkjets use the five colored inks, as well as black, to produce monochromes. With dot sizes now being so small it is only under the closest scrutiny that the multi-colored matrix that lies beneath our black and white prints is revealed. Balancing the different colors so that the final appearance is neutral is a very tricky task. Too many dots of one color and a gray will appear blue, too few and it will contain a yellow hue.

With just this type of situation in mind several of the bigger third party ink manufacturers have produced dedicated monochrome cartridges and ink sets for all popular desktop and wide format inkjet printers. The system is simple – pure black and white can be achieved by removing all color from the print process. The manufacturers produce replacement cartridges containing three levels of gray instead of the usual cyan, yellow and magenta or five levels instead of cyan, light cyan, magenta, light magenta and yellow for five-color cartridges. All inks are derived from the same pigment base and so prints made with these cartridges contain no strange color casts.

Printing with dedicated monochrome ink sets is the closest thing to making finely crafted fiber-based prints

that the digital world has to offer. Not only are your images cast free, but they also display an

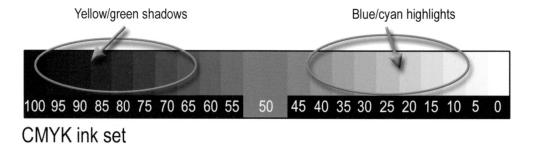

Dedicated Quad Black Neutral ink set

amazing range of grays. With pictures that have been carefully adjusted to spread image tones and retain shadow and highlight details, the Quad Black system produces unparalleled quality prints on a wide range of gloss, satin, matte and fine art stock.

After the success of the initial Quad Black system, Lyson produced two more monochrome ink sets – Warm Tone, affectionately known as 'sepia', and Cool Tone, sometimes called 'selenium'. Though the nicknames are familiar don't be confused, there are no toning processes involved here. The whole procedure is still digital and the images are produced with ink on paper. Quad tone sets are available for a selected range of photo quality printers from Canon and Epson. This includes those models that have chip-based cartridges designed to restrict the user to installing the manufacturer's own inks.

Multi-black printers

More recently all the major manufacturers have been hard at work creating machines that contain multiblack as well as color ink sets. Like Lyson's Quad Black system these new printers contain several gray inks (of varying strengths) plus black, but unlike the Lyson system they also include the standard color inks as well (CMYK). With as many as eight inks in the one printing head these models produce terrific black and white and color prints. For the first time, dedicated monochrome image makers have a machine that is up to the demanding task of producing the neutral grayscale masterpieces they love so much and at the same time they can still output a good color photo as well.

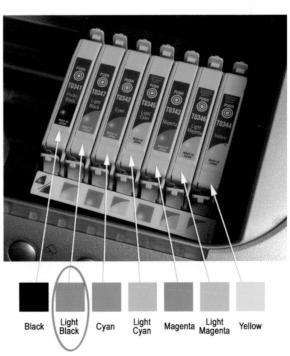

layers and channels photoshop photoshop photoshop photoshop photoshop photoshop photoshop photoshop photoshop photoshop

Serap Osman

phot

essential skills

shop

- Learn the creative potential of layers, adjustment layers, channels and layer masks.
- Develop skills and experience in the control and construction of digital montages.

Introduction

The traditional photograph contains all the picture elements in a single plane. Digital images captured by a camera or sourced from a scanner are similar in that they are also flat files. And for a lot of new digital photographers this is how their files remain – flat. All editing and enhancing work is conducted on the original picture but advanced techniques require things to be a little different.

Digital pictures are not always flat

Photoshop contains the ability to use layers with your pictures. This feature releases your images from having to keep all their information in a flat file. Different image parts, added text and certain enhancement tasks can all be kept on separate layers. The layers are kept in a stack and the image you see on screen in the work area is a composite of all the layers.

Sound confusing? Well try imagining, for example, that each of the image parts of a simple portrait photograph are stored on separate plastic sheets. These are your layers. The background sits at the bottom. The portrait is laid on top of the background and the text is placed on top. When viewed from above the solid part of each layer obscures the picture beneath. Whilst the picture parts are based on separate layers they can be moved, edited or enhanced independently of each other. If they are saved using a file format like Photoshop's PSD file (which is layer friendly) all the layers will be preserved and present next time the file is opened.

Layers and channels confusion

Another picture file feature that new users often confuse with layers is channels. The difference is best described as follows:

- Layers separate the image into picture, text, shapes and enhancement parts.
- Channels, on the other hand, separate the image into its primary base colors.

The Layers palette will display the layer stack with each part assembled on top of each other, whereas the Channels palette will show the photograph broken into its red, green and blue components (if it is an RGB image – but more on this later).

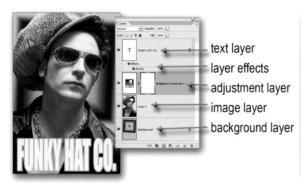

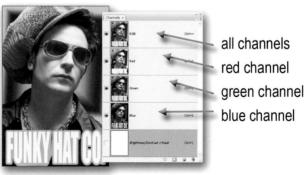

Example image showing the channels

Layers overview

Being able to separate different components of a picture means that these pieces can be moved and edited independently. This is a big advantage compared to flat file editing, where the changes are permanently made part of the picture and can't be edited at a later date. A special file type is needed if these edit features are to be maintained after a layered image is saved and reopened. In Photoshop, the PSD, PDF and PSB formats support all layer types and maintain their editability. It is important to note that other common file formats such as standard JPEG and TIFF do not generally support these features (although JPEG2000 and TIFF saved via Photoshop CS2 can support layers). They flatten the image layers while saving the file, making it impossible to edit individual image parts later.

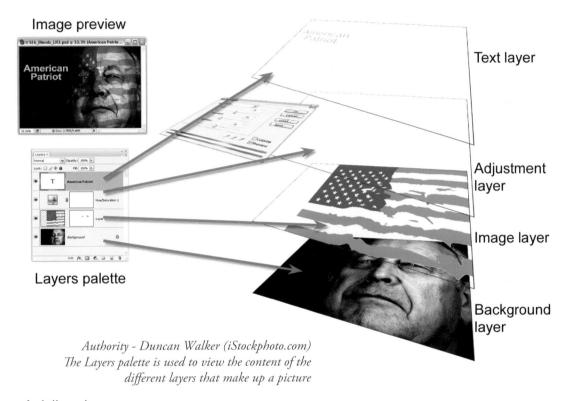

Adding layers

When a picture is first downloaded from your digital camera or imported into Photoshop or Bridge it usually contains a single layer. It is a 'flat file'. By default the program classifies the picture as a background layer. You can add extra 'empty' layers to your picture by clicking the Create New Layer button at the bottom of the Layers dialog or choosing the Layer option from the New menu in the Layer heading (Layer > New > Layer). The new layer is positioned above the currently selected layer (highlighted in the Layers palette).

Some actions such as adding text with the Type Tool automatically or drawing a shape create a new layer for the content. This is also true when adding adjustment and fill layers to your image and when selecting, copying and pasting image parts.

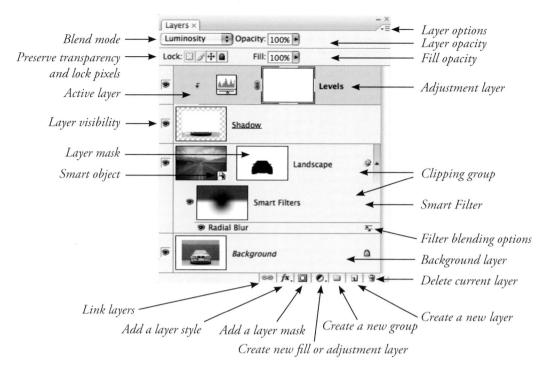

Viewing layers

Photoshop's Layers palette displays all your layers and their settings in the one dialog box. If the palette isn't already on screen when opening the program, choose the option from the Window menu (Window > Layers). The individual layers are displayed, one on top of each other, in a 'layer stack'. The image is viewed from the top down through the layers. When looking at the picture on screen we see a preview of how the image looks when all the layers are combined. Each layer is represented by a thumbnail on the left and a name on the right. The size of the thumbnail can be changed, as can the name of the layer. By default each new layer is named sequentially (layer 1, layer 2, layer 3). This is fine when your image contains a few different picture parts, but for more complex illustrations it is helpful to rename the layers with titles that help to remind you of their content (portrait, sky, tree). Layers can be turned off by clicking the eye symbol on the far left of the layer so that it is no longer showing. This action removes the layer from view but not from the stack. You can turn the layer back on again by clicking the eye space.

Working with layers

To select the layer that you want to change you need to click on the layer. At this point the layer will change to a different color from the rest in the stack. This layer is now the 'selected layer' or 'active layer' and can be edited in isolation from the others that make up the picture. It is common for new users to experience the problem of trying to edit pixels on a layer that has not been selected. Always check the correct layer has been selected prior to editing a multilayered image. Each layer in the same image must have the same resolution and image mode (a selection from one image that is imported into another image will take on the host image's resolution and image mode). Increasing the size of any selection will lead to 'interpolation', which will degrade its quality unless the layer is converted into a 'smart object' first.

Manipulating layers

Layers can be moved up and down the layer stack by click-hold-dragging. Moving a layer upwards will mean that its picture content may obscure more of the details in the layers below. Moving downwards progressively positions the layer's details further behind the picture parts of the layers above. In this way you can reposition the content of any layers (except background layers). Two or more layers can be linked together so that when the content of one layer is moved the other details follow precisely. Simply multi-select the layers to link (hold down the Shift key and click onto each layer) and click the Link Layers button (chain icon) at the bottom of the palette. A chain symbol will appear on the right of the thumbnail to indicate that these layers are now linked. To unlink selected layers click on the Link Layers button again. Unwanted layers can be deleted by dragging them to the trash icon at the bottom of the Layers

Unwanted layers can be deleted by dragging them to the trash icon at the bottom of the Layers palette or by selecting the layer and clicking the trash icon.

Layer styles

Layer styles or effects can be applied to the contents of any layer. Users can add effects by clicking on the 'Add a Layer Style' button at the bottom of the Layers palette (the 'fx' icon), by choosing Layer Style from the Layer menu, by clicking on the desired effect in the Styles palette or by dragging existing effects from one layer to another. The effects added are listed below the layer in the palette. You can turn effects on and off using the eye symbol and even edit effect settings by double-clicking on them in the palette.

Opacity

As well as layer styles, or effects, the opacity (how transparent a layer is) of each layer can be

altered by dragging the opacity slider down from 100% to the desired level of translucency. The lower the number, the more detail from the layers below will show through. The opacity slider is located at the top of the Layers palette and changes the selected layer only.

Blending modes

On the left of the opacity control is a drop-down menu containing a range of blending modes. The default selection is 'normal', which means that the detail in upper layers obscures the layers beneath. Switching to a different blending mode will alter the way which the layers interact.

Checking the 'preserve transparency' box confines any painting or editing to the areas containing pixels (transparent areas remain unaffected).

Layer shortcuts

- To display Layers palette Choose Windows > Layers.
- To access layers options Click sideways triangle in the upper right-hand corner of the Layers palette.
- To change the size of thumbnails Choose Palette Options from the Layers palette menu and select a thumbnail size.
- 4. To make a new layer Choose Layer > New > Layer.
- To create a new adjustment layer Choose
 Layer > New Adjustment Layer and then select
 the layer type.
- To create a new layer set Choose Layer > New > Layer Set.
- 7. To add a style to a layer Select the layer and click on the Layer Styles button at the bottom of the palette.

Layer groups (sets)

Layer groups are a collection of layers organized into a single 'folder'. Placing all the layers used to create a single picture part into a group makes these layers easier to manage and organize. Layers can be moved into the group by dragging them onto the group's heading. Layers in groups can have their stacking order (within the group) adjusted without ungrouping.

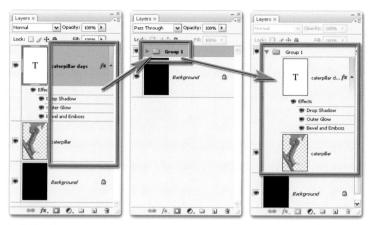

Individual layers

Layers in a group

To create a layer group click on the New Group button at the bottom of the palette or choose Layer > New > Group or multi-select the layers to include in the group and press Ctrl/Cmd + G. In previous versions of Photoshop this feature was referred to as Layer Sets.

Layer masks

A 'layer mask' is attached to a layer and controls which pixels are concealed or revealed on that layer. Masks provide a way of protecting areas of a picture from enhancement or editing changes. In this way masks are the opposite to selections, which restrict the changes to the area selected. Masks are standard grayscale images and because of this they can be painted, edited and erased just like other pictures. Masks are displayed as a separate thumbnail to the right of the main layer thumbnail in the Layers palette. The black portion of the mask thumbnail is the protected or transparent area and is opaque or shows the layer image without transparency. Grays, depending on the dark or lightness of the tone, will give varying amounts of transparency from partially transparent to almost opaque. Photoshop provides a variety of ways to create masks but one of the easiest is to use the special Quick Mask mode.

Quick steps for making a Quick Mask

- Click the Quick Mask mode button in the toolbox. The foreground and background colors automatically become black and white.
- Select the layer to be masked and using the Brush Tool paint a mask on the image. You will notice that the painted mask area is now ruby red. Painting with different levels of gray will create a semi-transparent mask which provides partial protection.
- 3. Remove areas of the mask with the Eraser Tool.
- 4. Switch back to the selection mode by clicking the Standard Mode button at the bottom of the toolbox. The non-masked area now becomes a selection ready for enhancement.

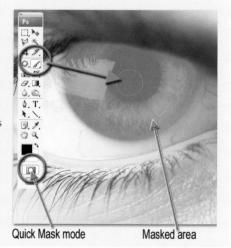

Layer types

Image layers: This is the most basic and common layer type containing any picture parts or image details. Background is a special type of image layer.

Text layers: Designed solely for text, these layers allow the user to edit and enhance the text after the layer has been made. It is possible to create 'editable text' in Photoshop. If the text needs to be modified (font, style, spelling, color, etc.) the user can simply double-click the type layer. To apply filters to the contents of a text layer, it must be rasterized (Layer > Rasterize) first. This converts the text layer to a standard image layer and in this process the ability to edit the text is lost.

Shape layers: Shape layers are designed to hold the shapes created with Photoshop's drawing tools (Rectangle, Ellipse, Polygon, Line and Custom Shape). Like text layers the content of these layers is 'vector' based and therefore can be scaled upwards or downwards without loss of quality.

Smart Object layers: Smart Object layers are special layers that encapsulate another picture (either vector or pixel based). As the original picture content is always maintained any editing action such as transforms or filtering that is applied to a Smart Object layer is non-destructive. Pixel-based editing (painting, erasing, etc.) can't be performed on Smart Objects without first converting them to a normal image layer (Layer > Smart Objects > Rasterize). You create a Smart Object layer by either converting an existing image layer (Layer > Smart Objects > Convert to Smart Objects) or by opening the original file as a Smart Object (File > Open as a Smart Object) when commencing initial editing. When a filter is applied to a Smart Object layer it is termed a Smart Filter and appears below the Smart Object layer. Because the effects of a Smart Filter can be

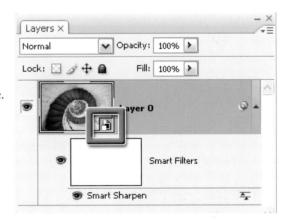

Smart Object layers are used for some non-destructive editing techniques as they contain and protect the original picture. In CS3 it is possible to filter a Smart Object using Smart Filters

altered or removed after application, this type of filtering is non-destructive.

3D Layers (*Photoshop Extended only*): The Extended edition of Photoshop CS3 also has the ability to open and work with three-dimensional architectural or design files. When Photoshop opens a 3D file it is placed on a separate layer where you can move, scale, change lighting and rendering of the 3D model. Editing of the 3D model can only occur in a 3D authoring program.

Adjustment layers: These layers alter the layers that are arranged below them in the stack. Adjustment layers act as a glass filter through which the lower layers are viewed. They allow image adjustments to be made without permanently modifying the original pixels (if the adjustment layer is removed, or the visibility of the layer is turned off, the pixels revert to their original value). You can use adjustment layers to perform many of the enhancement tasks that you would normally apply directly to an image layer without changing the image itself.

Background layers: An image can only have one background layer. It is the bottom-most layer in the stack. No other layers can be moved beneath this layer. You cannot adjust this layer's opacity or its blending mode. You can convert background layers to standard image layers by double-clicking the layer in the Layers palette, setting your desired layer options in the dialog provided and then clicking OK.

Saving an image with layers

The file formats that support layers are Photoshop's native Photoshop document (PSD) format, PDF, JPEG2000, PSB and Photoshop TIFF. The layers in a picture must always be flattened if the file is to be saved as a standard JPEG. It is recommended that a PSD with its layers is always kept as an archived master copy – best practice would keep in progress archives as well as the final image. It is possible to quickly flatten a multi-layered image and save it as a JPEG or TIFF file by choosing File > Save As and then selecting the required file format from the pull-down menu.

Quick Masks, selections and alpha channels

Selections isolate parts of a picture. When first starting to use Photoshop it is easy to think of selections, masks and channels as all being completely separate program features, but in the reality of day-to-day image enhancement each of these tools is inextricably linked. As your skills develop most image-makers will develop their own preferred ways of working. Some use a workflow that is selection based, others switch between masking and selections and a third group concentrates all their efforts on creating masks only. No one way of working is right or wrong. In fact, many of the techniques advocated by the members of each group often provide a different approach to solving the same problem.

The masks created with the Quick Mask feature are stored as alpha channels which can be viewed and edited via the Channels palette

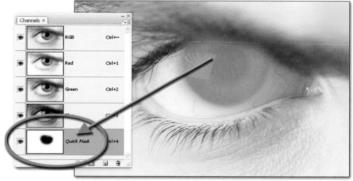

Switching between Mask and Selection modes

You can switch between Mask and Selection (also called 'Standard') modes by clicking on the mode button positioned at the bottom of the toolbox. Any 'marching ants' indicating active selections will be converted to red shaded areas when selecting the Mask mode. Similarly active masks will be outlined with 'marching ants' when switching back to Selection mode.

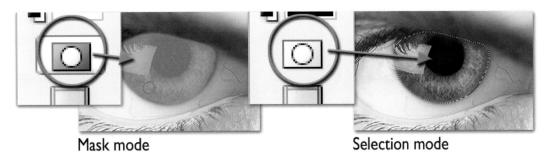

Saving selections

Photoshop provides users with the option to save their carefully created selections using the Select > Save Selection option. In this way the selection can be reloaded at a later date in the same file via the Select > Load Selection feature, or even after the document has been closed and reopened. Though not immediately obvious to the new user, the selection is actually saved with the picture as a special alpha channel and this is where the primary link between selections and masks occurs. Masks too are stored as alpha channels in your picture documents.

Alpha channels are essentially grayscale pictures where the black section of the image indicates the area where changes can be made, the white portion represents protected areas and gray values allow proportional levels of change. Alpha channels can be viewed, selected and edited via the Channels palette.

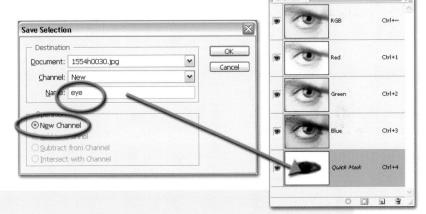

When you save a selection you create a grayscale alpha channel. You can name the selection inside the Save Selection dialog

Quick definitions

Selections – A selection is an area of a picture that is isolated so that it can be edited or enhanced independently of the rest of the image. Selections are made with a range of Photoshop tools including the Marquee, Lasso and Magic Wand tools.

Masks – Masks also provide a means of restricting image changes to a section of the picture. Masks are created using standard painting tools whilst in the Quick Mask mode.

Alpha channels – Alpha channels are a special channel type that are separate to those used to define the base color of a picture such as Red, Green and Blue. Selections and masks are stored as alpha channels and can be viewed in the Channels palette. You can edit a selected alpha channel using painting and editing tools as well as filters.

Channels

As we have already seen, channels represent the way in which the base color in an image is represented. Most images that are created by digital cameras are made up of Red, Green and Blue (RGB) channels. In contrast, pictures that are destined for printing are created with Cyan, Magenta, Yellow and Black (CMYK) channels to match the printing inks. Sometimes the channels in an image are also referred to as the picture's 'color mode'.

Viewing channels

Many image-editing programs contain features designed for managing and viewing the color channels in your image. Photoshop uses a separate Channels palette (Window > Channels). Looking a little like the Layers palette, hence the source of much confusion, this palette breaks the full color picture into its various base color parts.

Changing color mode

Though most editing and enhancement work can be performed on the RGB file, sometimes the digital photographer may need to change the color mode of his or her file. There are a range of conversion options located under the Mode menu (Image > Mode) in Photoshop. When one of these options is selected your picture's color will be translated into the new set of channels. Changing the number of channels in an image also impacts on the file size of the picture. Four-channel CMYK images are bigger than three-channel RGB pictures, which in turn are roughly three times larger than single-channel grayscale photographs.

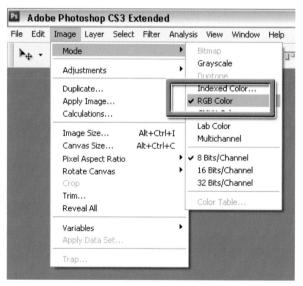

The type and number of color channels used to create the color in your pictures can be changed via the Mode option in the Image menu

When do I need to change channels?

For most image-editing and enhancement tasks RGB color mode is all you will ever need. Some high quality and printing-specific techniques do require changing modes, but this is generally the field of the 'hardened' professional. A question often asked is 'Given that my inkjet printer uses CMYK inks, should I change my photograph to CMYK before printing?' Logic says yes, but practically speaking this type of conversion is best handled by your printer's driver software. Most modern desktop printers are optimized for RGB output even if their ink set is CMYK.

Channel types

RGB: This is the most common color mode. Consisting of Red, Green and Blue channels, most digital camera and scanner output is supplied in this mode.

CMYK: Designed to replicate the ink sets used to print magazines and newspapers, this mode is made from Cyan, Magenta, Yellow and Black (K) channels.

LAB: Consisting of Lightness, A color (green–red) and B color (blue–yellow) channels, this mode is used by professional photographers when they want to enhance the details of an image without altering the color. By selecting the L channel and then performing their changes only the image details are affected.

Grayscale: Consisting of a single black channel, this mode is used for monochrome pictures. Duo-, Tri- and Quad tones are a special variation of grayscale images that include extra colors creating tinted monochromes.

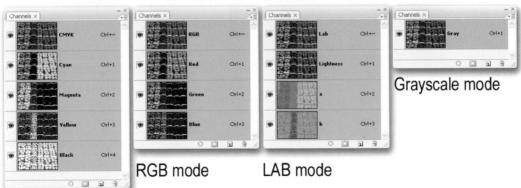

CMYK mode

The most used color modes (channel types) are RGB, CMYK, LAB and Grayscale. Unless you are working in the publishing industry, or you want to use advanced image-editing techniques, you should keep your picture in RGB mode

Adjustment and filter layers and editing quality

As introduced earlier, adjustment layers act as filters that modify the hue, saturation and brightness of the pixels on the layer or layers beneath. Using an adjustment layer instead of the 'Adjustments' from the 'Image' menu allows the user to make multiple and consecutive image adjustments without permanently modifying the original pixel values.

Non-destructive image editing

The manipulation of image quality using 'adjustment layers' and 'layer masks' is often termed 'non-destructive'. Using adjustment layers to manipulate images is preferable to working directly and repeatedly on the pixels themselves. Using the 'Adjustments' from the 'Image' menu, or the manipulation tools from the toolbox (Dodge, Burn and Sponge Tools), directly on pixel layers can eventually lead to a degradation of image quality. If adjustment layers are used together with 'layer masks' to limit their effect, the pixel values are physically changed only once when the image is flattened or the layers are merged. Retaining the integrity of your original file is essential for high quality output.

Note > With the release of Photoshop CS2 it became possible to scale or 'transform' a layer or group of layers non-destructively by turning the layer, or layers, into a 'Smart Object'. With Photoshop CS3 we can now apply filters (called Smart Filters) non-destructively to these smart objects.

Retaining quality

The evidence of a file that has been degraded can be observed by viewing its histogram. If the resulting histogram displays excessive spikes or missing levels there is a high risk that a smooth transition between tones and color will not be possible in the resulting print. A tell-tale sign of poor scanning and image editing is the effect of 'banding' that can be clearly observed in the final print. This is where the transition between colors or tones is no longer smooth, but can be observed as a series of steps, or bands, of tone and/or color. To avoid this it is essential that you start with a good scan (a broad histogram without gaps) and limit the number of changes to the original pixel values.

Layer masks and editing adjustments

The use of 'layer masks' is an essential skill for professional image retouching. Together with the Selection Tools and 'adjustment layers' they form the key to effective and sophisticated image editing. A 'layer mask' can control which pixels are concealed or revealed on any image layer except the background layer. If the layer mask that has been used to conceal pixels is then discarded or switched off (Shift-click the layer mask thumbnail) the original pixels reappear. This non-destructive approach to retouching and photographic montage allows the user to make frequent changes. To attach a layer mask to any layer (except the background layer) simply click on the layer and then click on the 'Add layer mask' icon at the base of the Layers palette.

A layer mask is automatically attached to every adjustment layer. The effects of an adjustment layer can be limited to a localized area of the image by simply clicking on the adjustment layer's associated mask thumbnail in the Layers palette and then painting out the adjustment selectively using any of the painting tools whilst working in the main image window. The opacity and tone of the foreground color in the toolbox will control whether the adjustment is reduced or eliminated in the localized area of the painting action. Painting with a darker tone will conceal more than when painting with a lighter tone or a dark tone with a reduced opacity.

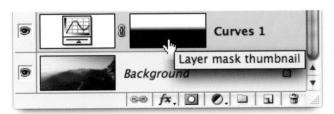

Painting or adding gradients to a mask will reveal or conceal the adjustment

A layer mask can be filled with black to conceal the effects of the adjustment layer. Painting with white in the layer mask will then reveal the adjustment in the localized area of the painting action. Alternatively the user can select the Gradient Tool and draw a gradient in the layer mask to selectively conceal a portion of the adjustment. To add additional gradients the user must select either the Multiply or Screen blend modes for the gradient in the Options bar.

Layer mask shortcuts

Disable/enable layer mask

Preview contents of layer mask

Preview layer mask and image

Shift + click layer mask thumbnail

Opt/Alt + click layer mask thumbnail

Opt/Alt + Shift + click layer mask thumbnail

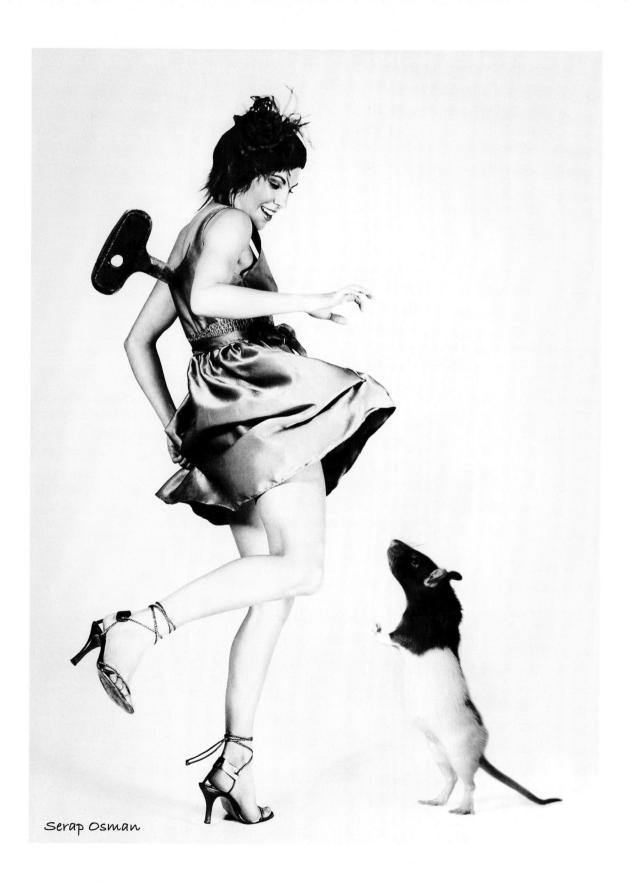

selections photoshop photo

shop photoshop

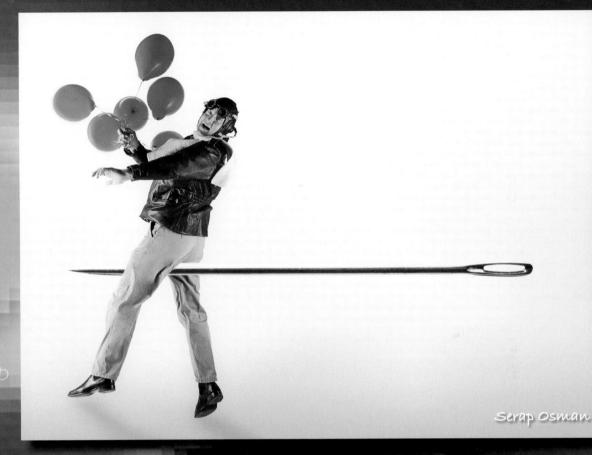

essential skills

Develop skills in creating and modifying selections to isolate and mask image content.

phot

- Develop skills using the following tools and features:
 - Selection Tools
 - Quick Mask, alpha channels and layer masks
 - Color Range and Extract filter
 - Pen Tool.

Introduction

One of the most skilled areas of digital retouching and manipulation is the ability to make accurate selections of pixels for repositioning, modifying or exporting to another image. This skill allows localized retouching and image enhancement. Photoshop provides several different tools that allow the user to select the area to be changed. Called the 'Selection' Tools, using these features will fast become a regular part of your editing and retouching process. Photoshop marks the boundaries of a selected area using a flashing dotted line sometimes called 'marching ants'. Obvious distortions of photographic originals are common in the media but so are images where the retouching and manipulations are subtle and not detectable. Nearly every image in the printed media is retouched to some extent. Selections are made for a number of reasons:

- Making an adjustment or modification to a localized area, e.g. color, contrast, etc.
- Defining a subject within the overall image to mask, move or replicate.
- Defining an area where an image or group of pixels will be inserted ('paste into').

Selection Tools overview

Photoshop groups the Selection Tools based on how they isolate picture parts. These categories are:

- The 'Marquee Tools' are used to draw regular-shaped selections such as rectangles or ellipses around an area within the image.
- The 'Lasso Tools' use a more freehand drawing approach and are used to draw a selection by defining the edge between a subject and its background.
- The 'Magic Wand' and the new 'Quick Selection' tools both create selections based on color and
 tone and are used to isolate groups of pixels by evaluating the similarity of the neighboring pixel
 values (hue, saturation and brightness) to the pixel that is selected.

Shape-based selections with the Marquee Tools

The Marquee Tools select by dragging with the mouse over the area required. Holding down the Shift key as you drag the selection will 'constrain' the selection to a square or circle rather than a rectangle or oval. Using the Alt (Windows) or Options (Mac) key will draw the selections from their centers. The Marquee Tools are great for isolating objects in your images that are regular in shape, but for less conventional shapes, you will need to use one of the Lasso Tools.

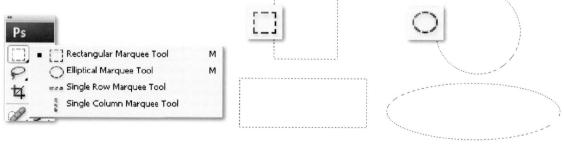

Selections based on shapes

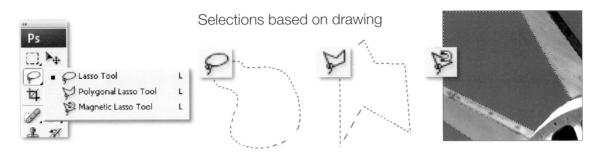

Drawn selections using the Lasso Tools

Select by encircling or drawing around the area you wish to select. The standard Lasso Tool works like a pencil, allowing the user to draw freehand shapes for selections. A large screen and a mouse in good condition (or a graphics tablet) are required to use the Freehand Lasso Tool effectively. In contrast, the Polygonal Lasso Tool draws straight-edged lines between mouse-click points. Either of these features can be used to outline and select irregular-shaped image parts. A third tool, the Magnetic Lasso, helps with the drawing process by aligning the outline with the edge of objects automatically. It uses contrast in color and tone as a basis for determining the edge of an object. The accuracy of the 'magnetic' features of this tool is determined by three settings in the tool's Options bar. **Contrast** is the value that a pixel has to differ from its neighbor to be considered an edge, **Width** is the number of pixels either side of the pointer that are sampled in the edge determination process and **Frequency** is the distance between fastening points in the outline.

Double-clicking the Polygonal Lasso Tool or Magnetic Lasso Tool automatically completes the selection using a straight line between the last selected point and the first.

Note > Remember the Magnetic Lasso Tool requires a tonal or color difference between the object and its background in order to work effectively.

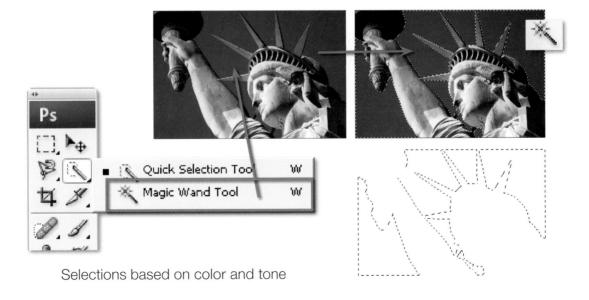

The Magic Wand

Unlike the Lasso and Marquee Tools the Magic Wand makes selections based on color and tone. It selects by relative pixel values. When the user clicks on an image with the Magic Wand Tool Photoshop searches the picture for pixels that have a similar color and tone. With large images this process can take a little time but the end result is a selection of all similar pixels across the whole picture.

Tolerance

How identical a pixel has to be to the original is determined by the **Tolerance** value in the Options bar. The higher the value, the less alike the two pixels need to be, whereas a lower setting will require a more exact match before a pixel is added to the selection. Turning on the **Contiguous** option will only include the pixels that are similar and adjacent to the original pixel in the selection.

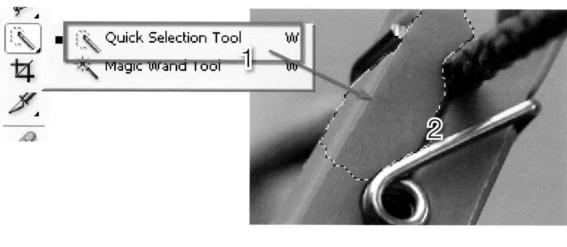

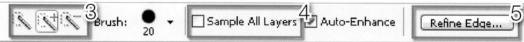

The new Quick Selection Tool is grouped with the Magic Wand in the toolbar (1). The feature creates intelligent selections as you paint over the picture surface (2). The tool's options bar contains settings for adding to and subtracting from existing selections (3), using the tool over multiple layers (4) as well as a button to display the new Refine Edges feature (5)

Quicker selections

Right from the very early days of Photoshop most users quickly recognized that being able to apply changes to just a portion of their images via selections was a very powerful way to work. It followed that the quality of their selective editing and enhancement activities was directly related to the quality of the selections they created. This was the start of our love/hate relationship with selection creation.

Over the years Adobe has provided us with a range of tools designed to help in this quest. Some, like the Magic Wand, are based on selecting pixels that are similar in tone and color; others, such as the Lasso and Marquee Tools, require you to draw around the subject to create the selection.

Well Photoshop CS3 now includes a new tool which does both. Called the Quick Selection Tool, it is grouped with the Magic Wand in the toolbar. The tool is used by painting over the parts of the picture that you want to select. The selection outline will grow as you continue to paint. When you release the mouse button the tool will automatically refine the selection further.

Moving a selection

If the selection is not accurate it is possible to move the selection without moving any pixels. With the Selection Tool still active place the cursor inside your selection and drag the selection to reposition it. To move the pixels and the selection, use the Move Tool from the Tools palette.

To remove a selection

Go to Select > Deselect or use the shortcut 'Command/Ctrl + D' to deselect a selection.

Customizing your selections

Basic selections of standard, or regular-shaped, picture parts can be easily made with one simple step – just click and drag. But you will quickly realize that most selection scenarios are often a little more complex. For this reason the thoughtful people at Adobe have provided several ways of allowing you to modify your selections. The two most used methods provide the means to 'add to' or 'subtract from' existing selections. This, in conjunction with the range of Selection Tools offered by the program, gives the user the power to select even the most complex picture parts, often using more than one tool for the task. Skillful selecting takes practice and patience as well as the ability to choose which Selection Tool (or Tools) will work best for a given task. Photoshop provides two different methods to customize an existing selection.

Use the mode buttons located in a special portion of the tool's Options bar to start changing your selections. The default mode is 'New Selection', which means that each selection you make replaces the last. Once another option is selected the mode remains active for the duration of the selection session. This is true even when you switch Selection Tools.

The user can make a selection before creating the adjustment layer and then when the adjustment layer is created the selection is used to automatically create a mask.

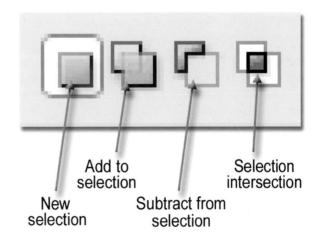

Add to a selection

To add to an existing selection hold down the Shift key while selecting a new area. Notice that when the Shift key is held down the Selection Tool's cursor changes to include a '+' to indicate that you are in the 'add' mode. This addition mode works for all tools and you can change Selection Tools after as needed to make further refinements.

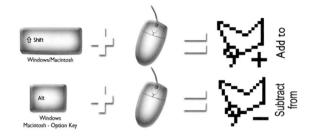

Keyboard shortcuts provide the fastest way to customize your selections

Subtract from a selection

To remove sections from an existing selection hold down the Alt key (Option – Macintosh) while selecting the part of the picture you do not wish to include in the selection. When in the subtract mode the cursor will change to include a '-'.

Selection intersection

In Photoshop often the quickest route to selection perfection is not the most direct route. When you are trying to isolate picture parts with complex edges it is sometimes quicker and easier to make two separate selections and then form the final selection based on their intersection. The fourth mode available as a button on the Selection Tool's Options bar is the Intersect mode. Though not used often, this mode provides you with the ability to define a selection based on the area in common between two different selections.

Inversing a selection

In a related technique, some users find it helpful to select what they don't want in a picture and then instruct Photoshop to select everything but this area. The Select > Inverse command inverts or reverses the current selection and is perfect for this approach. In this way foreground objects can be quickly selected in pictures with a smoothly graduated background of all one color (sky, snow or a wall space) by using the Magic Wand to select the background. Then the act of inversing the selection will isolate the foreground detail.

Professionals who know that the foreground will be extracted from the picture's surrounds often shoot their subjects against an evenly lit background of a consistent color to facilitate the application of this technique.

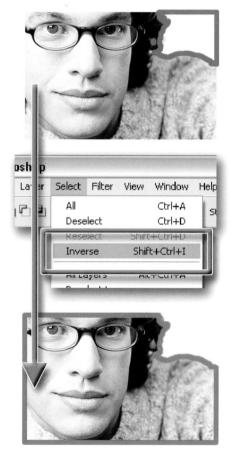

Sometimes it is quicker to select the area that you don't want and then inverse the selection to produce the required results

Refining selections

As well as 'adding to' and 'subtracting from' existing selections, Photoshop contains several other options for refining the selections you make. Grouped under the Select menu, these features generally concentrate on adjusting the edge of the current selection. The options include:

Border – Choosing the Border option from the Modify menu displays a dialog where you can enter the width of the border in pixels (between 1 and 200). Clicking OK creates a border selection that frames the original selection.

Smooth – This option cleans up stray pixels that are left unselected after using the Magic Wand Tool. After choosing Modify enter a radius value to use for searching for stray pixels and then click OK.

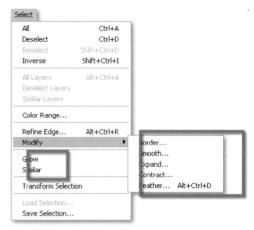

Other options for modifying your selections can be found under the Select menu

Expand – After selecting Expand, enter the number of pixels that you want to increase the selection by and click OK. The original selection is increased in size. You can enter a pixel value between 1 and 100.

Contract – Selecting this option will reduce the size of the selection by the number of pixels entered into the dialog. You can enter a pixel value between 1 and 100.

Feather – The Feather command softens the transition between selected and non-selected areas.

Grow – The Grow feature increases the size of an existing selection by incorporating pixels of similar color and tone to those already in the selection. For a pixel to be included in the 'grown' selection it must be adjacent to the existing selection and fall within the current tolerance settings located in the options bar.

Similar – For a pixel to be included in the 'similar' selection it does not have to be adjacent to the existing selection but must fall within the current tolerance settings located in the options bar.

Refine Edge – To coincide with the release of the Quick Selection Tool, Adobe has also created a new way of applying these refinements. The Refine Edge feature is accessed either via the button now present in all the Selection Tool options bars, or via Select > Refine Edge. The feature brings together five different controls for adjusting the edges of the selection (three of which existed previously as separate entries in the Select > Modify menu) with five selection edge preview options. Because of the preview options the feature makes what used to be a pretty hit and miss affair a lot easier to manage, with the ultimate result of the production of better selection edges for all.

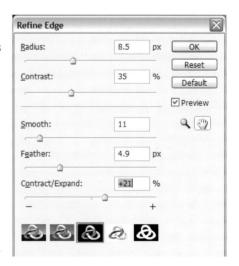

The Refine Edge dialog contains five sliders designed to customize your selection edges

New options

Two new options are available only in Refine Edge:

Radius – Use this slider to increase the quality of the edge in areas of soft transition with background pixels or where the subject's edge is finely detailed.

Contrast – Increase the contrast settings to sharpen soft selection edges.

Previewing edge refinements

The Preview mode buttons at the bottom of the Refine Edge dialog provide a range of different ways to view the selection on your picture.

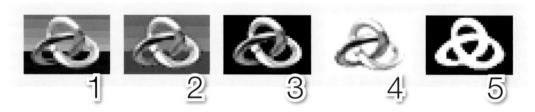

- 1) Provides a standard selection edge superimposed on the photo. 2) Previews the selection as a quick mask.
- 3) Previews the selection on a black background. 4) Previews the selection on a white background. 5) Previews the selection as a mask. Press the P key to turn off the preview of the current Refine Edge settings and the X key to temporarily display the full image view

Saving and loading selections

The selections you make remain active while the image is open and until a new selection is made, but what if you want to store all your hard work to use on another occasion? As we have already seen in the previous chapter Photoshop provides the option to save your selections/masks as part of the picture file. Simply choose Select > Save Selection and the existing selection will be stored with the picture.

To display a selection saved with a picture, open the file and choose Load Selection from the Select menu. In the Load Selection dialog click on the Channel drop-down menu and choose the selection you wish to reinstate. Choose the mode with which the selection will be added to your picture from the Operation section of the dialog. Click OK to finish.

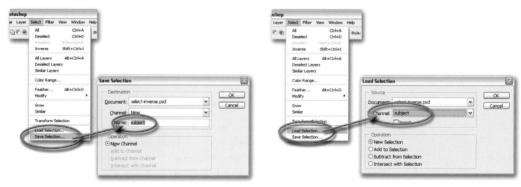

Save selection

Load selection

Feather and anti-alias

The ability to create a composite image or 'photomontage' that looks subtle, realistic and believable rests with whether or not the viewer is able to detect where one image starts and the other finishes. The edges of each selection can be modified so that it appears as if it belongs, or is related, to the surrounding pixels.

Options are available in Photoshop to alter the appearance of the edges of a selection. Edges can appear sharp or soft (a gradual transition between the selection and the background). The options to effect these changes are:

- Feather
- · Anti-aliasing.

Feather

When this option is chosen the pixels at the edges of the selection are blurred. The edges are softer and less harsh. This blurring may either create a more realistic montage or cause loss of detail at the edge of the selection.

You can choose feathering for the Marquee or Lasso Tools as you use them by entering a value in the tool options box, or you can add feathering to an existing selection (Select > Feather). The feathering effect only becomes apparent when you move or paste the selection to a new area.

Anti-aliasing

When this option is chosen the jagged edges of a selection are softened. A more gradual transition between the edge pixels and the background pixels is created. Only the edge pixels are changed so no detail is lost. Anti-aliasing must be chosen before the selection is made (it cannot be added afterwards). It is usual to have the anti-alias option selected for most selections. The anti-alias option also needs to be considered when using type in image-editing software. The anti-alias option may be deselected to improve the appearance of small type to avoid the appearance of blurred text.

Better with a tablet:

Many professionals prefer to work with a stylus and tablet when creating complex selections. All models change a tool's characteristics using pressure sensitivity with some including options such as intuitive motion as well.

Defringe and Matting

When a selection has been made using the anti-alias option some of the pixels surrounding the selection are included. If these surrounding pixels are darker, lighter or a different color to the selection a fringe or halo may be seen. From the Layers menu choose Matting > Defringe to replace the different fringe pixels with pixels of a similar hue, saturation or brightness found within the selection area.

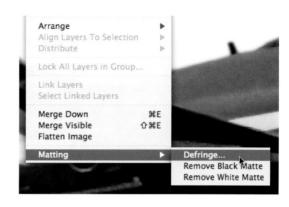

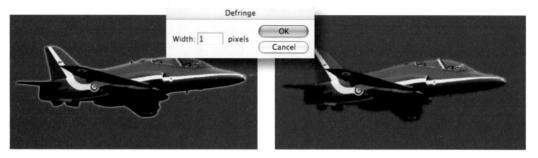

Fringe Defringe

The user may have to experiment with the most appropriate method of removing a fringe. The alternative options of Remove White Matte and Remove Black Matte may provide the user with a better result. If a noticeable fringe still persists it is possible to contract the selection prior to moving it using the Modify > Contract option from the Select menu.

Saving a selection as an alpha channel

Selections can be permanently stored as 'alpha channels'. The saved selections can be reloaded and/or modified even after the image has been closed and reopened. To save a selection as an alpha channel simply click the 'Save selection as channel' icon at the base of the Channels palette. To load a selection either drag the alpha channel to the 'Load channel as selection' icon in the Channels palette or Command/Ctrl-click the alpha channel.

It is possible to edit an alpha channel (and the resulting selection) by using the painting and editing tools. Painting with black will add to the alpha channel whilst painting with white will remove information. Painting with shades of gray will lower or increase the opacity of the alpha channel. The user can selectively soften a channel and resulting selection by applying a Gaussian Blur filter. Choose Blur > Gaussian Blur from the Filters menu.

Note > An image with saved selections (alpha channels) cannot be saved in the standard JPEG format. Use the PSD, PDF or TIFF formats or JPEG2000 if storage space is tight.

A magic workflow

The first port of call for many CS3 users wanting to create a quick selection will be the new Quick Selection Tool, but there will be times when the Magic Wand will be the preferred tool for the job in hand. This may be due to poor edge contrast where the Quick Selection Tool runs rampant or the color or tone to be selected is not contiguous (the color or tone exists as several islands of tone rather than one connected mass). If you are new to the magic of the wand (behind the Quick Selection Tool), enter the default setting of 32 in the Tolerance field of the Options bar (raising the value makes the ants increasingly frisky). Make sure the 'Anti-alias' box is checked as this smooths the edge of the selection (to stop it looking like the mouth of 'Jaws'). Checking the 'Contiguous' box will make sure your ants respect any boundaries and borders they encounter. Deselecting the Contiguous box will allow pixels with a similar color or tone to be selected, even if they are not connected. Before attempting to make a selection decide which is easier – selecting the background around the object or selecting the object itself (choose the one with fewest colors). You can always 'Inverse' the selection when you are done (Select > Inverse). A careful selection of the background can quickly be turned into a selection of the subject in this way.

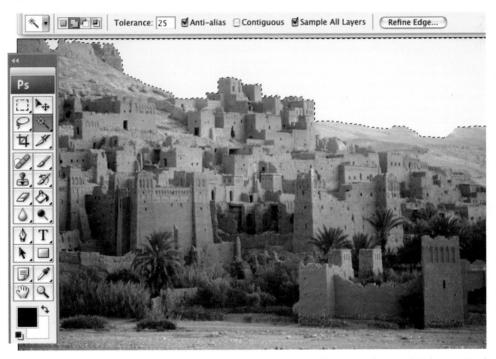

Deselecting the Contiguous option and clicking once is quicker than the Quick Selection Tool

Unleashing the trained magic ants

Unlike real magic wands you can't wave this one around but have to click on the area you wish to select instead. It is very unlikely that your ants will magically gravitate to the edges of your subject in one hit. These ants have to be trained. You can either click on the 'Add to selection' icon in the Options bar (holding down the Shift key has the same effect) or raise the tolerance of the Magic Wand and try again.

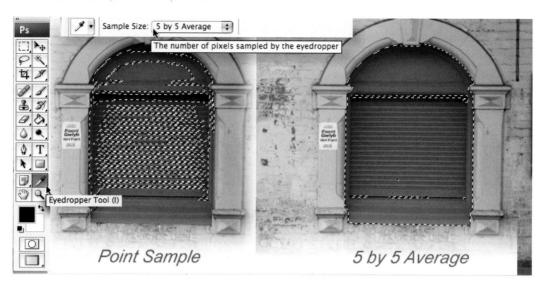

The Magic Wand is less intelligent than the Quick Selection Tool as it samples just once per click. If you raise the tolerance of the wand and the selection becomes patchy raise the setting of the eyedropper tool from 'Point Sample' to '5 by 5 Average'. The wand usually becomes a little more stable and the ants just might be encouraged to make the selection you are looking for.

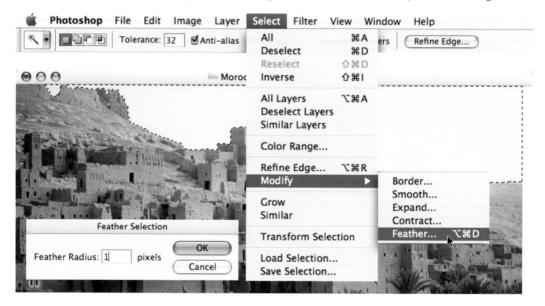

There is no feather option with the Magic Wand Tool so this important step is often overlooked. A small amount of feather is nearly always needed – even with seemingly sharp edges. One of the problems with the Magic Wand is that the magic ants have a fear of edges. They prefer to stand back and admire the view from a safe distance. Move the reluctant ants closer to the edge by expanding the selection (Select > Modify > Expand). This will counteract the halo effect that is all too often seen with poor selection work. A more refined edge can be achieved by selecting Refine Edge in either the Options bar or the Select menu.

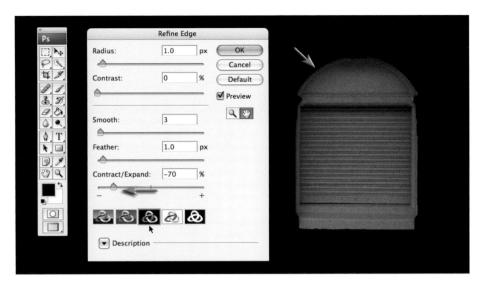

The Smooth, Feather and Contract/Expand options are now available in a single dialog box called Refine Edge in Photoshop CS3, together with two new controls (Radius and Contrast). The advantage of this dialog box over using the options available in Select > Modify is that we now have visual feedback as to the most appropriate settings to use for the selection. This is due to the fact that we can view the edge against a white or black matte or in a virtual Quick Mask mode.

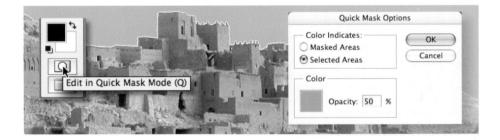

Quick Mask or Refine Edge

The problem with feathering and modifying selections using the Modify commands in the 'Select' menu is that the ants give very poor feedback about what is actually going on at the edge. Viewing the selection against a Matte color in the Refine Edge dialog box or as a 'Mask' in 'Quick Mask mode' allows you to view the quality and accuracy of your selection. Quick Mask allows the user to modify localized areas of the edge whilst Refine Edge works on the entire edge. Zoom in on an edge to take a closer look. Double-click the Quick Mask icon to change the mask color, opacity and to switch between 'Masked Areas' and 'Selected Areas'. If the mask is still falling short of the edge you can expand the selection by going to Filter > Other > Maximum. Choose a 1-pixel radius, select OK and the mask will shrink (expanding the selection). A 'Levels' adjustment in Quick Mask mode provides a 'one-stop shop' for editing the mask, giving you the luxury of a preview as with Refine Edge, but also gives you the advantage of localized editing.

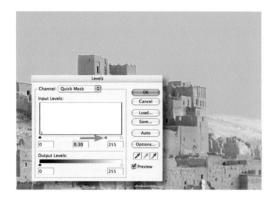

Using a 'Levels' adjustment (Image > Adjustments > Levels) in Quick Mask mode allows you to modify the edge quality if it is too soft and also reposition the edge so that it aligns closely with your subject. Make a selection of the edge using the Lasso Tool if you need to modify just a small portion of the Quick Mask. Dragging the shadow and highlight sliders in towards the center will reduce the softness of the mask whilst moving the midtone or 'Gamma' slider will move the edge itself. Unlike the Refine Edge dialog box you can paint in Quick Mask to refine localized areas of the selection.

Note > The selection must have been feathered prior to the application of the Levels adjustment for this to be effective.

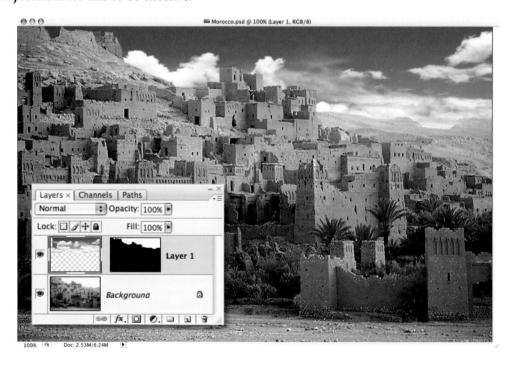

Save the selection as an alpha channel. This will ensure that your work is stored permanently in the file. If the file is closed and reopened the selection can be reloaded. Finish off the job in hand by modifying or replacing the selected pixels. If the Quick Selection Tool or Magic Wand Tool is not working for you, try exploring the following alternatives.

'Color Range'

The Quick Selection Tool may be the obvious tool for making a selection of a subject with a good color or tonal contrast, but Color Range can be utilized for making selections of similar color that are not contiguous. 'Color Range' from the Select menu is useful for selecting subjects that are defined by a limited color range (sufficiently different from those of the background colors). This option is especially useful when the selection is to be used for a hue adjustment.

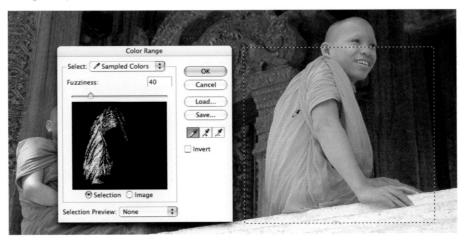

Use a Marquee Tool (from the Tools palette) to limit the selection area before you start using the Color Range option.

Note > The Color Range option can misbehave sometimes. If the selection does not seem to be restricted to your sampled color press the Alt/Option key and click on the reset option or close the dialog box and re-enter.

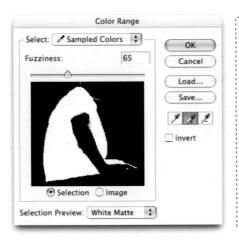

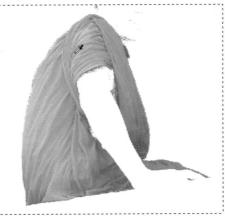

Use the 'Add to sample' eyedropper and drag the eyedropper over the subject area you wish to select. In the later stages you can choose a matte color to help the task of selection. Adjust the Fuzziness slider to perfect the selection. Very dark or light pixels can be left out of the selection if it is to be used for a hue adjustment only.

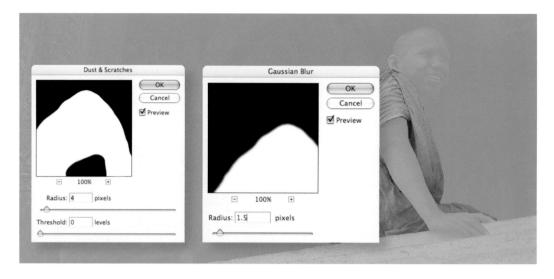

Select OK and view the selection in Quick Mask mode to gain an idea of the selection's suitability for the job in hand. The mask can be 'cleaned' using the Dust & Scratches filter and softened using a Gaussian Blur filter.

A selection prepared by the 'Color Range' command is ideal for making a hue adjustment. It is also recommended to view the individual channels to see if the subject you are trying to isolate is separated from the surrounding information. If this is the case a duplicate channel can act as a starting point for a selection.

Channel masking

An extremely quick and effective method for selecting a subject with reasonable color contrast to the surrounding pixels is to use the information from one of the channels to create a mask and then to load this mask as a selection.

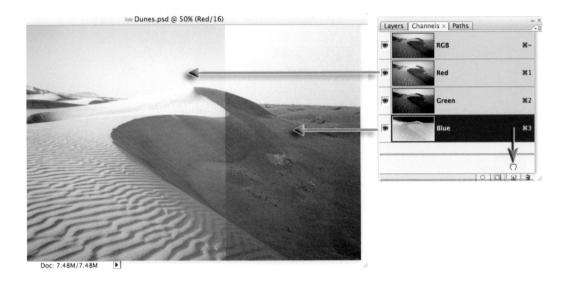

Click on each individual channel to see which channel offers the best contrast and then duplicate this channel by dragging it to the 'New Channel' icon.

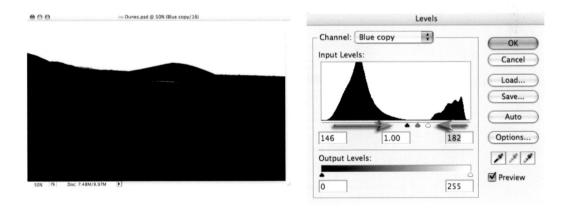

Apply a Levels adjustment to the duplicate channel to increase the contrast of the mask. Slide the shadow, midtone and highlight sliders until the required mask is achieved. The mask may still not be perfect but this can be modified using the painting tools.

Select the default settings for the foreground and background colors in the Tools palette, choose a paintbrush, set the opacity to 100% in the Options bar and then paint to perfect the mask. Zoom in to make sure there are no holes in the mask before moving on. To soften the edge of the mask, apply a small amount of Gaussian Blur.

Note > Switch on the master channel visibility or Shift-click the RGB master to view the channel copy as a mask together with the RGB image. This will give you a preview so that you can see how much blur to apply and if further modifications are required.

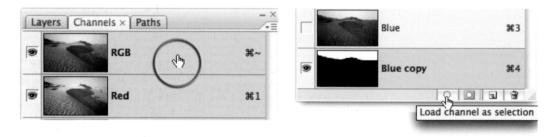

Click on the active duplicate channel or drag it to the 'Load channel as selection' icon. Click on the RGB master before returning to the Layers palette.

Channel masking may at first seem a little complex but it is surprisingly quick when the technique has been used a few times. This technique is very useful for photographers shooting products for catalogs and websites. A small amount of color contrast between the subject and background is all that is required to make a quick and effective mask.

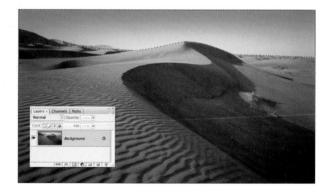

Selections from paths

The Pen Tool is often used in the creation of sophisticated smooth-edged selections, but strictly speaking it is not one of the selection tools. The Pen Tool creates vector paths instead of selections; these, however, can be converted into selections that in turn can be used to extract or mask groups of pixels. The Pen Tool has an unfortunate reputation – neglected by most, considered an awkward tool by those who have made just a passing acquaintance, and revered by just a select few who have taken a little time to get to know 'the one who sits next to Mr Blobby' (custom shape icon) in the Tools palette. Who exactly is this little fellow with the 'ye olde' ink nib icon and the awkward working persona? The Pen Tool was drafted into Photoshop from Adobe Illustrator. Although graphic designers are quite adept at using this tool, many photographers the world over have been furiously waving magic wands and magnetic lassos at the megapixel army and putting graphics tablets on their shopping lists each year in an attempt to avoid recognizing the contribution that this unique tool has to offer.

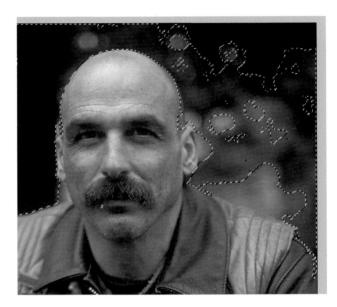

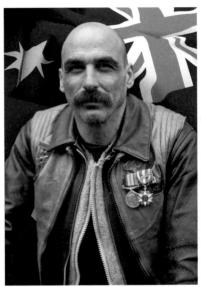

Not everything you can see with your eye can be selected easily with a selection technique based on color or tonal values. The resulting ragged selections can be fixed in Quick Mask mode, but sometimes not without a great deal of effort. The question then comes down to 'how much effort am I prepared to apply, and for how long?' Its about this time that many image-editors decide to better acquaint themselves with the Pen Tool. Mastering the Pen Tool in order to harness a selection prowess known to few mortals is not something you can do in a hurry – it falls into a certain skill acquisition category, along with such things as teaching a puppy not to pee in the house, called time-based reward, i.e. investing your time over a short period of time will pay you dividends over a longer period of time. The creation of silky smooth curvaceous lines (called paths) that can then be converted into staggeringly smooth curvaceous selections makes the effort of learning the Pen Tool all worthwhile.

Basic drawing skills

Vector lines and shapes are constructed from geographical markers (anchor points) connected by lines or curves. Many photographers have looked with curiosity at the vector tools in Photoshop's Tools palette for years but have dismissed them as 'not for me'. The reason for this is that drawing vector lines with the Pen Tool for the inexperienced image-editor is like reversing with a trailer for the inexperienced driver. It takes practice, and the practice can be initially frustrating.

The pen can multi-task (just like most women and very few men that I know). The pen can draw a vector shape whilst filling it with a color and applying a layer style – all at the same time. Although tempting, this has nothing to do with selecting a bald man's head, so we must be sure to disarm this charming little function. We can also use the training wheels, otherwise known as the 'Rubber Band' option, by clicking on the menu options next to 'Mr Blobby'.

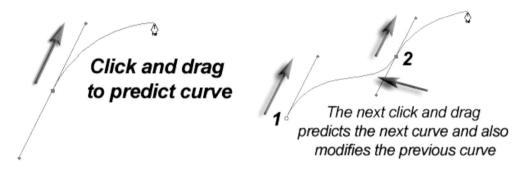

Basics Step 1 – Go to 'File > New' and create a new blank document. Choose 'White' as the 'Background Contents'. Size is not really important (no really – in this instance anything that can be zoomed to fill the screen will serve your purpose). Click on the Pen Tool (double-check the 'Paths' option, rather than the 'Shape layers' option, is selected in the Options bar) and then click and drag (hold down the mouse clicker as you drag your mouse) in the direction illustrated above. The little black square in the center of the radiating lines is called an anchor point. The lines extending either side of this anchor point are called direction lines, with a direction point on either end, and that thing waving around (courtesy of the Rubber Band option) is about to become the path with your very next click of the mouse.

Basics Step 2 – Make a second click and drag in the same direction. Notice how the dragging action modifies the shape of the previous curved line. Go to the 'Edit' menu and select 'Undo'. Try clicking a second time and dragging in a different direction. Undo a third time and this time drag the direction point a different distance from the anchor point. The thing you must take with you from this second step is that a curve (sometimes referred to as a Bézier curve) is both a product of the relative position of the two anchor points either side of the curve, and the direction and length of the two direction lines (the distance and direction of the dragging action).

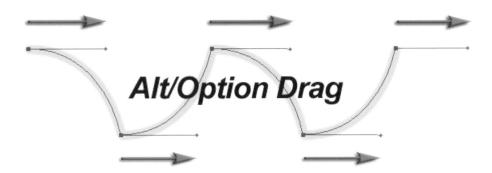

Basics Step 3 – Scenario one: Let us imagine that the first click and drag action has resulted in a perfect curve; the second dragging action is not required to perfect the curve but instead upsets the shape of this perfect curve – so how do we stop this from happening? Answer: Hold down the Alt key (PC) or Option key (Mac) and then drag away from the second anchor point to predict the shape of the next curve. This use of the Alt/Option key cancels the first direction line that would otherwise influence the previous curve.

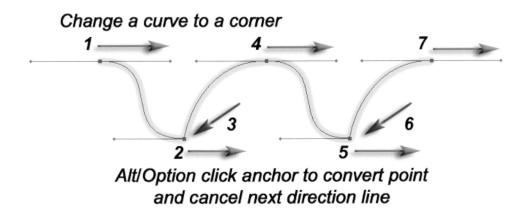

Scenario two: Let us imagine that we have created the first perfect curve using two normal click and drag actions (no use of a modifier key). The direction lines that are perfecting the first curve are, however, unsuitable for the next curve – so how do we draw the next curve whilst preserving the appearance of the first curve? Answer: The last anchor point can be clicked whilst holding down the Alt/Option key. This action converts the smooth anchor point to a corner anchor point, deleting the second direction line. The next curved shape can then be created without the interference of an inappropriate direction line.

Note > The information that you need to take from this third step is that sometimes direction lines can upset adjacent curves. The technique of cancelling one of the direction lines using a modifier key makes a series of perfect curves possible. These two techniques are especially useful for converting smooth points into corner points on a path.

Alt/Option Drag handle to modify previous or next curve

Basics Step 4 – Just a few more steps and we can go out to play. It is possible to change direction quickly on a path without cancelling a direction line. It is possible to alter the position of a direction line by moving the direction point (at the end of the line) independently of the direction line on the other side of the anchor point. To achieve this simply position the mouse cursor over the direction point and, again using the Alt/Option key, click and drag the direction point to a new position.

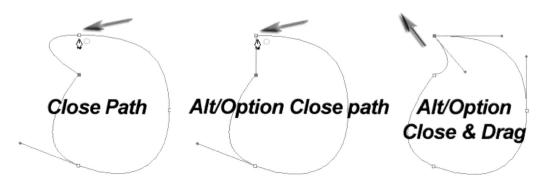

Basics Step 5 – If this path is going to be useful as a selection, it is important to return to the start point. Clicking on the start point will close the path. As you move the cursor over the start point the Pen Tool will be accompanied by a small circle to indicate that closure is about to occur. You will also notice that the final curve is influenced by the first direction line of the starting anchor point. Hold down the Alt/Option key when closing the path to cancel this first direction line. Alternatively, hold down the Alt/Option key and drag a new direction line to perfect the final curve.

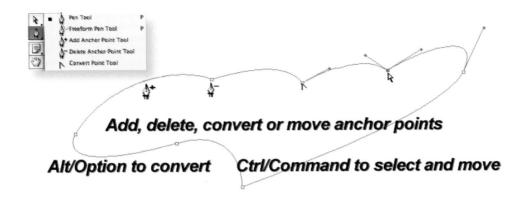

Basics Step 6 – When a path has been closed it is possible to add, delete, convert or move any point. Although these additional tools are available in the Tools palette they can all be accessed without moving your mouse away from the path in progress. If the Auto Add/Delete box has been checked in the Options bar you simply have to move the Pen Tool to a section of the path and click to add an additional point (the pen cursor sprouts a plus symbol). If the Pen Tool is moved over an existing anchor point you can simply click to delete it. Holding down the Ctrl key (PC) or Command key (Mac) will enable you to access the Direct Selection Tool (this normally lives behind the Path Selection Tool). The Direct Selection Tool has a white arrow icon and can select and move a single anchor point (click and drag) or multiple points (by holding down the Shift key and clicking on subsequent points). The Path Selection Tool has to be selected from the Tools palette and is able to select the entire path.

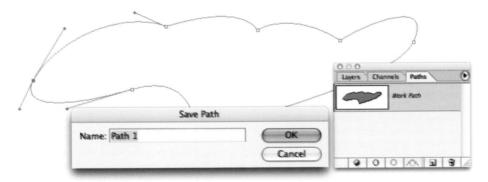

Basics Step 7 – The final step in the creation of a Path is to save it. All Paths, even Work Paths, are saved with the image file (PSD, PDF, PSB, JPEG or TIFF). If, however, a Work Path is not active (such as when the file is closed and reopened) and then the Pen Tool is inadvertently used to draw a new Path, any previous Work Path that was not saved is deleted.

Click on the Paths palette tab and then double-click the Work Path. This will bring up the option to save and name the Work Path and ensure that it cannot be deleted accidentally. To start editing an existing Path click on the path in the Paths palette and then choose either the Direct Selection Tool or the Pen Tool in the Tools palette. Click near the Path with the Direct Selection Tool to view the handles and the Path.

layer blends hop photoshop photoshop

American Patriot - Duncan P Walker www.iStockphoto.com

essential skills

- Learn the practical applications of layer blend modes for image retouching and creative montage work.
- ~ Develop skills using the the following techniques:
 - blend modes
 - layers and channels
 - layer masks.

Introduction

When an image, or part of an image, is placed on a separate layer above the background, creative decisions can be made as to how these layers interact with each other. Reducing the opacity of the top layer allows the underlying information to show through, but Photoshop has many other ways of mixing, combining or 'blending' the pixel values on different layers to achieve different visual outcomes. The different methods used by Photoshop to compare and adjust the hue, saturation and brightness of the pixels on the different layers are called 'blend modes'. Blend modes can be assigned to the painting tools from the Options bar but they are more commonly assigned to an entire layer when editing a multi-layered document. The layer blend modes are accessed from the 'blending mode' pull-down menu in the top left-hand corner of the Layers palette.

Serena Galante

The major groupings

The blend modes are arranged in family groups of related effects or variations on a theme. Many users simply sample all the different blend modes until they achieve the effect they are looking for. This, however, can be a time-consuming operation and a little more understanding of what is actually happening can ease the task of choosing an appropriate blend mode for the job in hand. A few of the blend modes are commonly used in the routine compositing tasks, whilst others have very limited or specialized uses only. The five main groups of blend modes after Normal and Dissolve that are more commonly used for image-editing and montage work are:

- Darken
- Lighten
- Overlay
- Difference
- Hue.

Opacity and Dissolve

At 100% opacity the pixels on the top layer obscure the pixels underneath. As the opacity is reduced the pixels underneath become visible. The Dissolve blend mode only becomes apparent when the opacity of the layer is reduced. Random pixels are made transparent on the layer rather than reducing the transparency of all the pixels. The effect is very different to the reduced opacity of the 'Normal' blend mode and has commercial applications as a transition for fading one image into another, but the effect has very limited commercial applications for compositing and photomontage of stills image work.

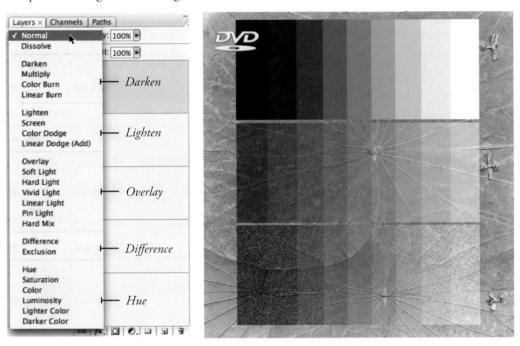

Image 02 Opacity. The groups of blend modes are listed using the name of the dominant effect. A step wedge is then used to demonstrate 'Normal' at 100% and 50% opacity and the 'Dissolve' blend mode with the layer set to 50% opacity

The 'Opacity' control for each layer, although not strictly considered as a blend mode, is an important element of any composite work. Some of the blend modes are quite pronounced or 'aggressive' in their resulting effect if applied at 100% opacity and could be overlooked if the user does not experiment with the combined effects of opacity and blend mode together.

Shortcuts

The blend modes can be applied to layers using keyboard shortcuts. Hold down the Shift key and press the '+' key to move down the list or the '-' key to move up the list. Alternatively, you can press the Alt/Option key and the Shift key and key in the letter code for a particular blend mode. If a tool in the painting group is selected (i.e. in use) the blend mode is applied to the Tool rather than the layer. See Keyboard Shortcuts for more information.

The 'Darken' group

It's not too hard to figure out what this group of blend modes have in common. Although Darken leads the grouping, Multiply is perhaps the most used blend mode in the group.

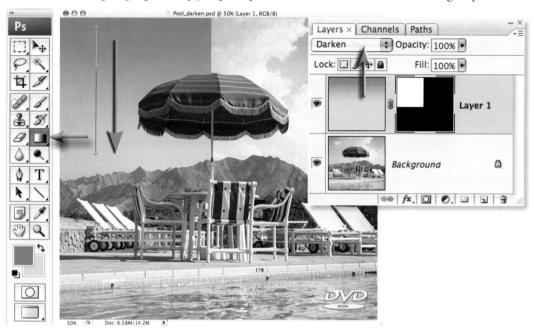

Image 03_Darken. The Darken mode can replace existing highlights while ignoring darker tones

Darken

The 'Darken' blend mode chooses pixels from either the blend layer or underlying layers to display at 100% opacity depending on their brightness value. Any underlying tone that is darker than the blend color remains unaffected by the blend mode, and any color that is lighter than the blend color is replaced rather than multiplied with the blend color. This blend mode is usually restricted to pasting a carefully chosen tone into the highlights of an image.

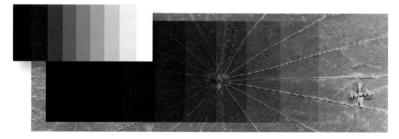

Multiply is a useful blend mode when overall darkening is required

Multiply

The 'Multiply' blend mode belongs to the 'Darken' family grouping. The brightness values of the pixels on the blend layer and underlying layer are multiplied to create darker tones. Only values that are multiplied with white (level 255) stay the same.

Image 04 Multiply. The Multiply blend mode is used to darken the top half of the image

Image 05 Multiply. The Multiply blend mode is used to apply a dark edge to the image

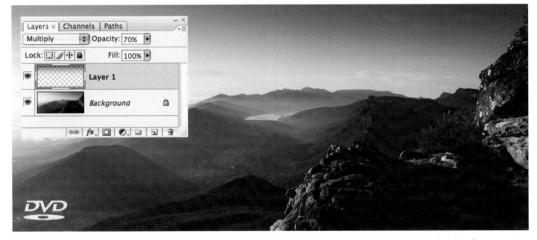

Image 06 Multiply. The Multiply blend mode is used to darken the sky in this landscape image

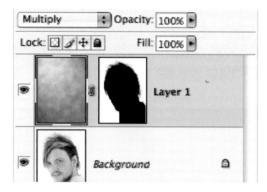

Image 07 Multiply. The Multiply blend mode is the secret to success when masking hair that was first captured against a white background. The new background layer and layer mask is positioned above the portrait and the layer is then set to the multiply mode. Note the difference before and after the blend mode has been applied (see Montage projects > Hair Extraction)

Image courtesy of Shari Gleeson

Image 08 Burn. Color Burn

Color Burn and Linear Burn

The image is darkened to reflect the blend color. Color Burn increases the underlying contrast to do this whilst Linear Burn decreases the underlying brightness. This is a difficult blend mode to find a use for at 100% opacity. Saturation can become excessive and overall brightness, now heavily influenced by the underlying color, can 'fill in' (become black).

The 'Lighten' group

Everything that was mentioned with the Darken group is now reversed for this group of blend modes. The 'Screen' blend mode is often considered the favorite of this group amongst photographers.

Image 09 Lighten. Two exposures are combined to balance the bright ambient light and the comparatively dim interior lighting of a building. A second image is captured at night and placed on a layer above the daylight exposure. The layer is then set to the Lighten blend mode – original images by John Hay

Lighten

The 'Lighten' blend mode chooses pixels from either the blend layer or underlying layers to display at 100% opacity depending on their brightness value. Any underlying tone that is lighter than the blend color remains unaffected by the blend mode, and any color that is darker than the blend color is replaced rather than multiplied with the blend color. This blend mode is particularly useful for introducing highlights into the underexposed areas of an image. This technique can also be useful for replacing dark colored dust and scratches from light areas of continuous tone.

Image 10 Screen. Screen is useful when overall lightening is required

Screen

The 'Screen' blend mode belongs to the 'Lighten' family grouping. The 'inverse' brightness values of the pixels on the blend layer and underlying layers are multiplied to create lighter tones (a brightness value of 80% is multiplied as if it was a value of 20%). Only values that are screened with black (level 0) stay the same.

Image11. Screen. A background layer is duplicated and a Screen blend mode is applied to lighten all levels

Image 12 Screen. The Screen mode can be used to apply a white border around an image

Blond Goddess -Katja Govorushchenko (www.iStockphoto.com)

Image 13 Screen. The Screen blend mode is useful when masking hair that was first captured against a black background (see Montage > Hair Extraction for more information about this technique)

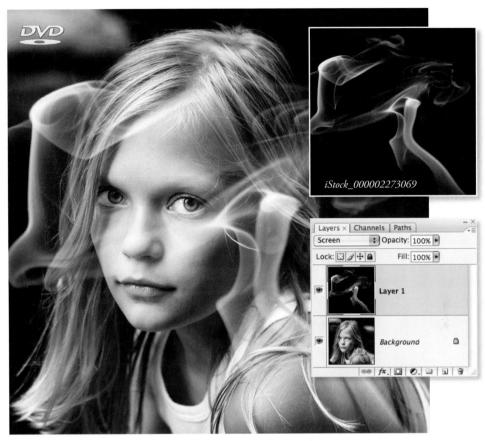

Girl by Shelly Perry (www.iStockphoto.com)

Image 14 Screen. The Screen blend mode is particularly useful for quickly dropping in elements that were photographed against black background such as smoke, bubbles, splashing or spurting water and fireworks. For transparent elements the lighting is usually positioned to one side or behind the subject matter to create the best effect

Image 15 Dodge. Color Dodge

Color Dodge and Linear Dodge

The image is lightened to reflect the blend color. Color Dodge decreases the underlying contrast to do this while Linear Dodge increases the underlying brightness. This again is a difficult blend mode to find a use for at 100% opacity. Saturation can become excessive and overall brightness, heavily influenced by the underlying color, can blow out (become white).

The 'Overlay' group

This is perhaps the most useful group of blend modes for photomontage work.

Image 16 Overlay. Applying the blend mode 'Overlay' to a texture or pattern layer will create an image where the form appears to be modelling the texture. Both the highlights and shadows of the underlying form are respected

Image 17 Overlay. The 'Overlay' blend mode is useful for overlaying textures over 3D form

Overlay

The Overlay blend mode uses a combination of the Multiply and Screen blend modes while preserving the highlight and shadow tones of the underlying image. The Overlay mode multiplies or screens the colors, depending on whether the base color is darker or lighter than a midtone. The effect is extremely useful when overlaying a texture or color over a form modelled by light and shade. Excessive increases in saturation may become evident when overlaying white and black. The 'Soft' and 'Hard Light' blend modes produce variations on this overlay theme.

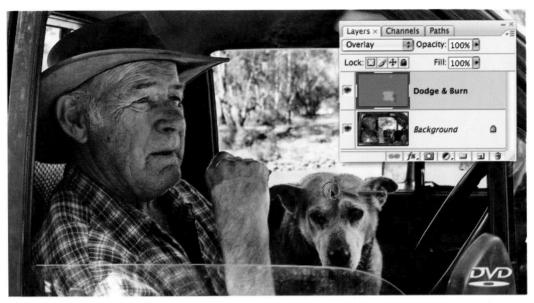

Image 18 Overlay. A 50% Gray layer set to Overlay or Soft Light mode can be used to dodge and burn the underlying image

Note > A layer filled with 50% Gray is invisible in Overlay and Soft Light mode and, as a result, is commonly used as a 'non-destructive' dodging and burning layer.

Soft and Hard Light - variations on a theme

The Soft and Hard Light blend modes are variations on the 'Overlay' theme. Photoshop describes the difference in terms of lighting (diffused or harsh spotlight). If the Overlay blend mode is causing highlights or shadows to become overly bright or dark or the increase in saturation is excessive then the Soft Light blend mode will often resolve the problem. The Hard Light, on the other hand, increases the contrast – but care must be taken when choosing this option as blending dark or light tones can tip the underlying tones to black (level 0) or white (255).

Image 19 Hard Mix

Hard Mix

The Hard Mix blend mode was new to Photoshop CS. It has a threshold effect when blending desaturated tones into a desaturated layer and a color posterization effect when blending saturated or desaturated tones with a color layer.

Blend modes for tinting and toning

The Hue and Color blend modes are predominantly used for toning or tinting images whilst the Saturation blend mode offers more limited applications. Photo filters were also introduced with Photoshop CS that create similar effects to the Color and Hue blend modes.

Hue

The 'Hue' blend mode modifies the image by using the hue value of the blend layer and the saturation value of the underlying layer. As a result the blend layer is invisible if you apply this blend mode to a fully desaturated image. Opacity levels of the blend layer can be explored to achieve the desired outcome.

Color

The 'Color' blend mode is useful for toning desaturated or tinting colored images. The brightness value of the base color is blended with the hue and saturation of the blend color.

Image 20 Hue-Color. Hue and Color blend modes

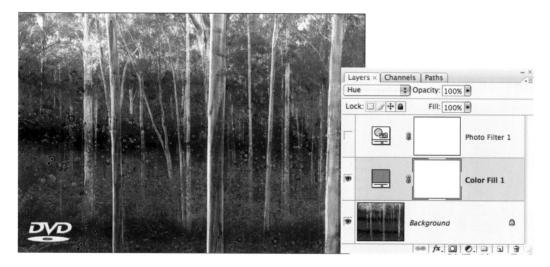

Image 21 Color

Note > Color fills can be used to tint or tone images by setting them to Hue or Color mode. Photoshop's Photo Filter layers (introduced with CS) perform a similar task but without the need to set the layer to the Hue or Color mode.

Saturation

The brightness or 'luminance' of the underlying pixels is retained but the saturation level is replaced with that of the blend layer's saturation level.

Note > This blend mode has limited uses for traditional toning effects but can be used to locally desaturate colored images. To work with this blend mode try creating a new empty layer. Then either fill a selection with any desaturated tone or paint with black or white at a reduced opacity to gradually remove the color from the underlying image.

Image 22 Saturation. The Saturation blend mode

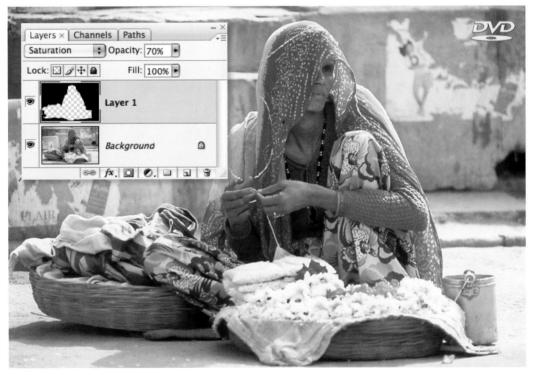

Image 23 Saturation. A Saturation layer is used to desaturate the underlying image

Luminosity

The 'Luminosity' blend mode creates the same result as the 'Color' mode if the layers are reversed, i.e. the color layer is underneath. The luminosity values within an RGB image have a number of very useful applications. The luminosity values can be extracted from an RGB image (from the Channels palette) and saved as an alpha channel, used as a layer mask or pasted as an independent layer above the background layer.

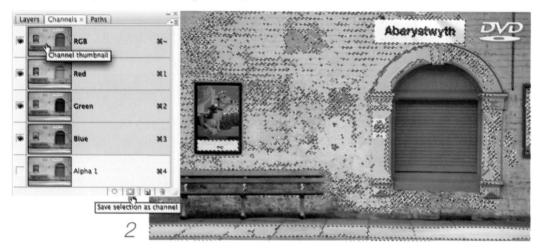

Creating a luminance channel

Image 24 Luminosity

- 1. In the Channels palette Command/Ctrl-click the master RGB channel to select the luminance values.
- 2. Click on the 'Save selection as channel' icon to create an alpha channel.
- 3. Choose 'Invert' (Image > Adjustments > Invert).

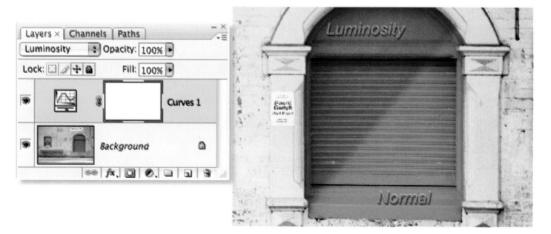

A Curves adjustment layer can be switched to Luminosity mode to eliminate shifts in saturation when contrast is increased. The example above illustrates what happens when contrast is increased using a Curves layer in Luminance and Normal blend modes. Open up the file and try it!

Difference and Exclusion

The Difference blend mode subtracts either the underlying color from the blend color or vice versa depending on which has the highest brightness value. This blend mode used to be useful for registering layers with the same content but this has now largely been replaced with the new Auto-Align layers command in CS3 for layers that are not Smart Objects. The Exclusion blend mode works in the same way except where the blend color is white. In this instance the underlying color is inverted.

Image 25 Difference. The Difference mode is used to align two layers

Image 26 Difference. Original image (Harmony) by Nicholas Monu (www.iStockphoto.com)

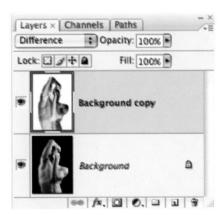

The Difference mode can also be used to create a 'solarized' or 'sabattier' effect. Duplicate the layer and go to Image > Adjustments > Invert. Apply the Difference blend mode to the background copy layer. Desaturate the image to create the more traditional look (made famous by the surrealist photographer 'Man Ray').

Creating a simple blend

Blending two images in the computer is similar to creating a double exposure in a film camera or sandwiching negatives in the darkroom. Photoshop allows a greater degree of control over the final outcome. This is achieved by controlling the specific blend mode, position and opacity of each layer. The use of 'layer masks' can shield any area of the image that needs to be protected from the blend mode. The blending technique enables the texture or pattern from one image to be applied to another image. The texture blended takes on the shadows and highlights of the underlying form but does not wrap itself around the contours or shape of the three-dimensional form unless further steps are taken to displace the pixels. This can be achieved using the Displacement filter (Filter > Distort > Displace) or the Liquify filter.

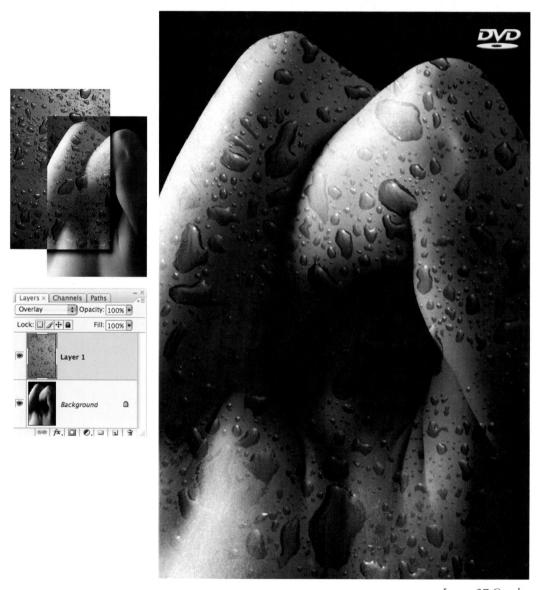

Image 27 Overlay

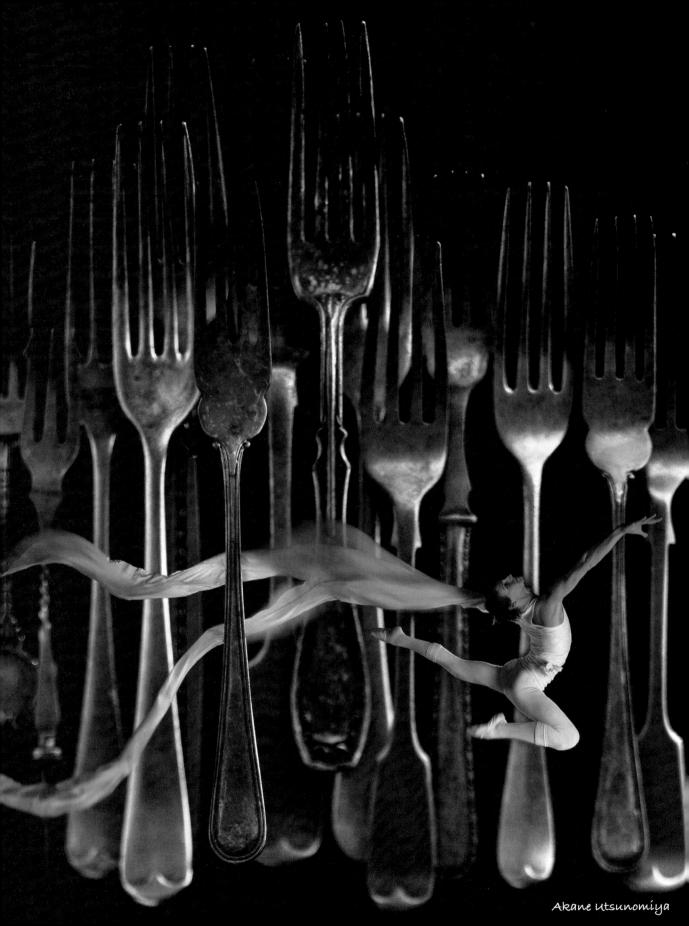

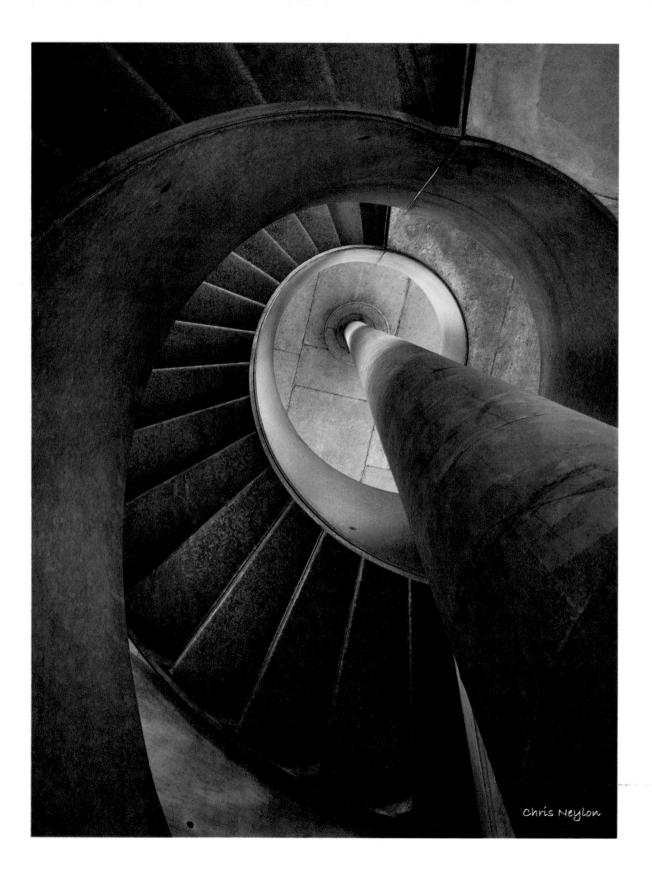

filters shop photoshop pho

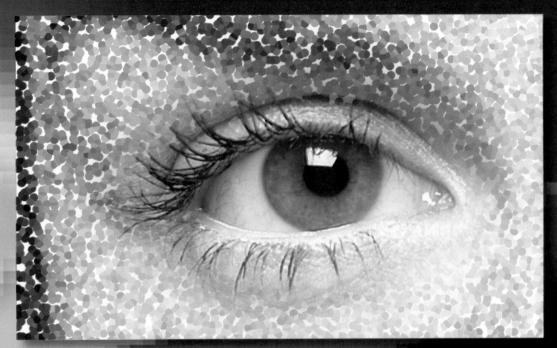

shop photoshop photoshop photoshop photoshop photoshop photoshop

essential skills

- ~ Apply filter effects to a picture.
- ~ Use the Filter Gallery feature to apply several filters cumulatively.
- ~ Use filters with text and shape layers.
- ~ Filter a section of a picture.
- ~ Paint with a filter effect.
- ~ Install and use third party filters.

Filtering in Photoshop

Traditionally the term filter, when used in a photography context, referred to a small piece of plastic or glass that was screwed onto, or clipped in front of, the camera's lens. Placing the filter in the imaging path changed the way that the picture was recorded. During the height of their popularity there were literally hundreds of different filter types available for the creative photographer to use. The options ranged from those that simply changed the color of the scene, to graduated designs used for darkening skies to multi-faceted glass filters that split the image in many fragments. Even now when their popularity has waned most photographers still carry a polarizing filter, maybe a couple of color conversion filters and perhaps the odd graduated filter as well. But apart from these few examples, much of the creative work undertaken by in-front-of-camera filters is now handled by the digital filters that are shipped with your imaging program. These options, like the filters of old, are designed to change the way that your picture looks, but you will find that it is possible to create much more sophisticated effects with the digital versions than was ever possible before.

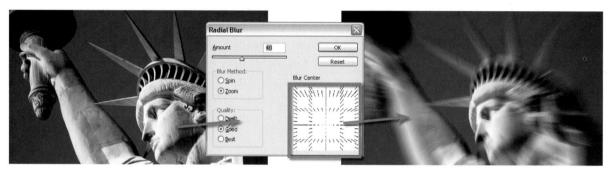

Statue of Liberty - Jeremy Edwards (www.iStockphoto.com)

Applying a filter is a simple process. After opening the image simply select the filter option from those listed under the Filter menu. This approach applies the effects of the filter to the whole of the photo, changing it forever. So be sure to keep a back-up copy of the original picture (or a copy of the background layer) just incase you change your mind later. Better still, use the new Smart Filter option to apply your filter changes losslessly.

To get you started, I have included a variety of examples from the range that comes free with Photoshop. I have not shown Gaussian Blur or all the sharpening filters as these are covered in techniques elsewhere in the text, but I have tried to sample a variety that, to date, you might not have considered using.

If you are unimpressed by the results of your first digital filter foray, try changing some of the variables or mixing a filtered layer (using the layer's Blending Mode or Opacity controls) with an unfiltered version of the image. An effect that might seem outlandish at first glance could become usable after some simple adjustments of the in-built sliders contained in most filter dialog boxes or with some multiple layer variations.

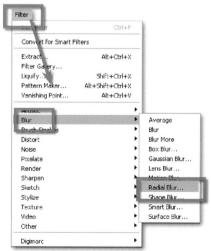

Smart Filters in CS3

The concept of non-destructive editing is ever growing in popularity and acceptance. Now many dedicated amateurs are working like professionals by embracing ways of enhancing and editing that don't destroy or change the original pixels in the end result. Masking techniques, Adjustment Layers and the use of Smart Objects are the foundation technologies of many of these techniques. But try as we may some changes have just not been possible to apply non-destructively.

Filtering is one area in particular where this is the case. For example, applying a sharpening filter to a picture irreversibly changes the pixels in the photo forever. For this reason many of us have been applying such filters to copies of our original document whilst all the time dreaming of a better way. Well the better way has arrived. Photoshop CS3 beta includes a new filtering option called Smart Filters and yes, you guessed it, this technology allows you to apply a filter to an image non-destructively. Cool!

Based around the Smart Object technology first introduced into Photoshop in CS2, applying a Smart Filter is a two-step process. First the image layer needs to be converted to a Smart Object. This can be done via the new entry in the Filter menu, Convert for Smart Filters, or by selecting the image layer and then choosing Layer > Smart Objects > Convert to Smart Objects. Next pick the filter you want to apply and adjust the settings as you would normally before clicking OK.

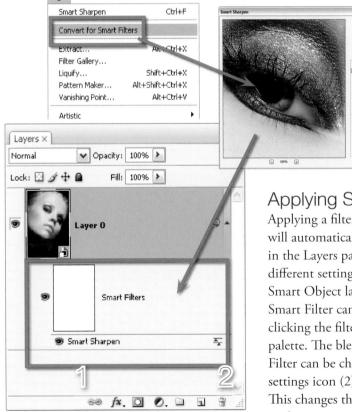

Applying Smart Filters

Applying a filter to a Smart Object Layer will automatically create a Smart Filter entry in the Layers palette. Multiple filters with different settings can be added to a single Smart Object layer. The settings for any Smart Filter can be adjusted by double-clicking the filter's name (1) in the Layers palette. The blending mode of the Smart Filter can be changed by double-clicking the settings icon (2) at the right end of the entry. This changes the way that the filter is applied to the image.

Reset

Smart Filters are added as an extra entry beneath the Smart Object in the Layers palette. The entry contains both a mask as well as a separate section for the filter entry and its associated settings. Like Adjustment Layers, you can change the setting of a Smart Filter at any time by double-clicking the filter's name in the Layers palette. The blending mode of the filter is adjusted by double-clicking the settings icon at the right end of the filter entry.

The Smart Filter mask can be edited to alter where the filter effects are applied to the photo.

The Smart Filter mask can be edited to alter where the filter effects are applied to the photo. In this release multiple smart filters can be added to a photo but they all must use the one, common mask.

Finally, in CS3 with the Smart Filter technology we have a way to apply such things as sharpness or texture non-destructively.

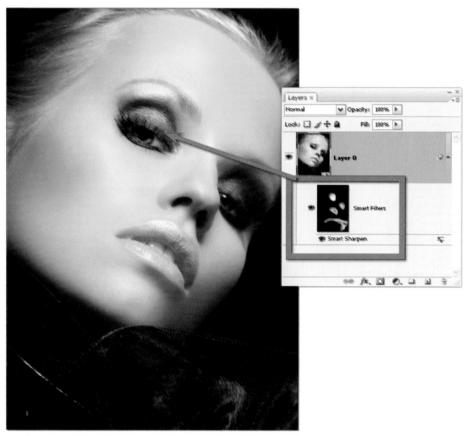

Beauty - Katja Govorushchenko (www.iStockphoto.com)

Masking Smart Filters

You can easily localize the effects of a Smart Filter by painting directly onto the mask associated with the entry. Here the mask thumbnail was selected first and then inverted using the Image > Adjust > Inverse option. Keep in mind that black sections of a mask do not apply the filter to the picture so inverting the thumbnail basically removes all filtering effects from the image. Next white was selected as the foreground color and the brush tool chosen. The opacity of the tool was reduced and with the mask thumbnail still selected, the areas to be sharpened are then painted in.

The Filter Gallery

Most Photoshop filters are applied using the Filter Gallery feature. Designed to allow the user to apply several different filters to a single image, it can also be used to apply the same filter several times. The dialog consists of a preview area, a collection of filters that can be used with the feature, a settings area with sliders to control the filter's effect and a list of filters that are currently being applied to the image. The gallery is faster and provides previews that are much larger than those contained in individual filter dialogs.

Filters are arranged in the sequence that they are applied. Filters can be moved to a different spot in the sequence by click-dragging up or down the stack. Click the 'eye' icon to hide the effect of the selected filter from preview. Filters can be deleted from the list by dragging them to the dustbin icon at the bottom of the dialog.

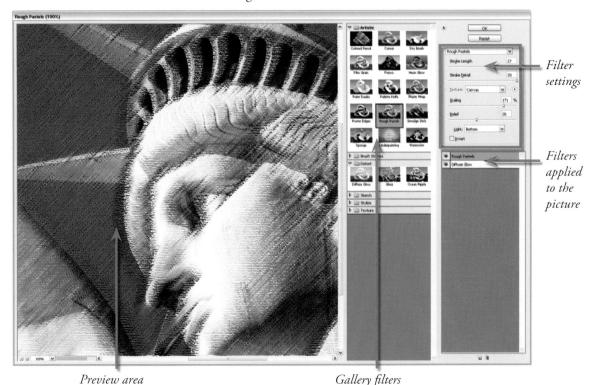

Filters that can't be used with the Filter Gallery feature are either applied directly to the picture with no user settings or make use of a filter preview and settings dialog specific to that particular filter, and they generally cannot be used on 16-bit images.

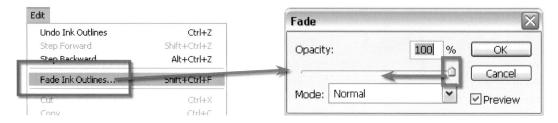

Fade Filter command

The opacity, or strength, of the filter effect can be controlled by selecting the Edit > Fade command when selected directly after the filter is applied. With a value of 0% the filter changes are not applied at all, whereas a setting of 100% will apply the changes fully. As well as controlling opacity the Fade dialog also provides the option to select a different blend mode for the filter changes. Note that the actual entry for the Fade command will change depending on the last filter applied.

Improving filter performance

A lot of filters make changes to the majority of the pixels in a picture. This level of activity can take considerable time, especially when working with high-resolution pictures or underpowered computers. Use the following tips to increase the performance of applying such filters:

- Free up memory by using the Edit > Purge command before filtering.
- Allocate more memory to Photoshop via the Edit > Preferences > Memory and Image Cache option before filtering.
- Try out the filter effect on a small selection before applying the filter to the whole picture.
- Apply the filter to individual channels separately rather than the composite image.

Third party filters are generally installed automatically into the Photoshop Plug-Ins > Filter folder. The program then attaches the extra plug-in to the bottom of the Filter menu the next time Photoshop is opened. Here the Applied Science Fiction Digital SHO filter is installed with other filters from the group's suite of enhancement filters

Installing and using third party filters

Ever since the early versions of Photoshop Adobe provided the opportunity for third party developers to create small pieces of specialist software that could plug into Photoshop. The modular format of the software means that Adobe and other software manufacturers can easily create extra filters that can be added to the program at any time. In fact, some of the plug-ins that have been released over the years have became so popular that Adobe themselves incorporated their functions into successive versions of Photoshop. This is how the Drop Shadow layer effect came into being.

Most plug-ins register themselves as extra options in the Filter menu where they can be accessed just like any other Photoshop feature. The Digital SHO filter from Applied Science Fiction is a great example of plug-in technology. Designed to automatically balance the contrast and enhance the shadow detail in digital photographs, when installed it becomes part of a suite of filters supplied by the company that are attached to the Filter menu. Other filters like those supplied by Pixel Genius Suite are automation filters and are therefore placed in the Automate folder.

Filtering a shape or text (vector) layer

Filters only work with bitmap or pixel-based layers and pictures. As text, vector masks and custom shape layers are all created with vector graphics (non-pixel graphics), these layers need to be converted to bitmap (pixel-based picture) before a filter effect can be applied to them. Photoshop uses a Rasterize function to make this conversion. Simply select the text or shape layer and then choose the Layer > Rasterize option.

Alternatively, if you inadvertently try to filter a vector layer Photoshop will display a warning dialog that notifies you that the layer needs to be converted before filtering and offers to make the conversion before proceeding.

Note: Especially in the case of text, you may want to create a copy of the vector layer as a back-up, to avoid the need to recreate the layer if the text layer needs to be edited again later.

The great filter round-up

The filter examples on the next few pages are grouped according to the menu heading that they fall under in Photoshop. Effects of different filter options are compared using a common 'crayons' image and the associated dialog box for controlling these effects is displayed alongside. Not all the filters in each group are shown and specific examples are used for major filters such as Liquify, Extract, Lens Blur and the new Vanishing Point filter.

Extract filter

The Extract filter was first included in Photoshop back in version 5.5 of the program. Here it was hidden away under the Image menu. Now the feature has pride of place in the first section of the Filter menu and provides users with a specialist selection tool that removes the background from the surrounds of an object.

The concept is simple: draw around the outside of the object you want to extract, making sure that the highlighter overlaps the edge between background and foreground, and then fill in the middle. The program then analyzes the edge section of the object using some clever fuzzy logic to determine what should be kept and what should be discarded, and 'Hey Presto' the background disappears.

The tool provides extracted objects faster than using the Lasso or Pen Tools as you don't need to be as accurate with your edge drawing, and it definitely handles wispy hair with greater finesse than most manual methods.

When previewing the results you can refine the edges left by the extraction process using the Cleanup and Edge Touchup Tools.

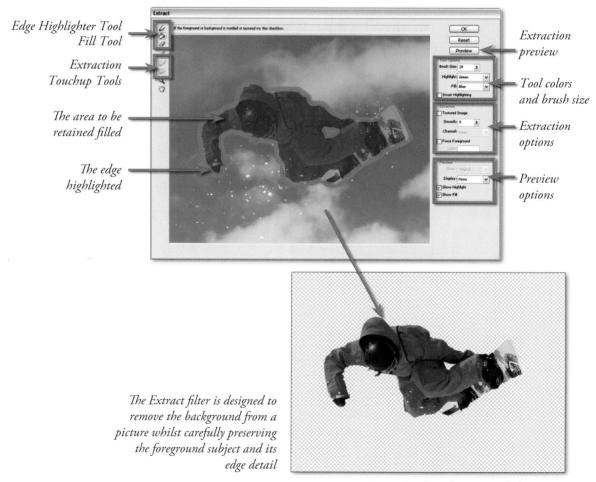

Jacom Stephens (www.iStockphoto.com)

Usage summary:

- 1. Select the layer you wish to extract.
- 2. Choose Filter > Extract from the Photoshop menus.

3. Use the Edge Highlighter Tool to draw around the edges of the object you wish to extract.

- 4. Select the Fill Tool and click inside the object to fill its interior.
- 5. Click Preview to check the extraction.
- 6. Click OK to apply the final extraction.

Extraction tips:

- Make sure that the highlight slightly overlaps the object edges and its background.
- For items such as hair, use a larger brush to encompass all strands.
- Make sure that the highlight forms a complete and closed line around the object before filling.
- Use the Smart Highlighting option to automatically locate the edge between foreground and background objects and to adjust the size of the highlighter to suit the clarity of the edge.
- Don't forget you can use the Extraction Touchup Tool for problem areas.
- Carefully read the tool-specific instructions provided at the top of the dialog box.

Liquify filter

The Liquify filter is a very powerful tool for warping and transforming your pictures. The feature contains its own sophisticated dialog box complete with a preview area and no less than ten different tools that can be used to twist, warp, push, pull and reflect your pictures with such ease that it is almost as if they were made of silly putty. In CS3 the filter now also works with 16-bit images. The effects obtained with this feature can be subtle or extreme depending on how the changes are applied. Stylus and tablet users have extra options and control based on pen pressure.

Liquify works by projecting the picture onto a grid or mesh. In an unaltered state, the grid is completely regular; when liquifying a photo the grid lines and spaces are intentionally distorted, which in turn causes the picture to distort. As the mesh used to liquify a photo can be saved and reloaded, the distortion effects created in one picture can also be applied to an entirely different image.

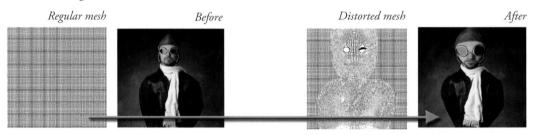

The tools contained in the filter's toolbox are used to manipulate the underlying mesh and therefore distort the picture. Areas of the picture can be isolated from changes by applying a Freeze Mask to the picture part with the Freeze Mask Tool. While working inside the filter dialog, it is possible to selectively reverse any changes made to the photo by applying the Reconstruct Tool. When applied to the surface of the image the distorted picture parts are gradually altered back to their original state (the mesh is returned to its regular form). Like the other tool options in the filter, the size of the area affected by the tool is based on the Brush Size setting and the strength of the change is determined by the Brush Pressure value.

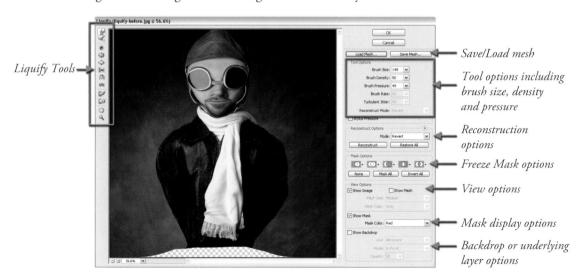

Usage summary:

1. Open an example image and then the Liquify filter (Filter > Liquify). The dialog opens with a preview image in the center, tools to the left and tool options to the right. The Size, Pressure, Rate and Jitter options control the strength and look of the changes, whereas the individual tools alter the type of distortion applied. In order to create a caricature of the example picture we will exaggerate the perspective of the figure. Select the Pucker Tool and increase the size of the Brush to cover the entire bottom of the subject. Click to squeeze inwards the lower part of the subject.

- 2. Now select the Bloat Tool and place it over the head; click to expand this area. If you are unhappy with any changes you can use the keyboard shortcuts for Edit > Undo (Ctrl + Z) to remove the last changes. Use a smaller brush size to bloat the goggles.
- 3. To finish the caricature switch to the Forward Warp Tool and push in the cheek areas. You can also use this tool to drag down the chin and lift the cheekbones.
- 4. The picture can be selectively restored at any point by choosing the Reconstruct Tool and painting over the changed area. Click OK to apply the distortion changes.

Liquify tools:

Forward Warp Tool – used to push pixels in the direction you drag the cursor across the picture surface.

Reconstruct Tool – restores the picture and mesh back to its original appearance before any distortion was applied.

Twirl Clockwise Tool – used for rotating pixels in a clockwise direction. Use with the Alt key to twirl in an anti-clockwise direction.

Pucker Tool – designed to suck or pinch the pixels towards the center of the brush.

Bloat Tool – balloons the pixels away from the center of the brush towards the outside edges.

Push Left Tool – used to move the pixels to the left or to the right (Alt-drag) of the drag.

Mirror Tool – used to copy and reflect the pixels perpendicular to the direction of the stroke. Use Alt-drag to reflect the pixels in the opposite direction.

Turbulence Tool – used for creating clouds, fire and waves by smoothly scrambling pixels.

Freeze Mask Tool – adds a mask that protects the masked area from liquify changes.

Thaw Mask Tool – acts as an eraser for the Freeze Mask Tool.

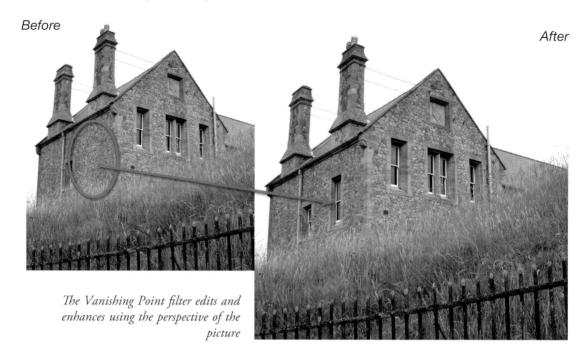

Vanishing Point

The Vanishing Point filter was first introduced in CS2 as an addition to the specialist filter line-up that includes Extract, Lens Blur and Liquify. Like the others, the feature has its own dialog complete with preview image, toolbox and options bar. The filter allows the user to copy and paste and even Clone Stamp portions of a picture whilst maintaining the perspective of the original scene. In Photoshop CS3 the filter has continued to evolve and now can be used in a multitude of ways as the perspective plans can now be linked at any angle (rather than just 90° as was the case in CS2). Using the filter is a two-step process:

Step 1: Define perspective planes

To start, you must define the perspective planes in the photo. This is achieved by selecting the Create Plane Tool and marking each of the four corners of the rectangular-shaped feature that sits in perspective on the plane. A blue grid means that it is correct perspective, yellow that it is borderline, and red that it is mathematically impossible. In the example, the four corners of a window were used to define the plane of the building's front face. Next, a second plane that is linked to the first at an edge is dragged onto the surface of the left side wall.

Step 2: Copy and Paste or Stamp

With the planes established the Marquee Tool can be used to select image parts which can be copied, pasted and then dragged in perspective around an individual plane and even onto another linked plane. All the time the perspective of the copy will alter to suit the plane it is positioned on. The feature's Stamp Tool operates like a standard stamp tool except that the copied section is transformed to account for the perspective of the plane when it is applied to the base picture.

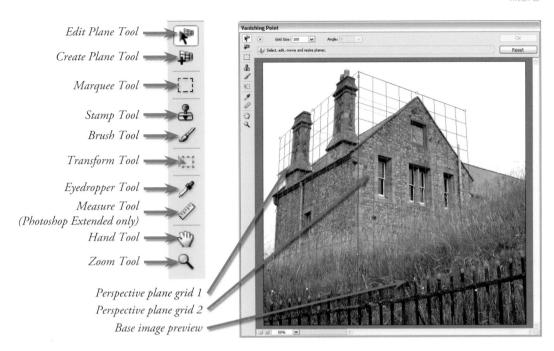

Usage summary:

- Create a new layer above the image layer to be edited (Layer > New > Layer) and then choose the Vanishing Point filter from the Filter menu.
- 2. Select the Create Plane Tool and click on the top left corner of a rectangle that sits on the plane you wish to define. Locate and click on the top right, bottom right and bottom left corners. If the plane has been defined correctly the corner selection box will change to a perspective plane grid. In the example, the front face of the building was defined first.

- 3. To create a second, linked, plane, Ctrl-click the middle handle of the existing plane and drag away from the edge. The left side of the building was defined using the second plane.
- 4. To copy the window from the building's front face, select the Marquee Tool first, set a small feather value to soften the edges and then outline the window to be copied. Choose Ctrl/Cmd + C (to copy) and then Ctrl/Cmd + V (to paste). This pastes a copy of the window in the same position as the original marquee selection.
- 5. Click-drag the copy from the front face around to the side plane. The window (copied selection) will automatically snap to the new perspective plane and will reduce in size as it is moved further back in the plane. Position the window on the wall surface and choose Heal > Luminance from the Marquee options bar.
- 6. Press 'T' to enter the Transform mode and select Flip from the option bar to reorientate the window so that the inside edge of the framework matches the other openings on the wall. Click OK to complete the process.

Vanishing Point tips:

- Use the Edit Plane Tool to click and drag the corners of the grid if grid lines do not match up with the edges of the picture parts that are sitting on the perspective plane.
- In order to copy and paste in full perspective the source plane and destination plane must be joined by a series of linked perspective planes.
- Use the Heal option to help match tones of the copied parts and their new locations.
- Grids can be output as layers, are 16-bit capable, text can be pasted into a grid and are auto-saved as part of the PSD file format.

Vanishing Point goes askew with VP2.0

When the Vanishing Point filter first appeared in Photoshop CS2 there were many admirers of its power to manipulate objects in three-dimensional space but comparatively few people who could find a use for it in their day-to-day workflows. One reason for this lack of popularity was that the feature assumed that all adjoining perspective planes met at a 90° angle. This is fine for buildings and boxes but is limited when it comes to a good many other surfaces.

The version of Vanishing Point that appears in Photoshop CS3 can now create perspective-based planes at almost any angle, making the feature much more usable in a variety of everyday images.

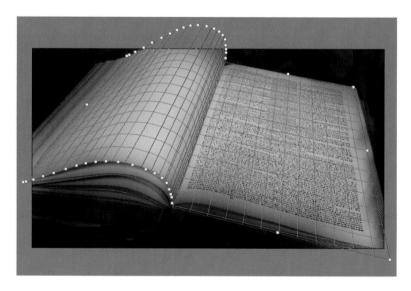

Vanishing Point 2.0 provides the ability to create perspective planes that join at angles other than 90°. In this example, the curve of the page was recreated with a series of small angled planes

Usage summary:

- 1. In the example image some text (or an image) needed to be added to the blank page on the left-hand side of the book. The text was photographed from another part of the book, the file opened in Photoshop and then copied to memory (Ctrl/Cmd + A, Ctrl/Cmd + C).
- 2. Next the book picture was opened into the Vanishing Point filter (Filter > Vanishing Point). To start, a new plane was created on the right side of the book using the edge of the text as a guide. The Create Plane Tool was selected and then the four corners of the plane dragged out to align with the edges of the text.

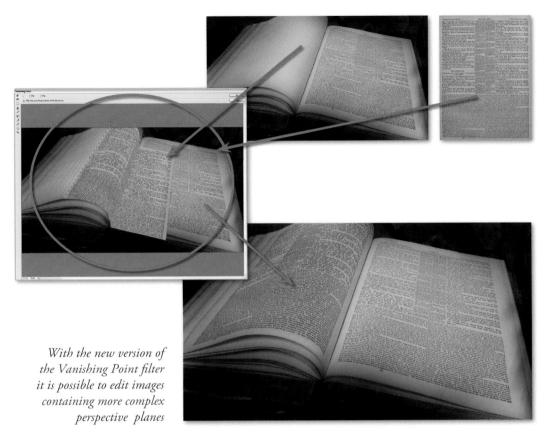

3. Once the plane is created the tool reverts to the Edit Plane mode for fine-tuning. The corners of the plane were then adjusted so that it extended to the edges of the page and, more importantly, the spine of the book.

- 4. To create a linked plane for the other side of the book, the Create Plane Tool was chosen a second time (or you could hold down the Ctrl/Cmd key whilst in Edit Plane mode) and a new plane was dragged from the center handle on the edge of the existing plane.
- Next the new Angle slider in the top of the dialog was used to rotate the plane so that it ran along the face of the curved page.
- 6. Using the page edge as a guide, add a series of small linked planes to the picture. Each need to be rotated and realigned to duplicate the perspective of the surface of the page.

- 7. Next the copied text was pasted (Ctrl/Cmd + V) into the Vanishing Point workspace and dragged to the first perspective plane.
- 8. The size of the text was then adjusted in the Transform mode (press T to enter) by click-dragging the corners of the marquee around the text before dragging into position on the curved page.

Artistic filters

The artistic group of filters contains a varied assortment of effects ranging from those that simulate fine art techniques such as the Watercolor, Dry Brush, Colored Pencil and Palette Knife filters, to those that produce very graphic results such as Neon Glow and Cutout filters. One very unusual inclusion is the Plastic Wrap filter, which recreates the look of the picture being wrapped in a thin sheet of plastic.

All the filters in this group are applied via the Filter Gallery dialog.

Colored Pencil...
Cutout...
Dry Brush...
Film Grain...
Fresco...
Neon Glow...
Paint Daubs...
Palette Knife...
Plastic Wrap...
Poster Edges...
Rough Pastels...
Smudge Stick...
Sponge...
Underpainting...
Watercolor...

Statue of Liberty - Jeremy Edwards (www.iStockphoto.com)

Fresco

Filter > Artistic > Fresco

Effect: Black edged painterly
effect using splotches of color.

Variables: Brush Size, Brush Detail, Texture

Paint Daubs

Filter > Artistic > Paint Daubs

Effect: Edges and tones defined with daubs of paint-like color.

Variables: Brush Size, Sharpness, Brush Type

Plastic Wrap

Filter > Artistic > Plastic Wrap

Effect: Plastic-like wrap applied to the surface of the image area.

Variables: Highlight Strength, Detail, Smoothness

Brush Strokes filters

The filters in the Brush Strokes group generally add outlines and surface texture to the various picture elements in your image. The most familiar of these options is the Crosshatch filter, which recreates the picture's tone and color with a series of alternating and overlapping strokes. Controls usually include the stroke length, sharpness and strength and, where an edge is added, the width and intensity of this border.

All the filters in this group are applied via the Filter Gallery dialog.

Accented Edges...
Angled Strokes...
Crosshatch...
Dark Strokes...
Ink Outlines...
Spatter...
Sprayed Strokes...
Sumi-e...

Accented Edges

Filter > Brush Strokes > Accented Edges

Effect: Image element edges are highlighted until they appear to glow.

Variables: Edge Width, Edge Brightness, Smoothness

Crosshatch

Filter > Brush Strokes > Crosshatch

Effect: Colored sharp-ended, pencil-like crosshatching to indicate edges and tones.

Variables: Stroke Length, Sharpness, Strength

Ink Outlines

Filter > Brush Strokes > Ink Outlines

Effect: Black ink outlines and some surface texture laid over the top of the original tone and color.

Variables: Stroke Length, Dark Intensity, Light Intensity

Blur filters

The Blur filters are designed to add a degree of softness to the photo. The most basic filters in this group are the Blur and Blur More options. These apply a set level of blur to your picture quickly and easily. For a more sophisticated and controllable Blur filter try Gaussian Blur or the new Box, Shape, Smart and Surface Blur versions. They all contain controls that alter the style and strength of the effect.

Average
Blur
Blur More
Box Blur...
Gaussian Blur...
Lens Blur...
Motion Blur...
Radial Blur...
Shape Blur...
Smart Blur...
Surface Blur...

The Lens Blur filter

One popular application for the Blur filters is to recreate a shallow focus photo where the main subject is sharp and the rest of the picture is unsharp. By selecting the areas to blur and then applying a filter you can create a crude shallow focus result. This approach does create a simple in-focus and out-of-focus effect but it would be hard to say that the results are totally convincing. To achieve a depth of field (DOF) effect that is more realistic and believable, the basic idea of this technique needs to be coupled with the Lens Blur filter.

Spiral Staircase by Bart Broek (www.iStockphoto.com)

Photoshop's Lens Blur filter is a dedicated feature designed to create realistic DOF effects in your pictures. From CS2 onwards the feature is 16-bit capable

If realism is your goal then it is necessary to look a little closer at how camera-based DOF works and, more importantly, how it appears in our images. Imagine an image shot with a long lens using a large aperture. The main subject situated midway into the image is pin sharp. Upon examination it is possible to see that those picture elements closest to the main subject are not as 'unsharp' as those further away. In effect the greater the distance from the point of focus, the more blurry the picture elements become.

This fact, simple though it is, is the key to a more realistic digital DOF effect. The application of a simple one-step blurring process does not reflect what happens with traditional camerabased techniques. The Lens Blur filter (Filter > Blur > Lens Blur) is designed specifically to help replicate this gradual change in sharpness. The filter uses selections or masks created before entering the feature to determine which parts of the picture will be blurred and which areas will remain sharp. In addition, if you use a mask that contains areas of graduated gray (rather than just black and white) the filter will adjust the degree of sharpness according to the level of gray in the mask.

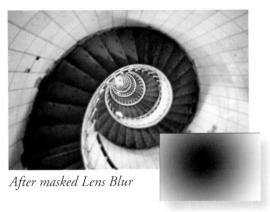

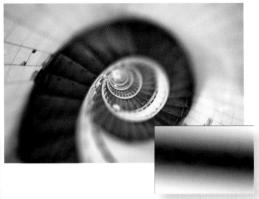

Mask

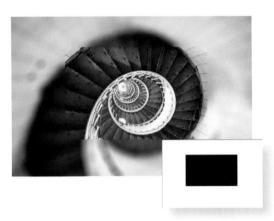

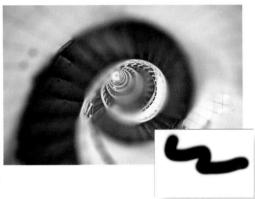

The Lens Blur filter uses a mask or selection to determine which parts of the picture will remain sharp and which areas will be blurred. In addition, the level of sharpness is directly related to the density of the mask. Graduated masks will produce graduated sharpness similar to that found in photographs with camera-based shallow DOF techniques

Lens Blur filter options

Preview – Faster to generate quicker previews. More accurate to display the final version of the image.

Depth Map Source – Select the mask or selection that you will use for the filter from the drop-down list.

Invert - Select this option to inverse the alpha channel mask or selection.

Iris Shape – Determines the way the blur appears. Iris shapes are controlled by the number of blades they contain.

Gaussian or Uniform – Select one of these options to add noise to the picture to disguise the smoothing and loss of picture grain that is a by-product of applying the Lens Blur filter.

Distort Filters

The Distort filters push, pull and twist the pixels within your pictures. Unlike other filter options, which recreate the image using different drawing or painting styles, the Distort filters deform the original image. The controls included are used to alter the strength of the distortion, sometimes the direction and often how to handle any areas of the image that are left blank by the filter's action. Generally the filters in this group are not applied via the Filter Gallery dialog but rather have their own specific dialog containing both controls and preview.

Diffuse Glow...
Displace...
Glass...
Lens Correction...
Ocean Ripple...
Pinch...
Polar Coordinates...
Ripple...
Shear...
Spherize...
Twirl...
Wave...
ZigZag...

Distort filters in action - Correcting lens distortion

Photoshop also contains a sophisticated Lens Correction filter (Filter > Distort > Lens Correction). The feature is specifically designed to correct the imaging problems that can occur when shooting with different lenses. Apart from correcting barrel and pincushion distortion, the filter can also fix the color fringing (color outlines around subject edges) and vignetting (darkening of the corners) problems that can also occur as a result of poor lens construction. Controls for changing the perspective of the picture (great for eliminating the issue of converging verticals) as well as how to handle the vacant areas of the canvas that are created after distortion correction are also included.

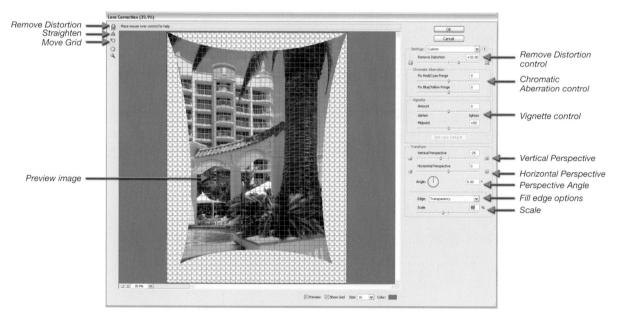

The symptoms of lens distortion

Barrel distortion is usually associated with images that are photographed with extreme wide-angle lenses. The characteristics of barrel distortion are straight lines that appear near the edge of the frame are bent, the whole image appears to be spherical or curved outward and objects that are close to the camera appear grossly distorted. The opposite effect is pincushion distortion, which can be created with some telephoto lenses. Rather than bulging the image seems to recede into the background and straight lines that appear near the edge of the frame are bent inwards.

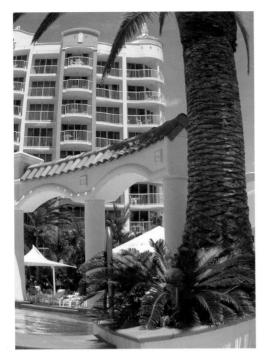

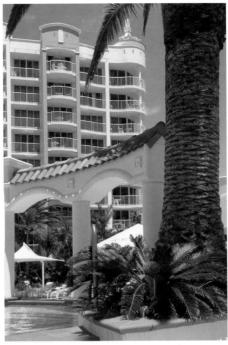

Correcting distortion and perspective

The example image was photographed with a wide-angle lens attached to a digital camera. It displays both barrel distortion and converging verticals that are in need of correction.

- 1. With the example open select Filter > Distort > Lens Correction. Zoom in or out using the Zoom control at the bottom left of the dialog and drag the grid with the Move Grid Tool, to a position where it can be easily used to line up a straight edge in the photo.
- Adjust the Remove Distortion slider to the right to correct the barrel effects in the picture. Your aim is to straighten the curved edges of what should be straight picture parts.

- 3. Now concentrate on correcting the converging verticals. Move the Vertical Perspective option to the left to stretch the details at the top of the photo apart and condense the lower sections. Again aim to align straight and parallel picture parts with the grid lines.
- 4. If the image is suffering from darkened edges select the Vignetting control and lighten the corners by moving the Amount slider to the right and adjust the percentage of the picture that this control affects with the Midpoint control.
- 5. Zoom in to at least 600% to check for chromatic aberration problems and use the Fix Red/Cyan Fringe or Fix Blue/Yellow Fringe controls to reduce the appearance of color edges. Click OK to apply the correction settings. Crop the 'fish tail' edges of the corrected photo to complete.

Noise filters

The Noise filters group contains tools that are used for either adding noise (randomly colored pixels) to, or reducing the existing noise in, a photo. Dust & Scratches is designed to automatically hide picture faults such as hairs or scratches in scanned photos. Despeckle, Median

Add Noise...
Despeckle
Dust & Scratches...
Median...
Reduce Noise...

and the new Reduce Noise filter remove or hide the noise associated with high ISO pictures and the Add Noise filter is used to create and add noise to photos.

All the filters in this group, except Despeckle, are applied via their own filter dialog.

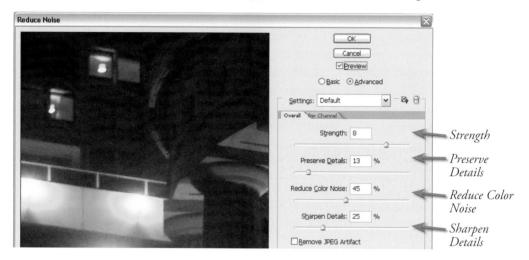

The Reduce Noise filter

The feature includes a preview window, a Strength slider, a Preserve Details control and a Reduce Color Noise slider. As with the Dust & Scratches filter you need to be careful when using this filter to ensure that you balance removing noise while also retaining detail. The best way to guarantee this is to set your Strength setting first, ensuring that you check the results in highlights, midtone and shadow areas. Next gradually increase the Preserve Details value until you reach the point where the level of noise that is being reintroduced into the picture is noticeable and then back off the control slightly (make the setting a lower number). For photographs with a high level of color noise (random speckles of color in an area that should be a smooth flat tone) you will need to adjust this slider at the same time as you are playing with the Strength control.

When the Advanced mode is selected the noise reduction effect can be applied to each channel (Red, Green, Blue) individually. This filter also works in 16-bit mode and contains saveable/loadable settings. There is also a special option for removal of JPEG artifacts. One of the side effects of saving space by compressing files using the JPEG format is the creation of box-like patterns in your pictures. These patterns or artifacts are particularly noticeable in images that have been saved with maximum compression settings. With the Remove JPEG Artifact option selected in the Reduce Noise dialog, Photoshop attempts to smooth out or camouflage the box-like pattern created by the overcompression. The feature does an admirable job but the results are never as good as if a lower compression rate was used initially.

Per Channel mode (Advanced section)

The Per Channel option provides the ability to adjust the noise reduction independently for each of the Red, Green and Blue channels. This allows the user to customize the filter for the channel(s) that have the most noise. The **Strength** setting controls the amount of Luminance or non-color noise reduction applied to each channel. The **Preserve Details** slider maintains the appearance of edge details at the cost of lowering the noise reduction effect. The best results balance both these options for each channel.

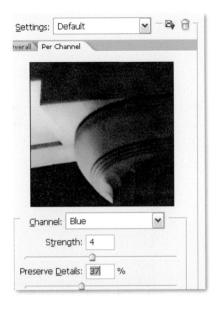

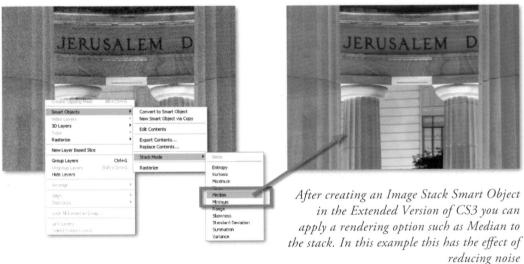

Reducing noise with image stacks

Another way to reduce noise is to take a series of images of the same scene in quick succession and then use the combined information from all the photos to produce a new, less noisy, composite picture. The process of achieving this outcome is easier in Photoshop CS3 Extended as with this release Adobe introduces the concept of image stacks as well as the ability to apply functions, such as the Median command, to these stacks. The process involves layering the sequential source images in a single document, applying the Auto-Align option (to ensure registration) and then converting the layers into Smart Object. Once in this Image Stack form it is possible to select one of a range of rendering options from those listed in the Layer > Smart Objects > Stack Mode menu. These options manage how the content of each of the layers will interact with each other.

In the noise reduction technique shown here the Median command creates the composite result by retaining only those image parts that appear (in the same spot) in more than 50% of the frames (layers). As noise tends to be pretty random, its position, color and tone changes from one frame to the next and so it is removed from the rendered photo, leaving just the good stuff – the picture itself.

In another example of how this technology can be used, in order to remove tourists from in front of your favorite statue there is no need to wait until they have all gone home, instead simply capture multiple pictures of the monument, group them together in an Image Stack and apply the Median function to the group. Hey presto tourists be gone!

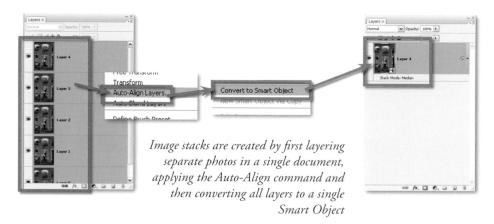

Using Image Stacks to remove noise in Photoshop Extended:

- 1. Reducing noise using this technique is a multi-step affair that starts at the time of capture. If you are confronted with a scene where it is essential that you use either a long exposure or high ISO setting (or both) then you can be pretty sure that your resultant images will contain some noise. So in these circumstances shoot several photos of the same scene. For best results maintain the same camera settings and camera position throughout the whole sequence.
- 2. Next open all photos into Photoshop and drag each picture onto a single document, creating a multi-layer file containing all the photos in the sequence.
- 3. Multi-select all the layers and choose the Auto-Align option (Auto Projection) from the Edit menu. Photoshop will arrange all the

Auto-Align Layers

Projection

Auto

OK

Cancel

 With the multiple layers still selected choose Layer > Smart Object > Convert to Smart Object. This places all the layers in Single Smart object.

layers so that the content is registered.

5. The last step in the process is to select the Smart Object layer and then choose how you want to render the composite image. Do this by selecting one of the options from the Layer > Smart Object > Stack Mode menu. To reduce noise we choose the Median entry.

Pixelate filters

The Pixelate filters break up the image surface in a variety of ways. Some replicate the effect of printing processes, such as Color Halftone and Mezzotint, others fracture the picture into smaller picture components of a regular size and shape. All the filters in this group, except Facet, are applied via their own filter dialog.

Mosaic

Filter > Pixelate > Mosaic

Effect: The image is broken into pixel-like blocks of flat color.

Variables: Cell Size

Mezzotint

Filter > Pixelate > Mezzotint

Effect: Adjustable stroke types are used

to give tone to the image.

Variables: Type

Render filters

The Render filters produce a range of different effects on the surface of your photo, including the creation of random clouds and fibers, the application of a flare highlight and the projection of a light source, or sources, onto the photo, creating areas of light and dark.

Clouds
Difference Clouds
Fibers...
Lens Flare...
Lighting Effects...

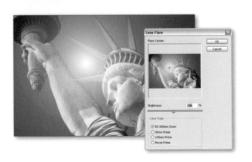

Lighting Effects

Filter > Render > Lighting Effects

Effect: Projects a variety of light sources onto the surface of the picture, creating areas of highlight and shade.

Variables: Style, Light Type, Properties, Texture Channel

Lens Flare

Filter > Render > Lens Flare

Effect: Creation of a lens flare effect that is then superimposed on the original image.

Variables: Brightness, Lens Type

Sharpen filters

Photoshop provides a variety of sharpening filters designed to increase the clarity of digital photographs. The options are listed in the Filter > Sharpen menu and include the Sharpen, Sharpen Edges, Sharpen More, Unsharp Mask filters as well as the new Smart Sharpen option.

Sharpen Sharpen Edges Sharpen More Smart Sharpen... Unsharp Mask...

Digital sharpening techniques are based on increasing the contrast between adjacent pixels in the image. When viewed from a distance, this change makes the picture appear sharper. The Sharpen and Sharpen More filters are designed to apply basic sharpening to the whole of the image and the only difference between the two is that Sharpen More increases the strength of the sharpening effect.

One of the problems with sharpening is that sometimes the effect is detrimental to the image, causing areas of subtle color or tonal change to become coarse and pixelated. These problems are most noticeable in image parts such as skin tones and smoothly graded skies. To help solve this issue, Adobe included the Sharpen Edges filter, which concentrates the sharpening effects on the edges of objects only. Use this filter when you want to stop the effect being applied to smooth image parts.

Customizing your sharpening

Out of all the sharpening options in Photoshop the Smart Sharpen and Unsharp Mask filters provide the greatest control over the sharpening process by giving the user a variety of slider controls that alter the way the effect is applied to their pictures. Both filters contain Amount and Radius controls. The Unsharp Mask filter includes a Threshold slider and the Smart filter contains controls for adjusting sharpness in Shadows and Highlights independently (in Advanced mode) as well as a Removal option for ridding images or specific blur types (Gaussian, Motion or Lens Blur).

Sharpening controls

The **Amount slider** controls the strength of the sharpening effect. Larger numbers will produce more pronounced results, whereas smaller values will create more subtle effects.

The **Radius slider** value determines the number of pixels around the edge that are affected by the sharpening. A low value only sharpens edge pixels. High settings can produce noticeable halo effects around your picture so start with a low value first.

The **Threshold slider** is used to determine how different the pixels must be before they are considered an edge and therefore sharpened.

The **Remove** setting locates and attempts to neutralize different blur types.

The **Shadow and Highlight** tabs contain options for adjusting the sharpening effects in these tonal areas.

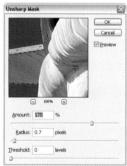

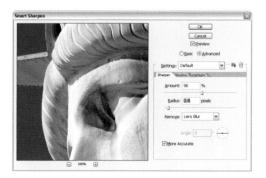

Stylize filters

The Stylize filters produce very graphic and often colorful versions of your photos. The aim with this set of filters is not realism but the creation of striking designs that use the base photo as a reference. This is not the filter group to use if you are looking for subtle changes to add to your photos.

Generally the filters in this group are not applied via the Filter Gallery dialog but rather have their own specific dialog containing both controls and preview.

Diffuse...

Emboss...

Extrude...

Find Edges

Glowing Edges...

Solarize

Tiles...

Trace Contour...

Wind...

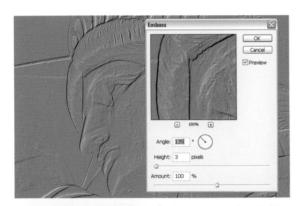

Extrude Types | Blocks | Dyvanids | Cx Sizes | 60 | Plosts | Cencel | Ceschi: 30 | Dyvanids | Level-based | Sold Growt Pace | Sold Growt Pac

Emboss

Filter > Stylize > Emboss

Effect: Recreates the look of beaten or embossed metal with the raised edges outlined and colored.

Variables: Angle, Height, Amount

Extrude

Filter > Stylize > Extrude

Effect: The 'building block' filter creates colored and stacked three-dimensional blocks out of your original image.

Variables: Type, Size, Depth, Solid Front Faces, Mask Incomplete Blocks

Wind

Filter > Stylize > Wind

Effect: Parts of the image are blurred in the direction of the prevailing wind.

Variables: Method, Direction

Sketch filters

The Sketch filters provide a range of generally monochrome fine art effects when applied to your photo. The controls included with each filter are used to alter the strength of the effect, sometimes the direction of the texture or the balance of light and dark changes. As many of the filters use the current foreground and background colors when applying their effects, changing these settings can provide drastically different results. Generally the filters in this group are applied via the Filter Gallery dialog.

Bas Relief...
Chalk & Charcoal...
Chrome...
Conté Crayon...
Graphic Pen...
Halftone Pattern...
Note Paper...
Photocopy...
Plaster...
Reticulation...
Stamp...
Torn Edges...
Water Paper...

Graphic Pen

Filter > Sketch > Graphic Pen Effect: Stylish black and white effect made with sharp-edged pen strokes.

Variables: Stroke Length, Light/ Dark Balance, Stroke Direction

Stamp

Filter > Sketch > Stamp

Effect: Just broad flat areas of black and white.

Variables: Light/Dark Balance, Smoothness

Bas Relief

Filter > Sketch > Bas Relief Effect: Color reduced image with cross lighting that gives the appearance of a relief sculpture. Variables: Detail, Smoothness,

Light Direction

Craquelure... Grain...

Mosaic Tiles...

Patchwork...

Texturizer...

Stained Glass...

Texture filters

The Texture filter group provides a range of ways of adding texture to your photos. Most of the filters apply a single texture type and include controls for varying the strength and style of the effect, but the Texturizer filter adds to these possibilities by allowing users to add textures they create themselves to a photo.

All filters in this group are applied via the Filter Gallery dialog.

The Texturizer filter

When applying the Texturizer filter the picture is changed to give the appearance that the photo has been printed onto the surface of the texture. The Scaling and Relief sliders control the strength and visual dominance of the texture, while the Light Direction menu alters the highlight and shadow areas. Different surface types are available from the Texture drop-down menu. The feature also contains the option to add your own files and have these used as the texture that is applied by the filter to the image.

Making your own textures

Any Photoshop file (.PSD) can be loaded as a new texture via the Load Texture option in the side-arrow menu, top right of the Texturizer dialog. Simply shoot, scan or design a texture image and save as Photoshop file (.PSD).

Craquelure

Filter > Texture > Craquelure Effect: Cracks imposed on the surface of the original image. Variables: Crack Spacing, Crack Depth, Crack Brightness

Stained Glass

Filter > Texture > Stained Glass

Effect: Image broken up into areas of color which are then bordered by a black line similar to stained glass.

Variables: Cell Size, Border Thickness, Light Intensity

Video filters

The Video filters deal specifically with problems associated with editing and enhancing still frames captured from video footage.

De-Interlace...
NTSC Colors

The De-Interlace filter

The De-Interlace filter is used to replace the missing picture detail that exists in captured video frames. It does this by either interpolating the pixels or duplicating the ones surrounding the area. Interpolation provides the smoothest results and Duplication the sharpest. The filter is not applied via the Filter Gallery dialog but rather has its own specific dialog that contains the Interpolation option.

The NTSC Colors filter

The NTSC Colors filter ensures that the colors in the image will fit within the range of hues available for the NTSC television format. This sometimes means that the color gamut of the original image is compressed to ensure that no single hue is oversaturated when displayed via the television system.

Other filters

The filters grouped together under the Other heading include the Custom filter, which is used for creating you own filter effects (see opposite page), the edge-finding High Pass filter, the Offset filter that shifts picture pixels by a set amount, and the Maximum and Minimum filters, which are most often used for modifying masks.

Filters in this group are not applied via the Filter Gallery dialog but rather have their own specific dialog containing both controls and preview.

Custom...
High Pass...
Maximum...
Minimum...

Offset...

Sharpening using the High Pass filter

The High Pass filter isolates the edges in a picture and then converts the rest of the picture to mid gray. The filter locates the edge areas by searching for areas of high contrast or color change. The filter can be used to add contrast and sharpening to a photo.

- To start, make a copy of the picture layer that you want to sharpen, then filter the copied layer with the High Pass filter. Adjust the Radius so that you isolate the edges of the image only against the gray background.
- Next select the filtered layer and switch the blend mode to Hard Light.
- 3. Finally, adjust the opacity of this layer to govern the level of sharpening being applied to the picture layer.

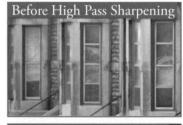

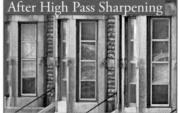

The ten commandments for filter usage

- 1. Subtlety is everything. The effect should support your image not overpower it.
- 2. Try one filter at a time. Applying multiple filters to an image can be confusing.
- 3. View at full size. Make sure that you view the effect at full size (100%) when deciding on filter settings.
- 4. *Filter a channel.* For a change try applying a filter to one channel only Red, Green or Blue.
- 5. *Print to check effect.* If the image is to be viewed as a print, double-check the effect when printed before making final decisions about filter variables.
- 6. Fade strong effects. If the effect is too strong try fading it. Use the 'Fade' selection under the 'Filter' menu.
- 7. Experiment. Try a range of settings before making your final selection.
- 8. *Mask then filter*. Apply a gradient mask to an image and then use the filter. In this way you can control what parts of the image are affected.
- 9. Try different effects on different layers. If you want to combine the effects of different filters try copying the base image to different layers and applying a different filter to each. Combine effects by adjusting the opacity of each layer.
- 10. Did I say that subtlety is everything?

Filter DIY

Can't find exactly what you are looking for in the hundreds of filters that are either supplied with Photoshop or are available for download from the Net? I could say that you're not really trying, but then again some people have a compulsion to 'do it for themselves'. Well, all is not lost. Photoshop provides you with the opportunity to create your own filtration effects by using its Filter > Other > Custom option.

By adding a sequence of positive/negative numbers into the 25 variable boxes provided you can construct your own filter effect. Add to this the options of playing with the 'Scale' and 'Offset' of the results and I can guarantee hours of fun. Best of all your labors can be saved to use again when your specialist customized touch is needed.

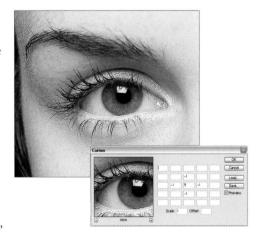

retouching projects photoshop photoshop photoshop photoshop photoshop photoshop photoshop photoshop photoshop photoshop

Mark Galer

photo

essential skills

shop

- Develop skills using layers, adjustment layers, channels and layer masks.
- Retouch and enhance images using the following techniques and tools:
 - Lens Correction Filter and Warp
 - Adjustment layers and layer masks
 - Target tones
 - Healing Brush, Clone Stamp Tool and Stamp Tool
 - Shadow/Highlight adjustment
 - High Pass, Unsharp Mask and Smart Sharpen.

Correcting perspective - Project 1

Many photographers prematurely jump to the conclusion that Photoshop is solely a tool for distorting reality or fabricating an alternative reality (the expression 'it's been photoshopped' still has negative connotations for some photographers). Although this may be the case in some instances Photoshop can, however, be used as a tool to correct the distortions introduced by the camera and lens and return an image back to how we remember the original subject or location, rather than how the camera interpreted it.

The Shrine of Remembrance, Melbourne - Nikon D200, Nikkor 12-24mm 1:4 G ED @ 12mm

Wide-angle lenses are an essential tool for the commercial photographer but they can introduce an unnatural and unnerving sense of perspective. In the natural landscape this exaggerated perspective may go unnoticed but when the photographer is in the urban environment and the photographer has to tilt the camera up in order to frame the shot the verticals will lean inwards – sometimes to an alarming extent. Architectural photographers may go into this environment equipped with specialized equipment such as shift lenses and large format cameras (some even take their own ladders). This specialized equipment allows the photographer to frame the view they need without tilting the camera from the horizontal axis. There is, however, a post-production answer that allows the photographer to create a more natural sense of perspective. This first project focuses its attention on correcting rather than distorting images and will look at perspective correction and chromatic aberration (the misalignment of colors commonly found in the corners of an image).

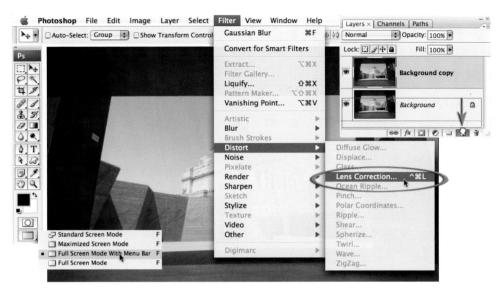

1. Start the process by selecting an appropriate screen mode by holding down the mouse clicker on the Change Screen Mode icon at the bottom of the Tools palette until the menu of screen modes appears. Choosing the 'Full Screen Mode With Menu Bar' option will allow you to reposition the image anywhere on your screen by holding down the Spacebar and dragging the image. This will be useful as we access the edges and corners of the image. Drag the Background layer in the Layers palette to the New Layer icon at the base of the palette to duplicate it (alternatively you can use the keyboard shortcut Ctrl + J (PC) or Command + J (Mac)). Select Filter > Distort > Lens Correction to open the Lens Correction dialog box.

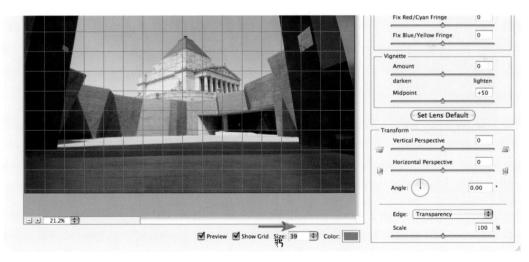

2. At the base of the Lens Correction dialog box make sure the Show Grid option is checked. Move your mouse cursor over the word 'Size' to the right of this checkbox. You should notice two arrows appear from the hand icon that indicates you can change the value in the field to the right (this tool for changing values in any numerical field is called a scrubby slider). If you now click and drag to the right the size of the grid will increase. Set the value to around 40.

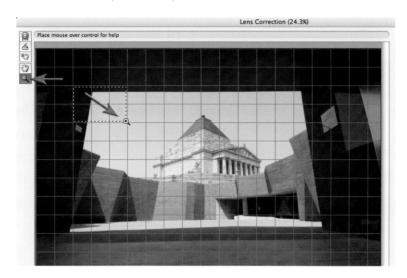

3. To check for Chromatic Aberration (color fringing as a result of misalignment of color channels) we will need to zoom in to 100% or 200% and view the edge detail in the corners of the image. Click on the Zoom Tool in the upper left-hand corner of the dialog box or use the keyboard shortcut Ctrl + Spacebar (PC) or Command + Spacebar (Mac) to access the Zoom Tool and then click and drag to target a zoom area in the upper left-hand corner of the image (where the dominant vertical line meets the dominant horizontal line). Click on the tab to the right of the magnification size (underneath the image in the Lens Correction dialog box) and select 200% from the menu of sizes. This will ensure that we get an accurate view of any chromatic aberration present in this image.

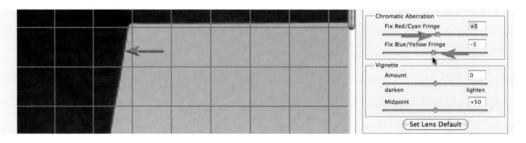

4. The chromatic aberration, if present, can be seen as a fringe running alongside the edges of lines within the corners of the image. The amount of aberration visible depends on the camera and lens used to capture the image and also, to a large extent, on the size of the reproduction of the image. By slowly moving the Red/Cyan Fringe and Blue/Yellow Fringe sliders it should be possible to greatly reduce the width of the color fringing, if not eliminate it altogether.

Note > As well as chromatic aberration some lenses will produce noticeable darkening in the corners (especially at wide apertures). These overly dark corners can be removed using the Vignette slider. The Set Lens Default option is able to record these settings and apply them to subsequent images taken with the same lens. This feature is most useful where the chromatic aberration and vignetting does not vary as a result of zooming to a different focal length or by using a different aperture.

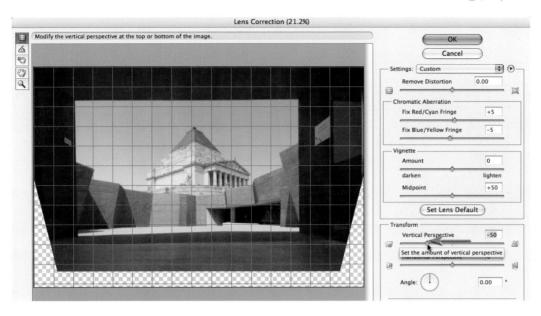

5. Now that the chromatic aberration is under control we can move on to the Transform section of the dialog box. The controls found in this section are not recorded as part of the Lens Default Setting, as the corrections required are variable for each image depending on the angle of the camera to the subject matter. In this image the Vertical Perspective slider is moved to the left (between -45 and -50) so that the verticals align with the grid lines that overlay this image.

Note > There is a limit to the amount of correction that can be undertaken before some shapes within the subject become misshapen. Where the converging verticals are very pronounced it is sometimes only possible to reduce the distortion rather than remove the converging verticals altogether. It is worth remembering that verticals converge even when using standard focal length lenses.

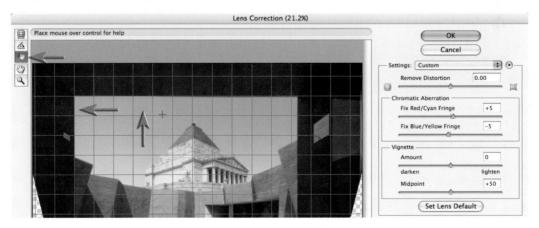

6. For an accurate assessment of the degree of correction you should click the Move Grid Tool and click and drag the grid so that it aligns with edges within the image that are meant to be vertical and horizontal.

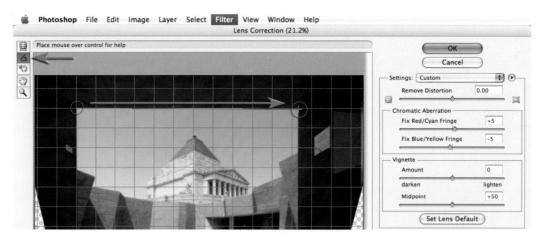

7. Use the Straighten Tool if the image appears slightly crooked when compared to the grid lines. Click on the tool in the upper left-hand corner of the dialog box and then click and drag along either a vertical or horizontal line. Let go of the mouse clicker when you get to the other end of the straight line to automatically straighten the image.

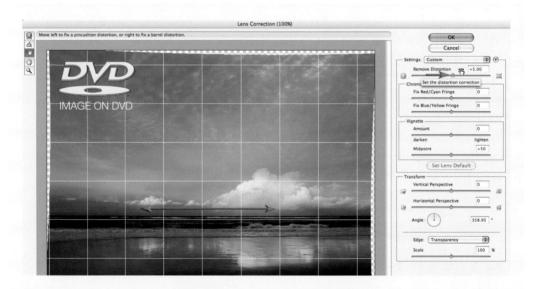

Pincushion distortion and barrel distortion

If the vertical or horizontal lines with the image appear to be curved rather than straight this is an indication that either 'barrel distortion' or 'pincushion distortion' is present within the image as a result of the lens that has been used. The slider to correct this distortion appears at the top of the control panel but is sometimes best implemented after the image has first been straightened and the vertical perspective corrected. The image used in the illustration above is a typical example where the horizon line curves excessively. After first straightening the image a small amount of barrel distortion is corrected. Pincushion distortion can be found in some images where a long telephoto lens has been used to capture the image. The image used in this illustration can also be found on the supporting DVD.

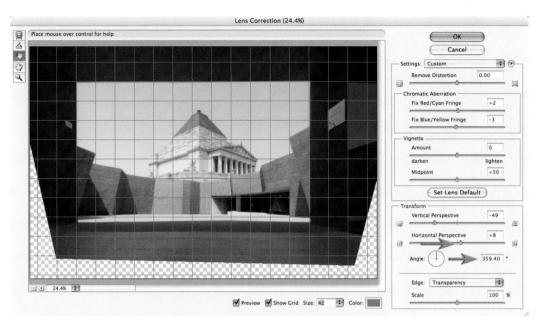

8. As a result of being slightly off-center when photographed it will be impossible to align both the horizontals and verticals that frame the sky without one further adjustment. Moving the Horizontal Perspective slider slightly to the right will ensure this entrance aligns to the grid lines. You may need to revisit some of the sliders a second time to perfect the alignment.

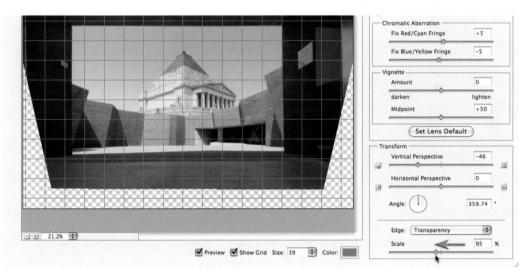

9. Scale the image down slightly using the slider in the bottom right-hand corner of the dialog box if quality rather than pixel quantity is the priority. The large correction required in this project will lead to a softening of image detail unless the scale is reduced to approximately 95%. As this is a 10-megapixel image there should be enough pixels (even at the reduced scale) to meet the final image requirements. Select OK to apply the changes and pass the corrected image back to the main Photoshop workspace.

10. After the Lens Correction filter has been applied it is still possible to fine-tune the correction in Photoshop's main workspace. Choose 'Rulers' from the View menu and then use the keyboard shortcut Ctrl + T (PC) or Command + T (Mac) to access the Free Transform command. Some images appear squashed after perspective correction so dragging the center handle of the transform bounding box either up or down can restore a more natural appearance to the image. This adjustment is optional in this project. The main reason for accessing the transform command is to correct some lines that were not possible using the Lens Correction filter.

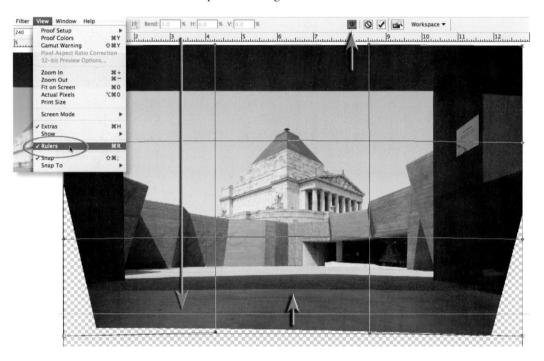

Click on the top rule and drag a guide to the lower portion of the image and align it with either end of the horizontal line on the concrete slab. You will notice how these lines in the lower portion of the image appear curved, even though the horizontal line in the top portion of the image appears comparatively straight. This is not something that the barrel distortion slider in the lens correction filter could compensate for (the uneven distortion is due to the fact that the horizontal lines near the base of the image are closer to the camera lens than the horizontal lines in the upper portion of the image, and have therefore been subject to a greater degree of barrel distortion). Click on the Warp icon in the Options bar and then move your mouse cursor over one of the curved lines in the central lower portion of the image. Click and drag gently upwards until the curved lines align with the guide you dragged into the image.

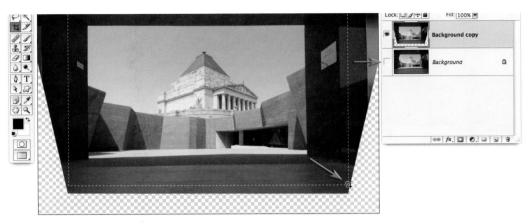

11. Switch off the visibility of the background layer so that you can see the part of the image that is now surplus to requirements. Select the Crop Tool and drag a cropping marquee around the picture area to be retained. Enter the crop dimensions and resolution in the Options bar if you are already aware of the final image requirements. Hit the Enter/Return key to apply the crop.

Move your cursor over the background layer and then right-click (PC) or Command-click (Mac) on the layer to open the context-sensitive menu. This menu will give you the option to flatten the image if you are now happy with the corrections. Select OK if you are presented with a warning dialog box asking you whether you want to discard the hidden layers.

12. To complete the project we need to sharpen this image as it has not been sharpened in camera or in ACR (Adobe Camera RAW). This sharpening is considered to be part of a normal corrective process that must be performed either in camera or in post-production to all images. The Smart Sharpen filter and the Unsharp Mask filter offer greater control than sharpening in either the camera or in ACR. With CS3 we are now able to apply filters non-destructively by first converting the layer for Smart Filters (Filter > Convert for Smart Filters). After converting the layer for Smart Filters (the layer is now known as a Smart Object) choose Filter > Sharpen > Smart Sharpen. We can use any filter on a Smart Object, not just the ones that have smart in their name.

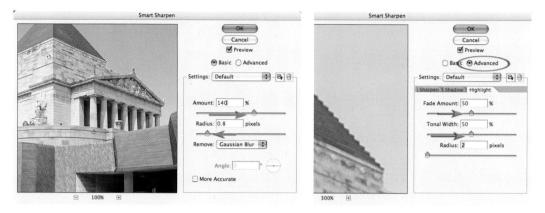

13. Images appear sharper when the contrast is raised at the edges within the image. In the Smart Sharpen dialog box we can control the amount of contrast by raising the Amount slider. Choose a generous amount of between 100% and 150%. The width either side of the edge where contrast is raised is controlled by the Radius slider. Choose a setting between 0.8 and 1.5 pixels. You should see a good overall improvement in sharpness using these settings. There is one unpleasant artifact that you may notice as a result of this sharpening process. If you click in the main image window where the roof of the war memorial meets the sky you may notice a halo appears at the edge. This halo can be reduced by clicking on the Advanced radio button and then clicking on the Highlight tab. Increase the Fade Amount and Tonal Width sliders to 50% to reduce the halo significantly. Click OK to apply these settings.

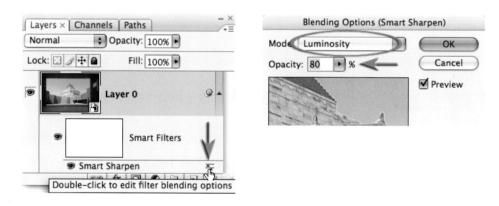

14. Double-click on the name of the filter in the Layers palette to reopen the Smart Sharpen dialog box. You will then be able to modify the settings if required. Double-click on the Blending Options icon to the right of filter name to open the Blending Options dialog box. Change the mode to Luminosity in order to reduce the risk of any additional color fringing as a result of the sharpening process (saturation is a by-product of contrast) and lower the opacity of the filter to 80%. This will in turn reduce the effect of the filter but give you the flexibility to optimize the amount of sharpening for different paper surfaces. Matt paper may require an increase in the filter opacity whilst outputting to gloss paper may require the opacity to be lowered further.

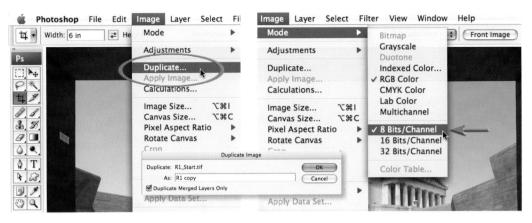

15. The corrections may be complete but it is usual to process a second image from this master file for print or screen display. The master image should be saved as a Photoshop file (PSD) and archived to an external drive or disk. The file should then be duplicated (Image > Duplicate). Select OK when the Duplicate Image dialog box appears. It is OK to select the 'Duplicate Merged Layers Only' box if your image has more than one layer. If this duplicate image is to be saved as a JPEG the bit depth of the image file must be dropped from 16 Bits/Channel to 8 Bits/Channel as the JPEG file format does not support higher bit depths.

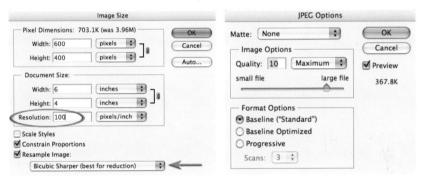

16. If the image is destined for web viewing the pixel dimensions will be too large. Go to Image > Image Size and click the Resample Image checkbox. Make sure the Constrain Proportions box is also checked (this will ensure the format or 'shape' of the image is preserved). Choose 'Bicubic Sharper' as the Interpolation method from the menu at the base of the dialog box. Type in the pixel dimensions that meet the output criteria (if known) or lower the resolution to 100 pixels/inch. Select OK to change the image size of this duplicate image.

From the File menu choose Save or Save As. Rename the file in the Save dialog box and choose the TIFF file format for publishing/ printing or the JPEG file format for web and screen viewing. Make sure the image is saved without layers and the profile is embedded.

Adjustment layers - Project 2

Image adjustments can be applied directly to the image from the Image menu or as non-destructive adjustment layers from the Layers palette. The advantage of using adjustment layers is that they can be re-edited an infinite number of times without causing any degradation to the image data and the adjustments can be applied to localized areas rather than globally by masking their effects using the adjustment layer mask that is attached to every adjustment layer. This project takes a look at the major adjustment layers used most frequently by photographers.

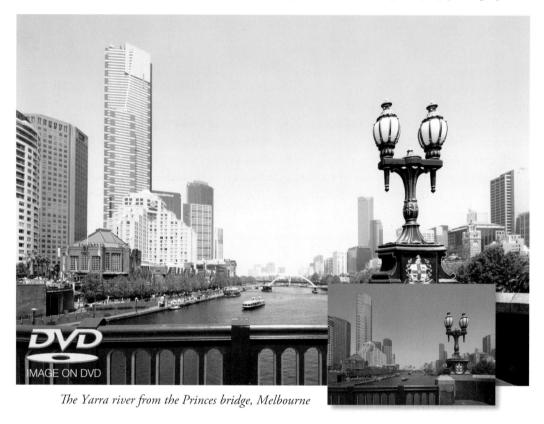

Many of these adjustments can also be applied non-destructively in Adobe Camera RAW but the adjustments carried out in this dialog box are always global in nature (there is no opportunity to restrict the adjustments to localized areas of the image). Many of the adjustments made to optimize or enhance an image are relatively subjective (no two people would use exactly the same settings in each of the adjustments – in fact, the same person may create different versions from the same image file depending on their mood or creative objectives on any particular day). The famous photographer Ansel Adams often compared photography with music. He likened the original film negative to the sheet of music and the print created from the negative in the darkroom to the musical performance from the sheet music. The digital file has now replaced the film negative and Photoshop is now the digital darkroom. The essential skills to master are to be able to previsualize the final outcome and be able to exercise control over Photoshop's tools to be able to realize this outcome.

1. Open the R2 support image from the DVD and then open the Layers palette. Click once on the 'Create new fill or adjustment layer' icon at the base of the Layers palette and then click on the Levels option from the menu that appears. The Levels adjustment feature will allow us to optimize the dynamic range of the image to ensure the image uses the full tonal range between black and white. The graph that appears in the Levels dialog box is called a histogram and is an indication of how many pixels there are at each level of brightness in this image. Level 0 on the left is absolute black and level 255 on the right is absolute white. The three sliders directly underneath the histogram (from left to right) are called the Shadow slider, the Gamma slider and the Highlight slider. The image you have opened has not been optimized in Adobe Camera RAW so we will need to drag both the Shadow slider and the Highlight slider in towards the center of the histogram in order to expand the contrast.

These sliders need to be moved a precise distance to give the best possible result. The aim is to expand the contrast without losing any detail in either the shadows or the highlights. A loss of detail is called 'clipping' and should be avoided if possible. Hold down the Alt key (PC) or Option key (Mac) and drag the Highlight slider slowly to the left. The image window will momentarily appear black (this is called a Threshold view). As you drag the slider underneath the start of the histogram you will notice more and more white areas appearing in the image (this is an indication of when clipping is occurring). Still holding down the Alt/Option key move the slider back to the right until there are no large patches of white remaining (the street lights should not have any large areas of clipping). Some minor clipping is inevitable when the light source is reflected off any shiny surfaces in the image (these are called specular highlights).

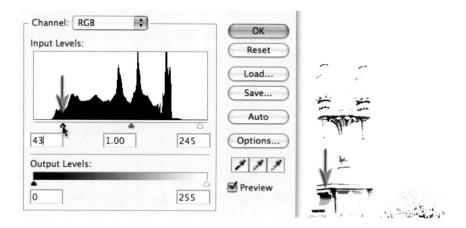

Repeat the process in the previous step using the Shadow slider. When holding down the Alt/ Option key move the slider until only thin lines appear in the image window. Any large areas of clipping should be avoided unless there is an absence of a surface in the image, e.g. the entrance to a cave or an open door to an unlit room. The Gamma slider underneath the center of the histogram can be moved to the left or the right to lighten or darken the image. We will, however, perform this adjustment using an alternative adjustment feature. Select OK in the top-right corner of the dialog box to apply the changes. The Levels dialog box will close.

Note > If the major clipping is evident before the sliders are moved this is an indication that the original image was either underexposed or overexposed in the camera. This is not something that can be corrected in Photoshop unless another image with a different exposure was also captured (see HDR).

2. From the same location that you selected the Levels adjustment layer now select Brightness/Contrast. This adjustment feature was seldom used by professional photographers in previous versions of Photoshop due to its destructive nature (without great care shadow and/or highlight detail quickly became clipped). In the dialog box make sure the legacy box is NOT checked to avoid the old destructive behavior of this adjustment feature. Raise both the Brightness and Contrast sliders until the required tonality is achieved. Unlike the Levels adjustment this is a fairly subjective adjustment so there are no specific settings that should be used.

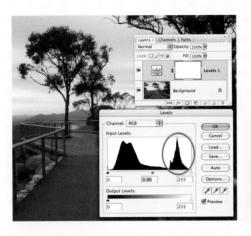

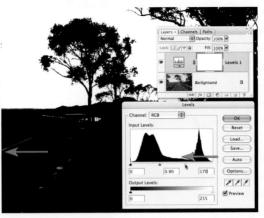

Localized levels

Sometimes when the levels are optimized for the entire image a portion of the image still appears flat. A close examination of the image used in this illustration (also on the DVD) will reveal that the range of levels on the right of the histogram belong only to the sky. None of the highlights in the foreground have been rendered higher than level 200, even after the Highlight slider has been adjusted. Greater contrast can be achieved if the user ignores the sky when setting the Highlight levels slider and then masks the sky later by painting into the layer mask to restore the tonality to this area of the image (preventing the highlights in the sky from becoming clipped by the adjustment). In this example a black/white gradient has been applied to the upper portion of the layer mask and then a new layer, in Multiply mode, with an added gradient has been used to darken the sky further.

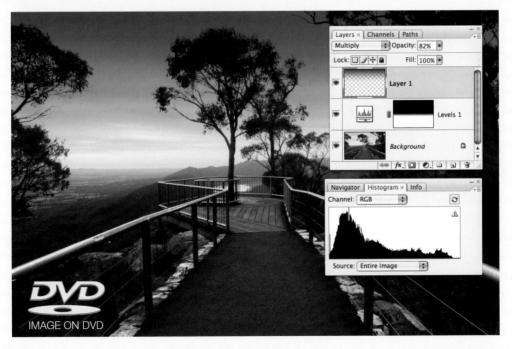

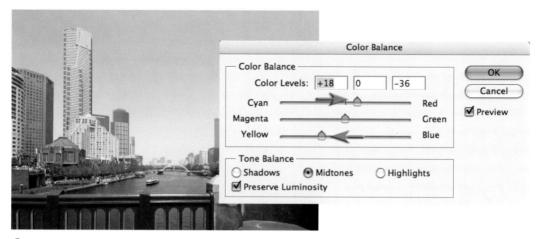

3. From the Layers palette select a Color Balance adjustment layer. The Color Balance dialog box allows color adjustments based around the primary and secondary colors. Theoretically it should be possible to achieve any color correction using just two of the three sliders. The image currently has a blue/cyan color cast so the top Cyan/Red slider needs to be moved to the right and the bottom Yellow/Blue slider needs to be moved to the left.

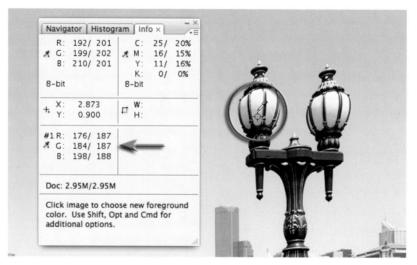

Quick and accurate color corrections can be difficult to achieve for newcomers to digital image editing without some guidance from the Info palette (palettes can be expanded from the dock or opened from the Window menu even when a dialog box is open). The user should attempt to identify a tone in the image that should appear gray (where the levels in the Red, Green and Blue channels are mixed in equal proportions). Move the mouse cursor into the image window and position the eyedropper over the shaded white areas of the street lamps. Observe the RGB readings in the Info palette. This should guide you as to which sliders to move, and in which direction, e.g. if the Red reading is lower than the other two readings move the slider in the Color balance dialog box towards Red to increase its value. Hold down the Shift key and the Alt/Option key and click to set a color sampler target. Move the sliders until all three numbers are equal. Select OK when you are happy with the Color Balance.

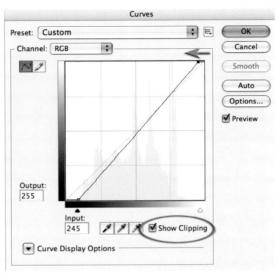

4. Perhaps the most powerful of all of the other adjustment features is Curves. With CS3 it has acquired even more control and flexibility. To demonstrate this control we will switch off the visibility of all three of the adjustment layers we have just created in the Layers palette. Open a Curves adjustment layer from the Layers palette. The diagonal line appears above a histogram. There is an adjustment point in the bottom left-hand corner and another in the top right-hand corner of the histogram window (equivalent to the Shadow and Highlight sliders in the Levels dialog box). The power of Curves comes in the ability to add additional points by clicking anywhere along the line to control specific areas of the histogram (we are not limited to just three sliders as with levels). Check the Show Clipping checkbox and then proceed to move the black point along the floor of the histogram window and the white points along the ceiling of the histogram window to positions where clipping just begins to occur. Switch off the Show Clipping checkbox when this step is complete. This sets the dynamic range of the image in the same way that we performed the task using the Levels dialog box in Step 1.

5. Click on the diagonal line about three-quarters of the way towards the top and drag the adjustment point higher in the window to brighten the highlights of the image. Now click halfway along the line and modify the midtone values with the image. Click one-quarter of the way along the line and drag the adjustment point to modify the shadow tones within the image. As the line gets steeper in the middle of the histogram the contrast of the image will increase. This performs the same task as the Brightness/Contrast adjustment but with a greater degree of control.

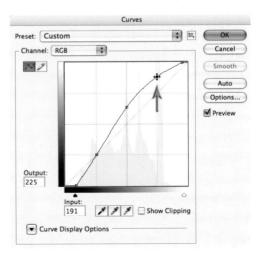

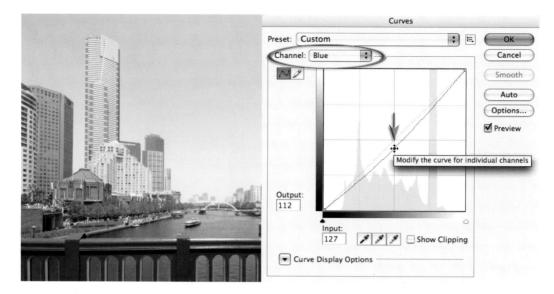

6. We can color correct the image in Curves in two different ways. We can use the individual channels in the Curves dialog box to balance the numbers. Select the Blue channel from the Channel menu in the Curves dialog box and then click to place an adjustment point halfway along the curve. Drag the adjustment point down to reduce the blue, observing the channel information in the Info palette. Repeat the process using the Red channel but this time raise the curve to increase the red values. The second alternative offers a more automated approach.

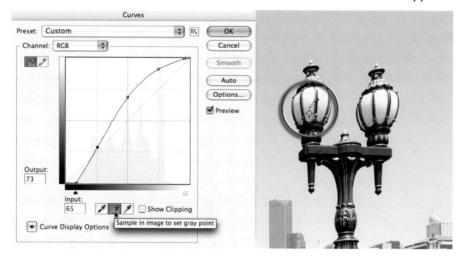

The quick alternative for color correction is to click on the center eyedropper below the histogram window. If you leave the cursor over this icon momentarily you will see the advice 'Sample in image to set gray point'. Move your mouse cursor out into the image window and locate the Color Sample target you created in Step 3. Click on this target to color balance your image. Select OK in the Curves dialog box to apply theses changes to your image.

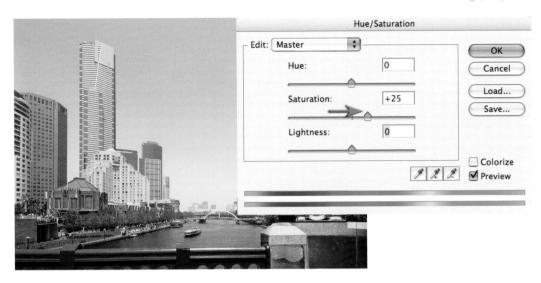

7. We have adjusted the hue and brightness of the pixels in this image but we have not yet had any control over the saturation values. An overall increase in saturation has occurred since we started editing this image due to the fact that we have increased the contrast (saturation increases as contrast increases). We need to open a Hue/Saturation adjustment layer in order to have precise control over this element of the corrective process. In the Hue/Saturation dialog box move the Saturation slider until the colors appear vibrant but realistic (a subjective decision). As the saturation increases the image appears to be sunnier.

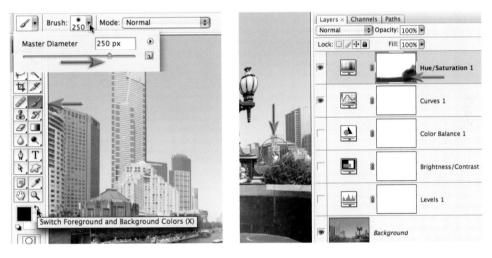

8. Some of the colors in the foreground and on the right side of the image have higher saturation values so they should be reduced to balance the image. This requires a localized adjustment by masking some of the effects of this adjustment layer. Select the Brush Tool from the Tools palette. Choose a large soft-edged brush and lower the opacity of the brush to 50% in the Options bar. Paint over any colors in the main image window that appear too saturated. Note how the layer mask in the Layers palette indicates which parts of the image are being shielded from the Hue/Saturation adjustment layer.

Selective color

Selecting a specific color in the Hue/Saturation dialog box is useful for controlling the saturation over a limited range of colors. Moving the mouse cursor into the image window and clicking on a specific color will fine-tune the color range that is adjusted. The Lightness slider has limited use in this dialog box as it introduces gray into the mix and always desaturates the targeted colors. If you need to darken a color slightly try using a Selective Color adjustment layer and raise the Black slider after first choosing the target color.

Scott Hirko (www.iStockphoto.com)

Colorize

The Hue/Saturation can quickly change all colors of one hue to another. If you want to change all of the colors to the same color, or add color to a gray tone, you must select the Colorize option in the Hue/Saturation dialog box. In the example above the studio backdrop and the color of the bike have been changed to suit the design objective.

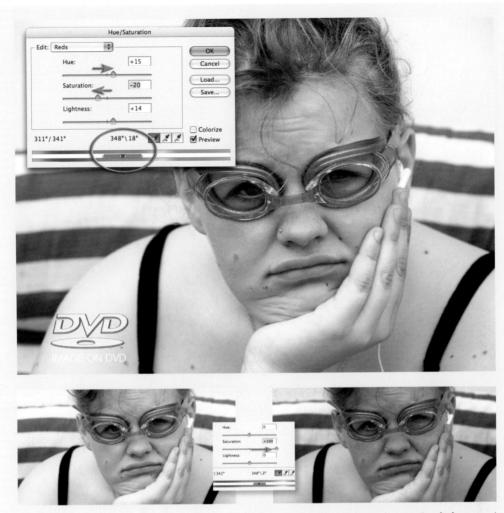

Tina Lorien (www.iStockphoto.com)

Adjusting narrow ranges of color

The Hue/Saturation adjustment feature can perform some truly remarkable adjustments. It is capable of targeting a very narrow range of color values and then adjusting them to match other colors within the image. In the example above the sunburn is targeted and then matched with the surrounding skin colors. To achieve this level of control the user must first select the broad color range that the color belongs to from the Edit menu inside the Hue/Saturation dialog box, e.g. reds, yellows, greens, cyans, etc. By clicking and dragging the sliders that sit between the two color ramps (at the base of the dialog box) closer together, or by using the 'Add to Sample' or 'Subtract from Sample' eyedroppers, the precise colors can be targeted. Moving the Saturation slider temporarily to -100 or +100 can help determine when the target colors have been isolated from their neighboring colors of a similar hue. When this has been achieved the Saturation slider is returned to 0 before moving the Hue slider to achieve the required match. Some fine-tuning using the Saturation and Lightness sliders will usually be required before the match is perfect.

9. The color corrections that were carried out in Steps 3 and 6 render neutral colors completely neutral. It is sometimes a requirement that colors are not neutral at all but rendered cool or warm depending on the mood that is required, e.g. the cool tones of winter or the warm tones of summer. With this in mind Photoshop gives us another way of adjusting the color of our images. The adjustment feature called Photo Filter has less control than Curves, or even Color Balance, but it has similarities with the way some photographers have traditionally used filters to adjust color at the time of capture. A warming or cooling filter can be selected (the numbers refer to glass filter equivalents that were attached directly to the camera lens) and the strength of the effect is controlled by the Density slider. To give this image a late afternoon feel (the image was actually captured just before noon) select an 85 Warming filter and set the density to 15%.

10. In order to optimize the image for print it is useful to assign two more color sample targets to the image so that we can optimize the image for the print. Double-click the Curves adjustment layer icon to re-open the Curves dialog box (make sure it is the icon you click and not somewhere else on the adjustment layer). Check the Show Clipping checkbox again. Drag the black adjustment point along the floor of the Curves window until you see the first patches of shadow tone appear. Move the cursor into the image window and hold down the Shift and Option/Alt key, and click to add one more Color Sample target to the file.

 $1\,1$. Click and drag the White adjustment point to the left until you see the first patches of highlight tone appear in the image window that are not specular highlights (specular highlights do not have an texture or detail). Shift + Option/Alt-click to assign a third Color Sample target to this highlight tone. Now that you have located and sampled the darkest shadow tones and the brightest highlights with detail in the image you can click Cancel in the Curves dialog box (you do NOT want to save the adjustments you have just made). If you click OK you will clip the shadow and highlight detail as a result of the changes you have just made.

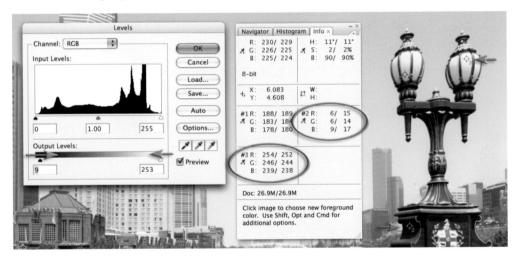

12. In the Layers palette click on the top adjustment layer to make it active and then select a new Levels adjustment layer (this final layer must appear on top of the layers stack). Move the black Output Levels slider underneath the gray ramp to the right whilst observing your #2 target in the Info palette. Move the slider until the second set of values read approximately 15 and then move the white output slider until the values read approximately 245 (adjust these values to suit your own print output requirements). You will need to average these three values as the shadow and highlight tones are not neutral tones. This procedure lowers the contrast of the image to ensure the highlights and shadow tones print with full detail. The visibility of this final adjustment layer can be switched off when the image is being viewed on screen and should also be renamed as a print target layer to prevent possible confusion later (double-click on the layer name).

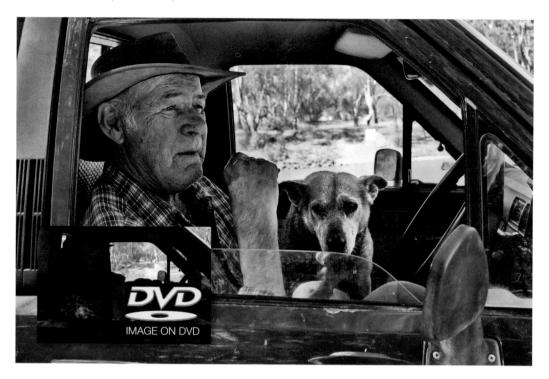

Shadow/Highlight - Project 3

The Shadow/Highlight adjustment feature is one of the most useful and powerful of all the adjustment features, but it has never been available as an adjustment layer. The adjustment can now be applied as a Smart Filter however (even though the adjustment does not live in the Filter menu). The strength of this adjustment feature lies in its ability to quickly, and gently, nudge tones that are too dark or too light to print or aggressively raise shadow brightness or lower highlight brightness while adding localized contrast to these tonal regions. The Curves adjustment feature is unable to compete with the Shadow/Highlight's ability to inject localized contrast into the modified tonal areas. For shadow recovery it is a little like a post-production version of fill-flash.

This project uses an image where the shadow tones have been greatly underexposed in camera (in order to preserve the highlight tones outside of the car window). Although the final quality of these rescued shadow tones will never be as good as if the exposure had been raised in camera, the project does illustrate the usefulness of this adjustment feature, especially where the photographer is unwilling or unable to add additional lighting to the image at the time of capture. When opening up shadow tones to this extent the photographer needs to be aware of possible problems with noise and/or tonal banding (steps of tone rather than smooth transitions). This project will also explore the use of localized color corrections and localized tonal corrections using a 'Dodge and Burn' layer (instead of using the Dodge and Burn tools from the Tools palette directly to an image layer). The project will utilize adjustment layers and Smart Filters (avoiding working on the pixels themselves) to achieve the goal of editing non-destructively.

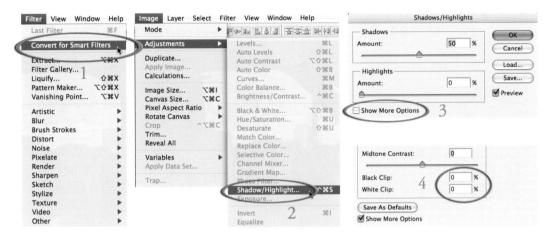

1. To prepare the image for the Shadow/Highlight adjustment we need to convert the background layer for Smart Filters (Filter > Convert for Smart Filters) and then select Shadow/Highlight from Image > Adjustments > Shadow/Highlight. When the Shadow/Highlight dialog box opens check the 'Show More Options' box to expand the dialog box. Enter 0 in the Black Clip and White Clip fields at the base of the dialog box so that the white and black points are left untouched. The default values are useful if you have not previously set the levels of your image.

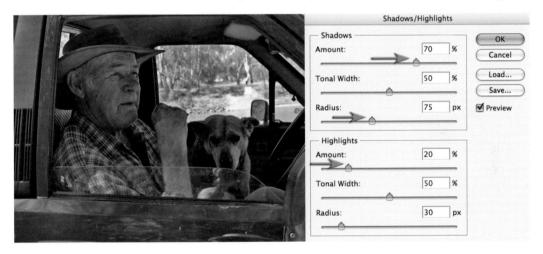

2. Raise the Amount slider in the Shadows section of the dialog box to around 70% to lighten the shadows. Leave the Tonal Width slider at 50% so that any tones darker than level 128 will come under the influence of the Amount slider above. The Radius slider controls the localized contrast in these shadows. If this slider is moved to the left or right you should notice how the contrast or lighting in these shadows appears to change. The precise value for this slider is very subjective and is determined only by the appearance of the shadow tones. In this project the Radius slider is raised to create the best appearance in the skin tones on the man's face. In the Highlights section of the dialog box the Amount slider is raised to lower the brightness of the tones outside the window. Beware of halos surround the dark tones when using this adjustment.

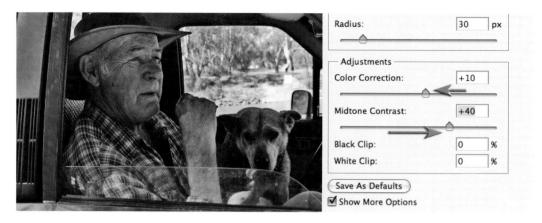

3. Additional contrast can be introduced into the shadow tones by raising the Midtone Contrast slider in the Adjustments section of the dialog box. The Amount slider in the Shadows section of the dialog box should then be raised to +90% to compensate for the tones being rendered darker. As the contrast increases in these midtones the Color Correction slider should be reduced to +10 in order to protect the midtones from excessive saturation. Select OK to apply these Shadow/Highlight changes.

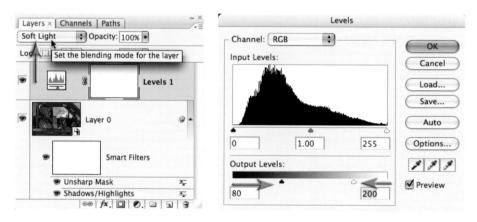

4. Blending modes can also be used to increase contrast. Create a new Levels adjustment layer and select OK without making any changes. Set the mode of this adjustment layer to Soft Light using the menu in the Layers palette. The resulting contrast is a result of the blend mode and not any changes you have made in the adjustment layer dialog box. Open the Levels dialog box by double-clicking the Levels icon on the adjustment layer. To restrict the increase in contrast to just the midtones drag both of the output sliders towards the center of the gray ramp. In this project I have used the output values of 80 and 200 but the precise values have to be fine-tuned for each image you apply this technique to. Select OK to apply the changes. Change the blend mode of this adjustment layer to Overlay to increase the contrast even further.

Note > Holding down the Option/Alt key as you select a new adjustment layer will open the New Layer dialog box. This dialog box will allow you to set the blend mode of the adjustment layer before it opens.

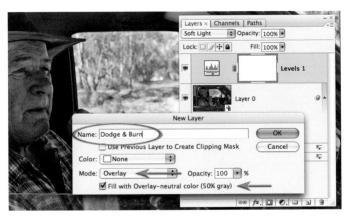

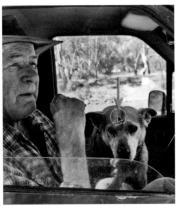

5. Blend modes can be utilized to modify the tonality of the image in other ways. The Dodge and Burn Tools in the Tools palette cannot be used on a layer that has been converted for Smart Filters. Instead of using these tools we can create a Dodge and Burn layer. Hold down the Option/ Alt key and click on the New Layer icon. In the New Layer dialog box choose Overlay as the mode and check the 'Fill with Overlay-neutral color (50% gray)' checkbox. Continue the practice of naming the layers, e.g. 'Dodge & Burn' instead of the default 'Layer 1'. Select OK to create the new layer. 50% gray in Overlay mode has no effect on the underlying pixels (pixels on this layer are effectively invisible when 50% gray). It is only when you lighten or darken pixels on this layer that you will be able to see any difference to the underlying pixels. Select the Brush Tool from the Tools palette and White as the foreground color. Choose a soft-edged brush with an Opacity of 20% from the Options bar. Paint any dark areas that need to be made lighter. Paint over the dog several times until the lightness is balanced with the rest of the image.

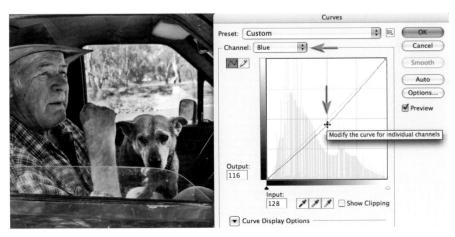

6. Although the dog is now lighter in tones the color will need correcting in this region. Create a new Curves adjustment layer. Select the Blue channel in the Curves dialog box and pull the curve down slightly to increase the yellow in the image. Concentrate your attentions only on the dog as the rest of the image will be masked later. Now go to the Red channel and raise the curve slightly until you have achieved some warmer colors in the coat of the dog. Select OK to apply these changes.

7. From the Edit menu choose Fill and from the Contents section in the Fill dialog box choose Black and then select OK. The keyboard shortcut for filling with the background color (the default color when a mask is selected) is Command + Delete (Mac) or Ctrl + Backspace (PC). The color adjustment has now been totally masked by the fill color. Choose the Brush Tool from the Tools palette and choose White as the foreground color. Select a soft-edged brush and set the opacity to 50%. Painting over the dog will erase some the fill color and slowly reveal the color correction that is required to achieve the correct color balance.

Note > If streaks appear where the brush strokes overlap you can either paint in a continuous action with a higher opacity or many times with a very low opacity.

8. To complete the project you should zoom in to 100% and assess the noise and sharpness levels of the image. The initial underexposure and the subsequent extensive tonal rescue will leave an image where the overall quality has been compromised when compared to an image where the exposure had been optimized for the shadows at the expense of the highlights. Some noise reduction may be required to the image before sharpening takes place (these can be applied as Smart Filters to the base layer – the layer that was converted for Smart Filters) so that the non-image artifacts are not exaggerated excessively. My preference for sharpening would be for the Unsharp Mask rather than Smart Sharpen in this instance. Raising the Threshold slider in the Unsharp Mask dialog box will restrict the sharpening to just the major tonal differences, thus reducing the grainy effect when compared to sharpening carried out by the Smart Sharpen filter.

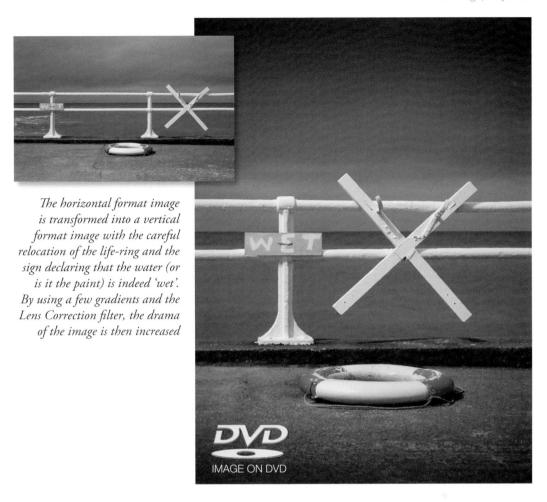

Clone and stamp - Project 4

It has become a common retouching task in image editing to move, remove or replace details within an image to fine-tune the composition or clean the image area so everything is in its right place and there is no superfluous detail to detract from the composition or distract the viewer's attention. In Photoshop CS3 a new palette called Clone Source has appeared. This enables a more controlled approach to copying pixels and painting them into a new location or into a new image. There is also a Stamp Tool in the Vanishing Point dialog box that offers additional features not found in the main workspace of Photoshop. Many photographers never seem to find an appropriate image that requires them to 'edit in perspective' in Vanishing Point and have therefore overlooked the performance features of the Stamp Tool in this editing space.

Vanishing Point may be a highly specialized editing space but the Stamp Tool that resides here can be used for a broader range of retouching activities that have no clearly defined perspective at all. This project is divided into two parts – the first part deals with the features of the Clone Stamp Tool and the Stamp Tool found in Vanishing Point, while Part 2 looks at image enhancement using gradients and the creation of a vignette in the Lens Correction filter.

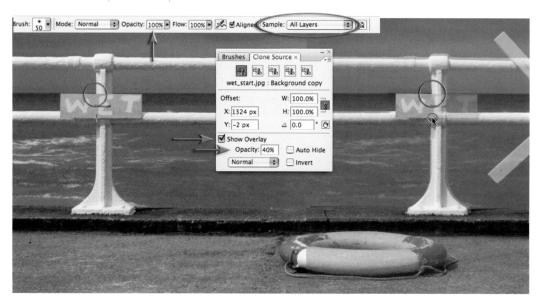

Part 1 - Clone and stamp

1. Open the supporting image and click on the New Layer icon in the Layers palette to create an empty new layer. Click on the Clone Stamp Tool in the Tools palette. Choose a small soft-edged brush from the Options bar and set the Clone Stamp Tool Opacity to 100%. Choose All Layers from the 'Sample' options. Open the Clone Source palette (Window > Clone Source) and check the Show Overlay checkbox and set the overlay Opacity to 40%. Hold down the Option/Alt key and click on the top of the Wet sign where it meets the horizon line. Move the mouse cursor over to the right side of the image and align the two ghosted upright poles (setting the mode to Difference in the Clone Source palette or checking the Invert option may help in the alignment process). When alignment has occurred click and drag to clone the new Wet sign into position. Uncheck the Show Overlay option in the Clone Source palette and assess the results. Although it is now easier to achieve precise alignment between the cloned pixel and the background layer the lack of a healing option makes it difficult to achieve a seamless result (the ocean and sky are slightly different tones).

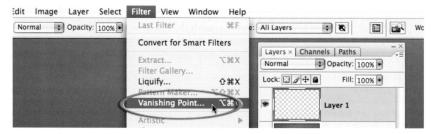

2. Discard Layer 1 in the Layers palette by dragging it to the trash can icon at the base of the Layers palette. Create another new empty layer by clicking on the New Layer icon. All of the modifications will be stamped into this layer, leaving the background layer unaffected. Go to the Filter menu and choose 'Vanishing Point'. Be prepared for a short wait while Photoshop opens the image into the Vanishing Point dialog box.

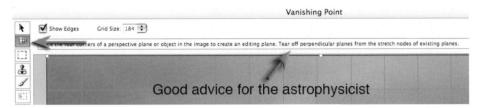

3. When the dialog box opens, Vanishing Point tries to be really helpful by giving you advice as to what to do next – sound advice that we will now ignore (unless of course you would like to 'tear off your perpendicular planes from the stretch nodes of existing planes'). What I would like you to do instead is to simply double-click the second icon from the top in the left-hand corner of the dialog box (the Create Plane Tool). This completely ignores Adobe's invitation to locate any planes of perspective (parallel lines that converge as they recede into the distance – a particularly rare animal in natural landscape and portrait photography) and instead just drops a nice blue grid over your entire image. This blue grid serves absolutely no purpose in this project – but is of course an essential step before Adobe will allow us to utilize the Stamp Tool.

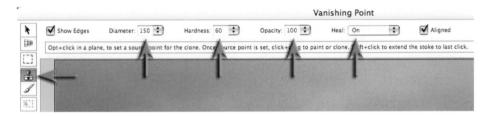

4. Now select the Stamp Tool in the Vanishing Point dialog box. Set the Opacity of the tool to 100% and switch the Heal option to 'On' or 'Luminosity'. Reduce the Hardness of the brush to around 60 and then increase the diameter of the brush to around 150.

Note > If the complex process of creating the 'planes of perspective' on your first visit to Vanishing Point seemed more trouble than it is was worth then you probably missed the significant difference between the seemingly identical Stamp Tool in Vanishing Point and the our old friend that resides in the Tools palette of the main editing space. On closer inspection they are not the same animal at all, for when you choose a brush size and hardness for the Stamp Tool in Vanishing Point and then choose a source point for the pixels you wish to clone (copy and paint to another area in the image) the brush displays the pixels that you will paint with rather than an overlay. The essential ingredient that enables us to achieve success when using the Stamp Tool is the fact that it adopts the behavior of the healing brush. The luminosity or healing options in the Options bar within the dialog box enable the cloned pixels to achieve a seamless blend with the surrounding pixels. This is achieved when the tool draws in the hue and luminosity values of the surrounding pixels (or just the luminosity values as is the case with the Luminosity option) into the feathered edge of the brush you are using. The softer the brush the broader the area of healing that occurs, but this may also increase the risk of drawing in adjacent values of an inappropriate value. Care must be taken to adapt the brush size and hardness to the area you are cloning into.

5. Alt/Option-click on the horizon line where it meets the upright pole, just above the sign 'wet', to select a source point for the pixels you wish to clone. Now move over to the vertical pole on the right side of the image and click on the similar intersection point where the horizon line meets the pole. Hold down the mouse clicker as you paint, stamp or clone just enough pixels to reveal the sign and its shadow into its new location.

Note > Choosing a precise intersection of horizontal and vertical lines as your initial source point is critical when attempting to clone pixels into another area of the image that shares these strong geometric lines.

6. Turn your attention to cloning the life-ring when the sign has been relocated. To prevent the horizontal edge above the life-ring being cloned out of alignment it will be necessary to reduce the size of the brush and increase its hardness to 80%.

7. Increase the size of the brush and decrease the hardness once again before selecting a new source point from the foreground concrete to the left of the life-ring. Proceed to remove the original life-ring from the image. If the left side of the original life ring starts to reappear when attempting to remove the life-ring try selecting a source point further over to the left side of the image. When the original life-ring has been successfully removed click OK to apply the changes made by the Stamp Tool. You will notice that all of your changes now appear in the new layer you created before using Vanishing Point and can be removed if you are not entirely happy by simply switching off the layer visibility. With the changes isolated to their own layer you also have the option to erase or mask just a few of the changes that are not entirely convincing.

Part 2 - Gradients and vignettes

8. Select the Gradient Tool from the Tools palette and choose the Foreground Transparent and Linear gradient options from the Options bar. Hold down the Alt key and sample an area of the blue cloud cover to select this as your foreground color. Before creating your gradient add a new layer by clicking on the New Layer icon in the Layers palette and set the blend mode of this layer to Multiply. Now proceed to drag a gradient from the top of the image to a position just above the top railing. Holding down the Shift key as you drag the gradient will ensure the gradient is constrained to a perfect vertical.

9. Sample a new color from the concrete in the foreground and add a second gradient into this layer.

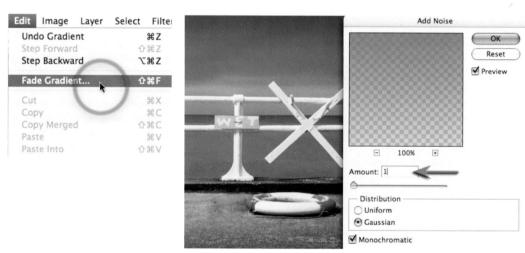

10. If you would like to reduce the effect of this second gradient without altering the effect of the first gradient you can proceed directly to the Edit menu and choose 'Fade Gradient'. To prevent any banding (visible steps of tone) appearing in the area of the gradient it is advisable to add a small amount of noise to this gradient layer. Go to the Filter menu and choose Add Noise from the Noise submenu: 1 or 2% noise using the Gaussian and Monochromatic options selected will usually prevent any banding issues on screen or in print.

Note > The Fade option is available for any filter or painting tool that you may have used but it is only available if it is the first step you take after the filter or painting action has been applied. Even the act of deselecting a selection will render the Fade option unavailable.

 $1\,1$. Duplicate your master PSD file (Image > Duplicate) and then crop your image to its new vertical format. When cropping I prefer to switch my shield color in the Options bar to white and reduce the opacity to 50% (you can take this action only after you have first dragged out a crop marquee). I find this gives me a better idea of the new composition when cropping rather than using the default option of Black at 75% opacity.

12. Create a new layer, fill it with white (Edit > Fill) and set the blend mode of the layer to Multiply. Now choose 'Lens Correction' from the Distort submenu. The vignette option in Lens Correction is designed to eliminate vignetting that may occur with some wide-angle lenses while shooting at wide apertures, but it is equally adept at adding vignettes for creative purposes.

Note > White is a neutral color in Multiply mode so the effects of this layer will be invisible until we darken the corners.

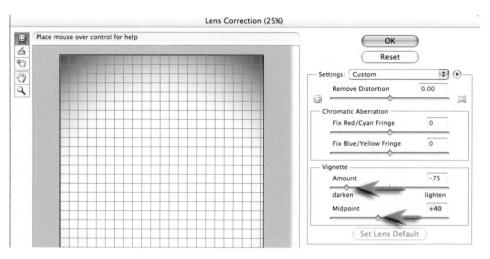

13. Reduce the Amount and Midpoint sliders in the Lens Correction dialog box to create the vignette you are looking for. Click OK when you are done. An advantage to using the Lens Correction filter to add a vignette as opposed to other techniques is that this process can be included as part of an automated 'action' that can be applied on a range of different resolution files, i.e. it requires no radius value for either a feather or mask.

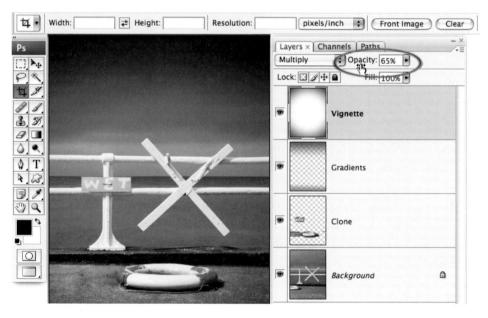

14. Reduce the opacity of the vignette layer until you strike the appropriate amount of drama in the image and then you are pretty much done. You will probably want to complete the project by merging all of the visible elements of the project to a new layer (hold down the Ctrl + Alt + Shift keys and then type the letter E) and then applying the Unsharp Mask or Smart Sharpen filter.

Note > Converting the background layer to a smart object and applying the sharpening as a smart filter will not sharpen the sign and life-ring which have been placed on another layer.

Clone or Heal

When cleaning an image of superfluous detail the question often arises as to which is the best tool for the job. When working in broad areas of texture to remove small blemishes the Spot Healing Brush Tool is hard to beat for speed and ease of use. As the areas requiring removal get larger, switching to the Healing Brush and nominating a texture avoids the errors that occur when using the Spot Healing Brush for this task. The limitations of the Healing Brush (and Spot Healing Brush) become apparent when working up against tones or colors that are markedly different to the area being cleaned. The Healing process draws luminance and color values from the surrounding area and when these colors are very different they contaminate the area to be healed. Problems can often be avoided in these instances by either using a harder brush or making a selection that excludes the neighboring tones that are different. When working up against a sharp edge even these actions may not be enough to avoid contamination — this is the time to switch to the Clone Stamp Tool. A selection will help to contain the repair while the Clone Source palette or Stamp Tool in Vanishing Point will help to align edges so that the repair is seamless.

Advanced sharpening techniques - Project 5

Most, if not all, digital images require sharpening – even if shot on a state-of-the-art digital mega-resolution SLR with pin-sharp focusing. Most cameras or scanners can sharpen as the image is captured but the highest quality sharpening is to be found in the image-editing software. Sharpening in the image-editing software will allow you to select the precise amount of sharpening and the areas of the image that require sharpening most. When you are sharpening for the screen, it is very much a case of 'what you see is what you get'. For images destined for print, however, the monitor preview is just that – a preview. The actual amount of sharpening required for optimum image quality is usually a little more than looks comfortable on screen – especially when using a TFT monitor (flat panel).

The basic concept of sharpening is to send the Unsharp Mask filter or Smart Sharpen filter on a 'seek and manipulate' mission. These filters are programmed to make the pixels on the lighter side of any edge they find lighter still, and the pixels on the darker side of the edge darker. Think of it as a localized contrast control. Too much and people in your images start to look radioactive (they glow), not enough and the viewers of your images start reaching for the reading glasses they might not own. The best sharpening techniques to use with sharpening filters are those that prioritize the important areas for sharpening and leave the smoother areas of the image well alone, e.g. sharpening the eyes of a portrait but avoiding the skin texture. These advanced techniques are essential when sharpening images that have been scanned from film or have excessive noise, neither of which will benefit from a simple application of the Unsharp Mask filter. So let the project begin.

Note > If you have any sharpening options in your capture device it is important to switch them off or set them to minimum or low (if using camera RAW set the sharpening amount to 0). The sharpening features found in most capture devices are often very crude when compared to the following technique. It is also not advisable to sharpen images that have been saved as JPEG files using high compression/low quality settings. The sharpening process that follows should also come at the end of the editing process, i.e. adjust the color and tonality of the image before starting this advanced sharpening technique. Reduce the levels of sharpening later if it proves too much.

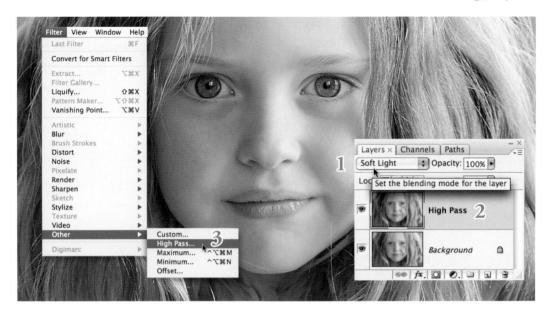

Technique one - High Pass

1. Duplicate the background layer and set the blend mode to Soft Light from the blend modes menu in the Layers palette. Change the name of this layer to High Pass. Go to Filter > Other > High Pass.

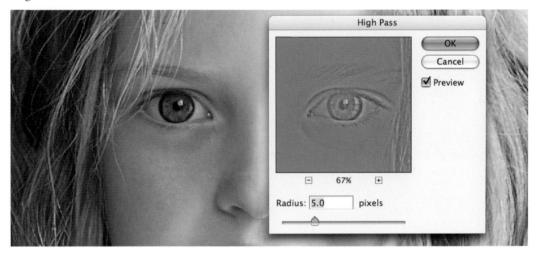

2. Choose a 5.0 pixels Radius for this project. A pixel radius between 1.0 and 5.0 would be considered normal if you were not going to proceed beyond Step 4 in this project.

Note > Use lower Radius values when printing to Gloss paper and higher values if printing to Matte paper. To adjust the level of sharpening later you can either lower the opacity of the High Pass layer (to decrease the amount of sharpening) or set the blend mode of the 'High Pass' layer to 'Overlay' or 'Hard Light' (to increase the level of sharpening).

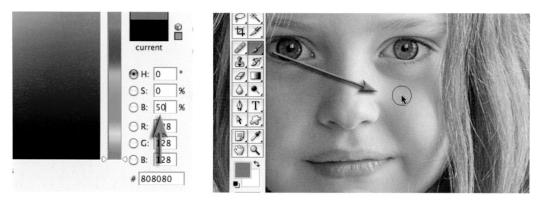

3. Click on the foreground color swatch in the Tools palette to open the Color Picker. Enter 0 in the Hue and Saturation fields and 50% in the Brightness field to choose a midtone gray. Select OK. Paint the High Pass layer to remove any sharpening that is not required, e.g. skin tones, skies, etc. This technique is especially useful for limiting the visual appearance of noise or film grain. Turn off the background layer momentarily to observe any areas you may have missed.

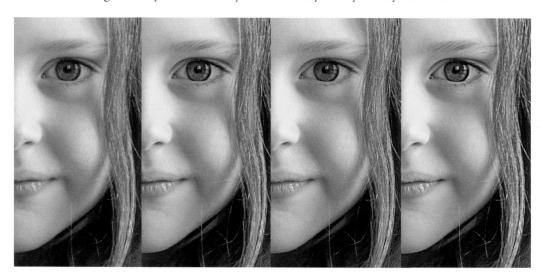

Detail from a portrait captured on a Nikon D1x. The RAW image was processed with 15% sharpening. First test has no subsequent sharpening. Second test uses a High Pass layer (3 pixel radius) in Soft Light mode. Third test has had the blend mode of the High Pass layer changed to Overlay mode. Fourth test has sharpening via a localized Unsharp Mask (100%) in Luminosity mode. The Opacity slider could be used to fine-tune the preferred sharpening routine

4. Remember at this point the settings you have selected are being viewed on a monitor as a preview of the actual print. To complete the process it is important to print the image and then decide whether the image could stand additional sharpening or whether the amount used was excessive. If the settings are excessive you can choose to lower the opacity of the 'High Pass' layer.

Saturation and sharpening

Most techniques to increase the contrast of an image will also have a knock-on effect of increasing color saturation. As the High Pass and Unsharp Mask filters both increase local contrast there is an additional technique if this increased color saturation becomes problematic. You may not notice this in general image editing, but if you become aware of color fringing after applying the High Pass technique you should consider the following technique to limit its effects.

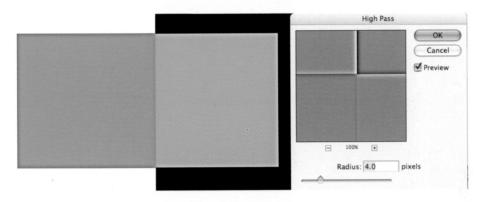

Technique two - Unsharp Mask/Smart Sharpen

The second technique is a continuation of the first technique and is intended to address the issues of increased saturation leading to the effect of color fringing. If a merged layer is used as the sharpening layer (as in Project 3) and this layer is then changed to Luminosity blend mode the effects of saturation are removed from the contrast equation. This second technique looks at how the benefits of localized sharpening and Luminosity sharpening can be combined.

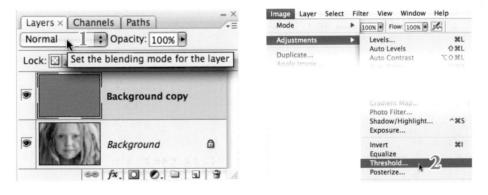

5. Change the blend mode of the High Pass layer back to Normal mode. Then apply a Threshold adjustment to the High Pass layer. Go to Image > Adjustments > Threshold.

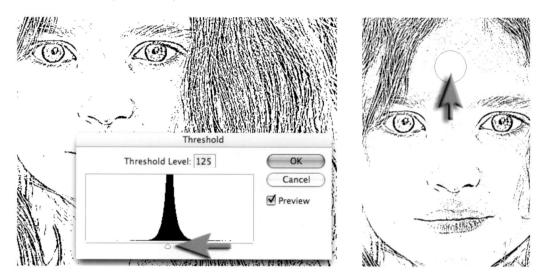

6. Drag the slider just below the histogram to isolate the edges that require sharpening. The aim of moving these sliders is to render all of those areas you do not want to sharpen white. Select 'OK' when you are done. Paint out, with a white brush, any black pixel areas that you do not want sharpened, e.g. in the portrait used in this example any pixels remaining in the skin away from the eyes, mouth and nose were painted over using the Paintbrush Tool with white selected as the foreground color.

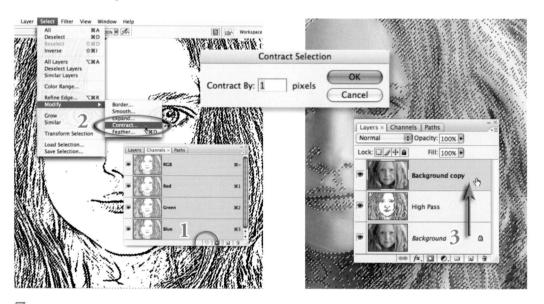

7. Go to the Channels palette and either Ctrl-click (PC) or Command-click (Mac) the RGB thumbnail or click on the 'Load channel as selection' icon from the base of the Channels palette to load the edge detail as a selection. Go to Select > Modify > Contract. Enter 1 pixel in the Contract dialog box and select OK. Return to the Layers palette and drag the background layer to the New Layer icon to make a background copy layer. Drag this background copy layer to the top of the layers stack.

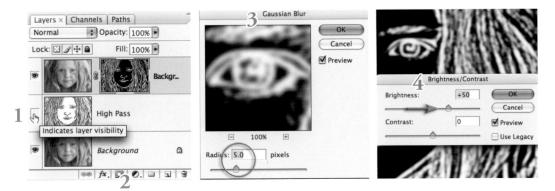

8. Switch off the visibility of the High Pass layer. Hold down the Alt or Option key and click on the 'Add layer mask' icon in the Layers palette. **Click on the layer mask thumbnail** to make sure this is the active part of the layer and then go to Filter > Blur > Gaussian Blur. Apply a 5-pixel radius blur to the mask and then go to Image > Adjustments > Brightness/Contrast and apply +50 Brightness adjustment to the layer mask. The mask is now softer and brighter.

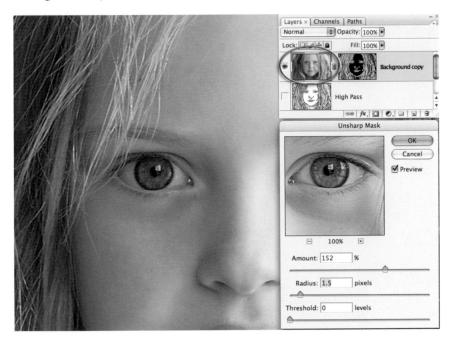

9. Now **click on the image thumbnail on the top layer (background copy)**. Ensure the image is zoomed in to 100% for a small image or 50% for a larger print resolution image (200–300 ppi). Go to 'Filter > Sharpen > Smart Sharpen or Unsharp Mask'. Adjust the 'Amount' slider to between 80 and 150%. This controls how much darker or lighter the pixels at the edges are rendered. Choose an amount slightly more than looks comfortable on screen if the image is destined for print rather than screen.

Note > See Capture and Enhance for basic settings of the Unsharp Mask filter. The exact Threshold and Radius settings are not so critical for this advanced technique.

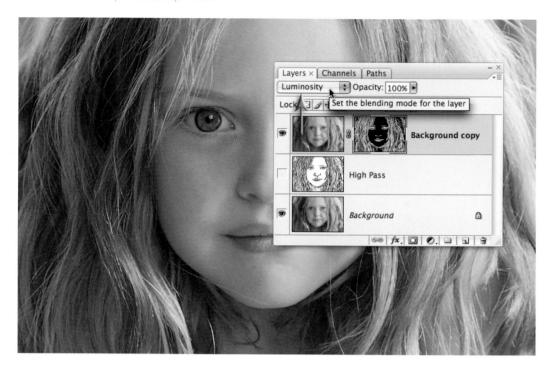

10. Change the blend mode of the sharpening layer (the uppermost layer) to Luminosity mode. Luminosity mode will restrict the contrast changes to brightness only, and will remove any changes in saturation that have occurred due to the use of the Unsharp Mask. The changes are often very subtle but this technique is recommended for all images and is a fast alternative to a technique that advocates changing the mode of the image to Lab and then sharpening the L channel only (L for Luminosity).

Darkened edge exhibits increased saturation prior to changing the blend mode to Luminosity

The illustration above is a magnified view of the effects of changing the blend to Luminosity. These two cutting-edge techniques are capable of producing razor sharp images that will really put the finishing touches to a folio quality image.

The Lens Correction filter can only correct converging verticals to a certain extent before excessive distortion enters the image. This amusement park was captured at nearly point blank range with a 12mm extreme wide-angle lens on a Nikon D200 and then optimized using the techniques outlined in this chapter

Combined techniques from Projects 1 and 5 of the Advanced Retouching chapter. Localized contrast and sharpening techniques are introduced from Projects 3 and 5 of the Retouching Projects chapter

advanced retouching

photo

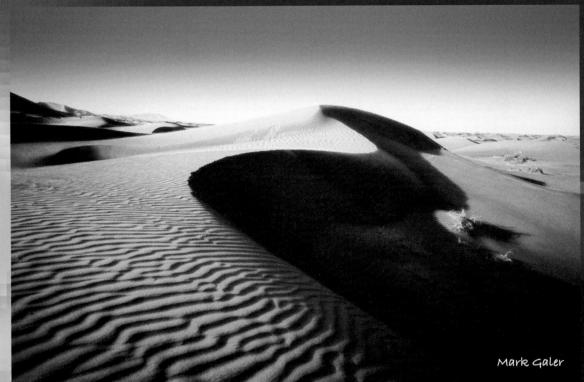

photo

essential skills

hop

- ~ Create a monochrome or black and white image from an RGB master.
- ~ Create a toned image using a 'Gradient Map'.
- ~ Create an image with reduced depth of field.
- ~ Use Smart Objects to balance the lighting within a scene.
- ~ Create smooth tone to subdue superfluous detail.
- ~ Create a mirror reflection, add morning mist and change the time of day.

Black and white - Project 1

When color film arrived over half a century ago the pundits who presumed that black and white film would die a quick death were surprisingly mistaken. Color is all very nice but sometimes the rich tonal qualities that we can see in the work of the photographic artists are something certainly to be savored. Can you imagine an Ansel Adams masterpiece in color? If you can – read no further.

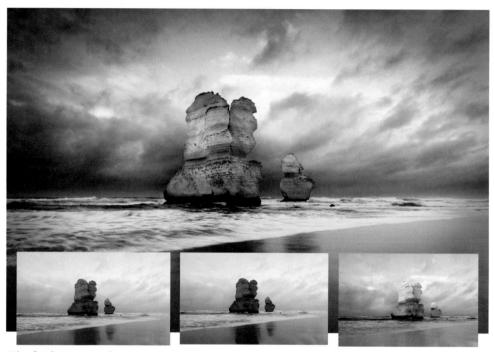

The final image in this project (main image) together with the original color, desaturated version and the result of processing the image using the Black and White adjustment feature

Creating fabulous black and white photographs from your color images is a little more complicated than hitting the 'Convert to Grayscale mode' or 'Desaturate' buttons in your image-editing software (or worse still, your camera). Ask any professional photographer who has been raised on the medium and you will discover that crafting tonally rich images requires both a carefully chosen color filter during the capture stage and some dodging and burning in the darkroom. Color filters for black and white? Now there is an interesting concept! Well as strange as it may seem, screwing on a color filter for capturing images on black and white film has traditionally been an essential ingredient to the recipe for success. The most popular color filter in the black and white photographer's kit bag, that is used for the most dramatic effect, is the 'red filter'. The effect of the red filter is to lighten all things that are red and darken all things that are not red in the original scene. The result is a print with considerable tonal differences compared to an image shot without a filter. Is this a big deal? Well yes it is – blue skies are darkened and skin blemishes are lightened. That's a winning combination for most landscape and portrait photographers wanting to create black and white masterpieces.

Note > The more conservative photographers of old (those not big on drama) would typically invest in a yellow or orange filter rather than the 'full-on' effects that the red filter offers.

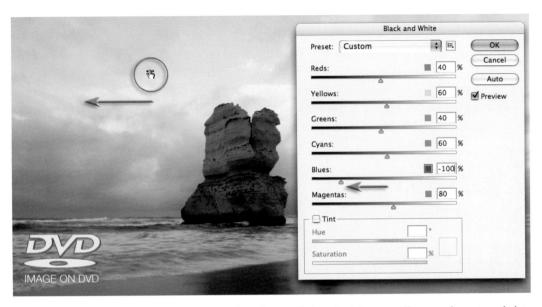

The Black and White adjustment offers a quick and controlled method for controlling tonality – just click in the main image window and drag left or right to darken or lighten the tonal value of this color range

Now just before you run out to purchase your red filter and 'Grayscale image sensor' you should be reminded that neither is required by the digital shooter with access to Photoshop. Shooting digitally in RGB (red, green, blue) means that you have already shot the same image using the three different filters. If you were to selectively favor the goodies in the red channel, above those to be found in the green or blue channels, you would, in effect, be creating a Grayscale image that would appear as if it had been shot using the red filter from the 'good old days'. You can see the different tonal information by using the 'Channels palette' to view the individual channels (turn off the visibility of all but one channel). Then you can selectively control the information using the fabulous new Black and White adjustment layer feature (also available from the main Image > Adjustments menu). This new adjustment feature is probably the easiest and most versatile way to convert images to black and white. No more juggling sliders in Channel Mixer to prevent clipping and no clever techniques (such as Russel Brown's dual Hue/Saturation layers technique) to implement this process. The adjustment feature is a breeze to use and very versatile. You can use the color sliders if you like or simply click on a color within the image window and drag to the right to make the color lighter, or to the left to make it darker. How easy is that! In fact, this technique is so easy to use it hardly warrants a project to master the technique. The adjustment feature does, however, have its limitations. Try creating the effect seen in the main image on the previous page using the Black and White adjustment feature from the Layers palette and you will quickly appreciate that the Black and White adjustment feature has its limitations. Dragging the sliders to their extreme values in the Black and White adjustment feature can introduce image artifacts and halos around adjusted colors and the image adjustment feature has no contrast adjustment within the dialog box. Total control over tonality still requires some additional and essential skills using the information from the individual channels in conjunction with the contrast blend modes such as Overlay and Soft Light. The skill of controlled black and white conversions also underpins most of the color toning projects that follow.

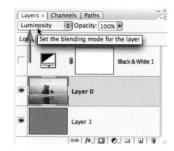

1. Keep the Black and White adjustment layer (described on the previous page) in place but switch off its visibility by clicking on the eye icon to the left of the layer in the Layers palette. Double-click on the background layer to open the New Layer dialog box and select 'OK' to convert this layer to an unlocked and editable Layer 0. Hold down the Ctrl key (PC) or Command key (Mac) and then click on the New Layer icon to create a new empty layer below Layer 0. From the Edit menu choose Fill and then select 50% Gray from the contents menu of the Fill dialog box before selecting OK. Change the blend mode of Layer 0 to Luminosity.

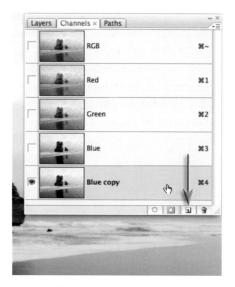

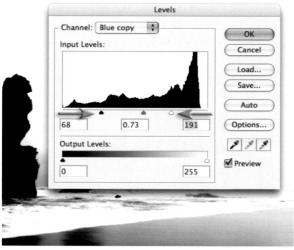

2. Turn off the visibility of Layer 1 (the 50% gray layer). Open the Channels palette and click on the Blue channel. Note how this channel offers the best contrast between the sky and the rocks (blue sky will be lighter in the Blue channel and opposite colors, such as the yellow rocks, will be darker in the Blue channel). We can use this channel to create a quick and effective mask for this project. This mask will allow us to work on the sky and the foreground separately to achieve optimum tonality and contrast in both areas. This technique is called channel masking and is a commonly used advanced technique for professional retouchers to save time. Drag the Blue channel to the New Channel icon to copy it. From the Image > Adjustments submenu choose 'Levels'. Drag the shadow slider in the Levels dialog box to the right until the dark rocks are mostly black. Drag the highlight slider to the left until the sky is mostly white (you should be left with a few gray clouds just above the horizon line). Click OK to apply the adjustment. Although not perfect, this mask can be optimized in the next step.

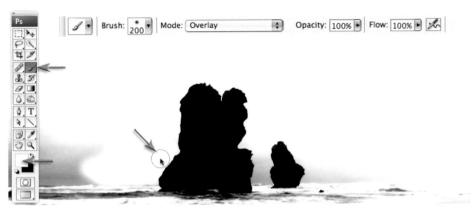

3. Painting in Photoshop is not everybody's flavor of the month. There is, however, a clever Brush technique when masking that makes it a far less painful procedure. Switch the blend mode of the Brush Tool to 'Overlay' in the Options bar and set the foreground and background colors to their default setting in the Tools palette. When you now paint in the layer mask all the gray tones are progressively rendered lighter or darker tones depending whether you are painting with white or black. The magic lies in the fact that black has no effect on the lightest tones and white has no effect on the darkest tones in Overlay mode. Painting with black in the white areas will have no effect. Switching between black and white (press X on the keyboard) and repeating the work in some areas results in a vastly improved mask with very little effort. Switch the mode of the brush back to Normal for final clean-up work in the sky away from the edges of the rocks. There is no need to work on the water or beach at this stage.

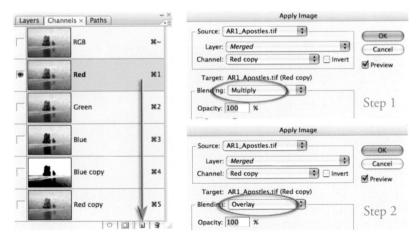

4. Duplicate the Red channel by dragging it to the New Channel icon. This channel offers the best tonal information in the sky but at the moment it lacks contrast. We could use the image adjustments to increase the contrast or we could use the blending options by going to Image > Apply Image. Check that the Red copy channel is selected in the Source section and then choose Multiply from the Blending options in the target section. Select OK and then proceed to select Apply Image a second time. This time choose Overlay as the blending option. This will darken (Multiply) and increase the contrast (Overlay) of the Red channel.

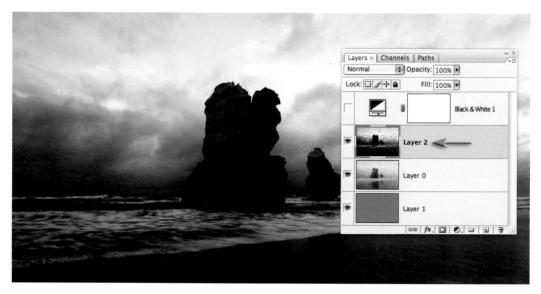

5. To copy the Red copy channel to the clipboard, choose All from the Select menu (Ctrl/Command + A) and then Copy from the Edit menu (Ctrl/Command + C). Open the Layers palette, select Layer 0 and create a new layer by choosing Paste from the Edit menu (Ctrl/Command + V).

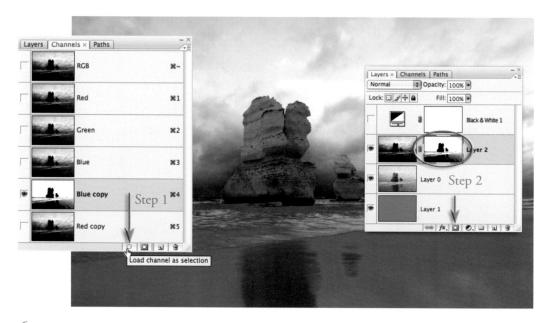

6. Drag the Blue channel to the Load channel as selection icon at the base of the Channels palette. Return to the Layers palette and turn on the visibility of Layer 1 (the 50% gray layer). Click on Layer 2 (the information from your Red copy channel) to make sure it is the active layer. Hold down the Alt/Option key and click on the 'Add layer mask' icon at the base of the Layers palette. The mask will require further work to ensure the modified sky is seamless and the immediate foreground (waves and sand) does not appear a little strange.

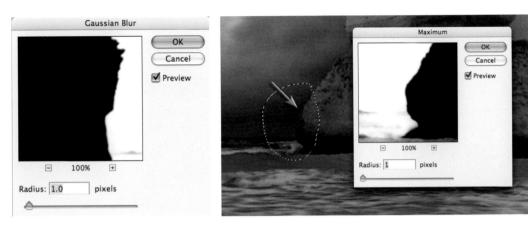

7. Click on the layer mask thumbnail on Layer 2 to make it active and then go to Filter > Blur > Gaussian Blur and apply a 1-pixel blur to soften the edge of the mask a little. Select OK and then zoom in and take a close look around the edges of the rocks. If you notice a halo around any section select that portion using the Lasso Tool. Go to Filter > Other > Maximum. A 1-pixel radius should be sufficient in most cases to remove the halo. Lasso additional areas if required and use the keyboard shortcut to apply the last used filter (Command/Ctrl + F).

Note > If the Maximum filter increases the halo effect when using alternate images, use the Minimum filter instead.

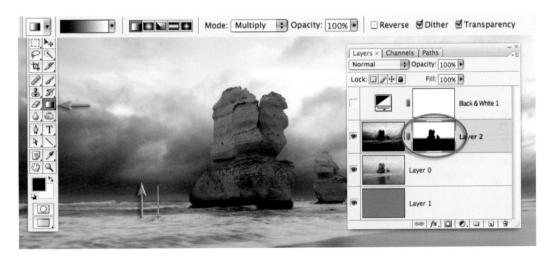

8. As we only require the tonality of the sky on this layer we will need to mask the water and beach using the Gradient Tool from the Tools palette. Choose the Black, White gradient and the Linear options and set the Opacity to 100% in the Options bar. Set the Mode to Multiply to add information rather than replace information in the layer mask. Drag a short gradient from just below the horizon line to just above the horizon line to mask the foreground.

Note > An alternative to the Black, White gradient in Multiply mode is to set the Foreground color to Black and then use the Foreground to Transparent gradient in Normal mode.

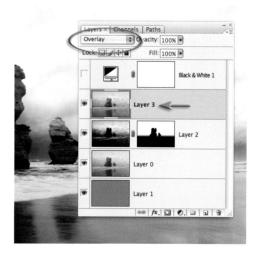

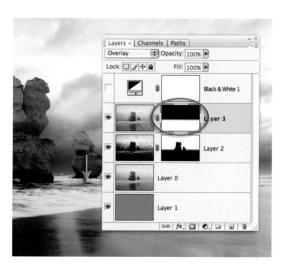

9. This step will add contrast to the waves and beach. Choose Select > All, then Edit > Copy Merged and then Edit > Paste. These three commands can be combined into a single command which is commonly referred to as Stamp Visible by professional retouchers. This command has an unlisted shortcut which is to hit the letter E while holding down the Ctrl + Alt + Shift keys (PC) or Command + Option + Shift keys (Mac). This will create a copy of what you see on the screen and paste it as a new layer. Switch the blend mode of this layer to Overlay and then add a layer mask. Add a short Black to White gradient to this mask from just above the horizon line to just below the horizon line.

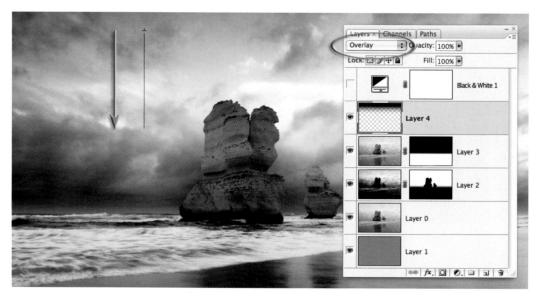

10. This step will darken the sky at the top of the image. Click on the New Layer icon at the base of the Layers palette and set the mode to Overlay. Choose Black as the Foreground color and select a Foreground to Transparent gradient. Drag a gradient from the top of the image to a position halfway to the horizon line. Adjust the opacity of the layer if you would like to reduce the effect.

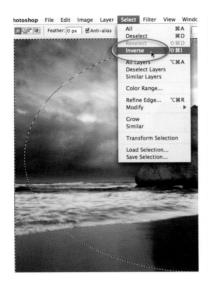

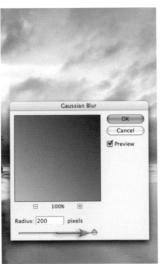

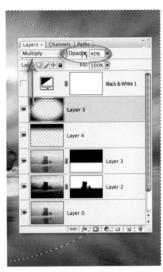

 $1\,1$. This step will create a subtle vignette that is designed to darken the corners of the image and increase the drama even further. Add another new layer and set the mode to Multiply. Select the Elliptical Marquee Tool from the Tools palette (behind the Rectangular Marquee Tool). Drag a selection from the top-left corner to the bottom-right corner of the image. Choose Inverse from the Select menu. Press the Q key to turn this selection into a 'Quick Mask'. Go to Filter > Blur > Gaussian Blur and apply a 200-pixel blur to this mask. Press Q on the keyboard to return to the selection. Be sure the foreground color is set to black and fill the selection with black using the keyboard shortcut Alt + Backspace (PC) or Option + Delete (Mac). Lower the opacity of the layer to around 40%. Finally, don't forget to choose Select > Deselect before going on to the next step.

12. Create a 'dodge and burn' layer (create a new layer and fill with 50% gray and then set the mode to Overlay). Select the Brush Tool from the Tools palette and then choose a soft-edged brush, Opacity 20% and Normal mode from the Options bar. Set the foreground color to white to dodge or black to burn, then paint over the rocks to lighten and increase their localized contrast. Paint several times until you are happy with the effect. It does not matter if the brushwork spills into the background sky. Hold down the Alt/Option key and drag the layer mask from Layer 2 to Layer 5. Holding down the Alt/Option key will copy the mask. Invert this mask using the Invert shortcut Ctrl + I (PC) or Command + I (Mac).

Reintroducing color

The original color can be reintroduced in a way that preserves the tonal values we have just created. Duplicate Layer 0 using the keyboard shortcut Ctrl + J (PC) or Command + J (Mac). Drag this layer to the top of the layers stack and change the mode to Color. Adjust the opacity until an appropriate balance between tonality and color is achieved. The colors on the main rock can be evened out by selecting the Color Replacement Tool from the Tools palette. Using the default settings of this tool hold down the Option/Alt key and sample a saturated color near the top of the rock. Increase the size of the Tool and paint over the rest of the rock to modify the color values. The edge of the brush can overlap the edges of the rock but care must be taken not to move the cross-hair in the center of the cursor over any areas of sky as this will change the color of the sky to yellow. Stamp or merge the visible elements of all layers (including or excluding the color layer) before applying the Smart Sharpen or Unsharp Mask filter. To compare the difference that has been achieved by incorporating blend modes and masking techniques into the mix, turn off the visibility of all of the other layers except Layer 0, set the Mode to Normal and switch the Black and White adjustment layer back on.

Note > The ability to modify color and tonality separately and then reunite them later in the editing process can be a powerful technique for creating information-rich images where luminance values have the priority over color values.

Gradient maps - Project 2

Burning, toning, split-grade printing and printing through your mother's silk stockings are just some of the wonderful, weird and positively wacky techniques used by the traditional masters of the darkroom waiting to be exposed (or ripped off) in this tantalizing digital tutorial designed to pump up the mood and ambience of the flat and downright dull.

Seeing red and feeling blue

It probably comes as no small surprise that 'color' injects images with mood and emotional impact. Photographers, however, frequently work on images that are devoid of color because of the tonal control they are able to achieve in traditional processing and printing techniques. Toning the resulting 'black and white' images keeps the emphasis on the play of light and shade but lets the introduced colors influence the final mood. With the increased sophistication and control that digital image-editing software affords us, we can now explore the 'twilight zone' between color and black and white as never before. The original image has the potential to be more dramatic and carry greater emotional impact through the controlled use of tone and color.

The tonality of the tutorial image destined for the toning table will be given a split personality. The shadows will be gently blurred to add depth and character while the highlights will be lifted and left with full detail for emphasis and focus. Selected colors will then be mapped to the new tonality to establish the final mood.

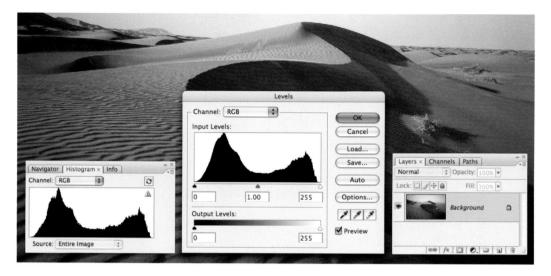

1. Open the project image from the support DVD. Although the Levels have already been optimized for this file the tonality will be adjusted extensively during the following steps. Although none of the steps will cause any of the tones to become clipped in the master image file, some of the shadow tones may need extensive recovery so that they will print with detail. It is recommended that you leave the Histogram palette open for the duration of the project to monitor these tones as you work.

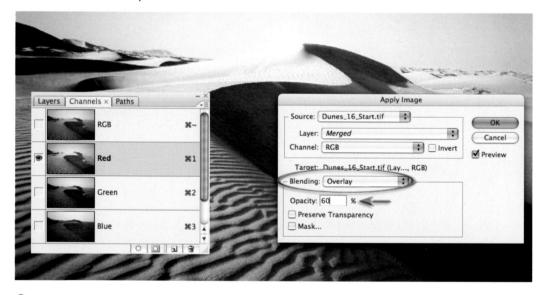

2. This step will create a black and white layer with good contrast above the background layer. Open the project image and select the Red channel in the Channels palette. Go to Select > All and then Edit > Copy. Select the RGB channel and then open the Layers palette and choose 'Paste' from the Edit menu. The information from the Red channel will now appear in its own layer above the background layer. Choose 'Apply Image' from the Image menu and choose 'Overlay' from the blending options in the Apply Image dialog box. Lower the Opacity to 60% and select 'OK'.

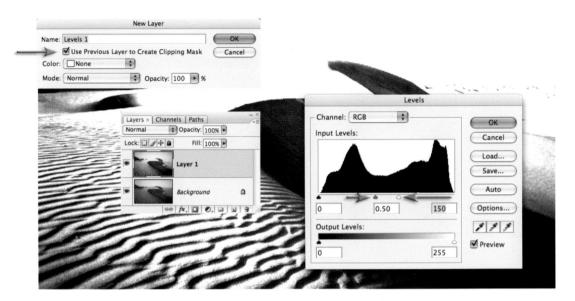

3. Use an 'adjustment layer' to adjust the tonality of this layer. Hold down the Alt/Option key on the keyboard and click on the 'Create new fill or adjustment layer' icon and select Levels. In the 'New Layer' dialog box check the 'Use Previous Layer to Create Clipping Mask' option. Click 'OK' to open the 'Levels' dialog box. Drag the highlight slider to the left until the highlights disappear. Move the 'Gamma' slider (the one in the middle) until you achieve good contrast in the shadows of the image. Select 'OK' to apply the levels adjustment.

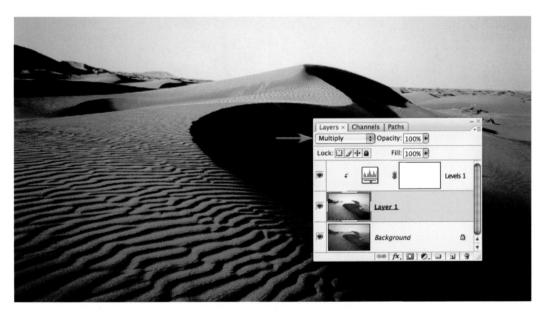

4. In the Layers palette select the black and white layer (not the adjustment layer) and switch the 'mode' of the layer to 'Multiply' to blend these modified shadow tones back into the color image. The image will appear excessively dark but will be corrected in Step 6.

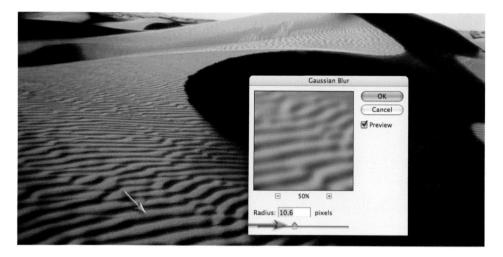

5. With the black and white layer still selected, go to 'Filter > Blur > Gaussian Blur' and increase the 'Radius' to spread and soften the shadow tones. With the Preview on you will be able to see the effect as you raise the amount of blur. Go to 'View > Zoom In' to take a closer look at the effect you are creating. There is no single amount of blur that will suit all images so experiment with alternate values when using images where the size and shape of the shadows are different.

Note > This effect emulates the silk-stocking technique when it is applied to only the high contrast part of the split-grade printing technique made famous by Max Ferguson and digitally remastered in his book *Digital Darkroom Masterclass* (Focal Press).

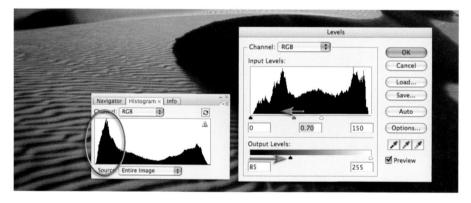

6. Open the Histogram palette and observe how the shadow tones have become compressed towards Level 0 but are not clipped. We need to open up these shadow tones to ensure they print with detail. Reopen the Levels adjustment that you created earlier (note how the histogram only reflects the tones present in the layer it is clipped with and not the overall image). Drag the shadows Output slider to the right (see the illustration to ensure you have the correct slider) to lighten the shadows and the Gamma slider to the left slightly to lighten the midtones if required. Observe the changes to the histogram in the Histogram palette. Use the Info palette if you need to gather feedback about specific shadow values.

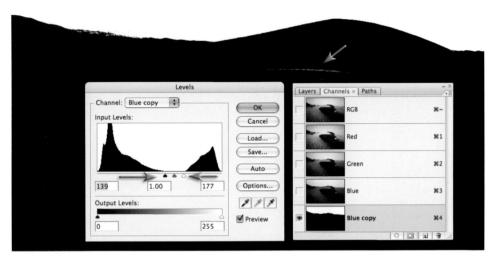

7. Bright areas of tone within the image can be distracting if they are not part of the main subject matter. It is common practice when working in a black and white darkroom to 'burn' the sky darker so that it does not detract the viewer's attention from the main focal point of the image. In the project image the overly bright sky detracts from the beautiful sweep of the dominant sand dune. To darken the sky create a selection using the channel masking technique outlined in the Selections chapter (duplicating the blue channel and increasing the contrast using a Levels adjustment). Fine-tune the mask by switching on the visibility of the alpha channel and the RGB master channel (remember you can change your mask color to a green to contrast better with the dunes). Use a hard-edged brush with the foreground color set to black and paint any areas missed by the channel masking process. Apply a 1.5-pixel Gaussian Blur to the finished mask.

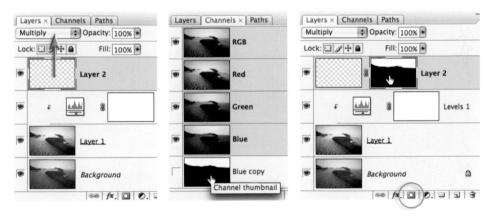

8. Create a new layer for the gradient by clicking on the New Layer icon in the Layers palette and switch the blend mode to Multiply. Load the channel mask you created in the previous step as a selection by holding down the Ctrl key (PC) or Command key (Mac) and clicking on the Blue Copy thumbnail (this selection will help shield the foreground from the gradient). With the selection active click on the 'Add layer mask' icon in the Layers palette and then click on the empty layer thumbnail to make this the active component of the layer.

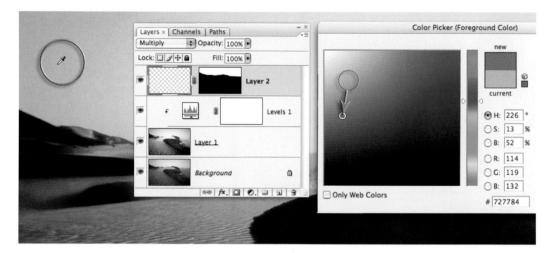

9. Select the Gradient Tool from the Tools palette. Hold down the Alt/Option key to turn the mouse cursor into the eyedropper icon and click on a deep blue from the sky within the image. Click on the foreground color swatch in the Tools palette to open the Color Picker. Make the color that you selected darker by moving the sample circle in the Color Picker lower or by lowering the brightness value. Select OK.

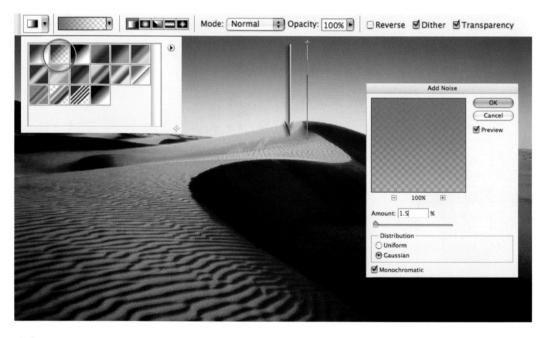

10. In the Options bar select the 'Foreground to Transparent' and 'Linear Gradient' options. Drag a gradient from the top of the image to just below the horizon line to darken the sky. Holding down the Shift key as you drag constrains the gradient, keeping it absolutely vertical. Go to Filter > Noise > Add Noise. Check the Monochromatic option and adjust the Amount slider to a value between 1 and 2%. Adding noise will help to reduce any banding (stepping of tone) that may occur as a result of using the Gradient Tool.

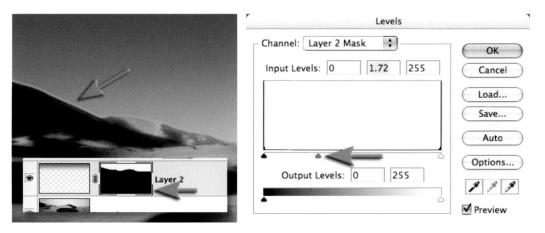

 $1\,1$. Zoom in and take a look at the edge where the sky meets the sand dunes. If you notice a small halo this can be corrected by making adjustments to the layer mask. Click on the layer mask thumbnail and from the Image > Adjustments menu choose 'Levels'. Moving the Gamma slider will realign the edge precisely with the edge of the sand dunes. Moving the shadow and highlight sliders in the Levels dialog box will render the edge of the mask less soft.

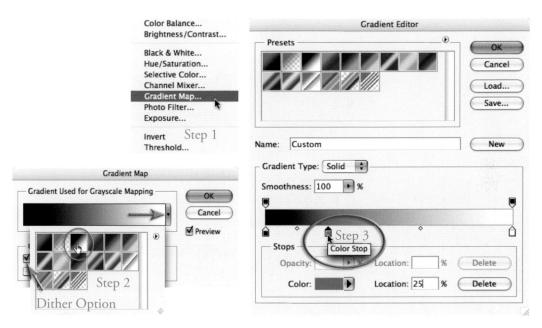

12. To introduce alternative colors into the image we can use a Gradient Map adjustment layer. In the dialog box, choose the 'Black, White' gradient from the gradient presets (this will remap the colors to a full tonal range black and white image), check the Dither option in the Gradient Map dialog box (to help to reduce banding) and then click on the gradient strip to open the 'Gradient Editor' dialog box. Click underneath the gradient ramp to add a color stop. Move the stop to a location of 25%. Click on the mini color swatch at the bottom of this dialog box to change the color of this stop. The Select Stop Color dialog box (color picker) will open.

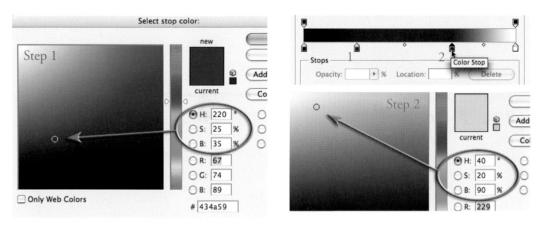

13. Choose a cool color with a brightness value of 35% to give character to the shadow tones. Choosing desaturated colors (less than 25%) will help to keep the effects subtle so the tonal qualities of the image are not suppressed by overly vibrant colors. If color rather than tone is to take center stage then saturation levels of the color stops can be increased beyond 25%. Select OK to return to the Gradient Editor dialog box. Create another stop by clicking underneath the gradient ramp in the Gradient Editor dialog box and move it to a location that reads approximately 70%. This time try choosing a bright warm color with a brightness value of 90% to contrast with the blue chosen previously.

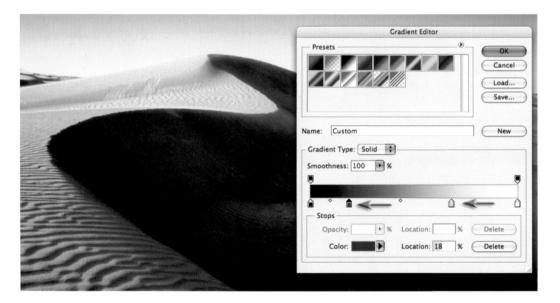

14. Fine-tune the tonality and color distribution in the image by moving each slider to the left or right to either darken or lighten this range of tones. In this project image the highlight and shadow tones are lightened by moving both stops slightly to the left. Note how the colors you have chosen are remapped to the tones as they change in brightness, i.e. as the shadow tones are made lighter they also become warmer.

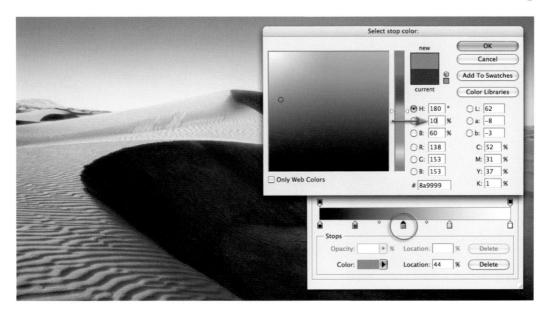

15. Add a third midtone color stop if required halfway between the shadow and highlight stops. In this project image I have chosen a cool Cyan color of only 10% saturation. Drag this color stop and observe how the highlight or shadow tones can be pushed back or drawn into the adjacent tones, e.g. moving the midtone color stop to the left will let the highlight color flow through to some of the ridges in the sand ripples.

Note > Be careful not to drag any of the sliders too close together as this will cause banding in the image. Once you have created the perfect gradient you can give it a name and save it by clicking on the 'New' button. This gradient will now appear in the gradient presets for quick access. Click OK in the Gradient Editor and Gradient Map dialog boxes to commit the gradient.

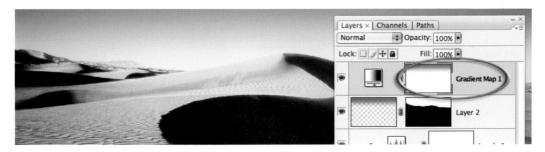

16. Lower the opacity of the Gradient Map adjustment layer or use the layer mask to remove some of the effects of the Gradient Map adjustment layer. Instead of changing the layer opacity, in this project image a 'Black, White' linear gradient has been added to the layer mask to bring back some of the tone and color of the underlying layers in this region. This will restore the smoother gradient that was disturbed by moving the color stops in the Gradient Map adjustment layer.

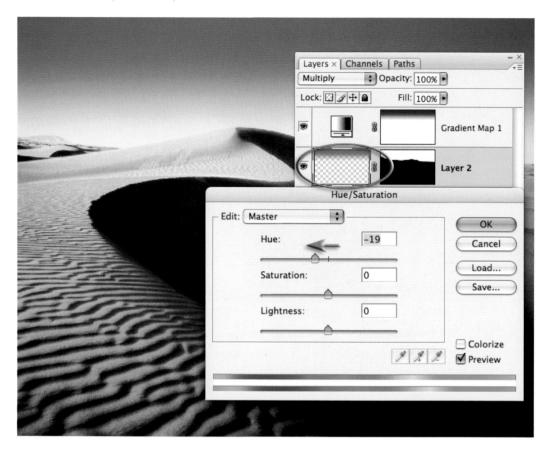

17. To adjust the hue of the sky on Layer 2 apply a Hue/Saturation adjustment (Image > Adjustments > Hue/Saturation). Move the Hue slider to the left in order to align the hue with shadow color added in the Gradient Map adjustment layer. Select OK when color consistency has been achieved.

Now all you need to do is lock yourself in the bathroom for half a day, dip your hands in some really toxic chemicals and you will have the full sensory experience of the good old days of traditional darkroom toning.

Note > If the original color of a gradient is black the Colorize checkbox in the Hue/ Saturation dialog box must first be checked.

Gradient presets

A range of gradient presets including the one used in this toning activity can be downloaded from the supporting DVD and loaded into the 'presets' by double-clicking the gradients preset file or clicking on the Load button in either the Gradient Editor or the Preset Manager.

Creative depth of field - Project 3

The Gaussian Blur filter or Lens Blur filter can be used creatively to blur distracting backgrounds. Most digital cameras achieve greater depth of field (more in focus) at the same aperture when compared to their 35mm film cousins due to their comparatively small sensor size. This is great in some instances but introduces unwelcome detail and distractions when the attention needs to be firmly fixed on the subject – and not the woman in the background picking her nose!

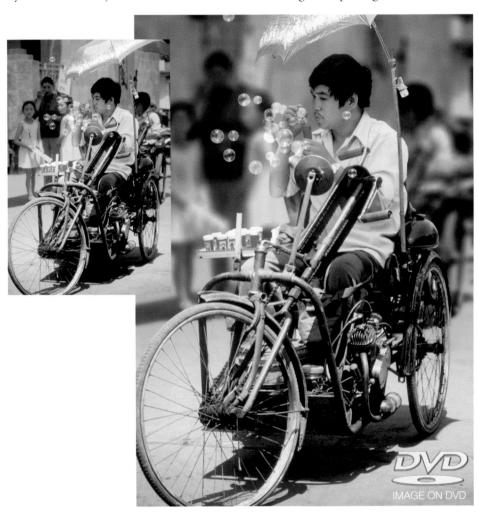

When capturing a decisive moment with a camera the most appropriate aperture or shutter speed for the best visual outcome often gets overlooked. Photoshop can, however, come to the rescue and drop a distracting background into smooth out-of-focus colors. A careful selection to isolate the subject from the background and the application of a blur filter usually does the trick. Problems with this technique arise when the resulting image, all too often, looks manipulated rather than realistic. The Gaussian Blur filter will usually require some additional work if the post-production technique is not to become too obvious. A more realistic shallow depth of field effect is created by using the 'Lens Blur filter'.

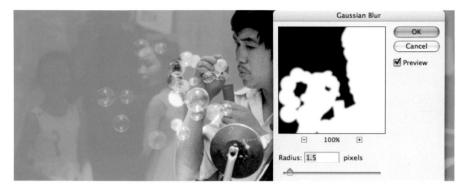

1. Duplicate the background layer by dragging it to the New Layer icon in the Layers palette. Make a selection of the foreground subject or open the Channels palette and hold down the Ctrl key (PC) or Command key (Mac) and click on the saved Alpha channel (the TIFF file on the supporting DVD has an Alpha channel of the main subject to allow you to fast-track this project). This selection will isolate the foreground subject from the blurring technique that will follow. Switch to Quick Mask mode (Q) and apply a Gaussian Blur filter (Filter > Blur > Gaussian Blur) to the mask to replicate the edge quality of the main subject. Exit Quick Mask mode (Q).

Note > If you intend to make your own selection and are using a mixture of selection tools, adjust the feather setting in the Options bar to 0. Perfect the selection using a hard-edged brush in 'Quick Mask mode' (the Refine Edge dialog box does not allow localized painting which may be required when working on the spokes of the wheel).

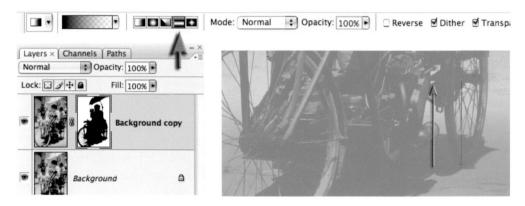

2. Alt/Option-click on the 'Add layer mask' icon in the Layers palette to convert the selection into a layer mask. The mask will require further work to create an area of sharp focus in the background for positioning or anchoring the subject realistically in its environment. The subject will need to be planted firmly on an area of ground that is not blurred to prevent the subject from floating above the background. A simple gradient will allow us to anchor the subject and allow the background to fade gradually from focus to out of focus. Set the Foreground Color to black and then select the Gradient Tool from the Tools palette. Choose the 'Foreground to Transparent', 'Reflected Gradient' and 'Opacity: 100%' options in the Options bar. Drag the Gradient Tool (while holding down the Shift key) from a point where the rear wheel of the wheelchair touches the road to the axle of the same wheel.

3. Click on the image thumbnail in the Layers palette to make sure this is the active part of the layer rather than the layer mask. From the 'Blur' submenu in the 'Filter' menu, select the Lens Blur filter. From the 'Depth Map' section of this dialog box choose 'Layer Mask'.

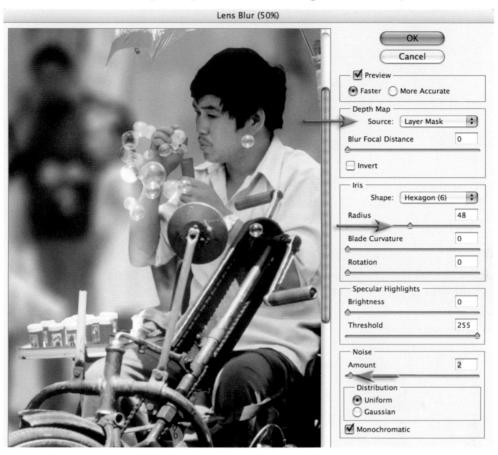

4. Choose the depth of field required by moving the Radius slider. The Blade Curvature, Rotation, Brightness and Threshold sliders fine-tune the effect. Zoom in to 100% before applying a small amount of noise (1 or 2 is usually sufficient) to replicate the noise of the rest of the image. Select OK to apply the lens blur and return to the main workspace.

Lens Blur or Gaussian Blur?

Gaussian Blur was always the first port of call prior to Photoshop CS for creating simulated shallow depth of field. The Gaussian Blur filter has a tendency to 'bleed' strong tonal differences and saturated colors into the background fog, making the background in the image look more like a watercolor painting rather than a photographic image. The Lens Blur filter was new to Photoshop CS and was then enabled for 16 Bits/Channel files in CS2 and introduces none of the bleed that is associated with the Gaussian Blur technique. The filter is extremely sophisticated, allowing you to choose different styles of aperture and control the specular highlights to create a more realistic camera effect.

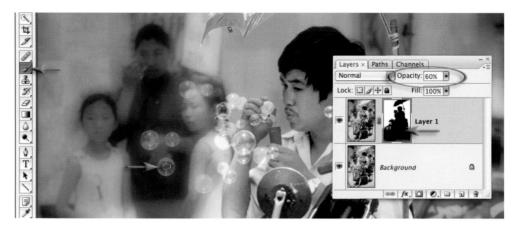

5. To retrieve areas of focus that were blurred accidentally (the appearance of the bubbles would benefit from sharper reflections) select black as the foreground color and a soft-edged Paintbrush with an opacity of 50%. Select the mask layer and paint any areas of the subject that appear too blurry to increase the detail present. Several passes of the brush set at 50% opacity will gradually increase the detail and leave a subtle edge. Hold down the Alt or Option key and the Shift key and click on the layer mask thumbnail to view the layer mask and image together if this helps the process.

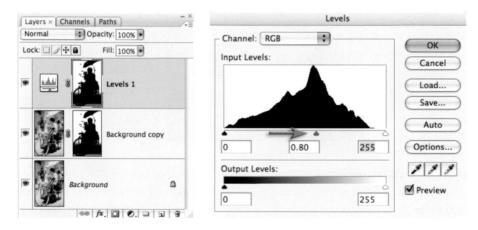

6. Hold down the Ctrl key (PC) or Command key (Mac) and click on the layer mask thumbnail to load the mask as a selection. Use the selection to create a localized 'Levels' adjustment layer to lower the overall brightness of the background to further draw attention to the foreground subject matter.

Future developments - shifting focus

If digital cameras are eventually able to record distance information at the time of capture this could be used in the creation of an automatic depth map for the Lens Blur filter. Choosing the most appropriate depth of field could be relegated to post-production image editing in a similar way to how the white balance is set in camera RAW.

Smart Objects - Project 4

Striking the right balance between ambient light and introduced light can be the difference between sweet success and dismal failure. This project (together with the Shadow/Highlight project in Retouching Projects) demonstrates the art of balancing the lighting in post-production rather than at the time of capture.

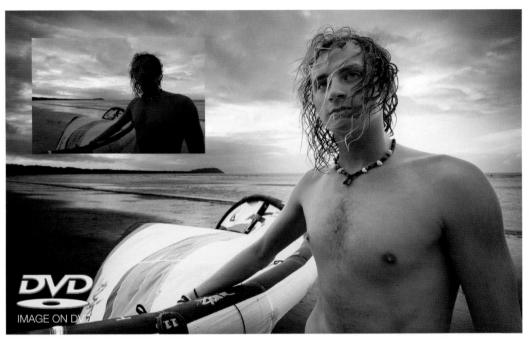

The original exposure is a compromise between background and foreground – neither delivers the goods but plentiful information is available in both to allow further work to be carried out

Instead of using the excellent Shadow/Highlight adjustment feature we now have the option with this project file of using the extended dynamic range of the Raw file format. Different exposures can be extracted from a single Raw file and combined in Photoshop's main workspace. This project will introduce the technique of using several Smart Objects, each being generated from the same Raw file. The initial camera Raw settings used to create each Smart Object can be subsequently modified if required. This ability to double-click on a Smart Object (generated from a Raw file), open the ACR dialog box and adjust the settings is similar to reopening an adjustment layer or smart filter to modify its settings. Even if the project file is in 8 Bits/Channel mode, any changes or modifications to the Smart Object, via the ACR dialog box, are occurring at a higher bit depth so optimum quality is preserved.

New horizons

Modifying exposure is just the tip of the iceberg when it comes to the creative possibilities of using Raw files as Smart Objects, e.g. the photographer could change from a small color space to a large color space and simply access the additional colors from the ACR dialog box.

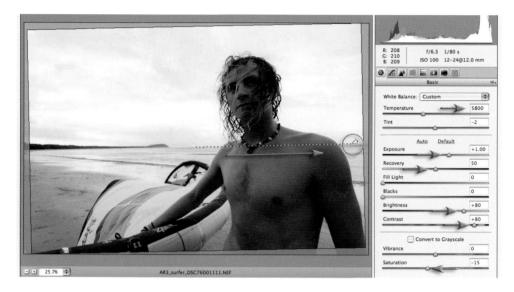

1. Open the Raw project file in the Adobe Camera Raw dialog box (ACR). Set the Color Temperature to 5800 and the Exposure slider to +1.00 to optimize the tonality for the young man. Raise the Recovery slider to +50 to prevent any clipping in the sky and lighter strands of hair. The Brightness and Contrast sliders can also be raised to +80 to further enhance skin tones. Lower the Saturation slider to -15. Click on the Straighten Tool in the ACR dialog box (upper left-hand corner) and click and drag along the horizon line.

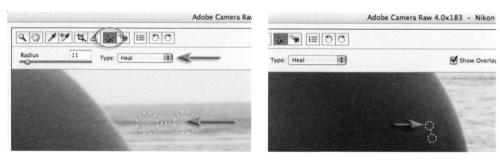

2. Click on the Retouch Tool (top left-hand corner of the ACR dialog box). Select 'Heal' from the 'Type' options. Zoom the image to 100% magnification and move to the area of the image just to the left of the man's shoulder (on the right side of the image). Remove the distracting dark item from the sea (just below the horizon line) by clicking on the center of the item and dragging until the selection area just covers the blemish. Let go of the mouse button for the healing action to work. Drag the second green circle (the source) to a new area for a better match (along the ridge of the wave). A small white dot (known as a 'hot pixel') appears on the man's arm close to the first retouching procedure (zoom to 200% if necessary). A third and final blemish can be removed from the sky on the left side of the image (a distant kite). Hold down the Shift key and select Open Object in the ACR dialog box to open this file into Photoshop's main workspace.

Note > See the Adobe Camera Raw chapter for more information about the Retouch Tool. Open Object can be set to the default option for Raw files in the Workflow Options of ACR.

3. From the File menu choose the Place command. Browse to the same Raw file and select Place. The ACR dialog box will open with the previous settings that were applied during Step 1. We will modify these settings to optimize the file for the sky by lowering the Exposure slider to -0.50. Increase the Vibrance slider to +50 and select OK. The file will open as a second Smart Object complete with a Transform bounding box. Select Commit Transform in the Options bar or hit the Return/Enter key.

4. In the Channels palette click and drag the Blue channel (the one with the best contrast between the sky and the foreground) to the 'Create a new channel' icon to duplicate it. From the Image menu choose Apply Image. Set the Blending mode to Overlay in the Apply Image dialog box and select OK to increase the contrast of the blue copy channel.

5. This step aims to create an effective mask for the sky. Select the Brush Tool from the Tools palette and set the foreground color to White. Set the Mode in the Options bar to Overlay and set the Opacity to 30%. Paint the dark areas of the figure until you have created a silhouette. Paint up to, but NOT over, the thin strands of hair. Switch the foreground color to Black in the Tools palette and paint around the head until you have created a good mask for the sky. The Overlay mode will help in the process of creating an effective mask as you cannot paint white over areas that are already black, and black over areas that are already white, using this blend mode. The foreground will be masked in the following step.

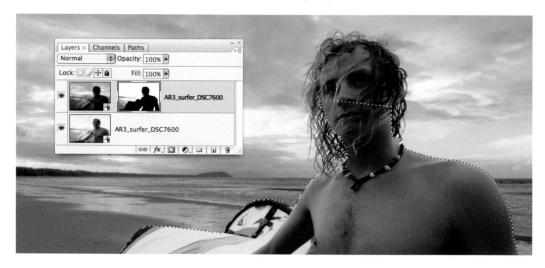

6. Load the Blue copy channel as selection (Ctrl/Command-click the channel thumbnail). Click on the RGB master channel to return to the normal RGB before returning to the Layers palette. Hold down the Alt/Option key and click on the 'Add layer mask' icon in the Layers palette to mask the sky. Make a selection of the figure and sail using either the Pen Tool or the Lasso Tool (ensure no feather is applied at this stage).

Note > A selection and path are available in the supporting TIFF file for this section of the image if you wish to fast-track the project.

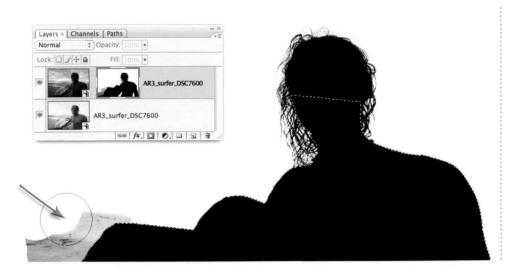

7. This step aims to render the water and the beach in the mask completely white. Hold down the Option/Alt key together with the Shift key and click on the layer mask thumbnail to view the layer mask contents. Fill the active selection of the figure and sail with black (Edit > Fill > Black). Invert the selection (Select > Inverse) and then select white as the foreground color. Set the blend mode to Normal and the Opacity to 100% and then proceed to paint all of the beach outside of the selection white. Be careful to avoid the hair in this procedure. From the Select menu choose Deselect. Click on the layer thumbnail to revert to the normal RGB view.

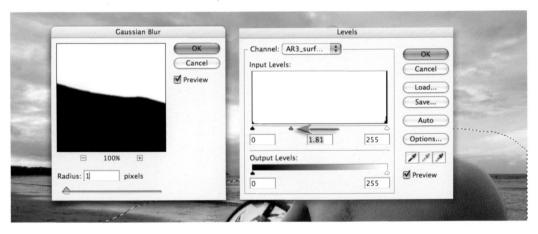

8. This step will optimize the edge quality of the mask. Click on the layer mask thumbnail to make it the active component of the layer. Select the Lasso Tool and make a selection of all of the mask except the hair. Go to Filter > Blur > Gaussian Blur and apply a 1 or 2-pixel blur to soften the hard edge of this mask. Go to Image > Adjustments > Levels and move the center Gamma slider in the Levels dialog box to the left to remove the majority of the lighter halos around the edge of the mask. Make another selection of the hair and apply Gaussian Blur and Levels adjustment only if required. Maker smaller selections of any problem areas and move the mask edge using the levels technique to fine-tune the transition between the two layers.

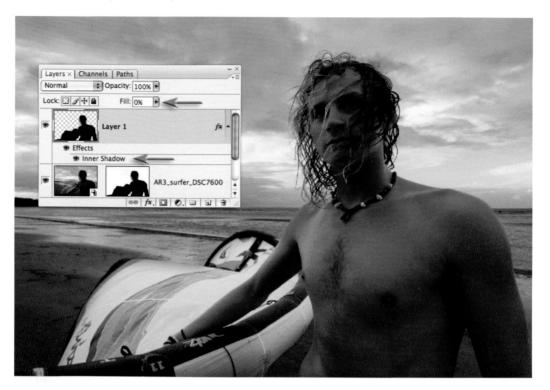

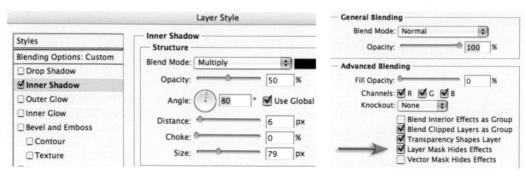

9. The lighter edge down the young man's left arm (right side of image) may appear too light even when the alignment of the mask is perfect (the arm is back lit against the lighter sky). Hold down the Ctrl key (PC) or Command key (Mac) and click on the layer mask thumbnail to load the mask as a selection. From the Select menu choose 'Inverse' and then click on the 'Create a new layer' icon in the Layers palette to create an empty new layer. From the Edit menu choose 'Fill' and select Black as the fill color before selecting OK. Go to Select > Deselect. Lower the Fill for this layer to 0% in the Layers palette (the black pixels will now be transparent but still allow us to add a visible layer style). Click on the fx icon (Layer style) at the base of the Layers palette and choose 'Inner Shadow'. In the Layer Style dialog box adjust the opacity, distance and size to darken the light edge on the arm (ignore any excessive darkening in other areas). Click on the Blending Options tab in the upper left corner of this dialog box and then check the 'Layer Mask Hides Effects' option before clicking OK to apply this layer style.

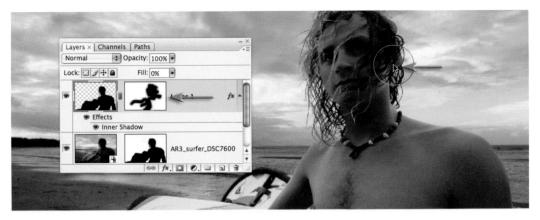

10. Add a layer mask to the layer and then paint with black at 100% Opacity to conceal any areas that do not require darkening.

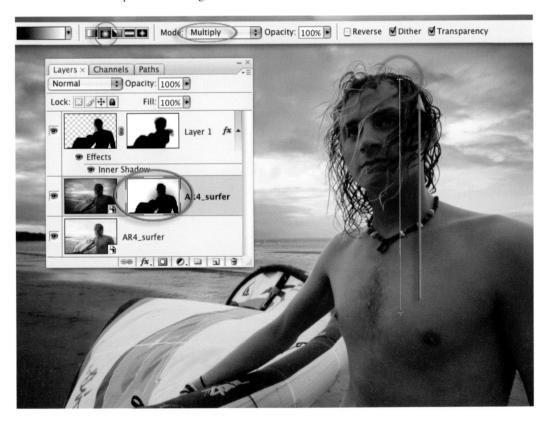

11. The edge around the body can be difficult to perfect if the tonal difference between the two exposures is too great. Create a gradient in the layer mask to reduce the tonal differences between the lightened body and darkened background. Select Black as the foreground color and then select the Gradient Tool. Select the Foreground to Transparent gradient, Radial gradient and 100% Opacity from the Options bar. Click just below the man's elbow in the center of the image and drag to a position just above the horizon line.

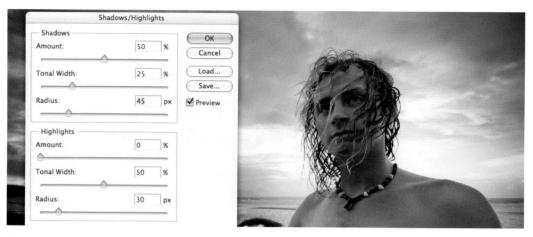

12. Click on the base layer in the layer stack. As this layer is a Smart Object you can apply a Shadow/Highlight adjustment and filters directly to this layer without having to convert it for smart filters first. Go to Image > Adjustments > Shadow/Highlight and lighten the shadows by 50%, using a Tonal Width of 25% and a 45-pixel Radius. Click OK to apply the tonal changes and then go to Filter > Sharpen > Unsharp Mask. Sharpen using a generous Amount of sharpening (100+) using a low Radius (0.8 to 1.0). Raise the Threshold to 7 so that the noise does not get sharpened along with the edge detail.

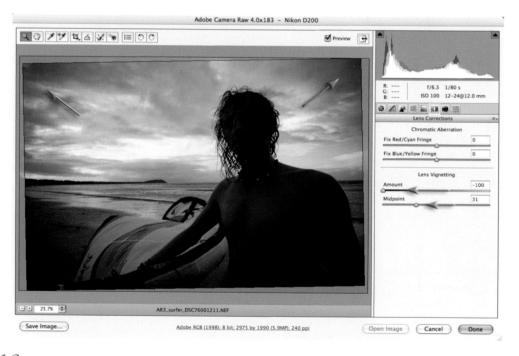

13. Double-click the second darker Smart Object to reopen the ACR dialog box. Click on the Lens Correction tab and move the Amount slider in the Lens Vignetting section to −100. Move the Midpoint slider to −30 to draw the darkening towards the center of the image. Click Done to apply the changes and update the file in the main workspace.

The smooth tone technique - Project 5

A fellow photographer was showing me some images the other day that he had captured with a camera that uses a plastic lens. The images had a certain attraction. Although the images had some pretty shocking vignetting and heavy distortion he was drawn to the beautiful liquid smooth tones that the plastic lens was offering up. Most women who look at photographs of themselves would agree that crunchy detail is just not a good look. A digital camera can be a very cruel tool that can capture way too much information. Most people would prefer their skin to appear smooth, but not featureless, and will thank the photographer when they can reveal a skin texture that does not shout its detail to the viewer.

Carmen Martinez Banus (www.iStockphoto.com) Remove unflattering detail using this smooth tone technique

I have over the years observed many photographers zoom in to 400% and laboriously start healing individual flaws in an attempt to make amends for an overly sharp lens and overly harsh lighting in order to flatter their sitter. This smooth tone technique avoids laboriously removing superfluous details one at a time. I use this technique so often in my own editing that I have now created an action for it (supplied on the DVD). I play this action on whole folders of images and am slightly disturbed how often I like all of the images it is applied to. I even apply it to landscapes. This technique does not just blur the entire image, which is the bit I like best. It is the areas of continuous tone that take the brunt of the smoothing, leaving edges with good contrast, crisp and sharp.

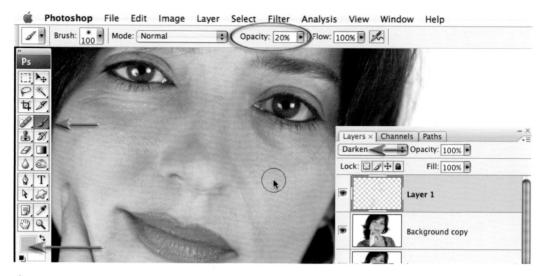

1. Duplicate the background layer by dragging it to the 'Create a new layer' icon in the Layers palette. The slightly oily skin has created some highlights on the cheeks, brow and hand that are not very flattering. Click on the 'Create a new layer' icon in the Layers palette and set the mode to 'Darken'. Select the Brush Tool from the Tools palette and choose a large soft-edged brush in the Options bar. Set the Opacity of the brush to 20%. Take a color sample by holding the Alt/ Option key and clicking on an area of skin just outside the highlight and then paint over the areas to suppress these highlights. A couple of passes with the brush may be required.

Note > In order to take a color sample that is representative of the color area ensure the sample size of the Eyedropper Tool is set to 5×5 in the Options bar.

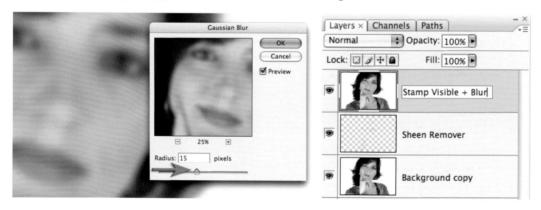

2. Stamp the Visible layers to a new layer. Go to the Select menu and choose 'All' and then choose 'Copy Merged' and 'Paste' from the Edit menu. The unlisted keyboard shortcut, known only to 'those-in-the-know', is to hold down the Ctrl + Alt + Shift keys (Command + Options + Shift keys for Mac users) while hitting the E key. Go to Filter > Blur > Gaussian Blur. Choose a very generous blur that sees all of the fine detail removed but that retains the general shape of the features and face. The precise amount will vary depending on the resolution of the image and how much of the frame the face occupies. This 6-megapixel image uses a 15-pixel radius blur.

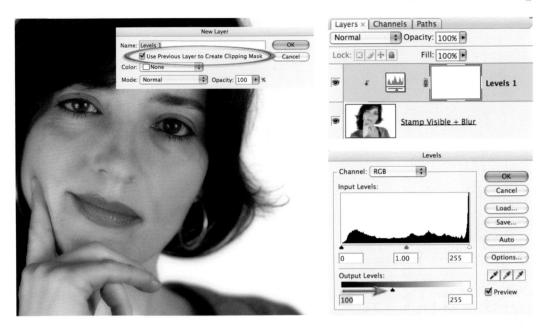

3. In the Layers palette change the mode of this blur layer to Multiply. Your image will, for the moment, appear very dark and saturated. Hold down the Alt/Option key and then click on the 'Create new adjustment layer' icon in the Layers palette. Choose 'Levels' from the dropdown menu. When the New Layer dialog box opens click on the 'Use Previous Layer to Create Clipping Mask' checkbox and then select OK. When the Levels dialog box opens move the shadow output slider to the right until the Output Levels read around 100 and then select OK. This will partly restore the shadow values to something approaching, but not quite, normal.

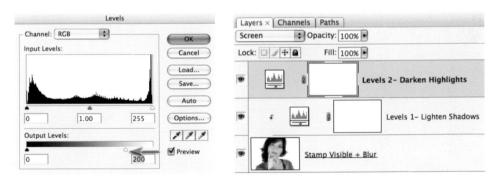

4. Hold down the Alt/Option key and select 'Levels' from the 'Create new adjustment layer' menu in the Layers palette. Set the mode to Screen in the New Layer dialog box and select OK. This will restore the midtones but push the highlights uncomfortably high. To rescue these highlight tones we will use a similar technique that we used to rescue the shadow tones in the previous step. In the Levels dialog box move the highlight output slider to the left until the Output Levels read around 200 and then select OK. This should fully restore the highlight tones to their normal value. You should now be getting an idea of the smooth tones we are achieving even if the tonal values and saturation values are not yet perfect.

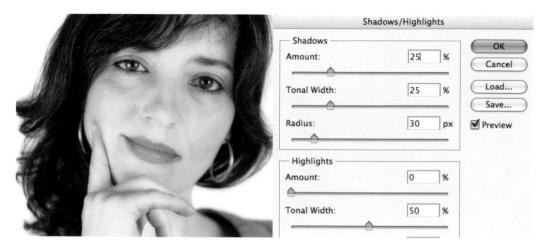

5. Stamp Visible again and use the Shadow/Highlight adjustment feature to fully restore the shadow values (go to 'Image > Adjustments > Shadow/Highlight'). Lower the tonal width to around 25% and raise the Amount slider just enough to restore the overly dark shadow values. Experiment with increasing the Color Correction slider in the Shadow/Highlight dialog box to make these adjusted shadow tones more colorful.

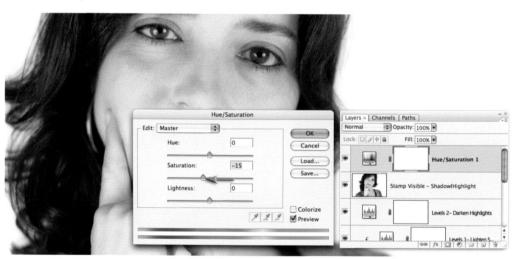

6. Create a Hue/Saturation adjustment layer and lower the saturation levels – lowering the saturation by –15 to –25 will put things back to normal – well normal minus the superfluous detail in the skin. If you were creating an action for this technique you would now sharpen the image. Sharpening the image will reveal that edge detail with contrast has not been sacrificed. Only Step 1 and Step 7 of this project cannot be actioned (they require you to selectively paint or heal).

Note > If making an action you should prepare variations for low-resolution and high-resolution images. I have created one action for 3- to 6-megapixel images and another for 8- to 12-megapixel images. The only setting that needs to be varied is the radius of the Gaussian Blur filter used in Step 2, i.e. a higher radius for higher resolution images.

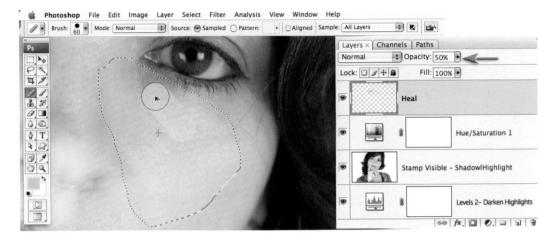

7. Click on the 'Create a new layer' icon in the Layers palette. Make a selection of the healing area that excludes the area of difference. Use a 2-pixel feather in the Options bar when using the Lasso Tool. Select the Healing Brush Tool (not the Spot Healing Brush Tool) from the Tools palette and select the Sample All Layers option in the Options bar. When working up against areas of different tone or hue you will need to sample an area of smooth skin tone from the cheek and then, using a hard-edged brush, paint your way to wrinkle-free skin. After painting over the lines and dark areas underneath the eyes the woman will appear to have undergone a rather dramatic Hollywood-style face-lift, so we need to give this woman back her dignity and a hint of her years by lowering the Opacity of the healing layer to around 50%.

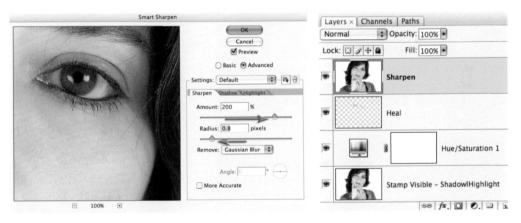

8. Create another Stamp Visible layer to act as a sharpening layer. Set the mode of this layer to Luminosity to eliminate the effects of increased saturation when the contrast at the edges is increased and then apply either the Unsharp Mask or the Smart Sharpen filter (Filter > Sharpen > Smart Sharpen/Unsharp Mask). Whichever technique you choose keep the Radius low and if you notice any artifacts rearing their ugly heads then switch from the Smart Sharpen filter to the Unsharp Mask and raise the Threshold slider to 4 or more. Take a look at the hair above the eyebrows to see how crisp and sharp this detail has now become. Take a long look at 100% View (Actual Pixels) of the skin. You will see the skin pores are visible – this is no plastic fantastic technique but a flattering makeover to reveal smoother tones.

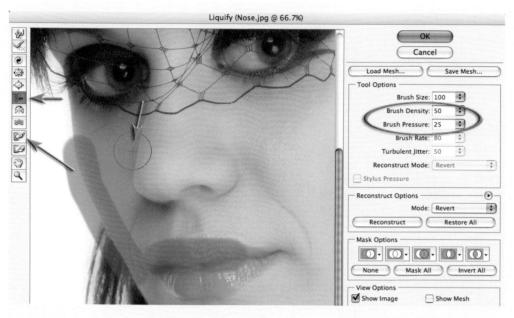

Photograph by Jennifer Stephens

Pixel surgery

The Liquify filter can reshape facial features, if this does not present an ethical dilemma for the retoucher or model. The various tools in the Liquify filter dialog box can be used to modify the shape or size of the sitter's features. The Pucker Tool and Bloat Tool can be used to contract or expand various features, e.g. grow eyes or lips and shrink noses. Perhaps the most useful of the Liquify tools, however, is the Shift Pixels Tool. This tool can be used to move pixels to the left when stroking down and to the right when stroking up. This tool is ideal for trimming off unsightly fat or reshaping features. In the illustration the brush pressure is dropped to 25%. The side of the face and the top of the lips have been frozen using the Freeze Mask Tool so that the side of the face and lips are not moved along with the nose. If things start to get ugly just remember the keyboard shortcut Ctrl/Cmnd + Z (undo)!

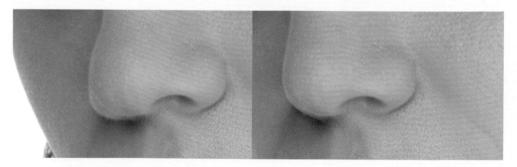

Note > It is important to exercise great restraint when using the Liquify filter, as the face can quickly become a cartoon caricature of itself when taken too far. The filter also softens detail that becomes obvious when overdone.

Time of day - Project 6

The commercial studio photographer is able to control the quality and direction of light to create the precise mood in order to meet the requirements of the brief. On location the photographer is at the mercy of the weather and the limitations of time (budget). Photoshop is able to lend some assistance to manipulate the mood so that the final image aligns more closely with the requirements of the client and still meets the specified budget. This project is a companion for the 'Replace a sky' project in the Montage chapter.

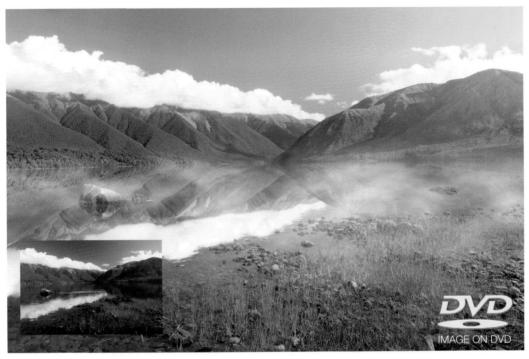

Original image of Lake Rotoiti in New Zealand's South Island (courtesy of John Hay)

OK, so the alarm clock failed to go off and by the time you arrive at the foreshore of the lake you can't help feeling that, although mightily majestic, these mountains and their reflections may just have been a little moodier 2 hours ago. We can perhaps only imagine what it might have looked like as the shafts of light penetrated the morning mist over the still waters with their mirror-like reflections of the distant mountains, but this project aims to provide you with a few tips and techniques for winding back the clock so that we can recapture the mood, mist and tranquillity of the dawn shot.

This project uses the Transform and Warp commands to perfect a reflection (simulated reflections are rarely as simple as just flipping a copy layer). A combination of adjustment layers and the Shadow/Highlight adjustment feature is used to change the color and contrast so that the light is closer to the soft light of dawn. The introduction of morning mist and shafts of warm light complete the picture of tranquility.

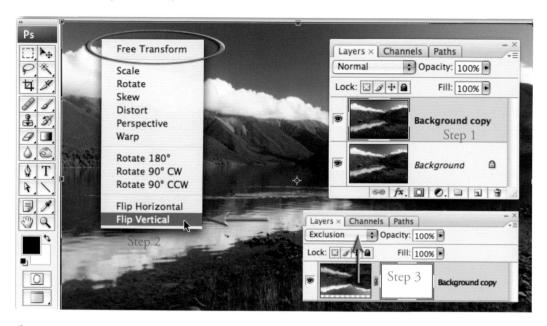

 ${\bf l}$. To create the mirror-like reflections in the water duplicate the background layer by dragging it to the 'Create a new layer' icon in the Layers palette and then flip it by going to Edit > Free Transform (Ctrl/Command + T). Access the context-sensitive menu (right-click or Command-click) and then select the Flip Vertical command. Change the mode of the layer to Exclusion and click and drag inside the Transform bounding box so that the distant foreshore and its reflection on the left side of the image line up.

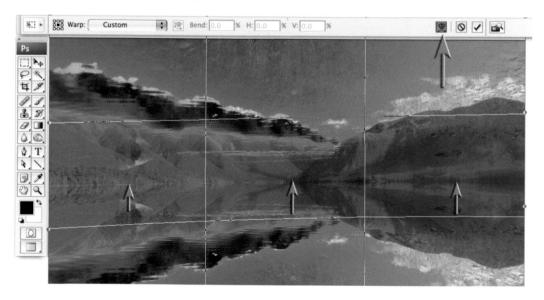

2. With the Free Transform bounding box still active click on the Warp mode in the Options bar. Move your mouse cursor just below the distant lake edge and drag the reflection up on the left, center and right-hand sides until the two shorelines are perfectly aligned. Select Commit Transformation to apply the transformations and warp to the layer.

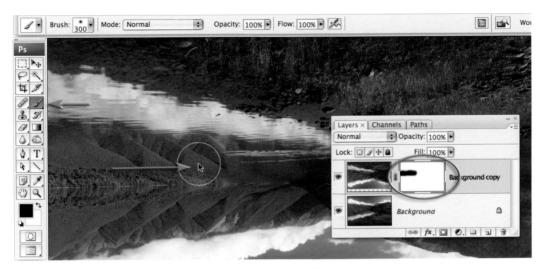

3. Change the blend mode of the top layer back to Normal. Add a layer mask to this layer and then select the Brush Tool in the Tools palette. Choose a large soft brush at 100% Opacity and select black as the foreground color. Paint just above the water's edge to mask everything above the water's edge to reveal the mountains and sky.

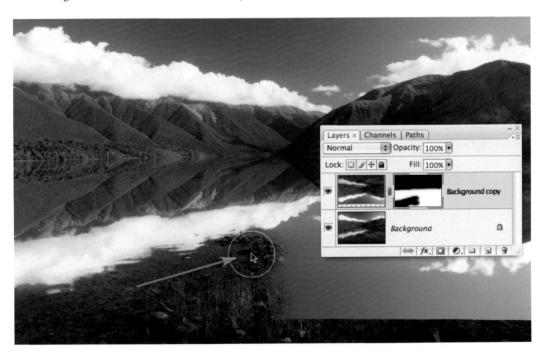

4. Paint with black to reveal the foreshore, submerged pebbles and that white-tipped rock in the middle of the lake using the Brush Tool (change the mode temporarily back to Exclusion to locate and mask the rock). Reduce the size of the brush and lower the Opacity in the Options bar to around 50% as you paint between the immediate foreshore and the reflected clouds in the water.

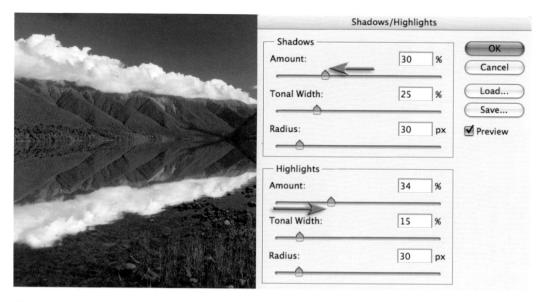

5. Stamp the visible elements of all of the layers into a single layer so that we can apply an image adjustment to both layers simultaneously. The shortcut to achieve this is to hold down the Ctrl + Alt + Shift keys (PC) or Command + Option + Shift keys (Mac) while you type the letter E. Go to Image > Adjustments and choose 'Shadow/Highlight'. Lighten the Shadows by 30% and darken the Highlights by 34%. Reduce the Radius to restrict the changes to the deep shadows and brightest highlights. This will soften the effects of the strong sunlight in the original image. Choose 'OK' to apply these changes.

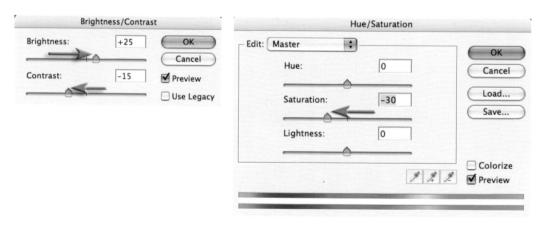

6. As the sun begins to rise, it starts to burn away the morning mist and the contrast and saturation of the colors start to increase. To return the colors to the pastel shades found nearer dawn we can use two adjustment layers. Add a Brightness/Contrast adjustment layer to increase the brightness and lower the contrast. Add a Hue/Saturation adjustment layer to lower the saturation by -30 (this can be adjusted to personal taste as saturation is a bit like sugar in tea – within moderation, varying levels are acceptable).

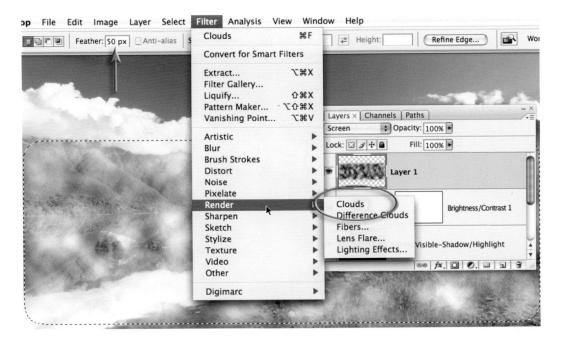

7. Click on the 'Create a new layer' icon in the Layers palette to create an empty new layer. Select the Marquee Tool in the Tools palette and enter a feather radius of 50 pixels in the Options bar. Select the bottom 2/3 of the picture. Make sure the foreground and background colors in the Tools palette are set to their default settings of Black and White (type D on the keyboard) and then from the Filter menu go to Render > Clouds. Set the mode of this layer to Screen to render the black component of this layer invisible.

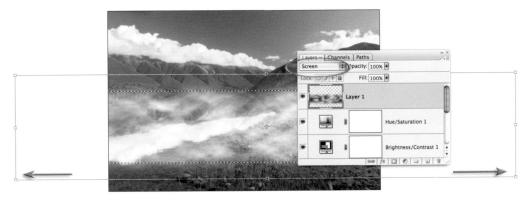

8. Go to Edit > Free Transform. Change the screen mode to either Maximized screen mode or Full Screen Mode and zoom out several times so that you can drag the side handles of the Free Transform bounding box. Stretch this layer so that it is double the width of the background layer. This will ensure the clouds look more like mist than clouds. Reduce the height of the mist if required and click and drag inside the bounding box to move the mist into the best position. Commit the transformation by hitting the Enter key (Return key on a Mac). Lower the opacity of the layer until you achieve the correct degree of subtlety.

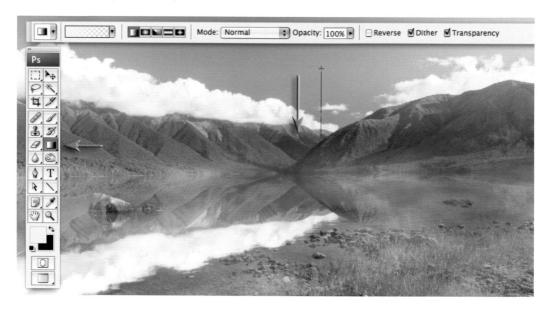

9. This step aims to recreate the soft light of a dawn sky. Create an empty new layer by clicking on the 'Create a new layer' icon in the Layers palette and set the mode to Soft Light. Select the Gradient Tool and choose the 'Linear' and 'Foreground to Transparent' options in the Options bar. Hold down the Alt/Option key and sample a light blue just above the clouds. Click on the Foreground Color Swatch to open the Color Picker. Set the Brightness to 100% and the Saturation to 10% and then select OK. Drag a gradient from the middle of the sky to a position just below the top of the mountains.

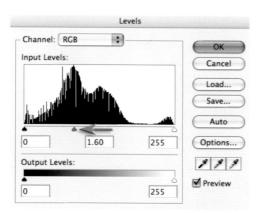

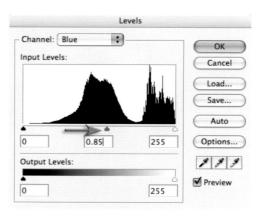

10. The next two steps create the illusion of low sunlight filtering into the image from the right-hand side. Create a Levels Adjustment layer and move the Gamma slider in the master RGB channel to the left to lighten the image. Select the Blue channel in the Levels dialog box and move the central slider to the right to introduce a warm yellow cast. You may also need to select the Green channel and move the slider to the right to increase the amount of Magenta to prevent the warm glow taking on a green cast. Fill the adjustment layer mask with Black (Edit > Fill Layer and then choose 'Black' as the contents color).

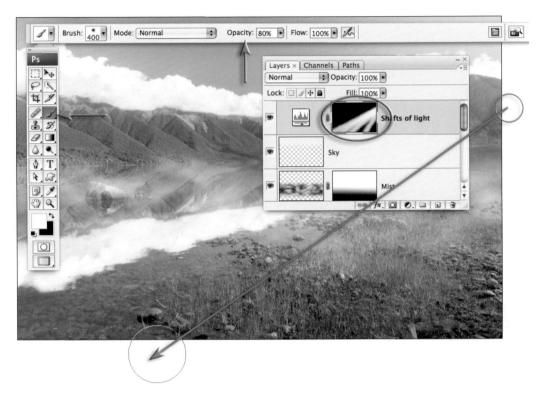

11. Select the Brush Tool and choose a large soft-edged brush from the Options bar. Select white as the foreground color and set the brush opacity to 80%. Click once just outside of the image window on the right-hand side and then move the mouse cursor to the lower left-hand side of the image window. Hold down the Shift key and click a second time to create a straight line of warm light in the image. Repeat this process several times to create numerous shafts of light.

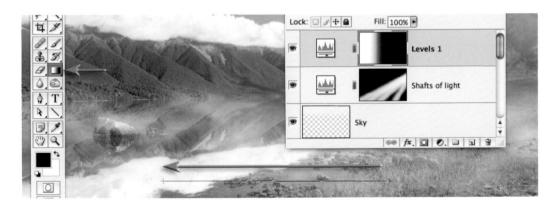

12. Create one final Levels adjustment layer and this time move the Gamma slider to the right to darken the image. Select 'OK' and then use a 'Linear' 'Black, White' gradient to mask the right side of the image and restrict the darkening to the left side of the image only.

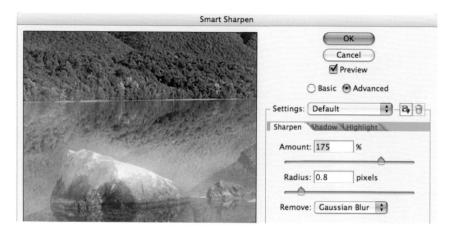

13. The final step is to sharpen the image. Stamp the visible elements of all the layers into a single new layer (see Step 6) and set the mode to Luminosity. Use either the Unsharp Mask or the Smart Sharpen. Be generous with the amount (150% or more) and very conservative with the Radius (1 pixel or less). Holding down the Alt/Option key and clicking on the visibility icon of the background layer will show you just how far you have come. Now your image has undergone a character transformation you are truly a master of time, light and weather.

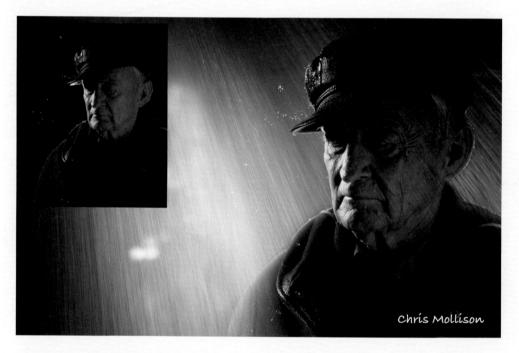

Adding weather

Extra rain is added to enhance the mood of the original scene. The Screen blend mode is the perfect technique for adding bright highlights that have first been captured against a black background. Subtle toning completes the rain-soaked scene.

montage projects photoshop photoshop photoshop photoshop photoshop

essential skills

10p

- ~ Use Quick Mask mode, alpha channels and layer masks to create a simple montage.
- ~ Create a simple montage using layer blend modes.
- ~ Use the Pen Tool to create a smooth-edged mask.
- Use channel masking and a blend mode for a perfect hair transplant.
- ~ Replace a sky and massage the tonality and color for a seamless result.
- Preserve the shadows of a subject and create realistic motion blur.
- ~ Create a panoramic image using the Photomerge filter.

Layer masks - Project 1

A common task in digital image editing is to strip out the subject and place it against a new background – the simplest form of montage. The effectiveness of such a montage is often determined by whether the image looks authentic (not manipulated).

In order to achieve this the digital photographer needs to modify the edge of any selection so that it is seamless against the new background. A crude or inappropriate selection technique will make the subject appear as if it has been cut out with the garden shears and is floating above the new background. A few essential masking skills can turn the proverbial sow's ear into the silk purse.

Open the project images for this tutorial from the Montage folder on the supporting DVD. As with any montage work it is advisable to check that the pixel dimensions of each image are similar and the image modes are the same. For a quick check depress the Alt/Option key and click the document size box at the base of the image window.

Note > The resolution and image mode of an image pasted into another image will automatically be adjusted to match the host file. The 'Transform' command can be used to adjust the scale of the imported image using 'Interpolation' but scaling an image up excessively can lower the overall quality of the image. It is better to 'downsample' the larger image (decrease the total number of pixels) rather than sample up the smaller one. Exceptions can be made for background images where there is little fine detail, e.g. water, sky, fire or if you intend to blur a background for a depth of field effect.

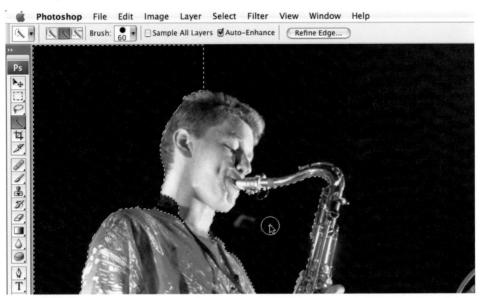

1. Start by selecting the majority of the sax image's background using either the Quick Selection Tool or the Magic Wand Tool (neither are that quick when selecting the subject in this particular image). When using the Quick Selection Tool make an initial selection by dragging the tool over an area of the black background. Then hold down the Option/Alt key and make a series of strokes around the inside edge of the saxophone player to define the areas you don't want to be included in the selection. The effect of these subtractive stokes will not be immediately obvious at this stage, as you are only helping to educate the tool as to which pixels you intend to exclude from any further selections. These are pre-emptive strokes that will help prevent the selection made by the Quick Selection Tool from leaking outside of the area you wish to select. After making the subtractive stroke continue to add to the original selection until most of the background has been selected. Hold down the Option/Alt key and stroke any areas of the saxophone with a small brush to subtract any areas that have been included in the selection by mistake. Do not spend too long trying to perfect difficult regions of the selection as we will use the 'Quick Mask mode' to complete the selection work in the next few steps. As the edge contrast is low in places, no one tool can easily select the entire subject in this image.

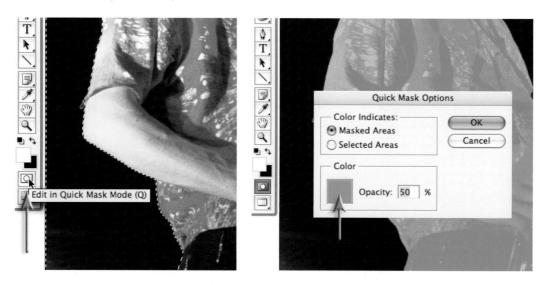

2. Set the foreground and background colors to their default setting in the Tools palette and then click on the 'Edit in Quick Mask Mode' icon in the Tools palette. Double-clicking the icon will open up the 'Quick Mask Options'. Choose either 'Masked Areas' or 'Selected Areas' depending on your preference. Click the color swatch to open the 'Color Picker' and select a contrasting color to that found in the image you are working on. Set the color to a saturated green with 50% Opacity.

Useful shortcuts for masking work

Brush size and hardness: Using the square bracket keys to the right of the letter P on the keyboard will increase or decrease the size of the brush. Holding down the Shift key while depressing these keys will increase or decrease the hardness of the brush.

Foreground and background colors: Pressing the letter D on the keyboard will return the foreground and background colors to their default settings (black and white). Pressing the letter X will switch the foreground and background colors.

Zoom and Hand Tools: Use the Command/Ctrl + Spacebar shortcut to access the Zoom Tool and the Spacebar by itself to drag the image around in its window. The combination of these shortcuts will make shorter work of creating accurate selections.

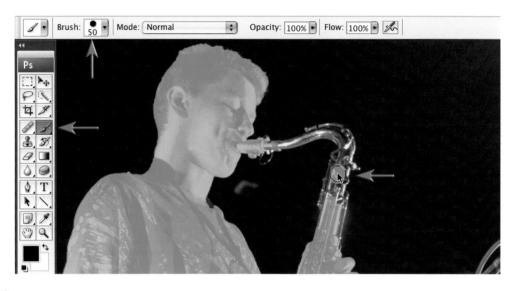

3. Select the Brush Tool from the Tools palette and an appropriate hard-edged brush from the Options bar. Painting or removing a mask with the brush will result in a modified selection when the edit mode is returned to Normal. The foreground and background colors can be switched when painting to subtract or add to the mask. Zoom in on areas of fine detail and reduce the size of the brush when accuracy is called for. Click on 'Edit in Standard Mode' when the painted mask is complete.

Note > Adding an adjustment layer to temporarily brighten the image may help you to paint an accurate mask against some of the dark edges. Switch off or delete the adjustment layer before proceeding if used.

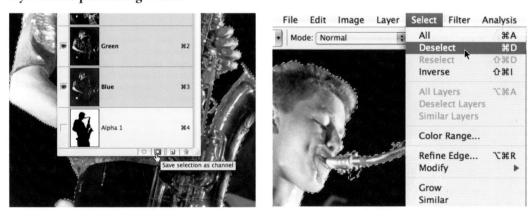

4. Save the selection as an alpha channel by going to the Channels palette and clicking on the 'Save selection as channel' icon. Now that the selection is stored, save your work in progress (File > Save As) and go to 'Select > Deselect'.

Note > Change the name of the original file and save as a Photoshop or TIFF file. The alpha channel contains a record of your selection. This selection can be recalled if the selection is lost or the file is closed and reopened.

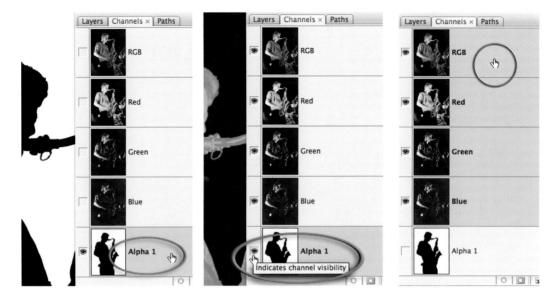

5. Click on the Alpha 1 channel to view the mask by itself or the 'visibility' or 'eye' icon to view the mask and image together. Before returning to the Layers palette, switch off the alpha channel visibility and select the master RGB channels view at the top of the Channels palette.

6. Position the new background image (zoom) alongside the saxophone image. Hold down the Shift key and then click on the background layer in the Layers palette and drag it to the saxophone image (the Shift key will ensure the new layer is centered). A border will appear momentarily around the saxophone image to indicate that it will accept the new layer.

7. The image now comprises two individual layers. The background layer is concealed by the zoom layer. Select the top layer (the zoom image) and then go to 'Edit > Free Transform' (Command/Ctrl + T). Use the keyboard shortcut Command/Ctrl + 0 to fit the Transform bounding box on the screen. Drag a corner handle to resize the image to fit the background. Holding down the Shift key while you drag will constrain the proportions while dragging inside the bounding box will move the image. Use the arrow keys for fine adjustments. Press the 'Commit' icon in the Options bar or press the Return/Enter key to apply the transformation.

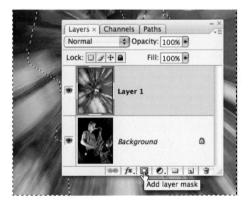

8. Click on the Alpha 1 channel in the Channels palette while holding down the Command key (Mac) or Ctrl key (PC) to load the channel as a selection. Return to the Layers palette and with the zoom layer as the active layer click on the 'Add layer mask' icon. The layer mask will conceal the portion of the zoom image to reveal the saxophone player. It is important to note that the section of the zoom image that is no longer visible has been masked and not removed permanently.

Note > The 'masked' and 'selected' areas are the reverse of each other. Areas that were not part of the original selection become the masked areas. Holding down the Option key as you select 'Add layer mask' reverses the layer mask so that the selection becomes the mask.

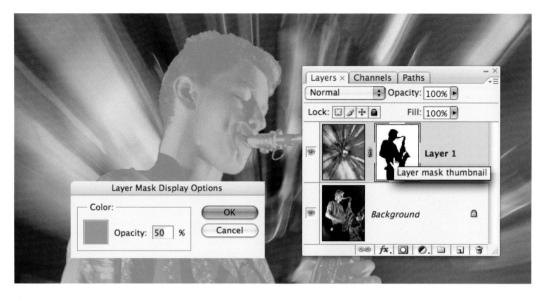

9. The edge of the mask at the moment has a sharp, well-defined edge that is not consistent with the edge quality in the original image. This will be modified so that the edge quality does not stand out now that the saxophone player is viewed against a lighter background color. Double-click the 'Layer 1 Mask' channel to open the 'Display Options'. Select the same options that you used for the 'Quick Mask mode' earlier. Hold down the Alt/Option and Shift keys and click on the layer mask to view the mask and image at the same time. If you wish to return to a normal view you can click on the image thumbnail.

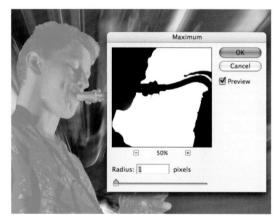

10. Contract the mask by going to 'Filters > Other > Maximum'. Increasing the pixel radius will move the edge of the mask to conceal any fringe pixels that are being displayed from the background layer.

Note > As well as moving the edge of the mask one pixel at a time the mask also becomes more 'rounded' and this can have a detrimental effect on any fine detail present at the edge of the subject.

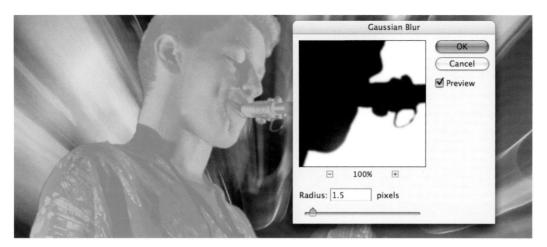

 $1\,1$. With the Layer 1 Mask active go to 'Filters > Blur > Gaussian Blur'. Soften the edge by increasing the pixel radius in this dialog box. One or two pixels will usually do the trick. Click the Layer 1 image thumbnail to review the edge quality of the saxophone player. The Gaussian Blur softens the edge of the mask but may reveal some of the background as a dark halo around some of the lighter edges.

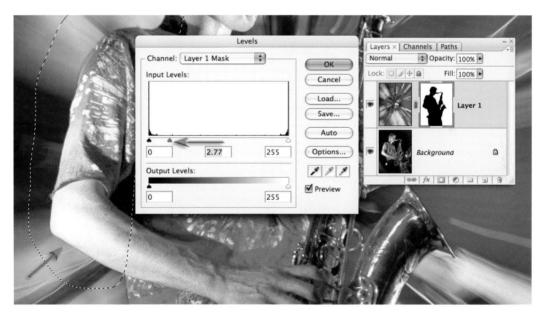

12. Look for any edges that have a dark line and make a selection off these edges using a Lasso Tool. Enter a feather value of 10 pixels in the Options bar so there is a smooth transition between edges that have been further modified and those that have not. Apply the Maximum filter again or go to Image > Adjustments > Levels. Move the central Gamma slider to the left to shrink the mask. Any imperfections still evident can be corrected by painting with black to increase the mask or painting with white to remove sections of the mask. You will need to match brush hardness with the slightly soft edge of the mask if your work is to go unnoticed.

Quick Mask and Refine Edge

When edge contrast is poor the editing process usually requires a range of Photoshop's selection and painting tools to be brought into play. The best workspace for this type of work may still be the Quick Mask mode in many instances. The Quick Mask mode allows the user to contract and expand localized portions of the mask by first making a selection (or by creating a path and then converting the path into a selection) and then using the Maximum/ Minimum filters or Levels technique (see Step 11 in this project). The user can also paint directly into the mask using any painting tools. None of these localized or painting options are available in the Refine Edge dialog box.

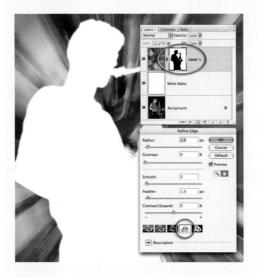

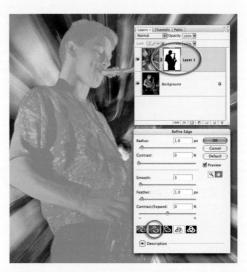

The layer mask is selected and the Refine Edge dialog box opened (Select > Refine Edge). Feedback as to the most appropriate settings to use in the Refine Edge dialog box may be compromised when the mask is not on the subject layer (the saxophone player). Although we can view the subject as a quick mask in the Refine Edge dialog box we are unable to edit this quick mask using the painting tools

Most professionals have traditionally preferred to refine masks rather than selections. Many may think that the new Refine Edge dialog box will change this working practice as Refine Edge can also be applied to masks (go to Select > Refine Edge). Although modifications to the selection edge in the Refine Edge dialog box are a vast improvement on the Feather and Modify commands found in previous versions of Photoshop, when the Refine Edge is applied to a mask attached to a new background layer (placed above the subject layer) the user may be unable to determine the appropriate settings to use in order to acquire the best possible edge. Unlike Quick Mask there are also no options to select a portion of the edge and then adjust the settings independently (not all edges of an object may appear equally sharp or soft and require the same global adjustment). If you make a selection of a portion of the mask and then use Refine Edge the dialog box defaults to working the edge of the selection rather than the edge of the mask. If quality of the visual outcome, rather than speed, is the primary objective when editing an image, then Quick Mask still offers many advantages over the new Refine Edge dialog box.

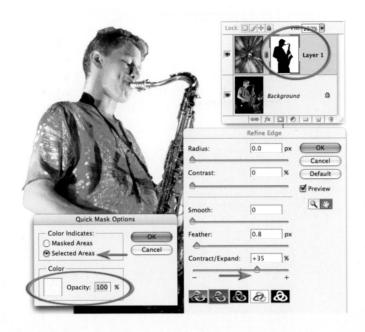

When using Refine Edge to work on a layer mask, the user may have to use a workaround in order to gain any useful feedback as the most appropriate settings to use. After the selection has been converted into a layer mask there may be no feedback when attempting to view the mask using the white or black matte options. The user must either view the mask in Standard mode and hide the selection edges (Command/Ctrl + H) or double-click the Quick Mask view and set the mask color to 100% black or white to create a black or white matte. You may also need to switch the Quick Mask option from 'Masked Areas' to 'Selected Areas' so that the background instead of the subject is masked. When switching to Selected Areas in Quick Mask Options the Contract/ Expand slider then works in reverse.

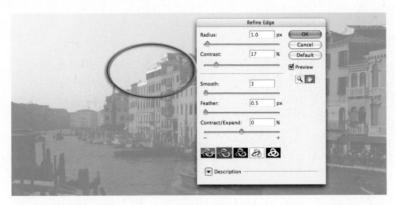

Quick selections may not, by their very nature, be very accurate selections. Missing elements cannot be added from within the Refine Edge dialog box. In Quick Mask mode, however, a selection can be made and then filled with black or the missing elements can simply be painted in prior to using Refine Edge or editing the edge quality from within the Quick Mask mode itself

Creating a simple blend - Project 2

Blending two images in the computer is similar to creating a double exposure in the camera or sandwiching negatives in the darkroom. Photoshop, however, allows a greater degree of control over the final outcome. This is achieved by controlling the specific blend mode, position and opacity of each layer. The use of 'layer masks' can shield any area of the image that needs to be protected from the blend mode. The blending technique enables the texture or pattern from one image to be merged with the form of a selected subject in another image.

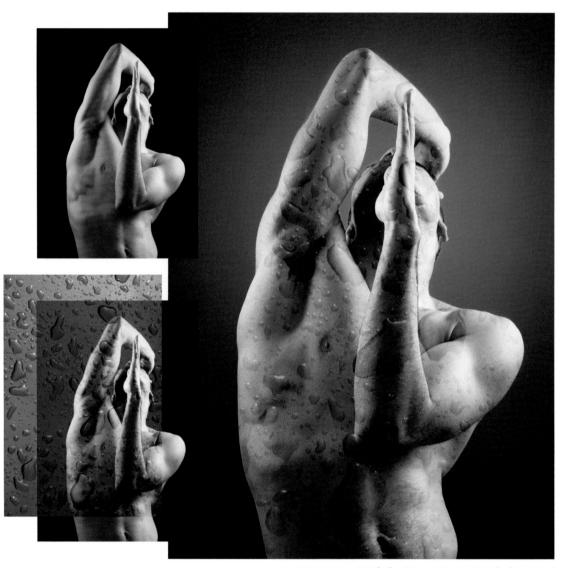

Harmony – Nicholas Monu (www.iStockphoto.com)

Note > In the montage above the image of the body has been blended with an image of raindrops on a car body. The texture blended takes on the shadows and highlights of the underlying form but does not wrap itself around the contours or shape of the three-dimensional form.

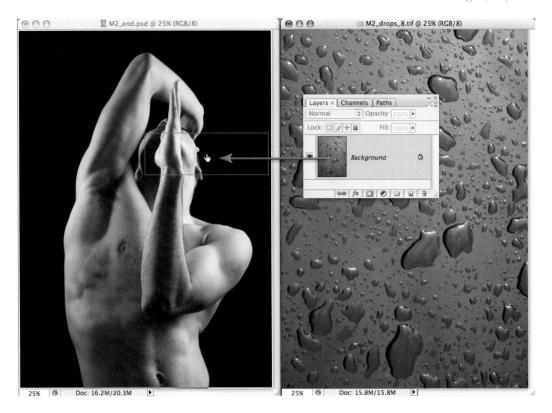

1. Open the images from the Montage folder on the supporting DVD. Click and drag the layer thumbnail of the texture image into the form image. Hold down the Shift key as you let go of the texture thumbnail to center the image in the new window. Use the Move Tool to reposition the texture if required. Use the Free Transform command (Edit > Free Transform) if required to resize the texture image so that it covers the figure in the image.

Selecting appropriate images to blend

Select or create one image where a three-dimensional subject is modelled by light. Try photographing a part of the human body using a large or diffused light source at right angles to the camera. The image should ideally contain bright highlights, midtones and dark shadows. Select or create another image where the subject has an interesting texture or pattern. Try using a bold texture with an irregular pattern. The texture should ideally have a full tonal range with good contrast. A subtle or low-contrast texture may not be obvious when blended. Alt/Option-click the document sizes in the bottom left-hand corner of each image window to check that the image pixel dimensions (width and height) are similar. It is possible to blend a colored texture with a grayscale image. If the color of the texture is to be retained when it is moved into the grayscale image containing the form, the grayscale image must first be converted to RGB by going to 'Image > Mode > RGB'.

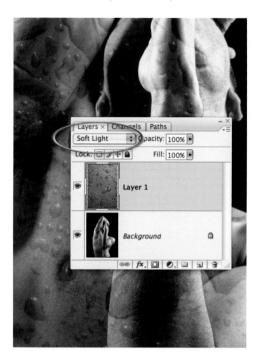

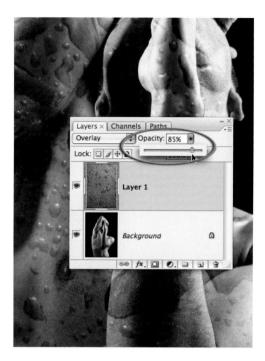

2. Set the blend mode of the top layer to Soft Light or Overlay. Experiment with adjusting the opacity of the layer using the Opacity slider in the Layers palette.

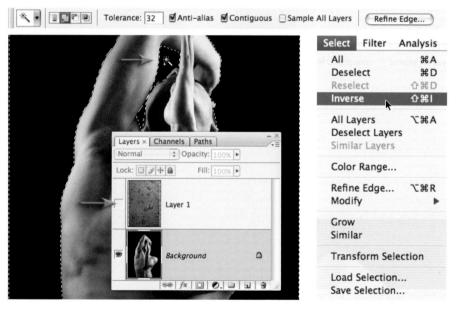

3. Switch off the visibility of Layer 1 in the Layers palette by clicking on the eye icon. Click on the background layer to make it the active layer. Select the Magic Wand Tool from the Tools palette. Click on the black background behind the figure to create a selection. Hold down the Shift key and click on the background just above the man's nose to add this to the selection. Choose Inverse from the Select menu.

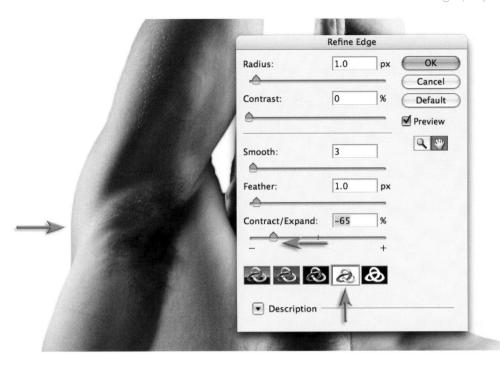

4. Click on 'Refine Edge' in the Options bar. The default settings in this dialog box (Radius 1 pixel, Smooth 3 and Feather 1 pixel) should improve the edge quality but it is difficult to see the changes to your selection without viewing your subject against a different color background. Click on the 'On White' icon to view your subject against a white background. A thin black fringe will now be apparent around your subject. Remove this fringe by moving the Contract/ Expand slider to a value of –65%. Select OK to apply these changes to your selection.

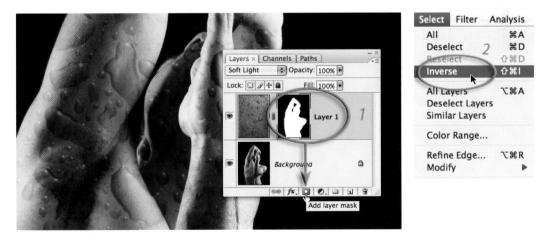

5. Switch on the visibility of Layer 1 and click on the 'Add Layer mask' icon in the Layers palette. Hold down the Command key (Mac) or Ctrl key (PC) and click on the layer mask to load it as a selection. Choose Inverse from the Select menu. We now have a selection that can be used to modify the background without affecting the subject.

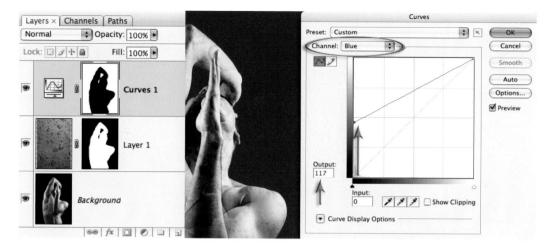

6. The next three steps will create the effect of a backlight behind the subject that slowly fades to black in the corners of the image. With the active selection click on the 'Create new fill or adjustment layer' icon in the Layers palette and choose a Curves adjustment layer. Select the Blue channel and click and drag the adjustment point sitting in the bottom left-hand corner of the diagonal line until the output value reads around 117.

Note > If a halo appears after this adjustment you may need to select the levels layer mask and then go to Filter > Other > Minimum and apply a 1 or 2 pixel radius before proceeding.

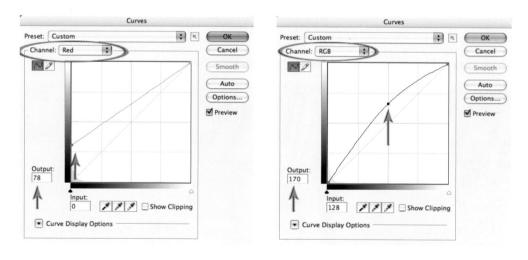

7. Select the Red channel in the Curves dialog box and raise the adjustment point at Level 0 to an output value of around 75. Select the Green channel and raise the same adjustment point to a similar value. These last two adjustments should desaturate the vibrant blue created in the previous step. In the master RGB channel click in the center of the diagonal line to set a new adjustment point. Drag this adjustment point to an Output value of around 170 to brighten the background tone. Select OK to apply the curves adjustment.

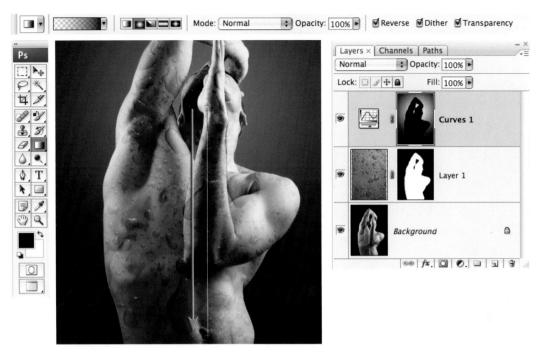

8. Select the Gradient Tool in the Tools palette. Select the Foreground to Transparent and Radial Gradient options. Set the opacity to 100% and select the Reverse, Dither and Transparency options. Click and drag from a position in the center of the man's head out towards the bottom edge of the image window to create the backlight effect.

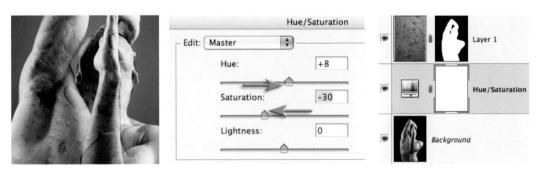

9. The final step will balance the warm skin tones with the cool colors of the raindrops. Click on the background layer to make this the active layer (all new layers will appear above the active layer) and then click on the 'Create new fill or adjustment layer' icon in the Layers palette and select a Hue/Saturation adjustment layer. In the Hue/Saturation dialog box drag the Hue slider to the right to a value of +8. Drag the Saturation slider to the left to lower the overall saturation of the skin tones while retaining the vibrancy of the blue tones (the raindrops on Layer 1 are above this adjustment layer so will not be affected by these adjustments). Complete the project by sharpening the image using techniques outlined in the Retouching chapter, i.e. merging all of the visible elements to a new layer (stamp visible) and then applying a sharpen filter.

Paths and selections - Project 3

With the basic dRawing skills covered in the previous section we are ready to create a path that can be converted into a selection and then used as a layer mask. To become a Path Master (for the pen is sometimes mightier than the light sabre or magic wand) this project will seek to mask part of an image that can be quite difficult to isolate using techniques outlined in Project 1 of the chapter.

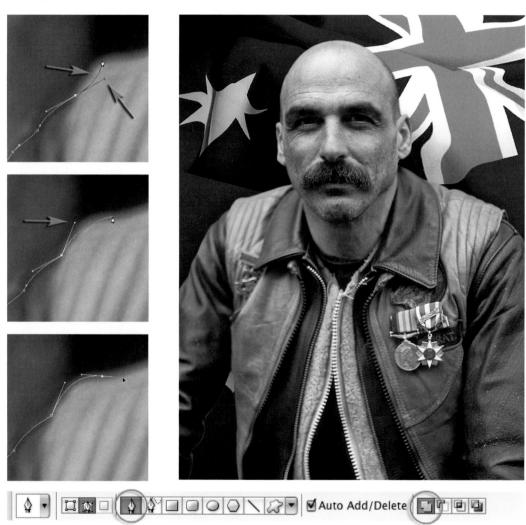

1. To select the man from the background, start on the left side of the project image 'Vet.tiff' (where the arm meets the side of the frame) and use as few anchor points as possible to reach the side of the man's head (see Selections, pages 147–151). Remember you can choose to cancel or move a direction line by holding down the Alt/Option key and clicking on either the last anchor point or its direction point before creating a new segment of the path. As the edge of the man's jacket is slightly blurry, due to the shallow depth of field, dRaw an edge that eliminates some of the blur.

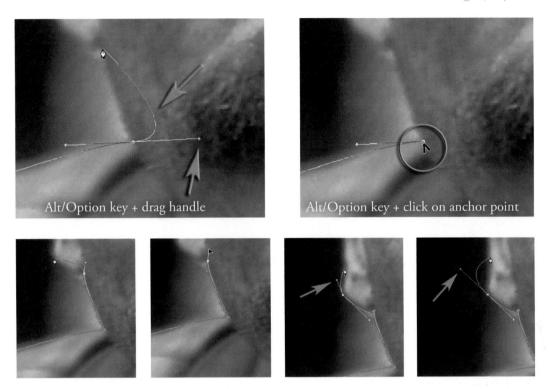

2. Continue to work your way around the neck and ear. Zoom in using the keyboard shortcut Ctrl + Spacebar (PC) or Command + Spacebar (Mac) and work close. Drag the image around in the image window using the Spacebar key to access the Hand Tool.

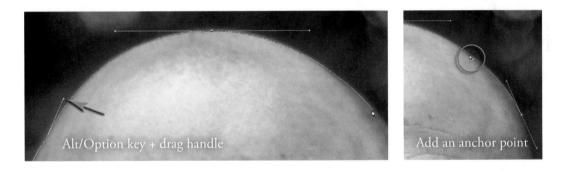

3. When you select the top of the head you will be able to work more quickly as fewer anchor points are required. Moving the Pen Tool over a segment of the path already completed will give you the option to click and add an anchor point to the path. Moving the Pen Tool over a previous anchor point will enable you to click to delete an anchor point.

Note > Check that you have the 'Auto Add/Delete' option checked in the Options bar if the above is not happening for you.

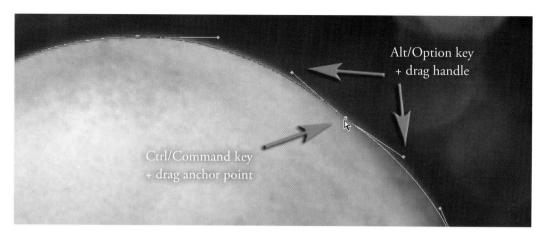

Holding down the Ctrl key (PC) or Command key (Mac) will momentarily change the Pen Tool to the Direct Selection Tool (a white arrow). The Direct Selection Tool enables you to move an anchor point (or its associated direction lines) by dragging it to a new location. Hold down the Shift key while the Direct Selection Tool is active to click on more than one anchor point and move multiple segments of the path. Note how an active anchor point is solid rather than hollow after it has been selected.

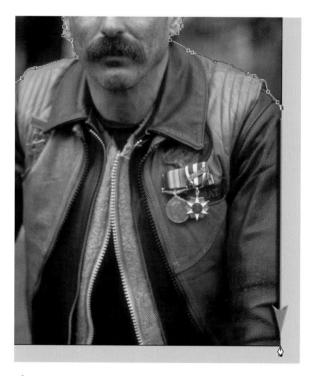

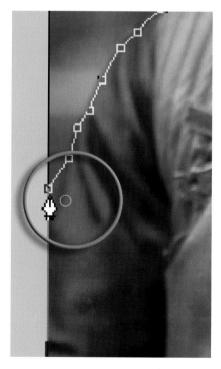

4. Continue creating anchor points until you reach the right side of the image window. Then place an anchor point in the bottom two corners of the image. Return to the start point and click on it to close the path.

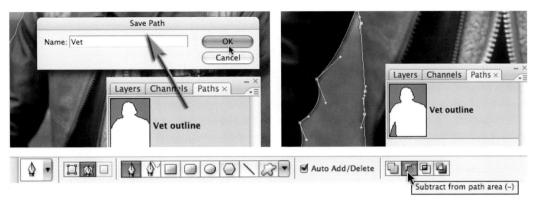

5. In the Paths palette double-click the Work Path. This will bring up the option to save the Work Path and ensure that it cannot be deleted accidentally. A saved path can be modified by first clicking on the path in the Paths palette, selecting the Pen Tool in the Tools palette and then selecting the 'Add to' or 'Subtract from path area' icon in the options bar. Select the 'Subtract from path area' icon and proceed to remove the area of background under the man's arm using the same pen techniques as before. The path is now complete so we must now prepare the file prior to loading the path as a selection.

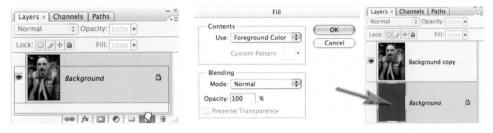

6. To test the effectiveness of the path it is best to view the subject that will be masked against a flat tone. In this example the background has been duplicated and the old background has been filled with a color (Edit > Fill).

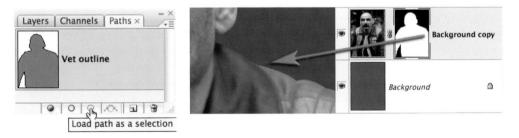

7. Load the path as a selection by clicking on the icon in the Paths palette and then, with the Vet layer selected in the Layers palette, click on the 'Add layer mask' icon. If you zoom in you will see just how smooth and crisp those edges really are. Although smooth and accurate they are in fact a little too sharp for most photographic masking. This can be rectified by applying a small amount of Gaussian Blur.

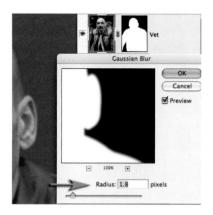

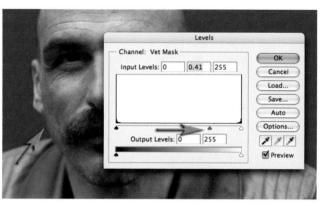

8. Apply a small amount of Gaussian Blur to the layer mask (Filter > Blur > Gaussian Blur). The radius of the Gaussian Blur should match the edge quality of the original subject. A 1 or 2 pixel radius will often be appropriate for most subjects. The alignment of the mask can be further modified (if required) by using a Levels adjustment (Image > Adjustments > Levels). This realignment is required only if a small halo is visible around any part of the subject (such as the right ear lobe area in this image). This will depend on the accuracy of your path and the tone and color of both the subject and the new background. In the Levels dialog box move the central Gamma slider to the right to remove any visible halo. Moving the black and/or white point sliders will remove some of the blur previously applied using the Gaussian Blur filter.

Note > If a halo is present in only an isolated section of the subject then you should first proceed to make a selection of this area using a Lasso or Marquee Tool using a small amount of feather and then proceed to use the Levels adjustment technique outlined above.

9. Open the file containing the new background 'Flag.tiff' and then drag the layer thumbnail into the Vet image. Hold down the Shift key as you let go of the thumbnail to center the flag in the Vet file. Project complete! Now if you put your hand on your heart, you will probably admit to this taking far longer than any other selection process you have ever used previously. With practice however comes speed, and although the pen is never going to replace the other selection tools there are times when, if you put your hand on the same heart, you will have to admit that this is sometimes the hands down winner when smooth edges are paramount.

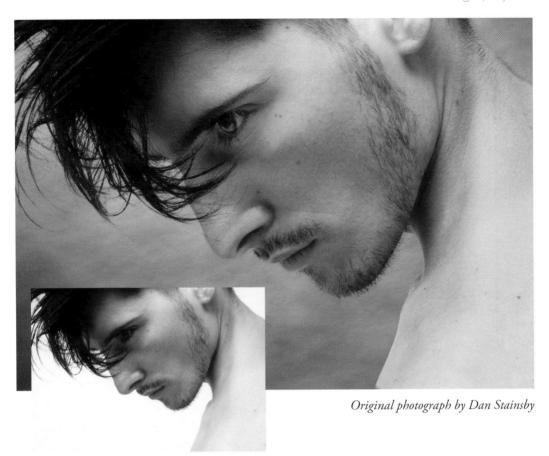

Extracting hair - Project 4

One of the most challenging montage or masking jobs in the profession of post-production editing is the hair lift. When the model has long flowing hair and the subject needs to change location many post-production artists call in sick. Get it wrong and, just like a bad wig, it shows. Extract filters, Magic Erasers and Tragic Wands don't even get us close. The first secret step must be completed before you even press the shutter on the camera. Your number one essential step for success is to first shoot your model against a white backdrop. The background must be sufficiently illuminated so that it is captured as white rather than gray. This important aspect of the initial image capture ensures that the resulting hair transplant is seamless and undetectable. The post-production is the easy bit – simply apply the correct sequence of editing steps and apply the Multiply blend mode for a perfect result. This is not brain surgery and there are no lengthy selection procedures as the foundations for the perfect mask lies in the Channels palette.

Note > When masking hair that was captured against a black background the technique is basically the same as outlined in this project – just change the blend mode to Screen. See the Layer Blends chapter for additional information.

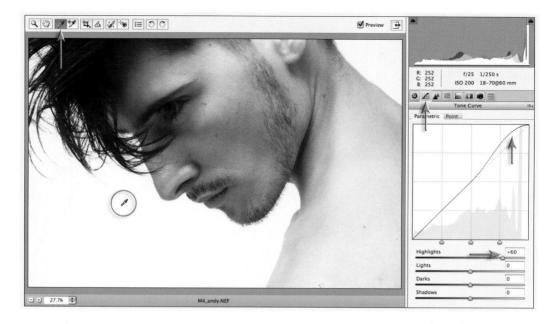

1. Open the Project 5 Montage file from the DVD (choose the Raw file if you would like to complete Step 1 of this project). Select the White Balance Tool in the Raw dialog box and click on the background in the image window to set the white balance. Raise the Brightness slider to +60 and lower the Saturation slider to –20 and then click on the Tone Curve tab. Raise the Highlights slider to +60. These steps should render the background both neutral and bright.

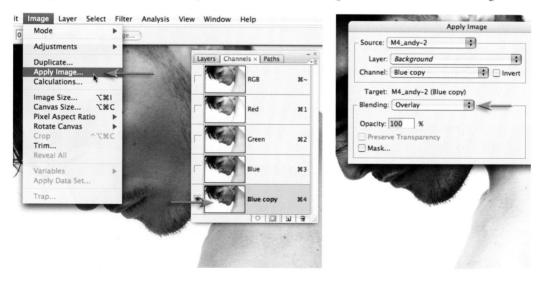

2. In the Channels palette drag the Blue channel (the one with the most contrast between the background and the skin tones) to the 'Create new channel' icon to duplicate it. In the Image menu select Apply Image. Choose Overlay from the Blending options to increase the contrast of the channel and then select OK to apply these changes.

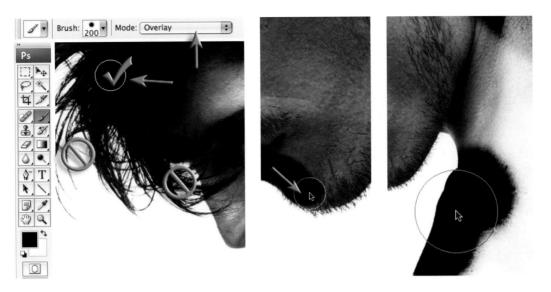

3. Select 'Black' as the foreground color and the 'Brush Tool' from the Tools palette. Choose a large hard-edged brush and 100% Opacity from the Options bar and set the mode to 'Overlay' (also in the Options bar). Painting in Overlay mode will preserve the white background and darken the rest of the pixels. Accuracy while painting in Overlay mode is not a concern when the background is white or is significantly lighter than the subject. Darken the body of the hair near the scalp but avoid the locks of hair that have white background showing through. Painting these individual strands of hair will thicken the hair and may lead to subsequent halos appearing later in the montage process. Darken the skin on the chin, but not the stubble. The bright tones of the shoulders can be rendered black by repeatedly clicking the mouse in Overlay mode.

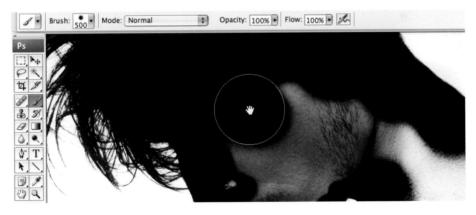

4. Switch the blend mode of the brush in the Options bar to 'Normal' mode when painting away from the edge of the subject. This will ensure a speedy conclusion to the mask-making process. The mask is now ready to use in the montage. Click on the master RGB channel.

Note > If any of the background has been darkened in the process of creating a black and white mask, switch the foreground color to 'White' and choose 'Overlay' in the Options bar. Paint to render any areas of gray background white.

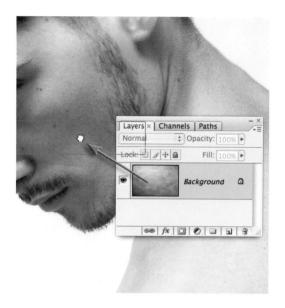

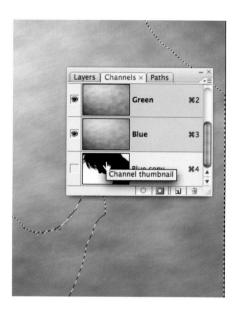

5. Open the background image from the supporting DVD and click and drag the background layer thumbnail (in the Layers palette) into the portrait image window. Hold down the Shift key as you release the mouse button so that the background image is centered. In the Channels palette press the Command key (Mac) or Ctrl key (PC) and click on the Blue copy channel thumbnail to load the channel as a selection.

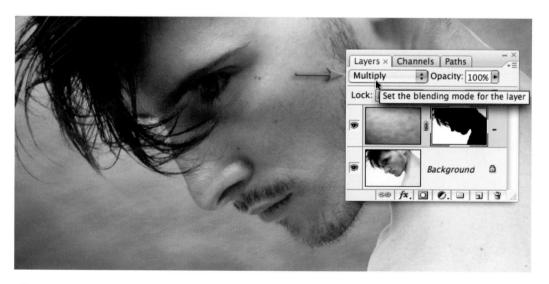

6. Apply a layer mask (using the active selection) to the texture layer just dragged in. Set the blending mode for the layer to Multiply. Notice the difference in the quality of the strands of hair before and after you switch the blend mode to Multiply. Setting the blend mode of the adjustment layer to 'Multiply' will bring back all of the fine detail in the hair. The background will not be darkened by applying the 'Multiply' blend mode as white is a neutral color. The subtle detail in the fine strands of hair will, however, be preserved in all their glory.

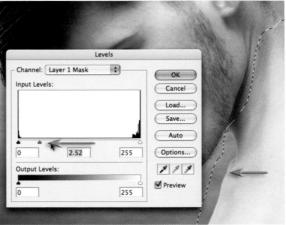

7. The accuracy and quality of the edge of the mask will usually require some attention in order for the subject to achieve a seamless quality with the new background. Make a selection of all of the edges that do not include any hair detail using the Lasso Tool with a small amount of feather set in the Options bar. With the adjustment layer mask selected choose the 'Gaussian Blur filter' (Filter > Blur > Gaussian Blur) and apply a 1-pixel Radius blur to the mask. Click OK and then from the Image > Adjustments menu choose a Levels adjustment. Move the central Gamma slider underneath the histogram to realign the edge of the mask with the subject edge (no dark or light halo should be visible).

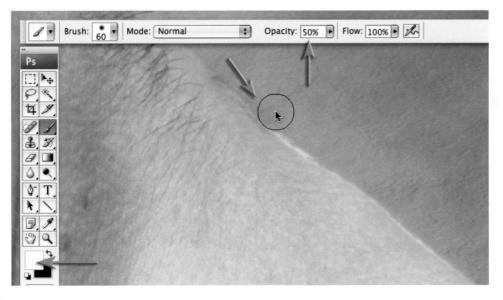

8. Zoom in to 100% Actual Pixels while working to accurately assess the quality of your mask. Any localized refinement of the mask can be achieved manually by painting with a small soft-edged brush directly into the layer mask. Paint with white at a reduced opacity to remove any fine halos present in localized areas. Several brush strokes will slowly erase the halo from the image.

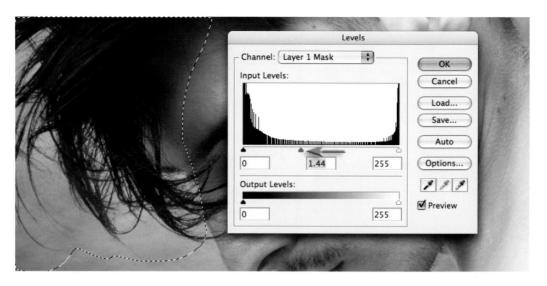

9. In most instances the hair is already looking pretty fabulous but to modify and perfect the hair even further you will need to make a selection of the hair only. Choose 'Levels' once again and move the central Gamma slider to the left to increase the density of the hair and eliminate any white halos that may be present. Moving the White slider to the left a little may help the process of achieving a perfect blend between subject and background. Select OK and choose 'Deselect' from the Select menu.

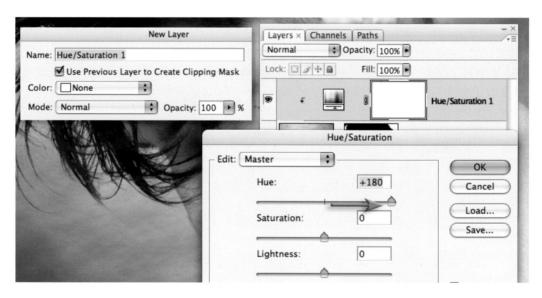

10. To modify the color of the new background without affecting the color of the skin hold down the Option/Alt key and select a Hue/Saturation adjustment layer from the 'Create new fill or adjustment layer' menu in the Layers palette. Check the Use Previous Layer to Create Clipping Mask option and select OK. In the Hue/Saturation dialog box drag the Hue slider to +180 to create a warm background color. Select OK to apply the changes.

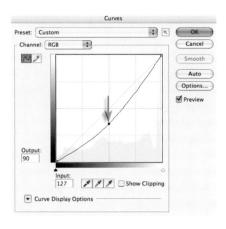

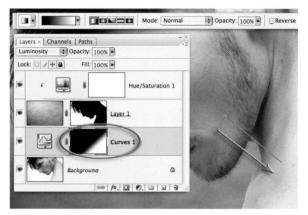

11. In this step we will darken the skin tones on the shoulder that are much brighter than the face. Click on the background layer in the Layers palette and then select a Curves adjustment layer. Click in the middle of the diagonal line to add an adjustment point and then drag down to darken the image. Select OK to apply the changes. Select the Gradient Tool from the Tools and choose the Black to White, Linear and 100% Opacity options in the Options bar and then drag a diagonal gradient from the chin to the shoulder to hide the adjustment from the face. Set the mode of this adjustment layer in the Layers palette to Luminosity to remove the saturation increase.

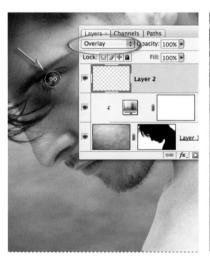

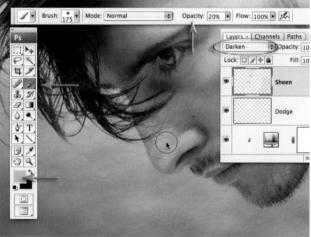

12. Click on the 'Create a new layer' icon and set the mode of the new layer to Overlay. Select the Brush Tool from the Tools palette and paint with a soft-edged brush with white at 20% Opacity to lighten the eye. Paint several times to increase the effect. Create another new layer and set the mode of this layer to Darken. Hold down the Option/Alt key and click on an area of warm colored skin to sample the color. Paint with this color to remove the sheen on the nose. Increase the size of the brush and paint this color over the shoulders as well. Now that the portrait has been optimized, sharpen the image using techniques outlined in the Sharpen project from the Retouching chapter.

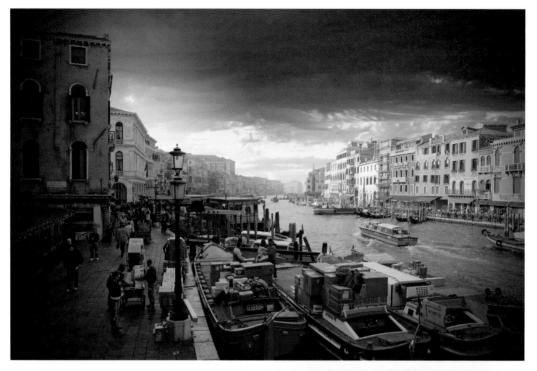

Original Venice image by Craig Shell (sky by Mark Galer)

Replacing a sky - Project 5

The sky is an essential ingredient of any memorable landscape image. Unfortunately it is not something the photographer can control unless we have limitless time and patience. The commercial photographer is often required to deliver the goods on a day that suits the client rather than the photographer and weather forecast. In these instances it is worth building a personal stock library of impressive skies that can be utilized to turn ordinary images with bland skies into impressive ones. The digital compact set to a low ISO is ideal for capturing these fleeting moments. The most useful skies to collect are the ones that include detail close to the horizon line, i.e. captured without interference from busy urban skylines, such as can be found at the beach or in the desert. A stock library of skies is included on the DVD to help you start, or add to, your own collection. In this project we explore how a sky can be adapted to fit the landscape so the montage is not immediately obvious.

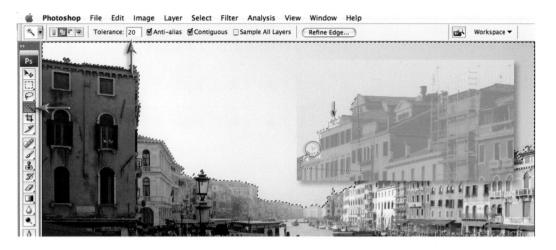

1. Select the Magic Wand Tool from the Tools palette and set the Tolerance to 20 in the Options bar. Select the Add to Selection icon in the Options bar or hold down the Shift key as you click multiple times to select all of the sky. Zoom in to 100% or 'Actual Pixels' and select Quick Mask mode from the Tools palette. Use the Polygonal Lasso Tool to select the tops of the buildings that were not included in the mask because the Magic Wand may have become overzealous. Fill this selection with black (if Black is the foreground color in the Tools palette you may use the keyboard shortcut Alt/Option + Backspace/Delete). Exit Quick Mask mode when this work is finished (keyboard shortcut is to press the letter Q).

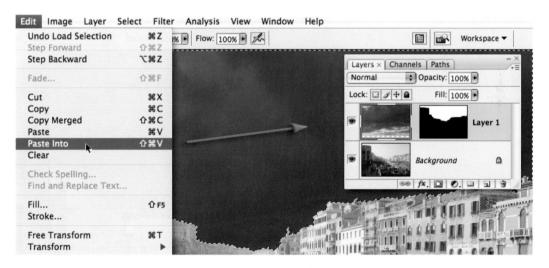

2. Open the Sky image used in this project and from the Select menu choose All. From the Edit menu choose Copy. Return to the Venice image and from the Edit menu choose Paste Into. Don't be alarmed at how bad it looks at the moment, we have several more steps to go before things start to look OK. For the moment we must be content that the sky was captured at a similar time of day to the Venice image and the direction of light is also similar. From the Select menu choose Deselect.

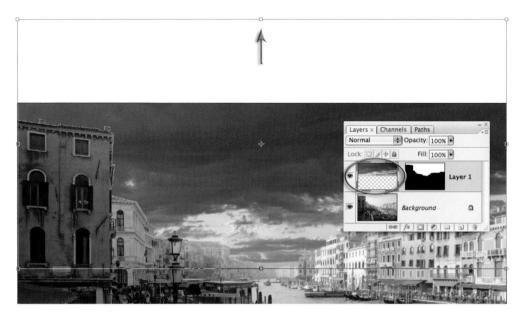

3. Make sure the image rather than the mask is the active component of the layer and then choose Free Transform from the Edit menu (Ctrl/Command + T). Click and drag inside the Transform bounding box to raise the sky into position. Click and drag on the top-center handle to further enhance the location and shape of the sky to fit the host image. Press the Enter/Return key to commit the transformation.

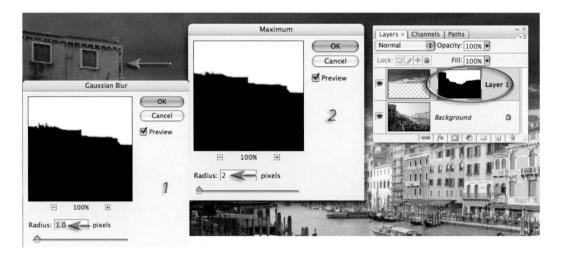

4. Click on the layer mask to make it active and then go to Filter > Blur > Gaussian Blur. Choose a 1-pixel Radius in the Gaussian Blur dialog box and select OK. Go to Filter > Other > Maximum and enter a Radius of 2 pixels. This should be sufficient to remove any light halo from around the edges of the buildings. A more precise method of controlling the accuracy of the edge would be to use a Levels adjustment as outlined in the previous project. Select OK to apply these changes to the mask.

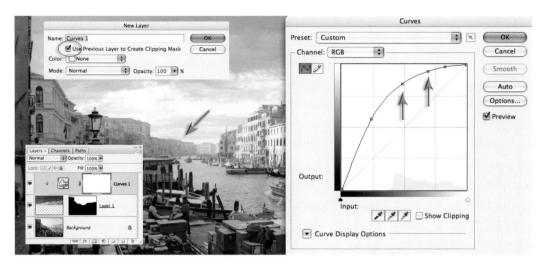

5. Hold down the Alt/Option key and select a Curves adjustment layer from the 'Create new fill or adjustment layer' icon in the Layers palette. In the New Layer dialog box check the Use Previous Layer to Create Clipping Mask option. Select OK to open the Curves dialog box. Create a curve that renders both the highlights and midtones of the sky very bright so that they match the tones of the distant buildings. Skies that have been captured in less humid conditions will always require this adjustment if they are to look at home in a location where there is reduced contrast together with lighter tones in the distant subject matter. Select OK to apply the changes.

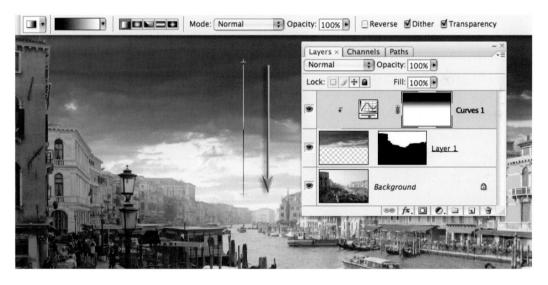

6. Select the Gradient Tool from the Tools palette. In the Options bar choose the Black, White and Linear gradient options and an Opacity setting of 100%. Click and drag a gradient from the top of the image to a position just above the horizon line. Hold down the Shift key to constrain the gradient. This will give the sky depth and ensure the sky retains its drama above the buildings in the foreground.

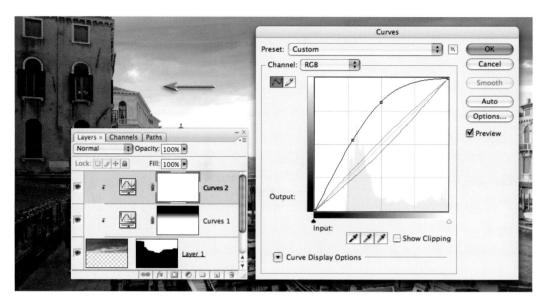

7. Create a second Curves adjustment layer by holding down the Alt/Option key and adding this layer to the Clipping mask. The purpose of this second adjustment layer is to increase the intensity of the light on the left side of the image. This will help establish the light source that is bathing the buildings on the right side of the image in a warm afternoon glow and help establish a realistic effect. Raise the overall brightness using the RGB channel and increase the warmth using the individual Red and Blue channels. Observe the effect above the foreground buildings on the left side of the image. When you have achieved a warm glow select OK.

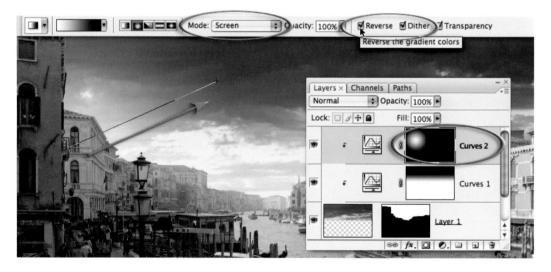

8. Fill the layer mask with Black (Edit > Fill > Black). Select the Gradient Tool from the Tools palette. Select the Black, White and Radial options. Set the mode to Screen and select the Reverse checkbox in the Options bar. Drag a short gradient from behind the buildings on the left side of the image to the top-center of the image.

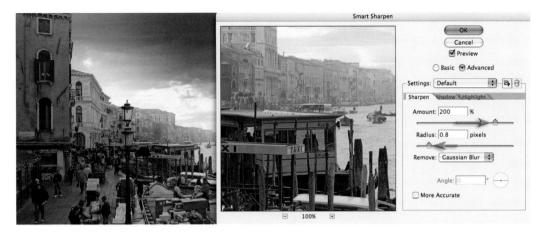

9. Click on the background layer and choose Convert Layer for Smart Filters. Go to Filter > Sharpen > Smart Sharpen. Sharpen the image and select OK. You can be generous with the sharpening as the opacity of the filter can be lowered or the settings modified at any point in the future in a completely non-destructive way.

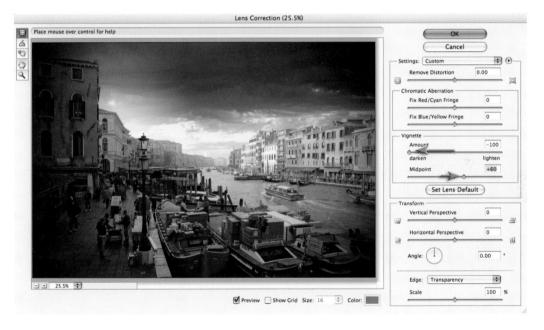

10. Stamp the visible layers to a new layer (Select All, Copy Merged and Paste). Go to Filter > Distort > Lens Correction. Go to the Vignette section of the dialog box and lower the Amount slider to -100. Again we can be generous with the amount as the opacity of the layer holding the vignette can be lowered to reduce the effect. Raise the Midpoint slider slightly so that the vignette does not encroach too heavily on the buildings on the extreme right-hand side of the image. Select OK to apply these changes. The project is now complete and the scene carries all of the mood of an old Venetian painting courtesy of a dramatic sky.

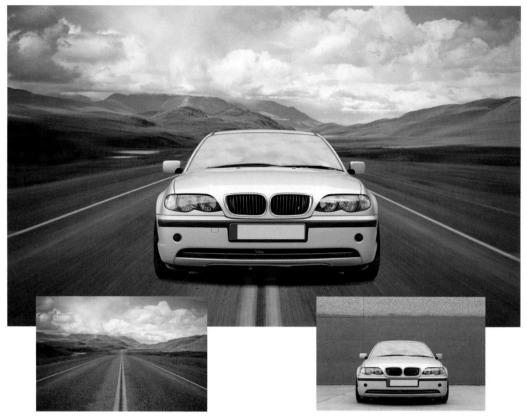

Endless Highway 2 - ra-photos and BMW 318i - felixR (www.iStockphoto.com)

Shadows and blur - Project 6

The preservation of the original shadows when the subject gets transported to a new location is one of the most essential ingredients for creating a realistic montage. Graphic designers all-too-often resort to recreating a shadow from scratch rather the preserving the original shadow, thereby creating a graphic, rather than a photographic, effect. When capturing a subject for a montage project try to capture all of the shadow on a smooth textured surface or on a surface with a similar texture to the new location. Other critical factors in the creation of a realistic montage are as follows:

- Continuity of vantage point (the camera angle to the subject and the background should be the same).
- Continuity of depth of field (if in doubt shoot both the subject and the background at a small aperture and reduce depth of field in post-production).
- Continuity of perspective. Keep the same relative distance from your subjects (zoom in rather than moving close to small objects).
- Continuity of lighting. The angle of light source to the subject and background and the quality of lighting (harsh or diffuse) should be the same.

This project will explore the technique of simulated movement to reanimate stationary objects or surroundings.

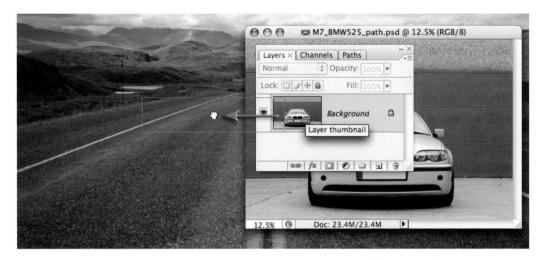

1. Open both of the project images and make the image of the car the active window. Click and drag the background layer thumbnail from the Layers palette into the landscape image and hold down the Shift key as you release the mouse button to center the image.

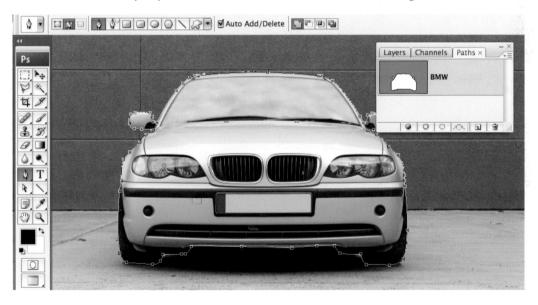

2. Use the Pen Tool to make an accurate Path around the car (see Project 3 in this chapter). A path of the car has already been created in both project files to fast-track this part of the project.

Note > The Path is also available in the landscape image as the path of the car will not be transferred to the landscape image by dragging the background layer thumbnail from the image file of the car. Dragging a Path thumbnail from the Paths palette into another image will transfer the path but it will only remain in alignment with the subject if an additional path is created around the corners of the image using the 'Intersect path areas' option in the Options bar. This has been included in the resource image for this project.

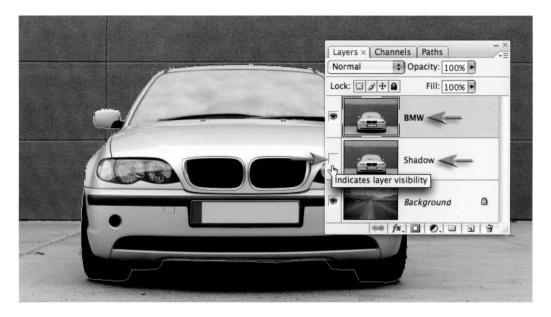

3. Duplicate the layer of the car (Ctrl/Command + J). Double-click on the name of each layer to rename the layers. Name the layer in the middle 'Shadow' and then click on the visibility icon to temporarily hide this layer.

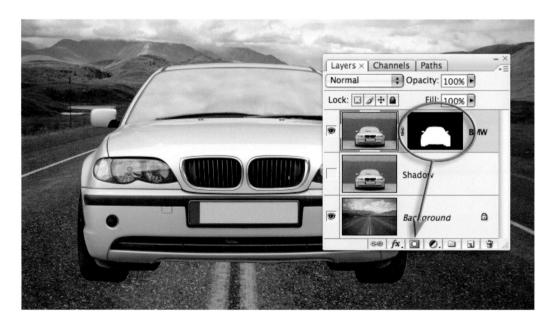

4. In the Paths palette hold down the Command key (Mac) or Ctrl key (PC) and click on the Path thumbnail to load it as a selection. Return to the Layers palette and select the car layer to make it the active layer. Click on the 'Add layer mask' icon in the Layers palette to create a layer mask that hides the background surrounding the car.

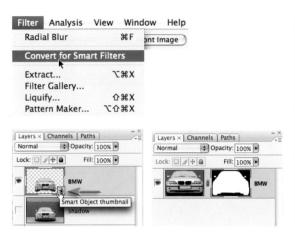

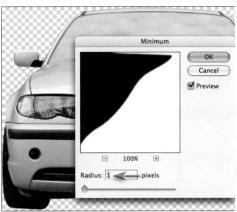

5. Convert this layer into a Smart Object by either selecting Convert for Smart Filters from the Filter menu or going to Layer > Smart Objects > Convert to Smart Object. The layer mask will now appear to be missing but it is still a part of the Smart Object and can be edited. Double-click the Smart Object thumbnail to access the layer mask. Click on the Layer mask and apply a 1-pixel Gaussian Blur (Filter > Blur > Gaussian Blur). Select OK and then apply the Minimum filter (Filter > Other > Minimum). Choose a 1-pixel Radius and select OK. Save the changes (Edit > Save) and close the file. These changes will update the Smart Object in the project file.

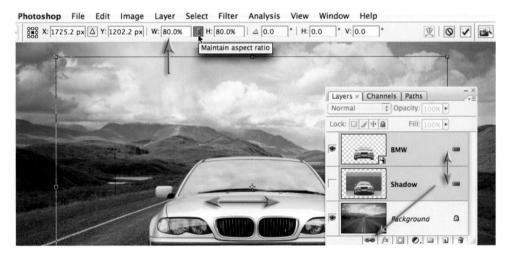

6. Hold down the Shift key and click on the shadow layer so that both the car layer and shadow layer are selected. Click on the 'Link layers' icon so that both layers are linked. Use the Free Transform command (Ctrl/Command + T) to modify the size of the car and its shadow at the same time. Click on the 'Maintain aspect ratio' in the Options bar and reduce the size to approximately 80% of its original size. Drag inside the Transform bounding box to center the car in the road. Press the Enter/Return key to commit the transformation. As the car layer is a Smart Object no pixels are being discarded in this process so the car can be made larger at any time with no loss in quality (scaling beyond the original size, however, will still result in a degraded image even in a smart layer).

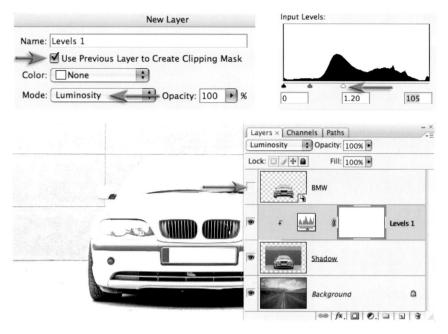

7. Turn off the visibility of the BMW layer. Click on the Shadow layer to make it the active layer. Hold down the Ctrl key (PC) or Command key (Mac) and go to the 'Create new fill or adjustment layer' menu in the Layers palette and select a Levels adjustment layer. Check the Use Previous Layer to Create Clipping Mask option and set the mode to Luminosity (the Luminosity mode will prevent changes in color values). Select OK and in the Levels dialog box drag the highlight slider (underneath the histogram) to the left until the road around the shadow is clipped to white. Adjust the central Gamma slider to control the brightness of the shadow itself. Select OK to apply these changes.

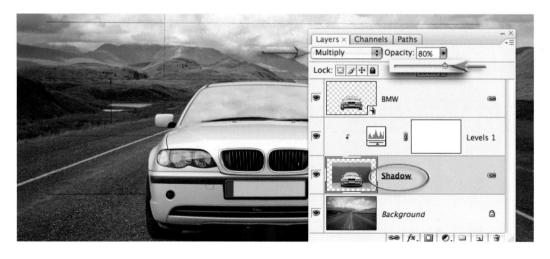

8. Change the blend mode of the Shadow layer to Multiply and adjust the opacity of the layer to further refine the quality of the shadow. Some details in the Shadow layer will still be visible at present but these will be removed in the next step.

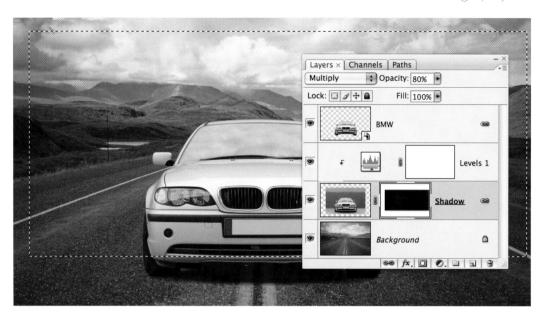

9. Add a layer mask to the Shadow layer and then make a selection that includes all of the image on this layer that is not part of the shadow. Fill this selection with Black (Edit > Fill > Black). Alternatively you could select the Brush Tool and paint in the layer mask with black to hide any bits of the wall that are still visible. Your car has now been reunited with its shadow.

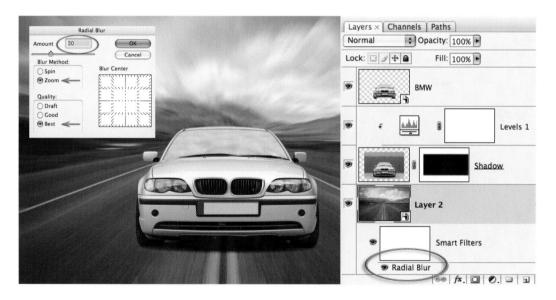

10. Select the background layer in the Layers palette. Select Convert for Smart Filters in the Filter menu and go to Filter > Blur > Radial Blur. Set the Amount slider to 30, select the Zoom option and select Good or Best from the Quality settings. Select OK to apply the filter. If the effect is not enough, or too excessive, double-click Radial Blur in the Smart Filter component of the layer to reopen the dialog box so that the settings can be adjusted.

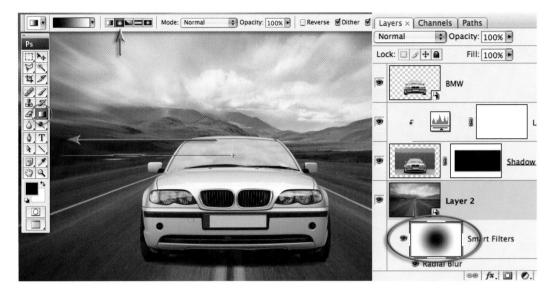

11. Click on the Smart Filters Layer Mask in the Layers palette. Select the Gradient Tool from the Tools palette. Choose the Black, White and Radial options in the Options bar. Set the Opacity to 100% and drag a gradient from the center of the image to the edge of the image window to conceal the effect as the subject matter recedes into the distance.

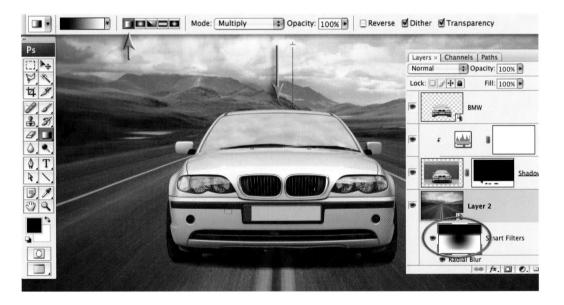

12. Switch to a Linear Gradient and set the mode to Multiply in order to add another gradient to the layer mask. Drag a gradient to hide the effects of the Radial Blur filter from the sky. As most of the components of this montage are 'smart', there are limitless opportunities to fine-tune the image without sacrificing any quality.

The best technique for subtle shadows

The technique outlined in this project provides those photographers burdened with a meticulous eye a useful way of retaining and transplanting subtle and complex shadows. Observe the subtle shadow cast by the leaf above that would be virtually impossible to re-create using any other technique. The primary reasons for not being able to use this technique are when the shadow falls over a surface with a different texture to the one in the new location, or the surface over which the shadow falls is particularly uneven or moves from a horizontal to a vertical plane over the length of the shadow.

Creating shadows

If it is not possible to preserve the original shadow, try to capture a second image from the direction of the light source. This second image will allow you to create a more accurate shadow than simply using the outline of the subject as seen from the camera angle. Start this technique by making a mask of your subject and place it on a layer above a new background you wish to use. Import the second image (captured from the direction of the light source) and position it between the subject layer and the background layer. Make a selection of the subject in this second image, create a new empty layer and then fill your selection with black. You can then hide or delete the layer that the selection was made from. Place your new shadow layer in Multiply mode. Lower the opacity of your shadow layer and apply the Gaussian Blur filter. Use the Free Transform command to distort and move the shadow into position.

Spinning wheels

The Motion Blur filter rather than the Radial Blur filter dominates the effect in the image above. The Radial Blur filter is, however, used to spin the wheels. When the wheels appear as an ellipse the following technique must be used to ensure a quality result.

Make a selection with the Circular Marquee Tool using a small amount of feather. Copy the wheel and paste it into a new layer. Use the Free Transform command and drag the side handle of the bounding box until the wheel appears as a circle instead of an ellipse. To get the best result from the Radial Blur filter we must present the wheel on the same plane to the one in which the filter works, i.e. front on. From the Blur group of Filters choose the Radial Blur filter. When you have applied the filter choose the Transform command again and return the wheel to its original elliptical shape.

High dynamic range - Project 7

Contrary to popular opinion – what you see is not what you always get. You may be able to see the detail in those dark shadows and bright highlights when the sun is shining – but can your CCD or CMOS sensor? Contrast in a scene is often a photographer's worst enemy. Contrast is a sneak thief that steals away the detail in the highlights or shadows (sometimes both). A wedding photographer will deal with the problem by using fill-flash to lower the subject contrast; commercial photographers diffuse their own light source or use additional fill lighting and check for missing detail using the 'Histogram'.

Upper Yarra River by Mark Galer

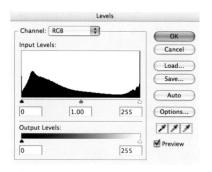

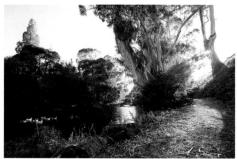

Landscape photographers, however, have dRawn the short stRaw when it comes to solving the contrast problem. For the landscape photographer there is no 'quick fix'. A reflector that can fill the shadows of the Grand Canyon has yet to be made and diffusing the sun's light is only going to happen if the clouds are prepared to play ball.

Ansel Adams (the famous landscape photographer) developed 'The Zone System' to deal with the high-contrast vistas he encountered in California. By careful exposure and processing he found he could extend the film's ability to record high-contrast landscapes and create a black and white print with full detail. Unlike film, however, the latitude of a digital imaging sensor (its ability to record a subject brightness range) is fixed. In this respect the sensor is a strait-jacket for our aims to create tonally rich images when the sun is shining – or is it? Here is a post-production 'tone system' that will enrich you and your images.

Note > To exploit the full dynamic range that your image sensor is capable of, it is recommended that you capture in Raw mode. JPEG or TIFF processing in-camera may clip the shadow and highlight detail (see Adobe Camera Raw).

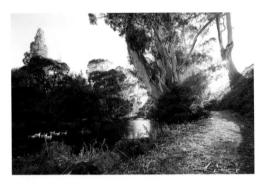

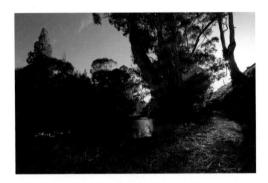

1. If we can't fit all the goodies in one exposure, then we'll just have to take two or more. The idea is to montage, or blend, the best of both worlds (the light and dark side of the camera's, not quite, all seeing eye). To make the post-production easier we need to take a little care in the pre-production, i.e. mount the camera securely on a sturdy tripod. Take four exposures – two overexposing from the auto reading, and the other two underexposing from the auto reading. One or two stops either side of the meter-indicated exposure should cover most high-contrast situations.

Note > If you intend to use the new 'Automate > Merge to HDR' (High Dynamic Range) feature Adobe recommends that you use the shutter speed to bracket the exposures. This will ensure the depth of field is consistent between the exposures.

Bracketing exposures

Setting your camera to 'auto bracket exposure mode' means that you don't have to touch the camera between the two exposures, thereby ensuring the first and second exposures can be exactly aligned with the minimum of fuss (the new Auto-Align Layers feature in CS3 does not work when your layers are Smart Objects). Use a cable release or the camera's timer to allow any camera vibration to settle. The only other movement to be aware of is something beyond your control. If there is a gale blowing (or even a moderate gust) you are not going to get the leaves on the trees to align perfectly in post-production. This also goes for fast-moving clouds and anything else that is likely to be zooming around in the fraction of a second between the first and second exposures.

Merge to HDR

The Merge to HDR (High Dynamic Range) automated feature has been improved for CS3. A series of bracketed exposures can be selected and the Merge to HDR feature then aligns the images automatically. The Merge to HDR dialog box then opens and the user is invited to select a bit depth and a white point. It is recommended to save the file as a 32-bit image. This allows the exposure and gamma to be fine-tuned after the image is opened into Photoshop by going to Image > Adjustments > Exposure. As editing in 32 Bits/Channel is exceptionally limited the user will inevitably want to drop the bit depth to 16 or 8 Bits/ Channel at some stage to make use of the full range of adjustment features.

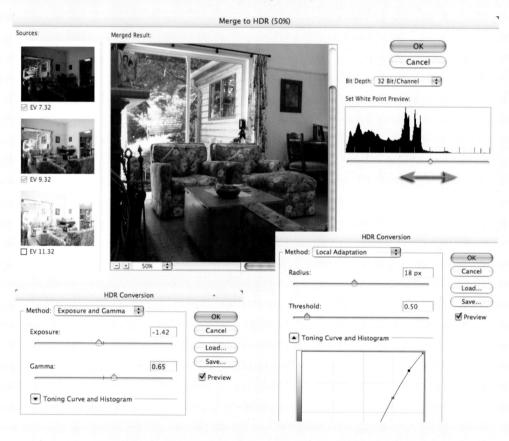

When the Photoshop user converts an HDR 32-bit image to 16 or 8 Bits/Channel the user can choose a conversion method that allows the best tonal conversion for the job in hand. With very precise working methods HDR images can provide the professional photographer with a useful workflow to combat extreme contrast working environments. For situations where HDR is required but people or animals are likely to move between exposures a manual approach to merging the exposures is highly recommended. The best manual technique for blending exposures is outlined in the following pages. The last two steps of the technique are also recommended for users who adopt the automated method as the results can often appear flat and unrealistic.

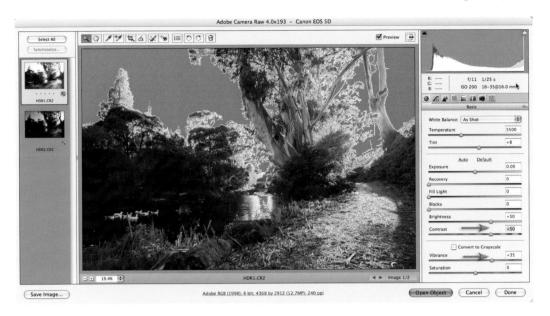

2. Select both of the HDR project images and open them in Adobe Camera Raw. Click on the lighter image thumbnail and optimize the shadow detail (pay no attention to the highlights that will clip). Raise the Brightness, Contrast and Vibrance sliders to optimize the shadows (+50, +50 and +35).

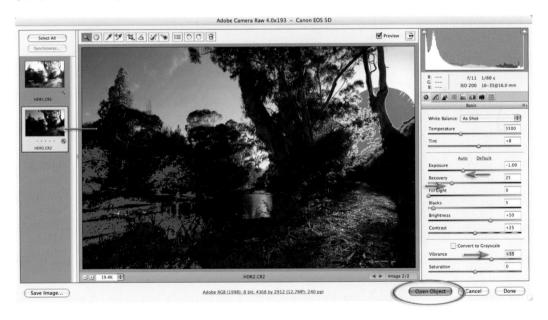

3. Click on the darker thumbnail and this time optimize the highlight detail. Drag the Exposure slider to -1.00, drag the Recovery slider to +25 and lower the Contrast slider to +25. A small amount of clipping will remain around the sun but this is perfectly acceptable. Click on Select All in the top left-hand corner of the ACR dialog box and while holding down the Shift key click on the Open Objects button.

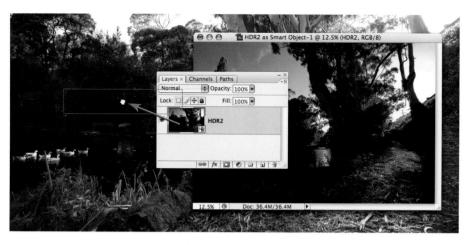

4. Select the 'Move Tool' in the Tools palette and drag the dark underexposed image into the window of the lighter overexposed image (alternatively just drag the thumbnail from the Layers palette with any tool selected). Holding down the Shift key as you let go of the image will align the two layers (but not necessarily the two images).

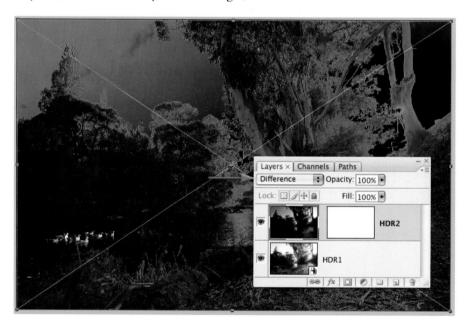

5. In the Layers palette set the blend mode of the top layer to 'Difference' to check the alignment of the two images. If they align no white edges will be apparent (usually the case if the tripod was sturdy and the two exposures were made via an auto timer feature or cable release). If you had to resort to a friend's right shoulder you will now spend the time you thought you had saved earlier doing the following steps. To make a perfect alignment you need to select 'Free Transform' (Edit > Free Transform). Nudge the left side into alignment and then move the reference point location in the Options bar to the left-hand side of the square. Highlight the numbers in the rotation field in the Options bar and then rotate the image into final alignment.

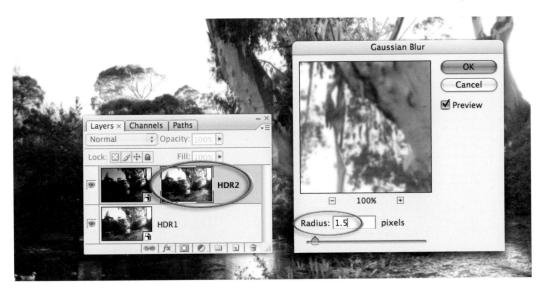

6. Click on the 'Add layer mask' icon in the Layers palette. Switch off the visibility of this layer by clicking on the eye icon next to the layer thumbnail. Choose 'All' from the Select menu (Ctrl/Command + A) and then choose Copy Merged from the Edit menu (Shift + Ctrl/Command + C). Hold down the Alt/Option key and click on the layer thumbnail. The image window should appear white as the layer mask is empty. Now choose 'Paste' from the Edit menu (Ctrl/Command + V). Apply a 1.5-pixel Gaussian Blur (Filter > Blur > Gaussian Blur) to this mask before. Alt/Command-click to return to the normal view.

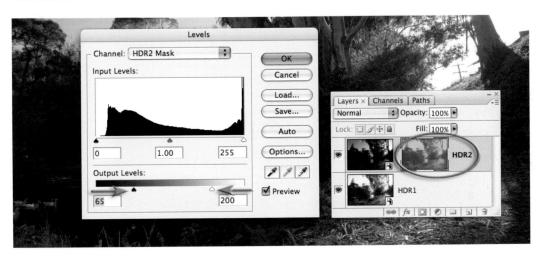

7. It is important to recreate the expanded contrast of the original scene otherwise the image will look slightly surreal if the overall contrast is low. The first technique to expand the contrast is to select the layer mask and apply a Levels adjustment (Ctrl/Command + L). Drag in the Output sliders (directly beneath the Shadow and Highlight sliders) until the final contrast appears high but not clipped (lowering the contrast of the mask increases the contrast of the final image).

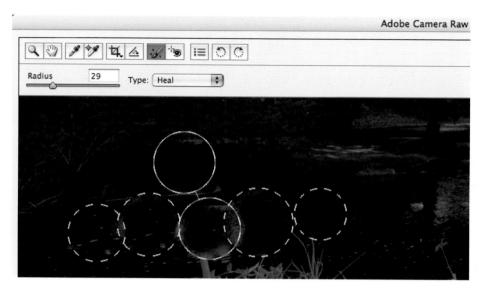

8. The observant among us will have noticed the ducks have been breeding. The ghost images can be removed by double-clicking the layer thumbnail of the top layer, or Smart Object, in the Layers palette to open the ACR dialog box. Use the Retouch Tool in the ACR dialog box to remove the ducks from the river. You will need to perform this task one or two ducks at a time to prevent the healing area from becoming too large. If the heal area becomes contaminated with lighter pixels from adjacent ducks switch from Heal to Clone in the Type options. Select OK to apply the changes.

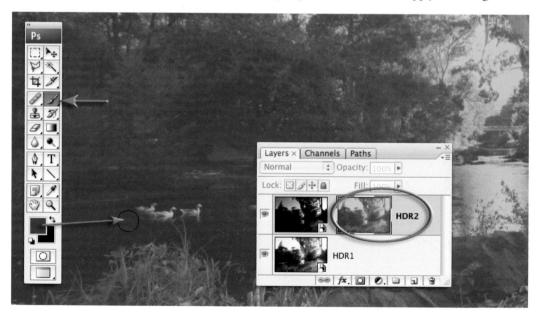

9. Hold down the Alt/Option key and click on the layer mask thumbnail. Select the Brush Tool and hold down the Alt/Option key and click on a gray tone next to the ducks to sample the color. Paint over the ducks using a soft-edged brush. Click on the Image thumbnail to return to the normal view. The ducks should now be ghost-free.

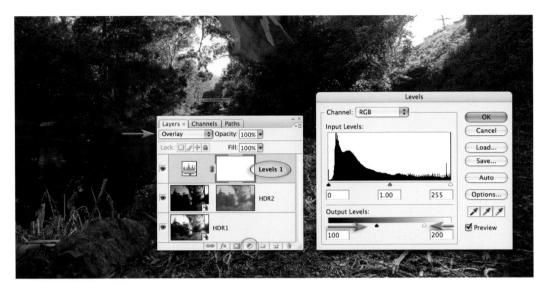

10. From the 'Create new fill or adjustment layer' menu in the Layers palette hold down the Alt/Option key and select a Levels adjustment layer. From the new Layer dialog box select the Overlay or Soft Light mode. In the Levels dialog box drag the two output sliders towards the center of the gray ramp to limit the increase in contrast to just the midtones (levels 100 to 200).

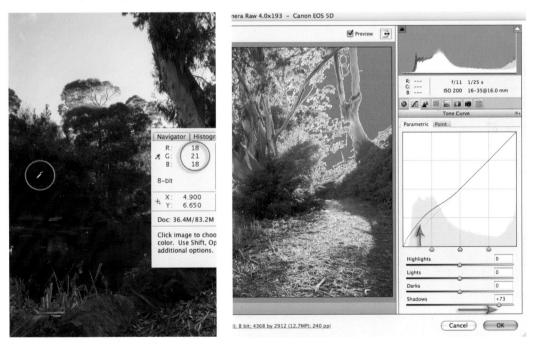

11. Open the Info palette and look at the RGB values when the mouse cursor is positioned over the dark shadow tones in the image window. If they are too dark to print to a typical output device (below level 15), you can double-click the bottom Smart Object to reopen the ACR dialog box. In the Tone Curve tab raise the shadow values as required. Select OK to apply the changes.

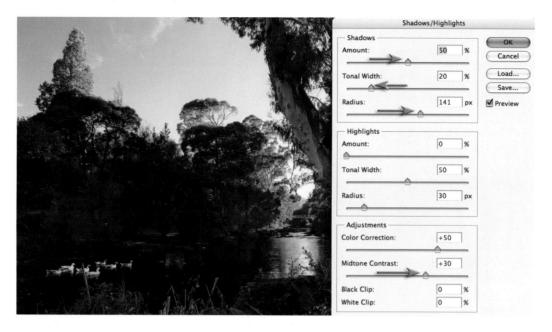

12. One way of controlling luminance and contrast in the shadows is to apply a Shadow/ Highlight adjustment to the base Smart Object (Image > Adjustments > Shadow/Highlight). Both the Midtone contrast slider and the Radius slider in the Shadows section can be used to control the localized contrast in the shadows. Select OK to apply this adjustment as a Smart Filter to the Smart Object.

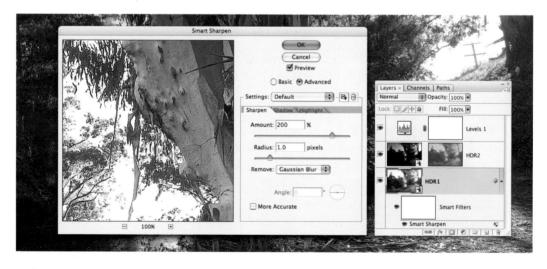

13. Complete the project by adding a Smart Sharpen filter to the same Smart Object, as this is where the bulk of the fine detail resides in this composite image. Select OK to apply the changes. Applying a sharpen filter to this Smart Object (a camera Raw file) instead of a rasterized layer (created by merging the visible elements to a new layer) means that we have deferred applying any 'destructive' changes to the image data in this file. The automated HDR feature would have to process the data to achieve the same result and the ducks would not be happy.

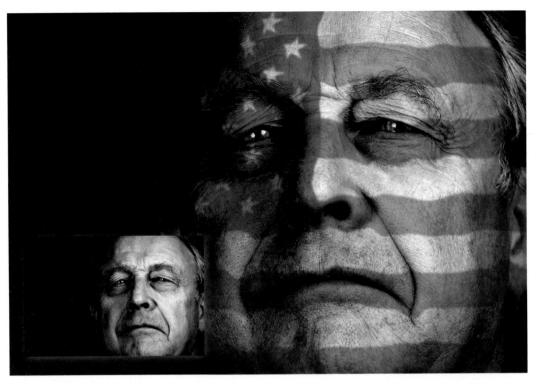

Original image by Duncan P Walker (www.iStockphoto.com)

Duncan P Walker also created the image titled American Patriot on page 153

Displace and Liquify - Project 8

The layer 'blend' modes are an effective, but limited, way of merging or blending a pattern or graphic with a three-dimensional form. By using the blend modes the pattern or graphic can be modified to respect the color and tonality of the 3D form beneath it. The highlights and shadows that give the 3D form its shape can, however, be further utilized to wrap or bend the pattern or graphic so that it obeys the form's perspective and sense of volume. This can be achieved by using the 'Displace' filter in conjunction with a 'displacement map'. The 'map' defines the contours to which the graphic or pattern must conform. The final effect can be likened to 'shrink-wrapping' the graphic or pattern to the 3D form.

Displacement requires the use of a PSD image file or 'displacement map' created from the layer containing the 3D form. This is used as the contour map to displace pixels of another layer (the pattern or graphic). The brightness level of each pixel in the map directs the filter to shift the corresponding pixel of the selected layer in a horizontal or vertical plane. The principle on which this technique works is that of 'mountains and valleys'. Dark pixels in the map shift the graphic pixels down into the shaded valleys of the 3D form while the light pixels of the map raise the graphic pixels onto the illuminated peaks of the 3D form.

The alternative to using a displacement map is to use the Liquify filter. The Liquify filter allows the use to push pixels around as if they were a thick liquid. It is possible to freeze areas of the image so that they are not accidentally moved in this process. This project will explore both alternatives.

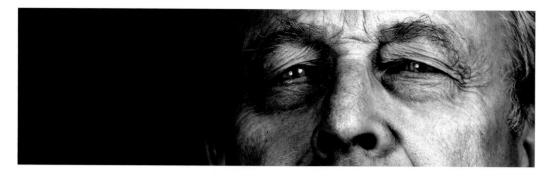

The limitation of the displacement technique is that the filter reads dark pixels in the image as being shaded and light pixels as being illuminated. This of course is not always the case. With this in mind the range of images that lend themselves to this technique is limited. A zebra would be a poor choice on which to wrap a flag while a nude illuminated with soft directional lighting would be a good choice. The image chosen for this project lends itself to the displacement technique. Directional light models the face. Tonal differences due to hue are limited.

Note how the straight lines of the flag are distorted after the Displace filter has been applied. The first image looks as though the flag has been projected onto the fabric, while the second image shows the effect of the displacement filter – it appears as though it has been woven or printed onto the surface of the fabric.

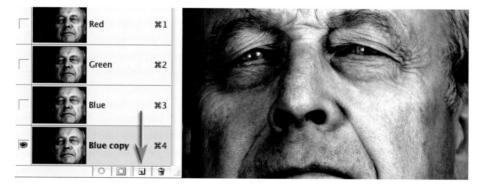

1. In order to apply the Displace filter you must first create a grayscale image to become the displacement map. Open the project images from the DVD. In the Channels palette locate the channel with the best tonal contrast between the shadows and the highlights (in this case the Blue layer). Duplicate this channel by dragging it to the New Layer icon at the base of the palette.

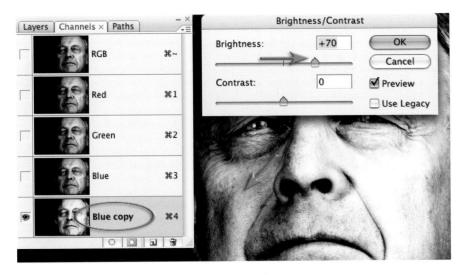

2. With the Blue copy selected, go to Image > Adjustments > Brightness/Contrast. Raise the Brightness slider so that the tonality on the left side of the face extends from deep shadows to bright highlights (this will ensure good displacement on this side of the face). Select OK.

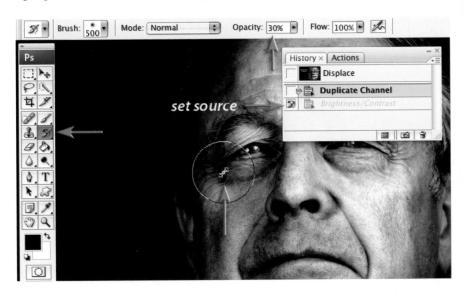

3. In the History palette click on the history step before this Brightness /Contrast adjustment to return to a point prior to the adjustment. Click in the checkbox to the left of the Brightness/Contrast history step to set the source for the History Brush Tool. Select the History Brush Tool in the Tools palette. Choose a large soft-edged brush and set the Opacity to 30%. Paint repeatedly over the left side of the face to apply the adjustment to the left side of the face only. You are creating a channel where both sides of the face have a full tonal range. You can further enhance the hills and valleys by selecting the Dodge or Burn Tools from the Tools palette. Set the Opacity to 20% or lower when using these tools and then proceed to either lighten the hills or darken the valleys as you see fit. Remember this is a displacement map not a photograph.

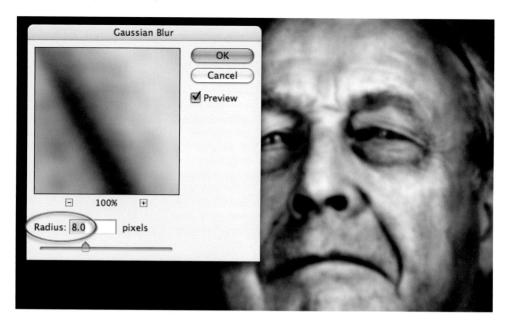

4. Apply 'Gaussian Blur' (Filter > Blur > Gaussian Blur) to the Blue copy channel. Applying a higher Radius of Gaussian Blur (closer to a Radius of 10 pixels) will create a mask that produces a smooth-edged displacement (minor flaws in the skin will be ignored). Using a lower Radius of Gaussian Blur (1 to 4 pixels) will create a mask that produces a ragged-edge displacement (every minor flaw in the skin will lead to displaced pixels).

Note > If the filters appeared 'grayed out' (temporarily not available) try clicking on the background layer in the Layers palette and then on the Blue copy channel.

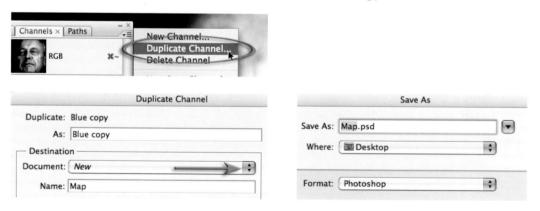

5. Export this channel to become the displacement map by choosing '**Duplicate Channel**' from the Channels menu and then '**Document** > **New**' from the Destination menu. When you select OK in the Duplicate Channel dialog box a file with a single channel will open in Photoshop. Save this file as a Photoshop file (your 'displacement map') to the same location on your computer as the file you are working on. You will need to access this 'map' several times in order to optimize the displacement.

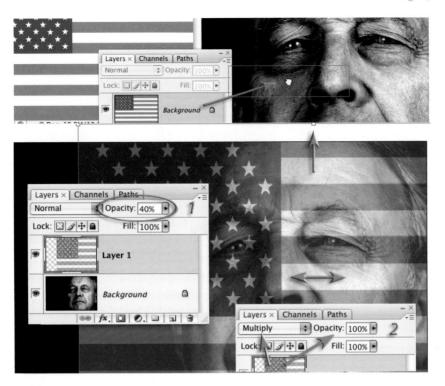

6. Open the flag image and drag the background layer thumbnail into the portrait image. Lower the Opacity of the layer to 40% and use the Move Tool to drag the image into a good location. Apply the 'Free Transform' from the Edit menu and drag the handles of the bounding box to achieve a 'good fit' (I have enlarged the flag slightly so the stars extend to the end of the nose). Hit the Return/Enter key to apply the transformation and then set the Opacity of the layer to 100% and the mode to Multiply.

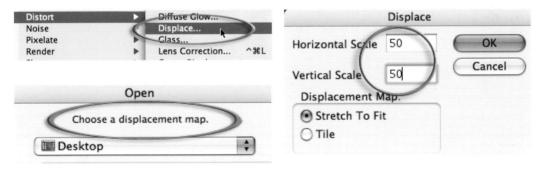

7. Choose Convert Layer for Smart Filters in the Filter menu. Choose 'Filter > Distort > Displace' and enter 40 to 50 in the Horizontal and Vertical Scale fields of the Displace dialog box. Select OK and then browse to the displacement map you created earlier. The displacement is then applied to the layer. The Displace filter shifts the pixels on the selected layer using a pixel value from the displacement map. Grayscale levels 0 and 255 are the maximum negative and positive shifts while level 128 (middle gray) produces no displacement.

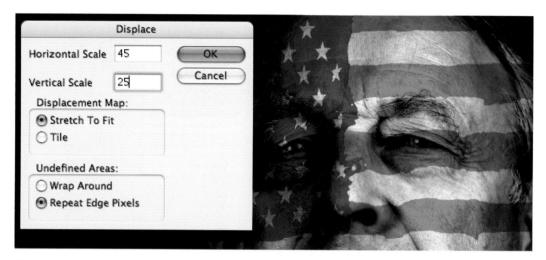

8. If the displacement is excessive, click on the Displace component of the Smart Filter to reopen the Displace dialog box, and then lower the settings. In the project image the Vertical Scale has been lowered to 25 so that the red stripes do not get excessively distorted. Notice how the filter will once again want to know where you stored your map. If you intend to re-edit this image at a later date the map must be stored with the image.

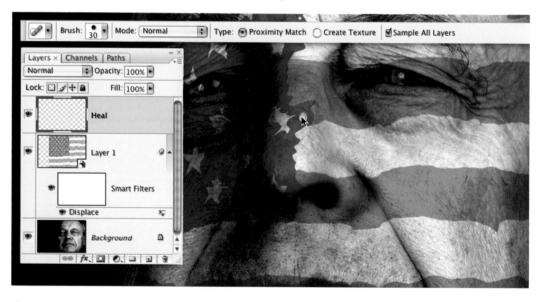

9. Click on the 'Create a new layer' icon in the Layers palette to add a new layer at the top of the layers stack. Choose the Spot Healing Brush from the Tools palette. Check the Sample All Layers option in the Options bar and choose a small hard-edged brush. Zoom in and paint over any 'holes' or 'islands' that may have appeared in the flag as a result of the displacement. Use a brush marginally bigger than the problem area to avoid creating further problems.

Note > If the Displace settings, Mode or Opacity of the flag layer is altered this layer will have to be deleted and a new one created. If you are happy with the displacement you could alternatively rasterize the Smart Object and apply the 'fixes' directly to the flag layer.

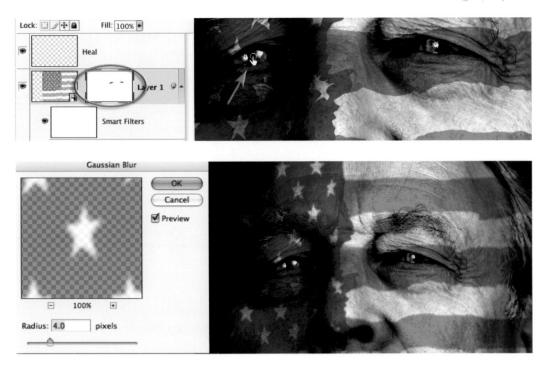

10. Apply a layer mask to the flag layer by clicking on the 'Add layer mask' icon in the Layers palette and then select the Brush Tool from the Tools palette. With Black as the foreground color choose a small soft-edged brush and set the Opacity to 100% in the Options bar. Paint over each eye to mask the flag in this region. Click on the flag thumbnail to make it the active component of the layer and then apply a 4-pixel Gaussian Blur (Filter > Blur > Gaussian Blur) to soften the effect.

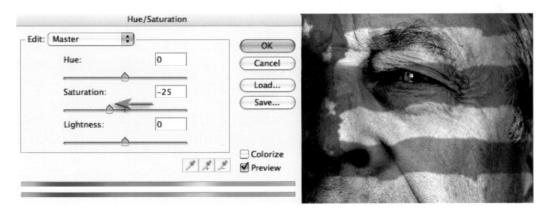

11. From the 'Create new fill or adjustment' menu in the Layers palette choose a Hue/ Saturation adjustment layer. Lower the saturation slider to -25 or until the colors of the flag feel comfortable against the desaturated tones of the portrait. You could alternatively apply the Hue/Saturation layer directly above the background layer and click on the Colorize option in the dialog box. In this case, move the Hue and Saturation sliders to -35 to achieve a skin tone.

Alternative approach using the 'Liquify' filter

An alternative approach to distorting the flag using the Displacement filter in 'Project 8' would be to use the 'Liquify' filter. Instead of using the 'Blue copy' channel to create a displacement map it can be used to 'freeze' an area of the image prior to selectively displacing the unfrozen pixels using the 'Warp Tool'. This alternative method of displacing pixels on one layer, to reflect the contours of another layer, is made possible in the Liquify filter due to the option to see the visibility of additional layers other than the one you are working on.

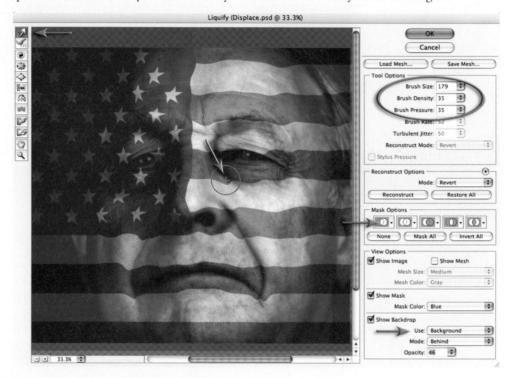

To try this alternative approach complete the first six steps of 'Project 8'. When you reach Step 7, instead of creating a displacement map, click on the flag layer and go to Filter > Liquify. Check the 'Show Backdrop' option in the dialog box and select 'background layer' from the menu. Adjust the opacity to create the optimum environment for displacing the pixels. To selectively freeze the darker pixels in the image load the 'Blue copy' channel in the 'Mask Options'. Select a brush size and pressure and then stroke the flag while observing the contours of the face to displace the lighter pixels. Select 'Invert All' in the 'Mask Options' so that you can displace the darker pixels.

Note > The Liquify filter cannot be applied to a Smart Object but the technique, although labor intensive, does offer the user a little more control over the displacement process. It is possible to save the distortions carried out in the Liquify filter as a 'Mesh'. This Mesh is like a topographic landscape and can be loaded to distort subsequent graphics to the same topography to create a similar distortion.

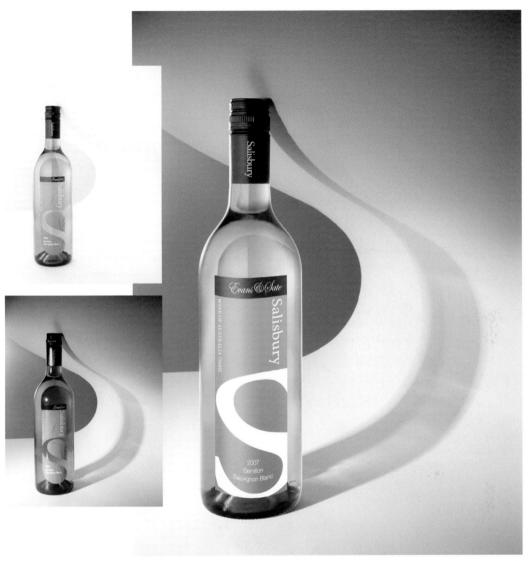

Paulina Hyrniewiecka

Composite lighting - Project 9

The lighting of a studio set is often compromised by either limitations of time or the complexity of the lighting that is required for the creative outcome. Take, for instance, the example above, where the ideal lighting required for the creative shadow and the wine is different. Perfect the lighting for one and the quality of the other is compromised. The solution is remarkably simple of course. Perfect the lighting for one at a time and then create a composite image in post-production. The drama of the shadow is created by a the use of a spotlight from the side, whereas the wine and label are lit with softer floodlights from the front and rear. Prior to CS3, pin-registering each exposure in-camera using a sturdy tripod was an essential requirement for the success of this technique. Small differences in camera position (such as knocking the tripod between exposures) can now be corrected using the new Auto-Align Layers command. This project concludes with replacing the label with a vector graphic.

1. Open the two project photographic images and make a composite image by dragging the background thumbnail (in the Layers palette) from the wine image into the shadow image. Rename the top layer (double-click the layer name) as 'Wine'. Shift-click both layers to select them. Select Auto-Align Layers from the Edit menu and select the Reposition Only option before selecting OK.

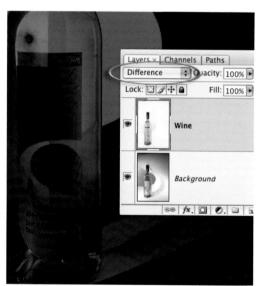

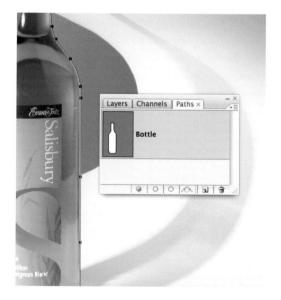

2. Check the alignment by temporarily setting the blend mode of the wine layer to Difference. If the layers have not been aligned using the Auto-Align Layers command (thin white lines along edges may be apparent, indicating misalignment), select the Move Tool and nudge them into position using the arrows on the keyboard. Return the blend mode to 'Normal' when alignment has been achieved. Make a path around the bottle using the Path Tool (see Paths and selections – Project 3). Save the Work Path and then hold down the Command key (Mac) or Ctrl key (PC) and click on the Path thumbnail to load it as a selection.

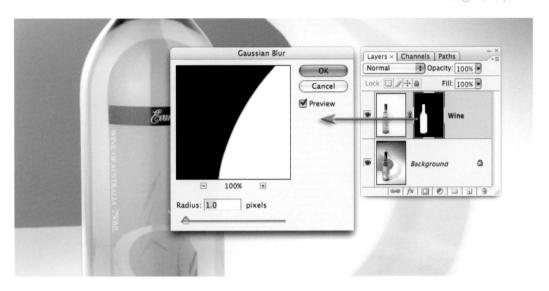

3. In the Layers palette select the Wine layer and then click on the 'Add layer mask' icon. Soften the edge of this layer mask by going to Filter > Blur > Gaussian Blur. A 1-pixel radius should be OK to give this bottle a smooth edge.

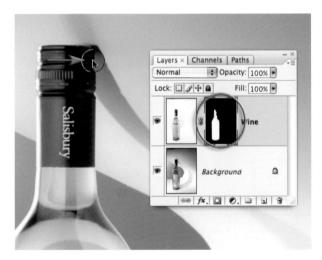

4. Select the Brush Tool from the Tools palette. Select Black as the foreground color and using a soft-edged brush set to 30% Opacity, paint to darken the right side of the bottle cap. Make several stokes with the brush to darken the cap further. Create a second Path around the label of the bottle. Save the Work Path and then hold down the Command key (Mac) or Ctrl key (PC) and click on the Path thumbnail to load it as a selection.

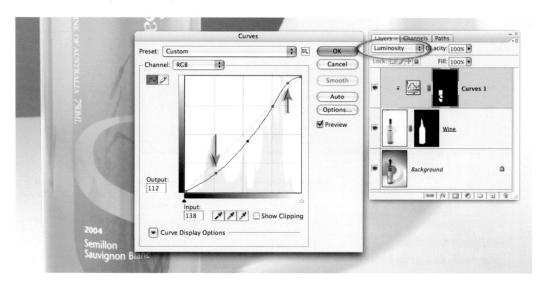

5. Hold down the Alt/Option key and select a Curves adjustment layer from the 'Create new fill or adjustment layer' icon in the Layers palette. In the New Layer dialog box that opens select the Use Previous Layer to Create Clipping Mask checkbox and set the mode to Luminosity. Select OK to open the Curves dialog box. Adjust the brightness and shadows to optimize the tonality for the label and select OK. Apply a 0.5-pixel Gaussian Blur filter to the mask (Filter > Blur > Gaussian Blur).

6. This step will straighten the sides of the bottle (not absolutely straight due to the slightly high camera angle). Stamp the visible elements of the layers into a new layer. The keyboard shortcut for this is to hold down the Ctrl + Alt + Shift keys and then type E (for PC) or to hold down the Command + Option + Shift keys and then type E (for Mac). With this composite layer on top of the layers stack use the Free Transform command (Command + T or Ctrl + T) and then click on the Warp icon in the Options bar. Access the rulers (Ctrl + R or Command + R) and then drag some guides into the edges of the bottle and label. The guides will provide feedback for when alignment has been achieved. Push gently at the sides of the bottle to make the bottle fit within the guides you have created.

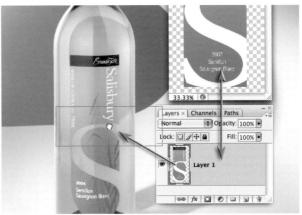

7. The image has been optimized for the shadow, the wine and the label, and the client then decides, belatedly, that the current pre-production label in three sections is to be changed in order to save production costs. They provide you with an EPS vector graphic (a vector file that can be scaled to suit the needs of your image) from the designer and have asked you to incorporate it into the image you have already captured. Open the EPS file in Photoshop choosing a 300ppi resolution in the Rasterize dialog box that opens. Drag the background thumbnail from the Layers palette into the composite image.

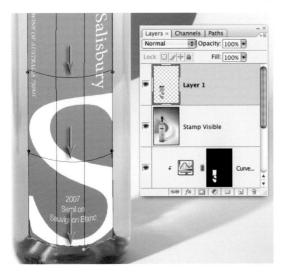

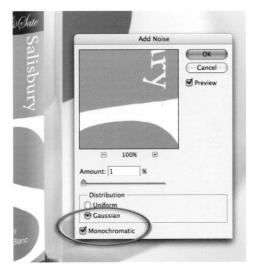

8. Apply the Free Transform command (Edit > Free Transform) to the label layer. Make the label slightly narrower by dragging one of the bounding box handles and then click inside the bounding box to drag the label into position. Select the Warp option in the Options bar and drag down just above each center section of the grid to recreate the curvature of the label (the curvature will be greater at the bottom than at the top of the label due to the camera angle used to capture the bottle). Commit the transformation by pressing the Return/Enter key and then go to Filter > Noise > Add Noise so that we can add texture to the label (the color in the graphic is flat at present). Add 1% Gaussian Noise to the label with the Monchromatic option checked.

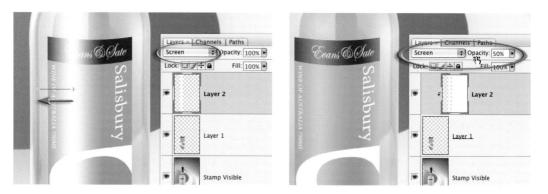

9. Click on the 'Create a new layer' icon in the Layers palette and set the blend mode of the layer to Screen. Select the Gradient Tool from the Tools palette and set the foreground color to White. In the Options bar choose the Foreground to Transparent gradient and the Reflected gradient option. Set the Opacity to 100%. Note the point just above the label where the reflection on the surface of the bottle is brightest. Click in this position and drag out towards the edge of the bottle (hold down the Shift key to constrain the gradient to a horizontal). Drop the Opacity in the Options bar to 50% and change to a Linear gradient. Again holding down the Shift key drag a second gradient from the right side of the bottle towards the center of the label. With Layer 2 active create a clipping mask (Layer > Create Clipping Mask) to restrict the gradients to the label only. Lower the Opacity of the layer to 50% to reduce the effect of these added highlights.

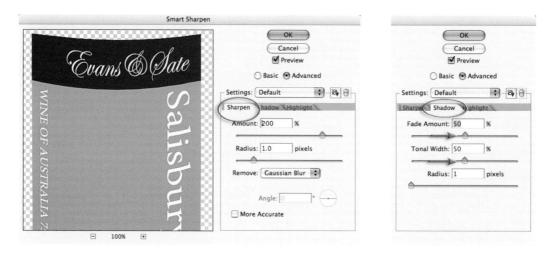

10. Convert the label layer to a Smart Object (Filter > Convert for Smart Filters) and then sharpen the label using the Smart Sharpen filter. In the advanced options set the Fade and Tonal Width sliders to 50% for both the Shadows and Highlights. Apply the same filter settings for the wine layer (Command/Ctrl + F). Hold down the Alt/Option key and click on the visibility icon of the Stamp Visible or composite layer. This will switch all of the other layers off so you can then see any areas that are transparent as a result of the Align Layers and Warp editing procedures. Crop away anything that is surplus to requirement and click on the Alt/Option visibility icon a second time to switch all of the layers back on.

Creating a panorama - Project 10

In recent years shooting multiple pictures of a scene and then stitching them to form a panoramic picture has become a popular project with digital photographers. For the last couple of versions of Photoshop, Photomerge has been the tool to use to stitch your photos together. In CS3 Photomerge and the blending and stitching technologies that sit beneath it have been given a total revamp. This feature combines a series of photographs into a single picture by ensuring that the edge details of each successive image are matched and blended so that the join is not detectable. Once all the individual photographs have been combined the result is a picture that shows a scene of any angle up to a full 360°.

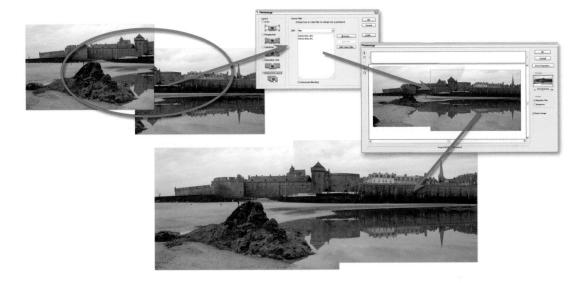

The feature can be started from the File menu (File > Automate > Photomerge) or via the Tools > Photoshop > Photomerge option in the Bridge file browser. The latter approach allows the user to select suitable source pictures from within the browser before activating the feature. Next you will be presented with a new Photomerge dialog containing five different stitching and blending or Layout options. They are:

Auto – aligns and blends source files automatically.

Perspective – deforms source files according to the perspective of the scene. This is a good option for panoramas containing 2 – 3 source files. Cylindrical – designed for panoramas that cover a wide angle of view. This option automatically maps the results back to a cylindrical format rather than the bow-tie shape that is typical of the Perspective option. Reposition Only – aligns the source files without distorting the pictures. Interactive Layout – transfers the files to the Photomerge workspace where individual source pictures can be manually adjusted within the Photomerge composition. This is the only non-auto option.

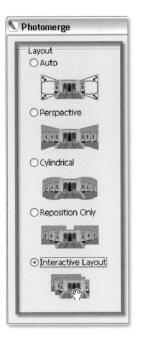

In most circumstances one of the auto options will easily position and stitch your pictures, but there will be occasions where one or more images will not be stitched correctly. In these circumstances use the Interactive Layout option. In the Photomerge workspace individual pieces of the panorama can be moved or rotated using the tools from the toolbar on the left-hand side of the dialog. Reposition Only and Perspective options are set using the controls on the right. Photoshop constructs the panorama when the OK button is clicked.

Ensuring accurate stitching

To ensure accurate stitching, successive images need to be shot with a consistent overlap of between 15 and 30%. The camera should be kept level throughout the shooting sequence and should be rotated around the nodal point of the lens (the pivot point of the lens/camera combination where the perspective in each photo remains constant) wherever possible. Special mounts that aid in nodal rotation are available for use on top of a standard tripod. The focal length, white balance, exposure and aperture need to remain constant while shooting all the source pictures (manual settings are suggested).

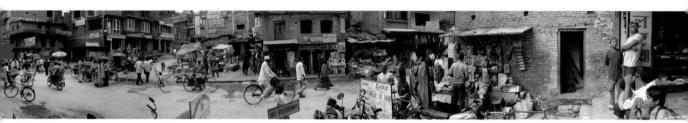

1. Select Photomerge from the File menu (File > Automate > Photomerge) to start a new panorama. Click the Browse button in the dialog box. Search through the thumbnails of your files to locate the pictures for your panorama. Click the Open button to add files to the Source Files section of the dialog. Alternatively you can start in Bridge by multi-selecting your source files first and then choosing Tools > Photoshop > Photomerge.

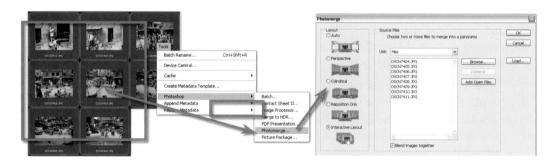

2. Now choose the Layout type from the Photomerge dialog. For most panoramas the Auto option is a good place to start. For very wide panoramas with many source files try the Cylindrical Layout and for stitches where it is important for the images to remain distortion free, pick Reposition only. For more manual control or in situations when the Auto option doesn't produce acceptable results choose the Interactive Layout option. The Advanced Blending option (bottom of the dialog) will try to smooth out uneven exposure or tonal differences between stitched pictures.

3. Select OK to start the stitching process. With all options the process will proceed automatically. The exception is the Interactive Layout option, which opens the Photomerge workspace and then allows you to start to edit the layout of your source images manually.

4. To change the view of the images in the Photomerge workspace use the Move View Tool or change the scale and the position of the whole composition with the Navigator. Images can be dragged to and from the light box to the work area with the Select Image Tool. With the Snap to Image function turned on, Photomerge will match like details of different images when they are dragged over each other. Checking the Use

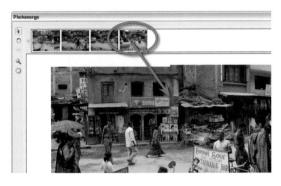

Perspective box will instruct Photoshop to use the first image placed into the layout area as the base for the composition of the whole panorama. Images placed into the composition later will be adjusted to fit the perspective of the base picture. The final panorama file is produced by clicking the OK button.

5. Once stitched the panorama opens in Photoshop. There will be edge portions of the document that contain no picture details. New picture detail can be cloned into these areas or the ragged edge of the panorama can be trimmed using the Crop Tool.

6. Though Photomerge does an admirable job of blending these individual street scenes together, there will be some areas in the finished panorama that have ghosted details or parts of a subject missing. These problems are due to people moving through the scene between exposures and occur most at the edges of frames. Thankfully the Photomerge file preserves the original

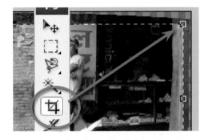

source images in separate layers and applies blending via a series of masks. Some of the ghosting problems can be corrected by editing the layer masks directly. Others can be fixed by masking the problem areas first before stitching (see Step 8 – *Mask then stitch* – for details). For example, the front wheel of the bike in the center of the picture is missing. To paint this detail back in, locate the bike layer and then hide the layer beneath it (click on the eye icon in the Layers palette). This approach works best if the source images have been captured with fixed exposure and white balance settings. When source images vary widely in brightness or color, balance these factors first, before stitching and mask editing.

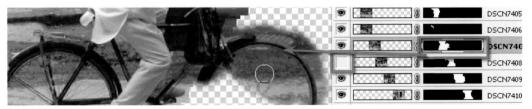

7. Next click onto the bike layer mask. Select the Brush Tool and set the foreground color to white (white reveals the image/black hides the image). Paint onto the image to reveal the wheel. Now show the under layer.

Notice that the wheel has now obscured the parking sign and the girl just behind it. Switch the foreground color to black and with the bike layer mask still selected, paint back in the parking sign and the girl. In reality, painting with black means that you are hiding the parts of the wheel that are obscuring the girl and sign.

If this mask editing solution still doesn't provide good results, try masking the problem areas such as the gent behind the bicycle and the girl in front of it, before sending the files to Photomerge.

8. Adjusting the blending masks should solve most ghosting problems, but in some circumstances you may need to find an alternative way to correct the problem. Try these solutions:

Remove – To remove the problem you can use the Healing Brush, Patch or Clone Stamp Tools to sample alternative parts of the scene and paint over stitching errors. The success of this type of work is largely based on how well you can select suitable areas to sample. Color, texture and tone need to be matched carefully if the changes are to be disguised in the final panorama. Be careful though, as repeated application of these tools can cause noticeable patterns or smoothing in the final picture. Repair – In some instances it is easier to select, copy and paste a complete version of the damaged subject from the original source image and paste it into the panorama picture. This approach covers the half blended subject with one that is still complete. If you have used the Perspective option in Photomerge or have resized the panorama then you will need to adjust the pasted subject to fit the background. Use the transformation tools such as Rotate, Perspective, Warp and Scale to help with this task.

Mask then stitch – Another option is to mask or erase the problem areas in the source images before using Photomerge to stitch the photos. With these picture parts no longer present in the source images Photomerge blends detail from other photos to fill the gap. When using this approach be sure to only mask (or erase) detail that is contained in the overlapping sections of the source photos. Going beyond this point will leave Photomerge no picture details in any source photos to use to fill the masked areas.

9. As a final touch you can non-destructively darken and lighten specific areas of the panorama (dodge and burn) by adding a blank layer to the top of the layer stack, changing the layer's blend mode to Soft Light and then painting with a black soft brush to darken and a white one to lighten. Both brushes are set to 30% Opacity or less.

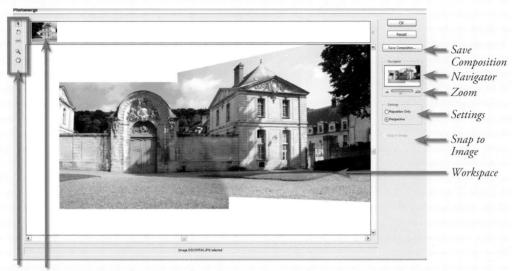

Tools Unused source images

Photomerge's Interactive Layout

The Interactive Layout option in the Photomerge dialog provides finer control over the placement of images within a composition. Unlike the other auto options, where blending and positioning of source images is determined by Photoshop, here you have control over where each photo is placed. Photomerge will still attempt to create a complete panorama from the files you have selected but once the workspace is open you can alter the composition in the following ways.

Removing pictures from the composition: Click and drag the photo to the slide bay at the top of the screen.

Adding unplaced photos: To place the images, make sure that the Snap to Image setting is checked (right side of the window) and then drag the picture into the workspace. In this way compositions can be slowly built from a series of source images.

Use perspective to place photos: Select the Perspective setting (right side of the screen). **Switch the photo used as the base image for perspective:** Select the Set Vanishing Point Tool (third from the top) and click onto a new source image.

To place photos without using perspective: Select the Reposition Only setting (right side of the screen).

To rotate source photos: Select the Rotate Image Tool (second from the top) and then click and drag the image to be rotated.

To reposition source photos within a composition: Choose the Select Image tool and click and drag the picture within the workspace. You may need to toggle the Snap to Image setting off and on to correctly align the picture.

To save a composition: After creating a complex panorama it is a good idea to save the composition with the button provided before leaving the Photomerge workspace.

To load a composition: Select File > Automate > Photomerge and click the Load button before browsing for the Photomerge Composition file (.PMG).

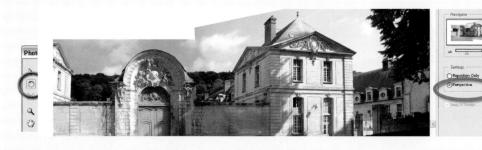

Solutions to common stitching problems

Misaligned picture parts

Shooting your source sequence by hand may be your only option when you are travelling light, but the inaccuracies of this method can produce panoramas with serious problems. One such problem is ghosting or misalignment. It is a phenomenon that occurs when edge elements of consecutive source pictures don't quite match.

When Photomerge tries to merge the unmatched areas of one frame into another the mismatched sections are left as semi-transparent, ghosted or misaligned.

You may be able to alleviate the problem by carefully rotating difficult source images using the Rotate Image Tool and then selecting the Perspective option from the settings on the right of the dialog. If all else fails then the only option may be to repair the affected areas using the Clone Stamp or Healing Brush Tools, but by far the best solution and certainly the most time-efficient one is to ensure that the camera and lens nodal point are situated over the pivot of the tripod at the time of capture. A little extra time spent in setting up will save many minutes editing later.

Changes in color and density

Changes in color and density from one source image to the next can occur for a variety of reasons – the sun went behind a cloud during your capture sequence or the camera was left on auto exposure or auto white balance and changed settings during the shooting of the source sequence. When these images are blended, sometimes the differences are noticeable at the stitch point in large areas of similar color and detail such as sky. If this occurs try these solutions:

Info				
RI	154	RI	154	
G: B:	13 33	∦G: B:	13 33	
8-bit		8-bit		
λ: Υ:	6.41	tim:		
11	1.18	Н:		
#1R:	220			
G: B:	0			
B:	43			

Auto fix – The 'Advanced Blending' feature in Photomerge will account for slight changes from one frame to the next by extending the graduation between one source image and the next. This 'auto' technique will disguise small variations in exposure/color and generally produce a balanced panorama, but for situations with large density discrepancies the source images may need to be edited individually.

Manual fix – The simple approach to balancing the density of your source images is to open two or more of the pictures and visually adjust contrast and brightness using tools like the Levels feature. For a more precise approach use the Info palette (Window > Info) to display the RGB values of specific common areas in pictures while adjusting their color and density using the Levels feature.

Extreme brightness range

Digital cameras have a limit to the range of brightness that they can capture before details in shadow and highlight areas are lost. For most shooting scenarios the abilities of the average sensor are up to the job, but in certain extreme circumstances such as when a panorama encompasses both a view of a sunlight outdoors scene as well as a dimly lit interior the range of tones is beyond the abilities of these devices. Rather than accept blown highlights or clogged shadows the clever panorama photographer can combine several exposures of the same scene to extend the range of brightnesses depicted in the image.

1. The process involves shooting three images of the one scene using different exposures. The difference in exposure should be great enough to encompass the contrast in the scene. Here a panorama head was used to ensure even spacing between all photos and registration of the three pictures of varying exposures. If such a tripod head is not available, use a standard tripod, switch you camera to bracket mode and shoot several images (of differing exposure) in quick succession before moving to the next shot in the sequence.

2. Now select the different exposure images in Bridge and then choose Tools > Photoshop > Merge to HDR. A new dialog will open with the source files on the left, preview in the center and white point slider on the right. Choose OK and open the HDR file into Photoshop. Save the image as a new HDR source file.

3. Import the new HDR source files into Photomerge and create an HDR 32-bit panorama. Save a copy of the file. To optimize the huge brightness range of the photo for print or presentation select Image > Mode > 16 Bits/Channel. Merge the layered file when prompted and then select the Local Adaptation setting option in the HDR Conversion dialog. Manipulate the curve to adjust the spread of tones in your photo, ensuring that both highlight and shadow detail is retained and midtone contrast is boosted. Click OK to apply the conversion. Be sure that you save a copy of the layered HDR panorama file before converting.

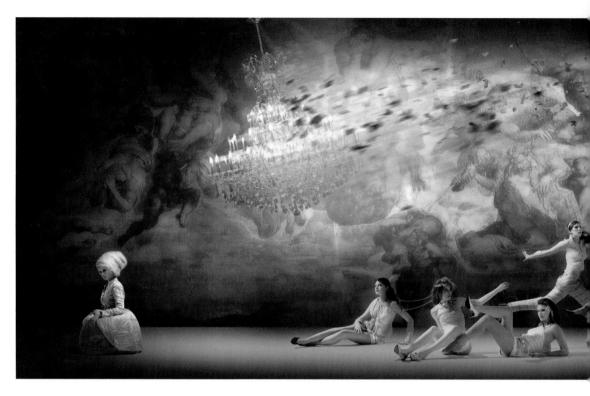

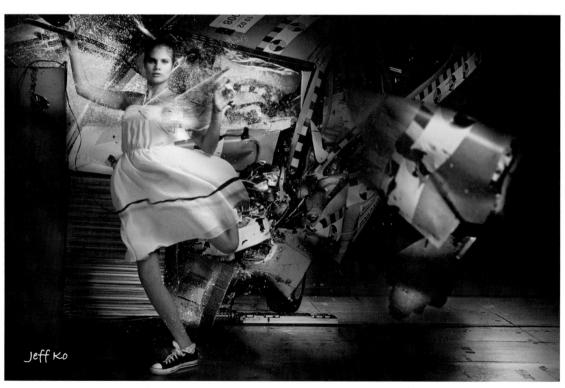

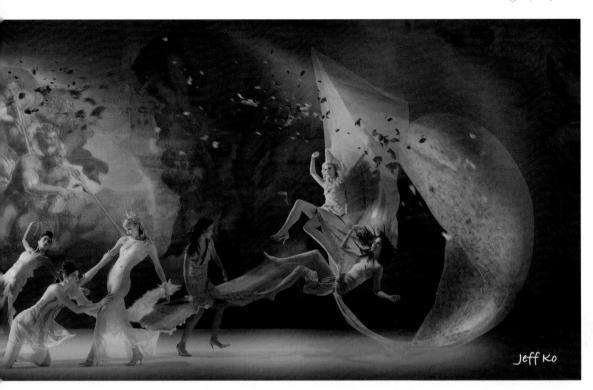

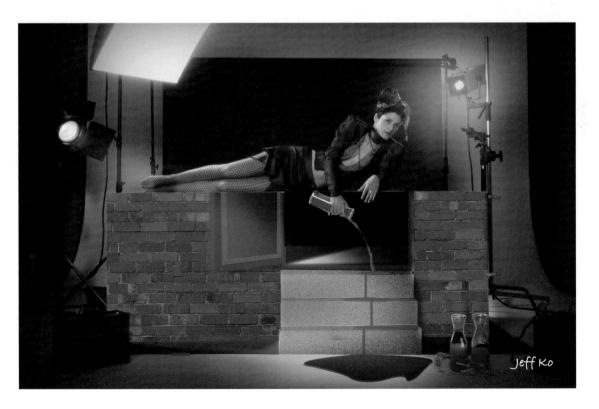

Let's sea a world of change!

OBSERVATION CHART

MR4

Every year, governments pour billions into subsidies for their fishing fleets. But details of how these billions are spent remain locked in government files. With subsidies increasingly linked to overfishing, it's time for greater transparency and accountability.

www.panda.org/endangeredseas

special effects shop photoshop photo

essential skills

- Create a posterized image using the 'Posterize' and 'Gradient Map' adjustment layers.
- ~ Explore the creative potential of digital diffusion.
- Create an image that emulates the Polaroid transfer effect.
- ~ Create an image that emulates the classic 'lith' print.
- ~ Apply non-destructive makeover techniques to enhance portraits.
- ~ Explore the creative potential of advanced blending.

Posterization - Project 1

Sometimes the difference between a good portrait and a great portrait is simply the quality of light used to illuminate the subject. Soft directional light is usually great for creating a flattering or glamorous portrait, but if the light is too flat, the drama or impact of a character portrait can be lost. In this activity the Posterize command comes to the rescue to enhance the character and create a little drama!

Using the Posterize command in Photoshop (Image > Adjustments > Posterize) is as simple as selecting the command and typing in the number of levels required. You will find the Posterize command can be very effective for dividing grayscale images into large flat areas of tone to create a dramatic graphic impact. The effects of posterization, however, are often far less successful if the command is applied directly to an RGB color image. The aim of this project is to create a successful and dramatic posterized color image.

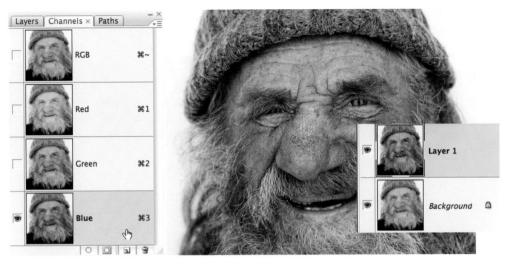

1. Open the project image from the supporting DVD. Click on the Blue channel in the Channels palette. Choose 'All' from the Select menu and 'Copy' from the Edit menu. Click on the RGB channel in the Channels palette. Choose 'Paste' from the Edit menu to create a monochrome layer above the background layer.

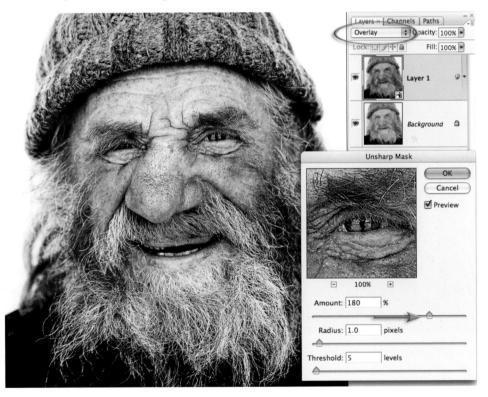

2. Select Layer 1 in the Layers palette and then select 'Convert for Smart Filters' in the Filter menu. Change the blend mode of the layer to Overlay and then go to Filter > Sharpen > Unsharp Mask. This project has used the settings: Amount 180, Radius 1.0 and Threshold 5.

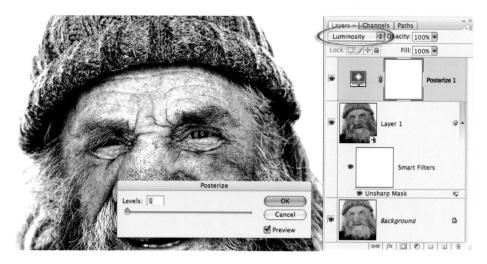

3. Create a Posterize adjustment layer (Layer > New Adjustment Layer > Posterize) to break up the smooth continuous tone into five distinct tonal steps. Enter '5' in the Levels field and select OK. Change the mode of this adjustment layer to Luminosity to remove the color artifacts.

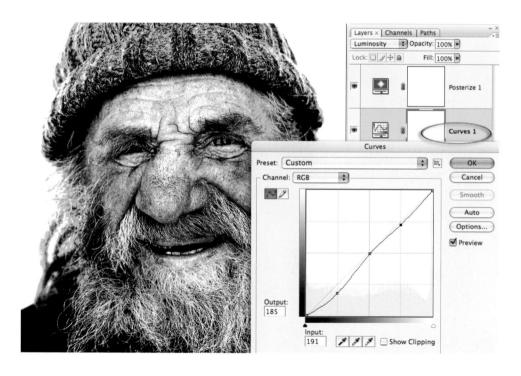

4. Click on Layer 1 in the Layers palette to make it the active layer and then create a Curves adjustment layer blow the Posterize adjustment layer. Create adjustment points to control the shadows, midtones and highlights. This Curves adjustment layer allows you to control the precise areas on the skin where the jump from one tone to the next occurs. Leave only small areas of bright highlights (white) for maximum effect.

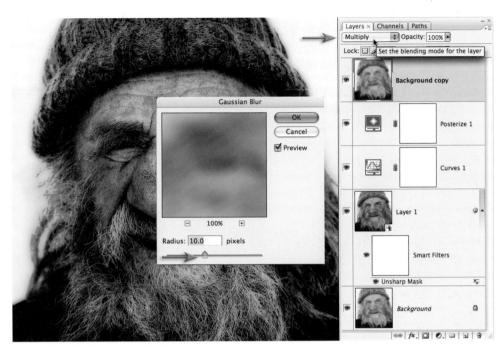

5. Duplicate the background layer by dragging it to the New Layer icon in the Layers palette. Drag this duplicate layer to the top of the layers stack and switch the blend mode to Multiply. Go to Filter > Blur > Gaussian Blur and apply a generous blur to this layer (10 pixels for the project image) to create a smooth tone that overlays the stepped tone.

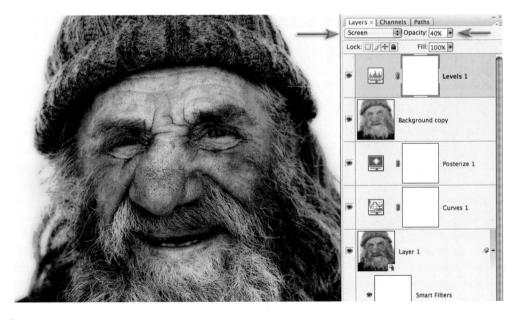

6. Create a Levels adjustment layer. Select OK in the Levels dialog box without making any adjustments. Change the blend mode of this adjustment layer to Screen to lighten the image. Lower the Opacity of this adjustment layer to reduce the lightening effect.

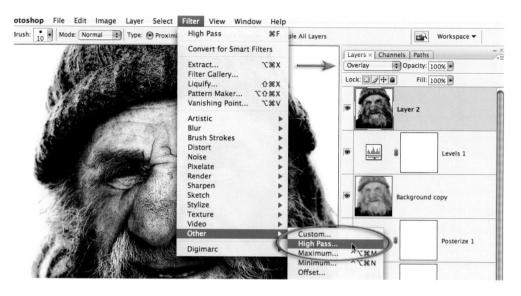

7. Stamp the visible layers to a new layer (Ctrl + Shift + Alt and then type E for PC users or Command + Shift + Option and then type E for Mac users) or go to the Select menu and choose 'All', Edit menu and choose 'Copy Merged', Edit menu again and choose 'Paste'. Make sure this layer is on top of the layers stack and change the blend mode to Overlay.

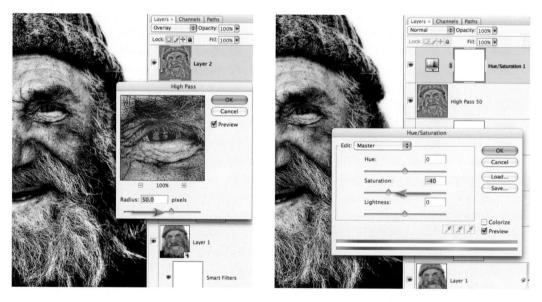

8. Go to Filter > Other > High Pass and choose a high Radius value. This filter will give more depth or three-dimensional modelling to the contours of the image (50 pixels was used with the project image). Create one final Hue/Saturation adjustment layer and lower the Saturation until the colors are balanced with the tonal qualities of this image. This project demonstrates how tonality can have a huge impact on the mood and drama, and how, with a little digital dexterity, the extraordinary can be released from the ordinary.

Digital diffusion - Project 2

Most photographers have an obsession with sharpness. It seems that we are all striving for the ultimate quality in our images. We carefully select good lenses and always double-check our focusing before making that final exposure. All this so that we can have sharp, well-focused images that we can be proud of.

It almost seems like a mortal sin then for me to be describing a technique on how to make your images 'blurry' but, like it or not, these days the photographic world is full of diffused or blurred imagery. From the color food supplements in our weekend papers to the latest in portraiture or wedding photography, subtle (and sometimes not all that subtle) use of diffusion in contemporary images can be easily found.

Traditionally, adding such an effect meant placing a 'mist' or 'fog' filter in front of the camera lens at the time of shooting or positioning diffusion filters below enlarging lenses when printing. The digital version of these techniques allows much more creativity and variation in the process and relies mainly on the use of layers, blending modes and the 'Gaussian Blur' filter.

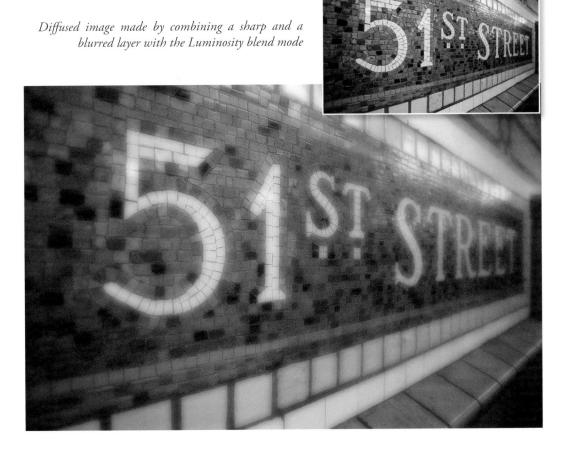

The Gaussian Blur filter effectively softens the sharp elements of the picture when it is applied. Used by itself, this results in an image that is, as expected, quite blurry and, let's be frank, not that attractive. It is only when this image is carefully combined with the original sharp picture that we can achieve results that contain sharpness and diffusion at the same time and are somewhat more desirable. So essentially we are talking about a technique that contains a few simple steps.

- 1. First, make a copy of the background layer by selecting Layer > Duplicate. Title the copy 'Blur Layer' using the Duplicate Layer dialog. Next, right-click the layer and select Convert to Smart Object from the pop-up menu.
- 2. With the new Smart Object layer selected, apply the Gaussian Blur filter. You should now have a diffused or blurred layer sitting above the sharp original. If you don't like the look of the Gaussian diffusion then you can choose another effect such as the Diffuse filter instead. This filter is not as controllable as Gaussian Blur but does
- 3. As the Gaussian Blur has been applied via a Smart Filter it is possible to adjust the filter settings at any time. Just double-click on the filter name (Gaussian Blur) in the layer stack to display the filter dialog complete with the settings currently being used to produce the effect.

achieve a different effect.

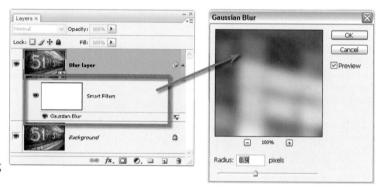

Layers ×

Lock: 🖸 🖋 💠 角

Normal

✔ Opacity: 100% ►

Fill: 100%

Layer Properties...

Blending Options...

Duplicate Layer...

- 4. Now change the layer 'blending mode' using the drop-down menu in the top left of the Layers palette. As we have already seen, Photoshop contains many different blend modes that control how any layer interacts with any other. The Lighten and Screen modes both work well for this picture. Of course, other modes might work better on your own images so make sure that you experiment. After choosing a blend mode, check your Gaussian Blur filter settings by double-clicking the filter name in the layer stack and adjusting the Radius setting.
- 5. Additionally, you can change the 'opacity' (top right of the dialog) of the blurred layer as well. Adjusting this setting changes the transparency of the blurred layer, which in turn determines how much of the layer below can be seen. More opacity means less of the sharp layer characteristics are obvious. By carefully combining the choice of blending mode and the amount of opacity, the user can create infinite adjustments to the diffusion effect.

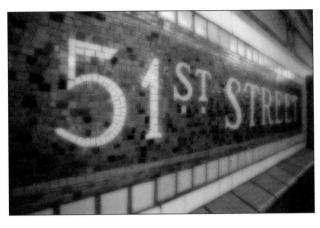

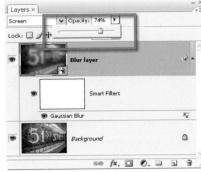

Another approach

In some instances it might be preferable to keep one section of the image totally free of blur. This can be achieved by applying the Gaussian filter via a graded mask to the Gaussian Blur Smart Filter. With this method some of the picture remains sharp while the rest is diffused.

1. Start with base image (without the layers from the previous technique) and make a copy layer of the background using the Layer > Duplicate Layer command. Convert this layer to a Smart Object. Next select the Gradient Tool and make sure that the Tool's options are set to 'Foreground to Transparent' and 'Radial Gradient'. Switch to Quick Mask mode and create a mask from the center of the '51' to the outer right-hand edge of the image.

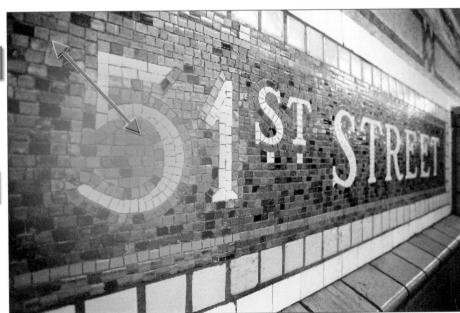

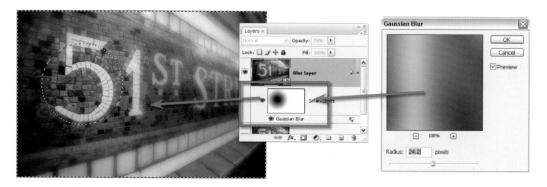

2. Switch back to the Selection mode to reveal the graded circular selection. Depending on the Quick Mask settings, the selection may enclose the parts of the picture that were masked or may isolate the opposite areas in the picture. Double-click on the Quick Mask Tool icon to access the mask settings, change them if necessary and then click OK to change to Selection mode (marching ants). To change between these two different selections use the Select > Inverse command. Apply the Gaussian Blur filter to the Smart Object with the selection still active. After applying this extra step to the Smart Object above the original image layer, it is possible to use blending modes and opacity to further refine the strength and character of the diffusion effect.

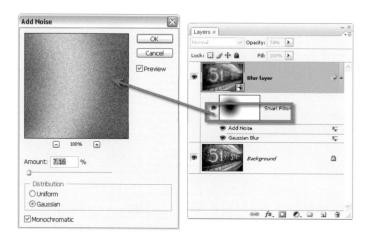

3. To complete the technique and disguise the areas of the picture that have been smoothed with the action of the Gaussian Blur filter you need to try to match the texture of the non-diffused and diffused areas. Do this by adding a very small amount of noise to the picture, but just as we applied the blur non-destructively using the new Smart Filter technology we will do the same with this filtering step. To add noise to the same masked area as the Gaussian Blur filter, select the Smart Object layer and then choose Filter > Noise > Add Noise. Makes sure that the filter is listed above the Gaussian Blur entry in the layer stack, otherwise click-drag it to the upper position. Apply only the minimum amount of noise necessary to disguise the changes.

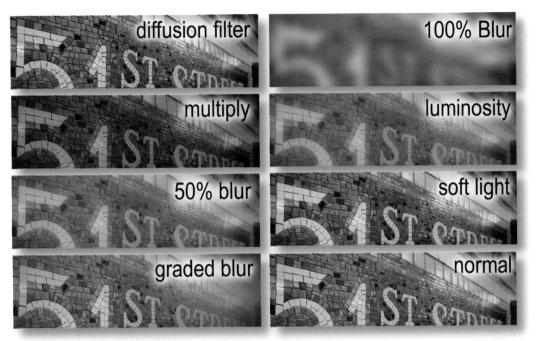

Examples of different diffusion techniques and blending modes

Even more control

You can refine your control over the diffusion process even more by using a layer mask to selectively remove sections of the blurred layer.

At its simplest level this will result in areas of blur contrasted against areas of sharpness; however, if you vary the opacity and edge hardness of the brush used to paint the mask then you can carefully feather the transition points.

The addition of the masking step allows much more control over the resultant image. It is possible to select, and highlight, the focal points of the photograph while not losing the overall softness of the image.

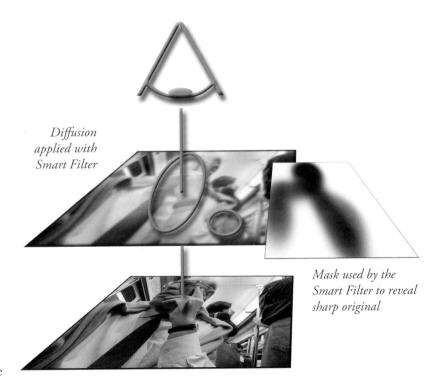

Sharp original enclosed in the Smart Object layer

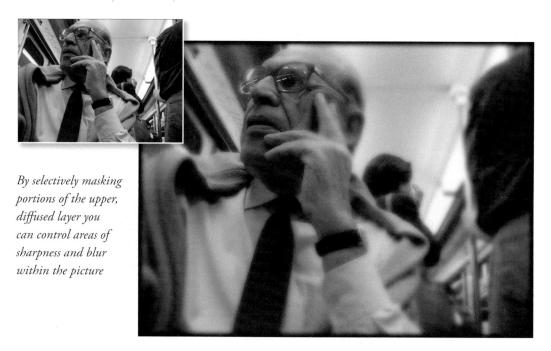

1. Rather than duplicate the base image layer (background) and apply the changes to the copy, this technique uses Smart Filtering to achieve the same effects. Start by converting the background layer to a Smart Object and then applying a Gaussian Blur. Double-click on the

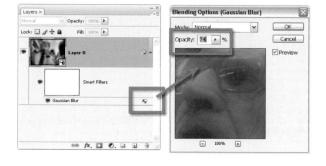

Filter Blending Options button in the layer stack and change the opacity (and blend mode if desired) of the filter.

2. Next select the Smart Filter mask in the Layers palette and choose a soft-edged brush with an Opacity of 20%. Set the foreground color to black and proceed to paint on the areas of the picture that you want to restore sharpness. Repeat the painting action to build up the mask's tone (make it darker) and thus reveal more of the original sharpness of the picture. To restore the blur to areas accidentally sharpened just switch the foreground color to white and paint over the area again.

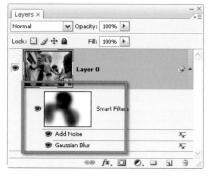

3. As a final step you may wish to add a noise filter effect to the blurred sections of the photo to help disguise the smoothing effects of the blur filter. Do this by adding an Add Noise filter to the Smart Filter stack. Be sure that the Add Noise filter appears uppermost in the stack.

Digital Polaroid transfer effect - Project 3

Most readers will probably be familiar with Polaroid instant picture products – you push the button and the print is ejected and develops right before your eyes. For many years professional image-makers have been using the unique features of this technology to create wonderfully textured images. The process involved substituting watercolor paper for the printing surface supplied by Polaroid. As a result the image is transferred onto the roughly surfaced paper and takes on a distinctly different look and feel to a standard Polaroid print.

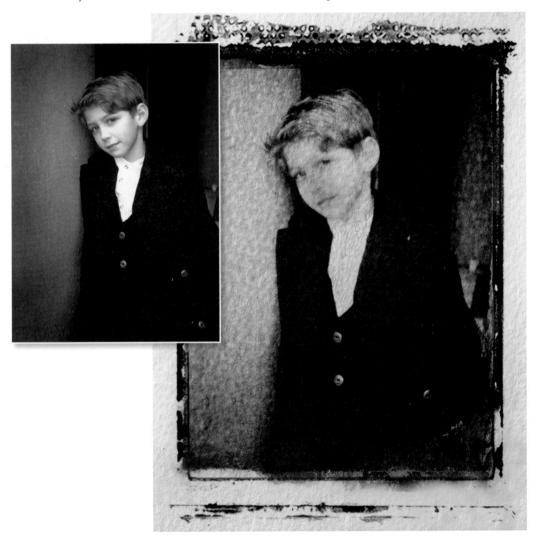

Much acclaimed for its artistic appeal, the technique was not always predictable and, much to the frustration of a lot of photographers, it was often difficult to repeat the success of previous results. There were three main problems – dark areas of an image often didn't transfer to the new surface, colors and image detail would bleed unpredictably, and it was difficult to control how dark or light the final print would be. I know these problems intimately as it once took me 16 sheets of expensive instant film to produce a couple of acceptable prints.

A digital solution

This success ratio is not one that my budget or my temperament can afford. So I started to play with a digital version of the popular technique. I wanted to find a process that was more predictable, controllable and repeatable. My first step was to list the characteristics of the Polaroid transfer print so that I could simulate them digitally. To me it seemed that there were four main elements:

- Desaturated colors
- Mottled ink
- Distinct paper texture and color
- The Polaroid film frame.

To duplicate these characteristics on the desktop would mean that I could capture the essence of the Polaroid process.

1. To start the process we will add a white background to the picture that will eventually accommodate the Polaroid edge or frame. Do this by creating a new layer (Layer > New > New Layer) and then dragging this layer beneath the image layer in the layer stack. If the image layer is a background layer then you will need to double-click it to change to a standard image layer before the move. Next, make sure that the default foreground and background swatches are selected (white = background) and then select the new layer and choose Layer > New > Background from Layer. With the Crop Tool selected draw a marquee around the whole of the image and then click-drag the corner handles outwards to extend the background layer (and the canvas) beyond the image area.

- 2. As the rest of the technique requires us to make filter changes to the image that are destructive we will now select both layers and convert them to a single Smart Object (Layer > Smart Object > Convert to Smart Object).
- 3. The Polaroid technique requires the watercolor paper to be slightly wet at the time of transfer. The moisture, while helping the image movement from paper to paper, tends to desaturate the colors and cause fine detail to be lost. These characteristics are also the result of the coarse surface of the donor paper.

So the next step of the digital version of the process is to desaturate the color of our example image. In Photoshop this can be achieved non-destructively using the Hue/Saturation adjustment layer (Layer > New Adjustment Layer > Hue/Saturation). With the dialog open carefully move the Saturation slider to the left. This action will decrease the intensity of the colors in your image. Here a value of -48 was used.

4. The distinct surface and image qualities of Polaroid transfer prints combine both sharpness and image break-up in the one picture. To reproduce this effect digitally and non-destructively, we will use the new Smart Filter options in CS3. My idea was to manipulate the look of the photo with a couple of filters to simulate the mottled effect of the transfer print and then use the Smart Filter blend mode and Opacity settings to adjust how much sharpness (of the original image) or mottle (from the filters) was contained in the final result.

To do this I selected the Smart Object layer and applied the first of two filters, Paint Daubs, to the picture. Though the look is not quite right, I found that by combining the effects of the Paint Daubs and Palette Knife filters I could produce reasonable results. When using these filters yourself keep in mind that the settings used will vary with the style and size of your image. Use the ones in the example as a starting point only. This part of the process is not an exact science. Play and experimentation is the name of the game and keep in mind that you can adjust the settings any time in the future as these are Smart Filters. You might also want to try other options in the Artistic, Sketch or Texture selections of the Filter menu.

5. Now to adjust how these filter effects combine with the original photo. This can be achieved by either changing the filter's blending mode or by adjusting its opacity, or both. For the example image a simple opacity change (to 59%) was all that was needed, but don't be afraid to try a few different blend/opacity combinations with your own work. To access these options double-click the settings icon at the

right hand end of the filter layer. This will display the Smart Filter Blending Options palette. Here you can alter both blend modes and opacity of the selected filter and view the changes in the associated preview. Be careful though, as any filter selected that is not on top of the filter stack will be previewed without the combined effects of the other filters.

- 6. The paper color and texture are critical parts of the appeal of the transfer print. These two characteristics extend throughout the image itself and into the area that surrounds the picture. To change the color of both the image and the white surround I played with the overall color of the document using a Levels adjustment layer (Layer > New Adjustment Layer > Levels). I altered the Blue and Red channels independently and concentrated on the lighter tones of the image so that rather than the paper being stark white it took on a creamy appearance. Specifically I dragged the white output slider in the Blue channel towards the center of the histogram (to add some yellow to the highlights) and I moved the white input slider of the Red channel to the left to bring in some warmth.
- 7. To add the texture to both image and the white background surround I added yet another filter to the Smart Object layer. This time I used the Texturizer filter combined with a custom texture of the surface watercolor paper that I created by photographing a section of paper that

was lit with a light source that was positioned low and to one side. You can download and use this very file from the book's DVD or pick one of the other options from the Texture pop-up list. To load the DVD image select the Texturizer filter from the Filter > Texture menu and then click onto the sideways arrow in the top right of the dialog and choose the Load Texture option. Browse for and select the texture file before adjusting the Scaling, Relief and Light options in the filter to suit.

8. The last part of the process involves combining the final image with a scan of a Polaroid film edge. You can make your own by scanning a Polaroid print and then removing the image or you can use the edge located on the book's DVD. Start by opening the edge file as a separate document. Click onto the edge picture and drag it onto your picture. The edge will automatically become a new layer on top of the existing image layer. Convert the edge layer to a Smart

Object by right-clicking on the layer and choosing the Convert to Smart Object entry. With the edge Smart Object layer selected change the layer's blend mode to Multiply. Notice that the white areas of the layer are now transparent, allowing the picture beneath to show through. Drag the edge layer to just above the image in the layer stack (below the Hue/Saturation and Levels adjustment layers) to ensure that the adjustments made by these layers are applied to the Polaroid edge image as well. Finally, use the Edit >Free Transform command to adjust the size of the edge to fit the image and the Crop Tool to remove any unwanted background areas.

Lith printing – Project 4

There is no doubt that a well-crafted lith print is, to borrow an oft-used phrase from my father-in-law, 'a thing of beauty that is (therefore) a joy forever'. The trick, for experienced and occasional traditional darkroom users alike, is the production of such a print. Even with frequent reference to publications penned by lith guru Tim Rudman, I have always had difficulty getting consistency with the production of my prints. Despite this frustration my love affair with the process still continues. There is something quite magical about the quality of images created using this technique and it is this magic that I hanker after. They are distinctly textured and richly colored and their origins are unmistakable.

The process, full of quirky variables like age and strength of developer and the amount of overexposure received by the paper, is unpredictable and almost always unrepeatable. In this regard at least, most printers, myself included, found the whole lith printing process both fascinating and infuriating. This said, it's a decade since lith printing started to become more commonplace and there is no sign of people's interest declining.

'Long live lith!' I hear you say, 'but I shoot digital.' Well, good news: the digital worker with basic skills, a copy of Photoshop and a reasonable color printer can reproduce the characteristics of lith printing without the smelly hands, or the dank darkroom.

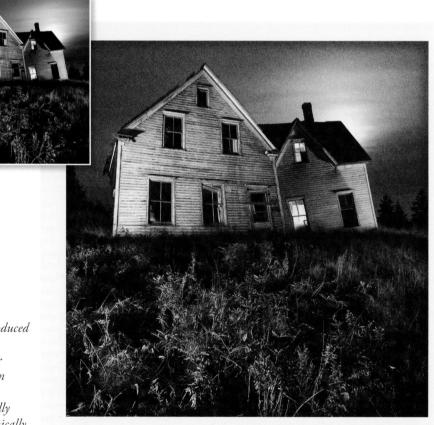

A digitally produced lith print can exhibit similar color and grain characteristics to those typically found in chemically produced originals

Leave a light on - Shaun Lowe (www.iStockphoto.com)

1. If you ask most photographers what makes a lith print special the majority will tell you it's the amazing grain and the rich colors. Most prints have strong, distinctive and quite atmospheric grain that is a direct result of the way in which the image is processed. This is coupled with colors that are seldom seen in a black and white print. They range from a deep chocolate, through warm browns, to oranges and sometimes even pink

tones. If our digital version is to seem convincing then the final print will need to contain all of these elements. Whether you source your image from a camera or a scanner, make sure that the subject matter is conducive to making a lith-type print. The composition should be strong and the image should contain a full range of tones, especially in the highlights and shadows. Delicate details may be lost during the manipulation process, so select an image that still works when the fine details are obscured by coarse grain. Good contrast will also help make a more striking print.

The next step after selecting a suitable image is to copy the file to your hard drive (if stored on CD or DVD), open and save the file in the PSD format. Now open the file in Photoshop as a Smart Object (File > Open As Smart Object). Basing your adjustments around a Smart Object will ensure that they can be tweaked at any time later and the original pixels are always maintained.

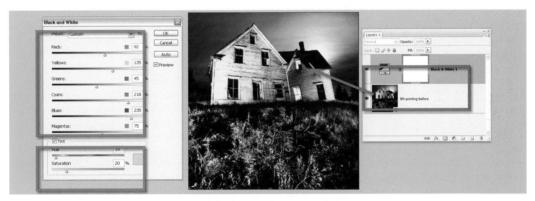

2. Now that you have selected a picture with a strong composition, let's add some color. Photoshop provides a couple of options for adding the distinctive lith colors. The simplest approach uses the Tint options in the new Black and White control. Previously we would have used Hue/Saturation but this new feature has the added bonus of providing the chance to manipulate the monochrome conversion (convert to gray) before adding the tint hues. As we are using a Smart Object-based workflow the Black and White feature is applied via an Adjustment layer (Layer > New Adjustment Layer > Black and White). Start by adjusting the color sliders in the upper section of the dialog. These allow you to control the way that specific colors are converted to gray. Try to maintain good contrast and a full range of tones. Next move to the bottom of the feature and check the Tint option. Use the Hue slider to select the color for the tint and the Saturation slider to adjust the vividness of the effect.

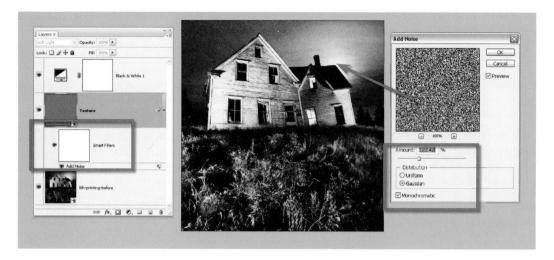

3. To simulate the texture of the lith print we will add a Noise filter to the photo, but rather than applying it directly more control is possible if the texture is applied to a separate layer first and then blended with the image. Start by creating a new layer (Layer > New > Layer) and filling it with 50% gray (Edit > Fill then choose 50% Gray from the contents menu). Name this layer Texture.

To ensure that we can adjust the settings used for the filtering effect later on, convert the Texture layer to a Smart Object (Layer > Smart Objects > Convert to Smart Object) and change the mode of the new Smart Object layer to Overlay or Soft Light. Next, Smart Filter the layer using either the Grain (Filter > Texture > Grain) or Noise (Filter > Noise > Add Noise) filter. Most of these types of filters have slider controls that adjust the size of the grain, its strength and how it is applied to various parts of the image. The settings you use will depend on the resolution of your picture as well as the amount of detail it contains. The stronger the filter effects the more details will be obscured by the resultant texture. Be sure to preview the filter settings with the image magnification set at 100% so that you can more accurately predict the results. Here I have the used the 'Noise' filter with both the Gaussian and Monochrome options set.

4. At this point in the project the lith-print effect is finished but to show the power of working with Smart Objects let's take the process a little further by adding some extra canvas space and a blurred border to the otherwise completed photo. Start by selecting the image Smart Object layer. Next choose Layer > Smart Objects > Edit Contents. This will open the original photo as a separate Photoshop document with no color or texture effects applied. Change the background layer to a standard image layer by double-clicking on its entry in the Layers palette. Next add a new layer and convert the layer

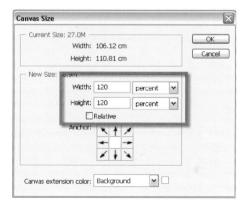

to a background layer by selecting Layer > New > Background from Layer. Make sure that the default Foreground/Background colors are selected before this step. To extend the white background, choose Image > Canvas Size, and add 120% for both Width and Height settings.

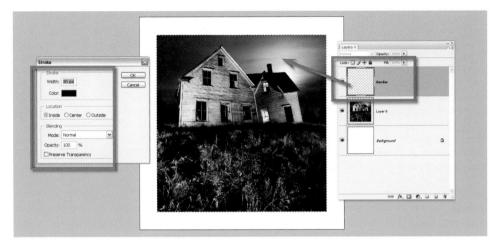

5. To add a blurred border the size of the image, create a new layer above the photo. Label this layer Border. Hold down the Ctrl/Cmd key and click on the picture in the thumbnail of the layer containing the image. This creates a selection based on the size and shape of the picture content of this layer. Now choose the Border layer and then select Edit > Stroke. Adjust the settings so the stroke is 30 pixels wide (this may change for your image), is black, and is located on the inside of the selection. Click OK to draw the stroke.

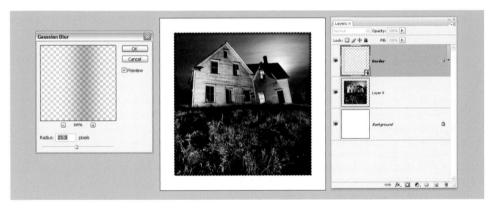

6. We will use the Gaussian Blur filter to blur this border but, before applying the filter, change the Border layer to a Smart Object. This way it will be possible to alter the settings used for the border later if needed. Select the layer and choose Layer > Smart Objects > Convert to Smart Object. Next with the selection that you used to create the border in the first place still active, apply the Gaussian Blur filter to blur the inner edge of the stroked border. If you have lost the selection recreate it by holding down the Ctrl/Cmd key and clicking on the image layer's thumbnail.

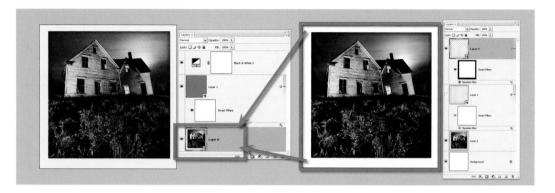

7. With the border now created it is time to apply the settings back to the original lith print. Save the file (File > Save) and then close the document. Photoshop will automatically update the picture Smart Object layer that sits inside the lith document with the changes. Using Smart Objects in this technique provides endless opportunity to adjust the settings for the color and texture of the final result. Even the blur of the border can be manipulated at a later date as applying the filter via a selection automatically creates a mask that will restrain the blur effect to the inside of the image.

Portrait makeovers - Project 5

When it comes to retouching, Photoshop is definitely the king of the image-editing heap. The program contains a host of tools, filters and adjustment options that can help turn ordinary-looking portraits into something that is truly dazzling. The sheer power and dominance of the program in this area is not difficult to see as most glossy magazine covers and celebrity life-style stories contain a plethora of photos that have been 'shopped' in one way or another. The results, in most cases, are amazing and, in a few instances, even a little scary. But for the average photographer the interest is not about wanting to recreate the plastic look of celebrity stardom but rather it centers around the gentle art of photo enhancement. And in truth, I feel that this is the best use of the retouching power of the program. So with this in mind, here are a few core techniques that are used by portrait photographers on a daily basis. Most work with, rather than paint over, the basic structure and texture of the model's face and in so doing they carefully enhance what already exists rather than replace it with something that is manufactured. Importantly all are non-destructive, keeping the original artwork free from any permanent changes.

Softening freckles

This technique aims to reduce the dominance of the freckles rather than removing them totally. In this way the underlying structure of the face shines through and is complemented with, rather than overridden by, just a hint of the freckles. In the end we are left with a result that retains much of the original charm of the initial photograph and a definite sense of reality that overworked images always lack. Remember in most cases the secret is to enhance not to replace.

- 1. Select the Eyedropper Tool and then check to see that the Sample Size (in the options bar) is set to average 3 × 3 or 5 × 5 pixels. Next select a flesh color from the portrait that represents a midtone of the range available across the face surface. The tone you select at this point in the process will determine which freckles are lightened. Choosing a darker skin tone will change only a few of the darkest freckles whereas a lighter tone selection will alter both midtone and dark freckles.
- 2. With the skin tone selected the next step is to create a new layer above the image layer. Label the layer Retouching and change the blend mode of the layer to Lighten.
- 3. Now select the Brush Tool and start to paint over the freckled areas. With the layer in the Lighten mode Photoshop compares the paint color with the pixels being painted over. If the pixels are darker then they are replaced with the paint color, effectively lightening the area.
- 4. To ensure that the changes are both effective and yet subtle you can also alter the opacity of the layer to adjust the strength of the enhancement. An opacity setting of 100% would produce a result that was too smooth. Reducing the opacity has the effect of allowing a little of the old freckle texture to show through, maintaining the feeling of realism whilst reducing the freckle's dominance.

 Continue to paint away the dominant freckles whilst being careful not to paint over details like eyelashes as you go.

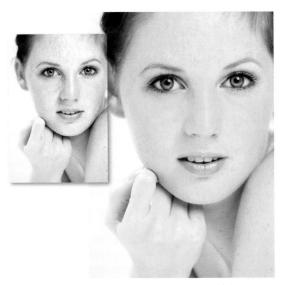

Kateryna Govorushchenko (www.iStockphoto.com)

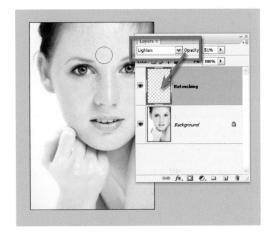

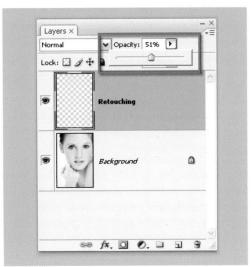

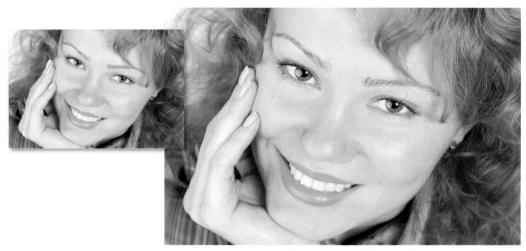

Image by Anna Bryukhanova (www.iStockphoto.com)

Removing the red

In this example the model's bright red (or is that orange) hair is coloring the light that is reflected back onto the skin tones, making them quite warm. Your initial thoughts might be to reach for the Color Balance and Curves feature and use these to reduce the warmth in the photo, but this action has the effect of reducing the vibrancy of the hair color at the same time as neutralizing the skin tones. So instead of making global (all over) changes to the picture this technique uses the Eyedropper Tool to sample an area of neutral skin and then employs the Brush Tool in Color mode to paint out the overly warm tones.

- 1. Start by ensuring that the Eyedropper Tool's Sample Size is set to an average of either ' 3×3 ' or ' 5×5 ' pixels and not the Point Sample setting. To do this select the tool and then choose a different option from the drop-down list on the tool's option bar. Next create a new retouching layer above the image layer and change the blend mode of this layer to Color.
- 2. Next locate a portion of skin tone that is free from red or magenta casts and click on it with the Eyedropper Tool. You will notice that the foreground color in the toolbox now contains the color you sampled. Check to see that the color is not too dark or light and that the hue is free from any strange casts. If this isn't the case, then resample a different areas of skin until you are happy with the color.
- 3. Check to see that the retouching layer is selected and then apply the skin-colored paint over the red/magenta areas in the photo using the Brush Tool. Notice that because the layer is in the Color mode the paint is laid down in such a way that the details of the photo beneath are retained and only the color is altered. To fine-tune the effect you can also adjust the opacity of the retouching layer.

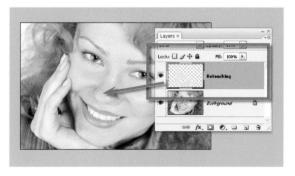

Eliminating blemishes

Ethical issues aside, Photoshop is a great tool for removing, or at least making less pronounced, a variety of unwanted photo elements. Despite the fact that skin blemishes and wrinkles are a normal everyday occurrence for most of us, photographers are constantly asked to retouch these sections of portrait photos. Like the other technique.

these sections of portrait photos. Like the other techniques discussed here, the secret behind successful retouching of these areas is not to remove them completely but rather to reduce their appearance. With this in mind let's look at a couple of the tools that Photoshop offers for blemish removal.

Clone Stamp

Serious – Amanda Rohde (www.iStockphoto.com)

- 1. The Clone Stamp Tool works by sampling a selected area and pasting the characteristics of this area over the blemish, so the first step in the process is to identify the areas in your picture that need repair. Then make sure that the image layer you want to repair is selected. To work non-destructively create a new layer first and then apply the cloning to this layer. Make sure that the Sample All Layers option is selected in the tool's options bar.
- 2. Next locate areas in the photograph that are a similar tone, texture and color as the picture parts that need fixing. It is these sampled areas that the Clone Stamp Tool will copy and then use to paint over the model's wrinkles. At this point you can also alter the transparency of the cloning action by adjusting the Opacity slider in the tool or the retouching layer. Values less than 100% will let some of the original texture through the cloned areas.
- 3. To select the area to be sampled, or the 'sample point', hold down the Alt key (Win) or the Option key (Mac) and click the mouse button (left button for Windows) when the cursor is over the desired sample tone, color or texture. Next move the cursor to the area to be fixed. Click on the blemish and a copy of the sample point area is pasted over the mark. Depending on how well you chose

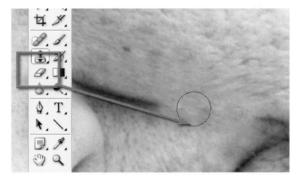

the sample area, the blemish will now be blended into the background seamlessly. Continue to click and drag to repair more areas.

4. You may need to reselect your sample point if you find that the color, texture or tone doesn't match the surrounding area of the blemish. You can also change the brush size and hardness to alter the characteristics of both the sample and stamp areas. A softer edge helps blend the edge areas of the newly painted parts of the picture with the original image.

Spot Healing Brush

- 1. The Spot Healing Brush removes the sampling step from the Clone Stamp process. To use the brush you simply select the feature, adjust the brush tip size and hardness, and then click onto, or drag over, the blemish. Almost magically the Brush will analyze the surrounding texture, color and tones and use this as a basis for painting over the problem area.
- 2. To apply the brush non-destructively create a new layer above the image layer first. Select this layer and ensure that the Sample All Layers option is selected in the tool's options bar. Now use the tool as you would normally but with this technique the healing changes are stored in the separate layer.
- 3. Sometimes the Spot Healing Brush samples unwanted areas from around the brush tip, causing a less than perfect result. If this occurs try drawing a feathered selection around the blemish area first before using the Spot Healing Brush.
- 4. If the healed area is still showing unwanted artifacts use a harder brush tip, or switching the blend mode of the tool to the Replace option can sometimes help. In this mode the tool preserves the texture at the edge of a soft-tipped healing brush.

Healing Brush

The Healing Brush is also a two-step process. After selecting the tool you hold down the Alt/ Option key and click on a clear skin area to use as the sample for the healing. This action is the same as you would take when using the Clone Stamp Tool to select a sample point. Fortunately in Photoshop CS3 the tool does have a Sample All Layers option so you can apply your retouching changes to a new layer to work non-destructively.

Advanced blending - Project 6

This project utilizes advanced blending via the Blending or Layer Options dialog box and the use of filters to create special effects. The project also makes use of the '**Transform**' commands to modify layer content.

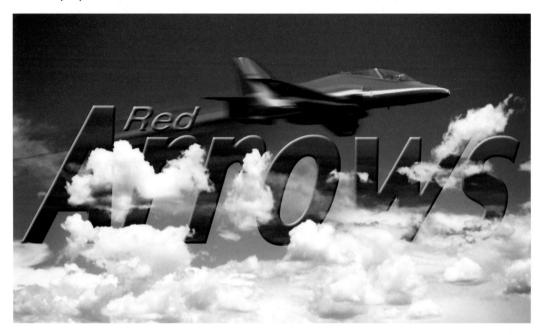

The technique of making the typography disappear among the cloud cover is created by a sandwiching technique and a selective blend mode applied to the top layer.

The sky is duplicated and the copy moved to the top of the layers stack. The darker levels (the blue sky) are blended or made transparent while the lighter levels (the clouds) are kept opaque. The typography now appears where the sky is darker and is obscured by the lighter clouds.

1. Open the image of the sky from the DVD. Click on the Type Tool in the Tools palette and create the desired typography. Click on the character palette icon in the Options bar to access additional type options. The example uses a font called Charcoal with the settings 'Faux Bold' and 'Faux Italic' (a Photoshop feature that allows any font to be made italic or bold). Any bold italic font would be suitable for this project.

- 2. The layer effect 'Bevel and Emboss' is applied to this type layer. Select 'Inner Bevel' from the Style menu and select an appropriate 'Angle' that is consistent with the light source in the rest of the image. Choose a blend mode, opacity and color for both the highlights and shadows. In the example both the highlight and shadow were set to 100% and the angle was set to 120°.
- 3. Duplicate the background layer 'Sky' by dragging the layer in the Layers palette to the 'New Layers' icon at the base of the Layers palette. Move the background copy to the top of the layers stack above the type layer (this action will temporarily obscure the type layer).

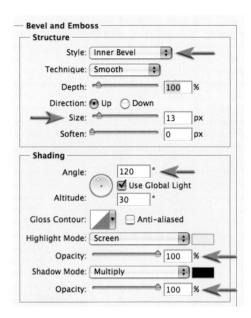

4. Double-click the background copy layer. The 'Blending Options' dialog box will open. This dialog box allows the user to change the opacity and blend mode of the layer. The bottom half of the box allows the user to control the range of levels that may be blended. Dragging the left-hand slider on the top ramp to a position of 150 allows all of the darker tones, or levels, to be made transparent. The typography on the layer below is now visible in all areas where the pixels are 0 to 150. The effect at present is abrupt. The type disappears suddenly into the clouds rather than gradually. A more gradual transition can be achieved by fading the effect over a range of pixels rather than selecting a single layer value at which 100% transparency takes place. By holding down the Option/Alt key and dragging the slider it is possible to split the black slider. Drag the right half of the slider to a value of around 200. This action creates the desired effect of the type fading slowly into the cloud cover.

- 5. Open the image that will be used to fill the type from the DVD (the image of storm clouds). Go to Select > All and Edit > Copy. Make the image with your text in the active window and then choose Paste from the Edit menu. The image is moved to a position directly above the type layer in the Layers palette and is 'clipped' to the type layer (Layer > Create Clipping Mask).
- 6. An adjustment layer is then added and clipped with the storm clouds and typography. The adjustment layer is used to shift the colors of the storm cloud towards blue. This can be achieved by using either a Color Balance or a Curves adjustment layer.

- 7. Select the top layer in the Layers palette. Open the image of the jet from the DVD. Drag the layer thumbnail of the jet from the Layers palette into the canvas area of the sky image.
- 8. Create a selection of the sky using the Magic Wand or Quick Selection Tool. Click on the 'Add layer mask' icon in the Layers palette. Remember to apply a small amount of Gaussian Blur to this layer mask or use the Refine Edge dialog box (Select > Refine Edge).

9. Go to the Edit menu and choose 'Transform > Flip Horizontal'. Then select the layer mask and paint out any edges that may have appeared as a result of blurring or contracting the layer mask (hold down the Shift key and click in each corner to make fast work out of this). Ctrlclick (Mac) or right-click (PC) on the layer mask thumbnail and select Apply Layer Mask.

To create the movement effect duplicate the aircraft layer twice (drag the layer to the 'Create new layer' icon). Choose Blur > Motion Blur from the Filters menu to apply a 15-pixel blur to the uppermost jet layer. Apply a 300-pixel Motion Blur to the bottom jet layer. Ensure that the 'Angle' is appropriate for the direction of travel or movement. If you need to see a preview of the effect drag inside the preview window until part of the aircraft appears.

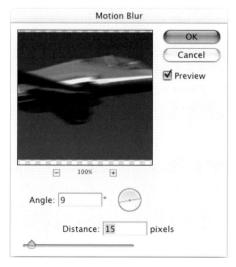

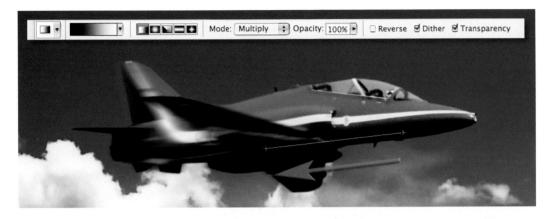

10. Select the top jet layer. Select the 'Gradient' Tool from the Tools palette. Select the 'Linear Gradient', 'Foreground to Background' and 'Multiply' mode options in the Options bar. Drag the Gradient Tool to conceal the front half of the blurred aircraft. With the 300-pixel blur layer selected choose Transform > Rotate from the Image menu and move the streak into position.

11. Select the Type Tool and click once in the image window to start an additional type layer. Set the font size to 36 pt and click on the color swatch in the Options bar to open the Color Picker. Move the cursor into the image window and select a red color from the aircraft using the eyedropper. Type the word 'Red' and then hold down the Ctrl/ Command key to click inside the bounding box and drag the type into position. From the Edit menu choose Transform > Skew to increase the angle of lean of the typography. Click on the 'Commit transform' icon in the Options bar to apply the changes. From the Filters menu choose Stylize > Wind and select 'From the Right' to give the appropriate direction of travel.

Note > To apply a filter to a type layer the type must either be rasterized (rendered into pixels) or the layer must be converted for Smart Filters (Filter > Convert for Smart Filters). If type is rasterized it is no longer editable. If you have converted the layer for Smart Filters you can double-click the layer to edit the text.

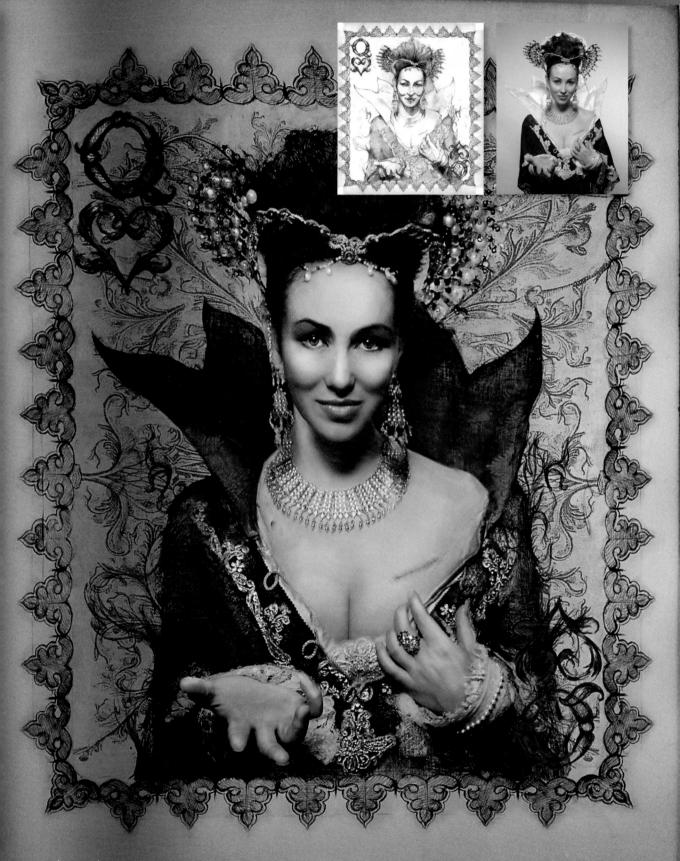

Glossary

ACR Adobe Camera Raw.

Additive color A color system where the primaries of red, green and blue mix to

form the other colors.

Adjustment layer Image adjustment placed on a layer. Adobe Camera Raw Adobe's own Raw conversion utility.

Adobe gamma A calibration and profiling utility supplied with Photoshop.

Adobe Photo Downloader Adobe's download utility used for transferring photos from card or

camera to computer. The utility ships with Bridge.

Algorithm A sequence of mathematical operations.

Aliasing The display of a digital image where a curved line appears jagged

due to the square pixels.

Alpha channel Additional channel used for storing masks and selections.

Analyze/Analysis To examine in detail.

Anti-aliasing The process of smoothing the appearance of a curved line in a

digital image.

APD Adobe Photo Downloader.

Aperture A circular opening in the lens that controls light reaching the film.

Area array A rectangular pattern of light-sensitive sensors alternately receptive

to red, green or blue light.

Artifacts Pixels that are significantly incorrect in their brightness or color

values.

Aspect ratio The ratio of height to width. Usually in reference to the light-

sensitive area or format of the camera.

Bit Short for binary digit, the basic unit of the binary language.

Bit depth Number of bits (memory) assigned to recording color or tonal

information.

Bitmap A one-bit image, i.e. black and white (no shades of gray).

Black and White CS3 now includes a new color to grayscale conversion feature

called Black and White. As well as customized mapping of colors

to gray the feature can tint monochromes as well.

Blend mode The formula used for defining the mixing of a layer with those

beneath it.

Bridge Adobe's sophisticated file browsing and organization program that

ships with Photoshop.

Brightness The value assigned to a pixel in the HSB model to define the

relative lightness of a pixel.

Byte Eight bits. The standard unit of binary data storage containing a

value between 0 and 255.

Captured A record of an image.

CCD Charge Coupled Device. A solid state image pick-up device used in

digital image capture.

Channels The divisions of color data within a digital image. Data is separated

into primary or secondary colors.

Charge Coupled Device See CCD.

CIS Contact Image Sensor. A single row of sensors used in scanner

mechanisms.

Clipboard The temporary storage of something that has been cut or copied.

Clipping group Two or more layers that have been linked. The base layer acts as a

mask, limiting the effect or visibility of those layers clipped to it.

Cloning Tool A tool used for replicating pixels in digital photography.

CMOS Complementary Metal Oxide Semiconductor. A chip used widely

within the computer industry, now also frequently used as an image

sensor in digital cameras.

CMYK Cyan, Magenta, Yellow and black (K). The inks used in four-color

printing.

Color fringes Bands of color on the edges of lines within an image.

Color fringing See *Color fringes*.

Color gamut The range of colors provided by a hardware device, or a set of

pigments.

Color Picker Dialog box used for the selection of colors.

Color space An accurately defined set of colors that can be translated for use as

a profile.

See CMOS.

ColorSync System level software developed by Apple, designed to work

together with hardware devices to facilitate predictable color.

Complementary metal

oxide semiconductor

Composition The arrangement of shape, tone, line and color within the

boundaries of the image area.

Compression A method for reducing the file size of a digital image.

Constrain proportions Retains the proportional dimensions of an image when changing

the image size.

Contact image sensor See CIS.

Context The circumstances relevant to something under consideration.

Continuous tone An image containing the illusion of smooth gradations between

highlights and shadows.

Contrast The difference in brightness between the darkest and lightest areas

of the image or subject.

CPU Central Processing Unit, used to compute exposure.
Crash The sudden operational failure of a computer.

Crop Reduce image size to enhance composition or limit information.

Curves Control for adjusting tonality and color in a digital image.

DAT Digital Audio Tape. Tape format used to store computer data.

Default The settings of a device as chosen by the manufacturer.

Defringe The action of removing the edge pixels of a selection.

Density The measure of opacity of tone on a negative.

Depth of field The zone of sharpness variable by aperture, focal length or subject

distance.

Descreen The removal of half-tone lines or patterns during scanning.

Device An item of computer hardware.

Device dependent Dependent on a particular item of hardware. For example,

referring to a color result unique to a particular printer.

color result that can be replicated on any hardware device.

Digital audio tape See DAT.

Digital image A computer-generated photograph composed of pixels (picture

elements) rather than film grain.

Digital Negative format Adobe's open source Raw file format.

Adobe's Digital Negative format.

Download To copy digital files (usually from the Internet).

Dpi Dots per inch. A measurement of resolution.

Dummy file To go through the motions of creating a new file in Photoshop

for the purpose of determining the file size required during the

scanning process.

Dye sublimation print A high quality print created using thermal dyes.

Dyes Types of pigment.

Edit Select images from a larger collection to form a sequence or

theme.

Editable text Text that has not been rendered into pixels.

Eight-bit image A single-channel image capable of storing 256 different colors or

levels.

Evaluate Assess the value or quality of a piece of work.

Exposure Combined effect of intensity and duration of light on a light-

sensitive material or device.

Exposure compensation To increase or decrease the exposure from a meter-indicated

exposure to obtain an appropriate exposure.

Feather The action of softening the edge of a digital selection.

File format The code used to store digital data, e.g. TIFF or JPEG.

File size The memory required to store digital data in a file.

Film grain See Grain.

Film speed A precise number or ISO rating given to a film or device

indicating its degree of light sensitivity.

F-numbers (f-stops) A sequence of numbers given to the relative sizes of aperture

opening. F-numbers are standard on all lenses. The largest number corresponds to the smallest aperture and vice versa.

Format The size of the camera or the orientation/shape of the image.

Frame The act of composing an image. See *Composition*.

essential skills: photoshop CS3

Freeze Software that fails to interact with new information.

FTP software File Transfer Protocol software is used for uploading and

downloading files over the Internet.

Galleries A managed collection of images displayed in a conveniently

accessible form.

Gaussian Blur A filter used for defocusing a digital image.

GIF Graphics Interchange Format. An 8-bit format (256 colors) that

supports animation and partial transparency.

Gigabyte A unit of measurement for digital files, 1024 megabytes.

Grain Tiny particles of silver metal or dye that make up the final image.

Fast films give larger grain than slow films. Focus finders are used to magnify the projected image so that the grain can be seen and

an accurate focus obtained.

Gray card Card that reflects 18% of incident light. The resulting tone is

used by light meters as a standardized midtone.

Grayscale An 8-bit image with a single channel used to describe

monochrome (black and white) images.

Half-tone A system of reproducing the continuous tone of a photographic

print by a pattern of dots printed by offset litho.

Hard copy A print.

Hard drive Memory facility that is capable of retaining information after the

computer is switched off.

HDR High Dynamic Range image.

High Dynamic Range A picture type that is capable of storing 32 bits per color channel.

This produces a photo with a much bigger possible brightness range that found in 16- or 8-bit per channel photos. Photoshop

creates HDR images with the Merge to HDR feature.

Highlight Area of subject receiving highest exposure value.

Histogram A graphical representation of a digital image indicating the pixels

allocated to each level.

Histories The memory of previous image states in Photoshop.

History Brush A tool in Photoshop with which a previous state or history can be

painted.

HTML HyperText Markup Language. The code that is used to describe

the contents and appearance of a web page.

Hue The name of a color, e.g. red, green or blue.

Hyperlink A link that allows the viewer of a page to navigate or 'jump' to

another location on the same page or on a different page.

ICC International Color Consortium. A collection of manufacturers

including Adobe, Microsoft, Agfa, Kodak, SGI, Fogra, Sun and Taligent who came together to create an open, cross-platform

standard for color management.

ICM Image Color Management. Windows-based software designed

to work together with hardware devices to facilitate predictable

color.

Image Color Management

See ICM.

A device used to print CMYK film separations used in the Image setter

printing industry.

The pixel dimensions, output dimensions and resolution used to Image size

define a digital image.

Infrared film A film that is sensitive to the wavelengths of light longer than

720nm, which are invisible to the human eye.

An exposure that is fast enough to result in a relatively sharp Instant capture

image free of significant blur.

International Color

Consortium

Interpolation

Interpolated resolution Final resolution of an image arrived at by means of interpolation.

Increasing the pixel dimensions of an image by inserting new

pixels between existing pixels within the image.

International Standards Organization. A numerical system for ISO

rating the speed or relative light sensitivity of a film or device.

Internet Service Provider, allows individuals access to a web ISP

server.

See ICC.

A storage disk capable of storing slightly less than 2GB, Jaz

manufactured by Iomega.

Joint Photographic Experts Group. Popular image compression JPEG (.jpg)

file format.

To open a file in another application. Jump

Placing objects or subjects within a frame to allow comparison. **Juxtapose**

Kilobyte 1024 bytes.

A device-independent color model created in 1931 as an LAB mode

international standard for measuring color.

Lasso Tool Selection Tool used in digital editing.

An image created by exposure onto light-sensitive silver halide Latent image

ions, which until amplified by chemical development is invisible

to the eye.

Ability of the film or device to record the brightness range of the Latitude

subject.

A feature in digital editing software that allows a composite Layer

digital image where each element is on a separate layer or level.

Layer mask A mask attached to a layer that is used to define the visibility of

pixels on that layer.

A group of Photoshop layers that have to be converted into a Layer Stacks

Smart Object for the purposes of performing image analysis on

the differences between the picture content of each layer.

essential skills: photoshop CS3

LCD Liquid Crystal Display.

LED Light-Emitting Diode. Used in the viewfinder to inform the

photographer of exposure settings.

Lens An optical device usually made from glass that focuses light rays

to form an image on a surface.

Levels Shades of lightness or brightness assigned to pixels.

Light cyan A pale shade of the subtractive color cyan. Light magenta A pale shade of the subtractive color magenta. LiOn

Lithium ion. Rechargeable battery type.

Lithium ion See LiOn.

LZW compression A lossless form of image compression used in the TIFF format.

Magic Wand Tool Selection Tool used in digital editing.

Magnesium lithium See MnLi.

Marching ants A moving broken line indicating a digital selection of pixels.

Marquee Tool Selection Tool used in digital editing.

Maximum aperture Largest lens opening.

Megabyte A unit of measurement for digital files, 1024 kilobytes.

Megapixels More than a million pixels.

Memory card A removable storage device about the size of a small card. Many

technologies available result in various sizes and formats. Often

found in digital cameras.

Merge to HDR Photoshop's feature for creating HDR images from a series of

photos with bracketed exposures.

Metallic silver Metal created during the development of film, giving rise to the

appearance of grain. See Grain.

Minimum aperture Smallest lens opening.

MnLi Magnesium lithium. Rechargeable battery type.

Mode (digital image) RGB, CMYK, etc. The mode describes the tonal and color range

of the captured or scanned image.

Moiré A repetitive pattern usually caused by interference of overlapping

symmetrical dots or lines.

Motherboard An electronic board containing the main functional elements of a

computer upon which other components can be connected.

Multiple exposure Several exposures made onto the same frame of film or piece of

paper.

Negative An image on film or paper where the tones are reversed, e.g. dark

tones are recorded as light tones and vice versa.

NiCd Nickel cadmium. Rechargeable battery type.

Nickel cadmium See NiCd. Nickel metal hydride See NiMH.

NiMH Nickel metal hydride. Rechargeable battery type.

Noise Electronic interference producing white speckles in the image. Non-destructive editing An editing approach that doesn't alter the original pixels in a

photo throughout the enhancement process. Typically used for Raw processing or in techniques that make use of Smart Object

technology.

Non-imaging To not assist in the formation of an image. When related to light

it is often known as flare.

ODR Output Device Resolution. The number of ink dots per inch of

paper produced by the printer.

Opacity The degree of non-transparency.

Opaque Not transmitting light.

Optimize The process of fine-tuning the file size and display quality of an

image or image slice destined for the web.

Out of gamut Beyond the scope of colors that a particular device can create.

Output device resolution See ODR.

Path The outline of a vector shape.

PDF Portable Document Format. Data format created using Adobe

software.

Pegging The action of fixing tonal or color values to prevent them from

being altered when using Curves image adjustment.

Photomerge Adobe's own panoramic stitching utility.

Photo multiplier tube See *PMT*.

Piezoelectric Crystal that will accurately change dimension with a change

of applied voltage. Often used in inkjet printers to supply

microscopic dots of ink.

Pixel The smallest square picture element in a digital image.

Pixelated An image where the pixels are visible to the human eye and

curved lines appear jagged or stepped.

PMT Photo Multiplier Tube. Light-sensing device generally used in

drum scanners.

Portable Document Format See *PDF*.

Pre-press Stage where digital information is translated into output suitable

for the printing process.

Primary colors The three colors of light (red, green and blue) from which all

other colors can be created.

Processor speed The capability of the computer's CPU measured in megahertz.

PSD Photoshop Document format.

Quick Mask mode

Quick Selection Tool

Temporary alpha channel used for refining or making selections.

A selection tool added to Photoshop in version CS3 that tries to

predict the shape of the selection as you draw. The feature takes into account tone, color, texture and shape of the underlying

photo as it creates the selection.

essential skills: photoshop CS3

RAID Redundant Array of Independent Disks. A type of hard disk

assembly that allows data to be simultaneously written.

RAM Random Access Memory. The computer's short-term or working

> memory. See RAID.

Redundant array of independent disks

Reflector A surface used to reflect light in order to fill shadows.

Refraction The change in direction of light as it passes through a transparent

surface at an angle.

Resample To alter the total number of pixels describing a digital image. Resolution A measure of the degree of definition, also called sharpness. RGB Red, Green and Blue. The three primary colors used to display

images on a color monitor.

Rollover A web effect in which a different image state appears when the

viewer performs a mouse action.

Rubber Stamp A tool used for replicating pixels in digital imaging. Also called

Clone Stamp Tool.

Sample To select a color value for analysis or use.

Saturation (color) Intensity or richness of color hue.

Save a Copy An option that allows the user to create a digital replica of an

image file but without layers or additional channels.

Save As An option that allows the user to create a duplicate of a digital

> file but with an alternative name, thereby protecting the original document from any changes that have been made since it was

opened.

Scale A ratio of size.

Scratch disk memory Portion of hard disk allocated to software such as Photoshop to

be used as a working space.

Screen real estate Area of monitor available for image display that is not taken up

by palettes and toolbars.

Screen redraws Time taken to render information being depicted on the monitor

as changes are being made through the application software.

Secondary colors The colors cyan, magenta and yellow, created when two primary

colors are mixed.

Sharp In focus, Not blurred.

Single lens reflex See SLR camera.

Slice Divides an image into rectangular areas for selective optimization

or to create functional areas for a web page.

Slider A sliding control in digital editing software used to adjust color,

tone, opacity, etc.

SLR camera Single Lens Reflex camera. The image in the viewfinder is

> essentially the same image that the film will see. This image, prior to taking the shot, is viewed via a mirror that moves out of the

way when the shutter release is pressed.

Smart Filter An extension of the Smart Object technology that allows the non-

destructive application of Photoshop filters to an image.

Smart Object Technology first introduced in Photoshop CS2 that maintains

the original form of an embedded image but stills allows it to be edited and enhanced. Smart Objects are used in many non-

destructive editing or enhancement techniques.

Snapshot A record of a history state that is held until the file is closed.

Soft proof The depiction of a digital image on a computer monitor used to

check output accuracy.

Software A computer program.

Stack Several photos grouped together in the Bridge workspace.

Subjective analysis Personal opinions or views concerning the perceived

communication and aesthetic value of an image.

Subtractive color A color system where the subtractive primary colors yellow,

magenta and cyan mix to form all other colors.

System software Computer operating program, e.g. Windows or Mac OS.

Tagging System whereby a profile is included within the image data of

a file for the purpose of helping describe its particular color

characteristics.

Thematic images A set of images with a unifying idea or concept.

TIFF Tagged Image File Format. Popular image file format for desktop

publishing applications.

Tone A tint of color or shade of gray.

Transparent Allowing light to pass through.

Tri-color A filter taking the hue of either one of the additive primaries, red,

green or blue.

True resolution The resolution of an image file created by the hardware device,

either camera or scanner, without any interpolation.

TTL meter Through-The-Lens reflective light meter. This is a convenient way

to measure the brightness of a scene as the meter is behind the

camera lens.

Tweening — Derived from the words in betweening — an automated process

of creating additional frames between two existing frames in an

animation.

UCR Under Color Removal. A method of replacing a portion of the

yellow, magenta and cyan ink, within the shadows and neutral

areas of an image, with black ink.

Under color removal See *UCR*.

Unsharp Mask See USM.

Unsharp Mask filter A filter for increasing apparent sharpness of a digital image.

URL Uniform Resource Locator. The unique web address given to

every web page.

USM Unsharp Mask. A process used to sharpen images.

essential skills; photoshop CS3

Vanishing Point A Photoshop feature designed to allow the manipulation of

photos within a three-dimensional space.

Vector graphic A resolution-independent image described by its geometric

characteristics rather than by pixels.

Video card A circuit board containing the hardware required to drive the

monitor of a computer.

Video memory Memory required for the monitor to be able to render an image.

Virtual memory Hard drive memory allocated to function as RAM.

Visualize To imagine how something will look once it has been completed.

Workflow Series of repeatable steps required to achieve a particular result

within a digital imaging environment.

Zip An older style storage disk manufactured by Iomega, available in

either 100MB or 250MB capacity.

Zoom Tool A tool used for magnifying a digital image on the monitor.

Keyboard Shortcuts

 ∇ = Option \triangle = Shift \Re = Command \boxtimes = Delete/Backspace

Action Keyboard Shortcut

Navigate and view

Fit image on screen Double-click Hand Tool or \$\mathbb{H}/\text{Ctrl} + 0 '(zero)'

View image at 100% Double-click Zoom Tool or √/Alt + ♯/Ctrl + 0

Zoom Tool (magnify) #/Ctrl + Spacebar + click imageZoom Tool (reduce) $\frac{1}{\sqrt{\text{Alt}}} + \frac{\#}{\text{Ctrl}} + \text{click image}$

Full/Standard/Maximized screen mode

Show/hide rulers $\mbox{$\mathbb{H}$/Ctrl + R$}$ Show/hide guides $\mbox{$\mathbb{H}$/Ctrl + ;}$ Hide palettes $\mbox{$\mathbb{H}$}$ Tab key

File commands

Open $\frac{\#/\text{Ctrl} + O}{\text{Close}}$ $\frac{\#/\text{Ctrl} + W}{\text{Save}}$ $\frac{\#/\text{Ctrl} + S}{\text{Save}}$

Save As $\triangle + \Re/\operatorname{Ctrl} + S$ Undo/Redo $\Re/\operatorname{Ctrl} + Z$

Step Backward $\nabla/Alt + \Re/Ctrl + Z$ Step Forward $\Re/Ctrl + \Delta + Z$

Selections

Add to selection Hold & key and select again

Subtract from selection Hold √/Alt key and select again

Copy $\mbox{$\m$

Distort image in Free Transform Hold **#** key + move handle

Feather $\#/\text{Ctrl} + \sqrt{\text{Alt} + D}$

Select All #/Ctrl + ADeselect #/Ctrl + DReselect $\triangle + \#/\text{Ctrl} + D$ Inverse selection #/Ctrl + I

Edit in Quick Mask mode Q

Painting

Set default foreground and background colors Switch between foreground and background color

Enlarge brush size (with Paint Tool selected)
Reduce brush size (with Paint Tool selected)

Make brush softer [+ Shift
Make brush harder] + Shift

Change opacity of brush in 10% increments

(with Brush Tool selected) Fill with foreground color

Fill with foreground color

T/Alt ♥

Fill with background color

#/Ctrl ♥

Adjustments

Levels #/Ctrl + LCurves #/Ctrl + MHue/Saturation #/Ctrl + USelect next adjustment point in Curves Ctrl + Tab

Layers and masks

Load selection from layer mask or channel

Change opacity of active layer in 10% increments

#/Ctrl + click thumbnail

Press number keys 0–9

D

X

1

Press number keys 0-9

Move layer down/up #/Ctrl + [or]

Group selected layers #/Ctrl + G

Create Clipping Mask $\#/\text{Ctrl} + \sqrt{Alt} + G$

 Disable/enable layer mask
 ♣ + click layer mask thumbnail

 Preview contents of layer mask

 ∇/Alt + click layer mask thumbnail

Group or clip layer #/Ctrl + G

Blend modes $\nabla/Alt + \Delta + (F, N, M, S, O, Y)$ Soft Light

Normal, Multiply, Screen, Overlay, Luminosity

Crop

Enter crop Return key

Cancel crop Esc key

Constrain proportions of crop marquee Hold ☆ key

Turn off magnetic guides when cropping

Hold √/Alt � keys + drag handle

Web Links

Information and blogs

http://www.photoshopessentialskills.com Essential Skills

Photoshop Support http://www.photoshopsupport.com

Adobe Digital Imaging http://www.adobe.com/digitalimag/main.html

Martin Evening http://www.martinevening.com

Luminous Landscape http://www.luminous-landscape.com

Digital Photography Review http://www.dpreview.com http://www.digitaldog.net Digital Dog

http://www.epson.com Epson

http://www.photoshopblog.net/ Photoshop Blog http://blogs.adobe.com/jnack/ John Nack http://www.photoshopnews.com/

Tutorials

Photoshop News

Adobe http://www.adobe.com/designcenter/

Essential Skills http://www.photoshopessentialskills.com

Russell Brown http://www.russellbrown.com

Photoshop Support http://www.photoshopsupport.com Planet Photoshop http://www.planetphotoshop.com

Photoshop Workshop http://www.psworkshop.net

Illustrators

iStockphoto www.iStockphoto.com Paul Allister obscur@hotpop.com

Magdelena Bors www.magdalenabors.com/ www.samanthaeverton.com Samantha Everton

www.linkafoto.com.au Paulina Hrvniewiecka

Chis Mollison photography@chrismollison.com.au

www.chrisneylon.net Chris Nevlon

Serap Osman www.seraposman.com.au Rod Owen www.owenphoto.com.au Craig Shell tzsshell@netspace.net.au Daniel Stainsby www.danstainsbv.com Akane Utsunomiya akane@antsushi.com

Victoria Verdon-Roe vverdonroe@yahoo.com

3D forms, 351 3D layers, 121 4-ink printers, 98 6-ink printers, 98 8-bit images, 80, 409 12-bit capture, 86 16-bit editing, 57 32-bit editing, 57, 344

Aberration see Chromatic aberration Accented Edges filter, 187 Accessing resources, 53 Acquisition of skills, xii ACR see Adobe Camera Raw Adams, Ansel, 214, 250, 343 Adding: gradients, 127 keywords, 51 layer masks, 303, 311 layers, 117 noise, 192, 236, 264, 384, 386

to selections, 133, 134 unplaced photos, 369 Additive color, 21, 407

Adjusted White Point see Target White Point Adjustment layers, 109, 117, 121, 126

advanced blending project, 403 Black and White, 251-2

blend project, 312-13 definition, 407

Gradient maps, 261, 265, 267 layer masks, 127, 301

levels, 215-16, 272, 292-3, 349

Posterization project, 378-9 project, 214-25

replacing sky project, 329-30 selections, 133

Shadow/Highlight project, 228 time of day project, 287, 290, 292-3

Adjustments: blend modes, 166

color, 65-7 editing, 127 exposure, 87-92 hue, 143-4

narrow color ranges, 223 points selection, 83

Shadow/Highlight, 226-30

shortcuts, 418 test print analysis, 107 tone, 61-5, 82-3, 89

Adobe Camera Raw (ACR), 52, 75-96

adjusting exposure, 87–92 definition, 407

sensors, 343

Smart Objects project, 273-5

see also Camera Raw; Raw format Adobe gamma, 407

Adobe Photo Downloader (APD), 48-9, 407

Adobe RGB, 79

Advanced mode, Bridge, 49 Advanced techniques:

blending, 366, 370, 401-5

retouching, 249-96 sharpening, 240-8

Algorithms, definition, 407

Aliasing, 407

see also Anti-aliasing

Alignment:

layers, 194, 346, 359-60 panorama parts, 370

sliders, 209

Allister, Paul, 74, 419

Alpha channels, 122-3, 138, 301-3, 407

Alt/Option key, 149-51

Amount sliders, 69, 196, 212, 227-8

Analysis, definition, 407 Anchor points, 315-16 Anti-aliasing, 16, 137, 407 'Ants', 139-40, 412

see also Magic Wand

APD see Adobe Photo Downloader Apertures, 407, 412

Apple Macintosh see Macintosh computers Application of skills, xii

Applied Science Fiction filters, 176-7 Applying filters, 172, 173-4

Archiving Raw files, 94

Area array, 407

Artifacts, definition, 407 Artistic filters, 186

Aspect ratio, definition, 407 Auto-Align Lavers, 194, 359-60

Auto options, Photomerge, 365-6, 370

Background layers, 117, 119, 122 blend modes, 158, 160, 310, 313

color, 300-1, 321 depth of field, 270

duplicating, 282, 379 extracting hair project, 322

layer mask project, 298-9, 302-3

replacing sky project, 331 Smart Objects, 238

Backlight effect, 312-13 Balance see White balance

Banding, 86, 126, 264, 267

Barrel distortion, 190-1, 208, 210

Bas Relief filter, 198 Basic dRawing skills, 148-51

Batch removal, dust, 93-4

Bevel and Emboss layer effect, 402

Bicubic resampling, 36, 37 Bit, definition, 407

Bit depth, 23, 57, 80, 344, 407 Bitmaps, definition, 407

Black and White, 250–68, 407	Brush Strokes filters, 187
see also Monochromes	Brush Tool:
Blacks slider, 82	Black and White, 253, 257
Blemish removal, 399–400	composite lighting project, 361
Blend modes, 153–70	Displace and Liquify project, 353, 356-7
advanced blending, 401–5	extracting hair project, 321–3, 325
Auto-Align Layers, 360	High Dynamic Range project, 348
Darken group, 156–8, 325	layer mask project, 301, 305
definition, 407	portrait makeover project, 397, 398, 400
diffusion project, 381–6	Shadow/Highlight project, 230
extracting hair, 319–25	size and hardness shortcut, 300
filters, 390	Smart Objects project, 276
image selection, 309	smooth tone technique, 282, 285
layers, 119, 153–70, 228–9, 308–13, 319–25, 351	time of day project, 289, 293
	see also Healing Brush; Painting
Lighten group, 159–61, 397	3
Luminosity, 166, 242–3, 246, 285, 336, 381	Burn:
major groupings, 154	Black and White, 257, 263
Overlay group, 162–3, 168, 229, 253, 276, 321	blend modes, 158, 163
portrait makeover project, 397	Displace and Liquify project, 353
project, 308–13	panorama project, 368
retouching projects, 228–9, 243, 246	Shadow/Highlight project, 226, 229
Spot Healing Brush, 400	Bytes, definition, 407
tinting and toning, 164–5	
Blend options, Photomerge, 365-6, 370	Cache, 8, 47
Bloat Tool, 181	Calibration, 3–4, 100
Blogs, xiii, 419	Camera Raw, 25, 75–96, 273–5, 343, 407
Blue channel, 252, 254, 275–6, 320	see also Raw format
Blur filters, 172, 188–9	Cameras:
advanced blending project, 404	adjusting exposure, 87
Black and White project, 255, 257	depth of field, 269, 272
depth of field, 269–72	digital capture, 58
diffusion project, 381–6	filters, 172
Displace and Liquify project, 354	High Dynamic Range project, 342–3
Gradient maps, 262	image size, 34
lith printing project, 395–6	panorama project, 366, 370, 371
montage projects, 305, 317-18, 328	perspective, 204
project, 332–41	Raw format, 76
smooth tone technique, 282–4	sharpening techniques, 240
see also Sharpen	SLR, 414
Borders, 135, 395-6	smooth tone technique, 281
Bors, Magdalena, 97, 152, 419	Capturing images, 23, 55-74, 86, 240, 407, 411
Bounding boxes, 288, 291, 303	CCD, definition, 408
Bracketing exposures, 343–4	Central Processing Unit (CPU), 408
Bridge program, 41–54	Channels, 17, 115-16, 124-5
definition, 407	alpha channels, 122-3, 138, 301-3, 407
filtering files, 43, 50	Black and White, 252-4
image size, 24	blend project, 312
Loupe view, 43, 45	changing, 124
panels, 43, 46	Curves adjustment, 220
setting up, 44–5	definition, 408
thumbnails, 43, 46	duplicating, 354
tools, 51–2	editing, 57
version 2.0 , 43, 45	extracting hair project, 319–25
Brightness, 19–20	filters, 193, 201
adjustment layers, 216	Gradient maps, 260, 263
adjustments, 61–3	layer mask project, 301–3
blend modes, 156, 158–9	luminance, 166
definition, 407	masking, 145–6
Displace and Liquify project, 353	palette, 21
panorama project, 371	Posterization project, 377
see also Hue	saving selections as, 138
Browsing files 42	sharpening images, 244
DELLAVATION THEN, 47	and Denniq initiales, 277

Smart Objects project, 275–6	Color casts, 65–6
types, 125	Color Dodge, 161
Charge Coupled Device see CCD	Color fringing, 190, 212, 408
Chromatic aberration, 204, 206–7	see also Chromatic aberration
see also Color, fringing	Color gamut, 22, 98–9, 408, 413
CIS, definition, 408	Color management, 22, 103–6
Cleaning images, 68	Color mode, 17, 124
Click and drag skills, 148–50	see also Channels
Clipboard, definition, 408	Color Picker, 20, 21, 408
Clipping, 67, 215–16	Color profiles, 99, 111
advanced information, 82	Color Range, selections, 143–4
blending project, 403	Color space, 79, 84, 273, 408
group, 408	Colorize option, 222
replacing sky project, 329–30	ColorSync, definition, 408
saturation, 84	Commands, xiv, 2, 417
Clone Source palette, 231–2, 239	Compensation, exposure, 409
Clone Stamp Tool, 68, 231–9, 399	Complementary metal oxide semiconductor see CMOS
Cloning Tool, 408	Composite lighting project, 359-64
Cloud effects, 291, 401–3	Compositions, definition, 408
CMOS, definition, 408	Compression, 24-6, 28-9, 71, 408
CMY images, 17, 21	Constrain Proportions, 35, 408
CMYK images, 17, 21, 124–5	Contact Image Sensor see CIS
CMYK ink system, 98–9, 112, 113, 408	Context, definition, 408
CODEC process, 28	Contiguous option, selections, 132, 139
Color:	Continuity factors, montage, 332
additive, 21, 407	Continuous tone, 18, 408
adjustments, 65–7	Contract option, selections, 135
Black and White, 250–1, 258	Contrast:
blend mode, 164	adjustment layers, 216, 221
chart, 81	adjustments, 61–3
conversions, 98–9	definition, 408
corrections, 66, 218–19, 224–5, 237	projects, 228, 342–3, 347, 350
creating and sampling, 20	selections, 131, 136
extracting that sumpling, 20	Convergence of verticals, 207, 247
fill color, 230	Conversions:
Gradient maps, 259–68	color, 98–9
layer mask project, 300–1	Raw files, 52
levels, 18–20, 66	Cool colors, 224, 266
lith prints, 392, 393	Copy and paste, 182
monitors, 3	Corner points, 149
narrow ranges, 223	Corrections:
noise, 85	
	color, 66, 218–19, 224–5, 237
overview, 21–2	lens distortion, 190–1, 204–10, 237–8, 247
panorama stitching, 370	perspective, 190–1, 204–13
paper, 390	see also Adjustments
perception, 22	CPU see Central Processing Unit
Posterization project, 376–80	Craquelure filter, 199
primary colors, 17, 21, 413	Crash, definition, 408
reintroducing, 258	Cropping, 59–60
removing red, 398	Camera Raw images, 92
samples, 20, 282	definition, 408
secondary colors, 414	processing projects, 78
selections based on, 131	retouching projects, 211, 237
selective, 222	shortcuts, 418
settings, 5, 100	Cross-platform saving, 27
subtractive, 21, 415	Crosshatch filter, 187
temperature, 3	CRT monitors, 3–4
time of day project, 290–1	Curves, dRawing, 149
Type layer, 405	Curves adjustment feature, 64, 83, 166
working space, 100	blend project, 312
Color Balance, 218	definition, 408
Color Burn, 158	Posterization project, 378

replacing sky project, 329–30	Shadow/Highlight project, 226, 229
retouching projects, 219-20, 224-6, 229	DOF see Depth of field
Custom filter, 200, 201	Dots per inch <i>see</i> dpi
Customization:	Downloading, 48, 409
selections, 133–4	Downsampling, 299
Sharpen filters, 196	dpi (dots per inch), 32, 409
Cyan, Magenta and Yellow see CMY	Dragging see Click and drag
Cylindrical format, panoramas, 365, 366	DRawing:
	basic skills, 148–51
Darken blend modes, 156-8, 325	project, 314–18
DAT, definition, 408	selections based on, 131
Data, Raw, 77	Drivers, 104
De-Interlace filter, 200	Drives, 24, 410
Decompression, 28	DSLR cameras, 87
Default settings, 10, 103, 408	Dummy files, definition, 409
Defringe, 138, 409	Duplicate:
Density, 370, 409	background layers, 282, 379
Dependent devices, 409	channels, 354
Depth of field (DOF), 188, 269–72, 332, 409	images, 213
Depth Map Source, 189	layers, 334
Desaturation, 165, 167, 389	Dust & Scratches filter, 192
see also Saturation	Dust on sensors, 93–4
Descreen, definition, 409	DVD, supporting, x-xi, xiii, 53, 77-94, 208, 326, 391
Despeckle filter, 192	Dye sublimation print, 409
Device, definition, 409	Dyes, definition, 409
Difference blend mode, 167	,
Diffusion project, 381–6	Edge Highlighter Tool, 178–9
Digital Audio Tape see DAT	Edges:
Digital basics, 15–40	extracting hair project, 323
Digital cameras see Cameras	layer mask project, 304–5
Digital capture, 58	paths and selections project, 314
see also Capturing	Polaroid images, 391
Digital darkroom, 1–14	refinements, 132, 135-6, 140-2, 306-7, 311
Digital diffusion, 381–6	Edit Plane Tool, 183, 184-5
Digital exposure, 86–92	Editable text, 121, 409
Digital files, 30–1	Editing:
see also File	8-bit, 80
Digital images, 116, 409	16-bit, 57
Digital Negative format see DNG format	32-bit, 57, 344
Digital Polaroid transfer effect, 387–91	adjustments, 127
Digital printing, 97–114	definition, 409
see also Printers/printing	non-destructive, 126, 413
Dimensions, pixels, 35	over 8-bits per channel, 23
Direct Selection Tool, 151, 316	quality, 126
Disks, 9, 24, 414	Effects see Filters; Special effects
Displace filter, 351–8	Efficiency of memory, 9
Displacement maps, 351–8	Eight-bit images see 8-bit images
Display resolution, 30	Eliminating see Removing
Dissolve blend mode, 155	Emboss, 197, 402
Distort filters, 190-1, 205-10, 237-8, 247	Enhancing images, 55–74
DNG format, 25, 26, 409	EPS vector graphics, 363
archiving files, 94	Evaluation, definition, 409
converting files, 52	Everton, Samantha, 55, 419
definition, 409	Exclusion blend mode, 167
see also Raw format	Expand option, selections, 135
Docking palettes, 7	'Exposing right', 88, 90
Document size, 35	Exposure, 86–92
Dodge:	adjusting in ACR, 87–92
Black and White, 257	bracketing exposures, 343–4
blend modes, 161, 163	compensation, 409
Displace and Liquify project, 353	definition, 409
panorama project, 368	multiple, 412
and the second s	COLUMN TO THE PROPERTY OF THE

essential skills: photoshop CS3

panorama project, 371	see also File formats
slider, 82	Forward Warp Tool, 181
Extended Photoshop CS3, 121, 194	Foundation project, 58–72
Extract filter, 178–9	Frame, definition, 409
Extracting hair project, 319–25	Freckles, softening, 396-7
Extreme Brightness Range, 371	Free Transform command, 362–3
Extrude filter, 197	see also Transform command
Eyedroppers, 65, 282, 398	Freeze, definition, 410
	Freeze Mask Tool, 180–1, 286
F-numbers, definition, 409	Frequency:
Fade option, 176, 236	pixels, 131
Feathering, 135, 137, 140, 142, 409	saving, 56
Ferguson, Max, 262	Fresco filter, 186
File, see also Digital files; Image; Modified files;	Fringing, 138, 190, 212, 311, 408
TIFF files	see also Chromatic aberration
File browsing, 42	
	FTP software, definition, 410
File command shortcuts, 417	Colonta Commo 151
File formats, 25–7, 29, 409	Galante, Serena, 154
see also individual file formats	Galer, Mark, 73, 95, 203, 247–9, 326, 342
File location, Bridge, 50	Galleries, 175, 410
File names, 27	Gamma, definition, 407
File size, 24, 31–3, 71, 409	Gamma slider, 107, 215–16, 261
Fill color, 230	Gamut, color, 22, 98–9, 408, 413
Film grain see Grain	Gaussian Blur, 172, 188-9
Filter Gallery, 175	definition, 410
Filter layers, 126, 164	diffusion project, 381-6
Filter panel, Bridge, 43, 50	lith printing project, 395
Filters, 171–202	montage projects, 305, 317-18, 328
advanced blending, 404–5	Radius, 354
applying, 172, 173–4	retouching projects, 269-71, 282, 284
artistic group, 186	Ghosting problems, 348, 367-8, 370
Black and White, 250, 255	GIF format, 26, 410
Brush Strokes, 187	Gigabytes, definition, 410
Clone and Stamp, 231–9	Gleeson, Shari, 158
color corrections, 224	Gradient maps, 259–68
digital Polaroid transfer effect, 389–91	Gradient presets, 268
Distort, 190–1, 205–10, 237–8, 247	Gradient Tool, 264
improving performance, 176	advanced blending project, 405
lith printing project, 394–6	Black and White, 255–6
Posterization project, 380	blend project, 313
project, 351–8	Clone and Stamp, 235–8
Render, 195	depth of field effects, 270
Shadow/Highlight project, 227	extracting hair project, 325
Sketch, 198	layer masks, 127
Smart Objects, 126	•
smooth tone technique, 282–6	replacing sky project, 329–30
	shadows and blur project, 338
Stylize, 197	Smart Objects project, 279
Texture, 199, 390–1	Grain, 392, 393, 410
Video, 200	see also Texture
see also Blur filters; Noise filters; Sharpen filters	Graphic Interchange Format see GIF format
Flash light, 88	Graphic Pen filter, 198
'Flat' images, 116–17	Gray cards, 81, 410
Flatten image, 211	Gray point, 66
Fonts, 401–2, 405	Grayscale:
Foreground:	channels, 123, 125
color, 300–1, 321	images, 23, 251, 309, 352, 376, 410
masks, 276–9	levels, 355
Format Options, JPEG, 71	GretagMacbeth ColorChecker Chart, 81
Formats, 409	

Grids, 184	see also Brightness; Saturation
Grow feature, selections, 135	Hue, Saturation and Brightness (HSB), 19–20, 21
Guides, 13	Hyperlinks, definition, 410
caracs, 15	Hypertext markup language see HTML
Hair:	,
extracting, 319–25	IBM version, TIFF, 27
red removal, 398	ICC:
Half-tone, definition, 410	definition, 410
Halos:	profiles, 99, 111
montage projects, 312, 318, 323–4	ICM, definition, 411
retouching projects, 312, 212, 227, 255, 265	Illustrators' web links, 419
Hand Tool, 11, 300	Image capture see Capturing images
Hard copy, 410	3 ,
	Image Color Management <i>see</i> ICM Image compression, 28–9
see also Printers/printing	see also Compression
Hard drives, 24, 410	NOT THE PROPERTY OF THE PROPER
Hard Light mode, 162–3	Image layers, 117, 121
Hard Mix blend mode, 163	Image modes, 17, 299
Hay, John, 159, 287, 419	Image Options, JPEG, 71
HDR see High dynamic range	Image quality see Quality
Heal area, 93–4, 274, 285	Image selection, blending, 309
Healing Brush, 68, 233, 239, 285, 356, 400	Image sensor, 30
High Dynamic Range (HDR), 342–50, 371, 410, 412	Image setter, definition, 411
High Pass filter, 200, 241–3, 380	Image size, 34–8
Highlights, 64–5	Bridge, 24
adjusting in ACR, 88	cropping, 59
Darken blend modes, 156	definition, 411
definition, 410	duplicate images, 213
Extract filter, 178–9	Internet browsing, 70
Gradient maps, 261, 263, 266-7	options, 35
High Dynamic Range project, 342–50	resolution, 31, 35
maximization, 108	Image stacks, 193–4
Overlay blend modes, 162–3	Image window, 7
retouching projects, 215, 217, 225, 226-30	Independent devices, 409
Sharpen filters, 196	Info palette, 21
sliders, 82	Information web links, 419
Smart Objects project, 280	Infrared film, definition, 411
smooth tone technique, 283–4	Ink cartridges, 101, 108–9, 112–13, 124
time of day project, 287, 290	Ink Outlines filter, 187
Histograms, 61–2	Inkjet printers, 98, 105, 112
8-bit editing, 80	Installing filters, 177
definition, 410	Instant capture, definition, 411
Gradient maps, 262	Interactive Layout, Photomerge, 365–7, 369
optimization, 63, 102	Interface, 5, 43
quality, 126	International Color Consortium see ICC
retouching projects, 215–17, 219	International Standards Organization see ISO
Histories/History Brush, 353, 410	Internet, 70, 72
Horizontals, 234	see also Web links
Hot pixels, 274	Internet Service Provider see ISP
Hryniewiecka, Paulina, 296, 359, 419	Interpolation, 37–8, 118, 299, 411
	Intersection mode, selections, 134
HSB see Hue, Saturation and Brightness	
HTML, definition, 410	Invert:
Hue:	Lens Blur filter, 189
adjustment layers, 221–3	selections, 134
adjustments, 143–4	shortcut, 257
blend modes, 164, 313	Iris Shapes, 189
Color Range, 143–4	ISO, definition, 411
definition, 410	ISP, definition, 411
Displace and Liquify project, 357	iStockPhoto.com:
extracting hair project, 324	images, 153, 167, 281, 308, 351
Gradient maps, 268	web link, 419
	Jaz, definition, 411

essential skills: photoshop CS3

JPEG format, 25–6 compression abilities, 29	selections, 133 sharpening techniques, 241–6
converting files, 52	shortcuts, 418
definition, 411	smooth tone technique, 282–5
duplicate images, 213	styles, 119
Reduce Noise filter, 192	types, 121–3
saving modified files, 71	viewing and working with, 118
JPEG2000 , 26, 29	see also Adjustment layers; Layer masks
Jump, definition, 411	Layout options, Photomerge, 365–7, 369
Juxtapose, definition, 411	LCD, definition, 412
saxapose, acimilion, 111	Learning approach, xiii
Keogh, Anitra, xii	LED, definition, 412
Keyboard shortcuts see Shortcuts	Lee, Seok-Jin, 54
Keyboards, 2	Lens, definition, 412
Keywords, 51	Lens Blur filter, 188, 269–72
Kilobytes, definition, 411	Lens distortion, 190–1, 204–10, 237–8, 247
Ko, Jeff, 372–3, 419	Lens Flare filter, 195
1.0/3011/372 3/113	Levels, 18–20
LAB mode, 37, 125, 411	adjustment layers, 215–16, 272, 292–3, 349
Labelling pictures, 51	advanced blending project, 401–2
Landscape photography, 342–3	color, 18–20, 66
Lasso Tools, 130, 131, 411	definition, 412
Latent image, definition, 411	digital exposure, 86
Latitude, definition, 411	Grayscale, 355
Layer groups, 109, 120	localized, 217
Layer masks, 90, 120	Quick Masks, 141–2
blend mode protection, 168	Smart Objects project, 277
blend project, 308	tonal adjustments, 18, 61, 63
definition, 411	Light/lighting:
Displace and Liquify project, 357	backlight effect, 311–12
editing, 126, 127	composite lighting project, 359–64
effects projects, 385–6, 403–4	continuity, 332
extracting hair project, 322	overview, 21–2
High Dynamic Range project, 347	primary colors, 17, 21
Multiply blend mode, 158	printing, 101, 107
paths and selections project, 314, 317–18	time of day project, 287–95
project, 298–307	see also Flash light
retouching projects, 245, 254–5, 257, 265, 270–2,	Light cyan/magenta, definition, 412
278	Light-Emitting Diode see LED
shadows and blur project, 334–5, 337–8	Lighten blend modes, 159–61, 397
shortcuts, 127	Lighting Effects filter, 195
Layer sets see Layer groups	Linear Burn, 158
Layer stacks, definition, 411	Linear Dodge, 161
Layers, 115–23	Linear Gradient, 279
adding, 117	LiOn, definition, 412
advanced techniques, 251–2, 254–6, 261–3, 265,	Liquid Crystal Display see LCD
401–5	Liquify filter, 180–1, 286, 351–8
alignment, 194, 359–60	Lith printing project, 392–6
blend modes, 119, 153–70, 228–9, 308–13,	Lithium Ion see LiOn
319–25, 351	Loading:
definition, 411	panoramas, 369
duplicating, 334	selections, 136, 138
editing quality, 126	Localized levels, 217
effects projects, 377–9, 381–6, 388–9, 391, 394–5,	Lossless compression, 26, 28, 29
397, 400	Lossy compression, 25, 28, 29
filters, 173–4, 177, 201	Loupe view, 43, 45
montage projects, 329–31, 334–8, 340, 346–7,	Low-key images, 89
350, 355–6, 364	Luminance noise, 85
overview, 117–20	Luminosity blend mode, 166, 242–3, 246, 285, 336
retouching projects, 232, 237–8, 276–8, 287,	381
290–2	Luminosity heal option, 233
saving images with, 122	Lysons ink systems, 113
Juving illiages with, 122	Lysuis IIIk systems, 113

LZW compression, 26, 412	Midtone colors, 267
see also Lossless compression	see also Tone
	Minimum aperture, definition, 412
Macintosh computers, xiv, 2, 27	Minimum filter, 200, 255
Magic Wand, 130, 132, 139-41, 327, 412	Mirror Tool, 181
Magnesium lithium see MnLi	Misalignment, 370
Magnetic Lasso Tool, 131	<i>see also</i> Alignment
Makeover project, 396–400	MnLi, definition, 412
Management:	Modes, 17
color, 22, 103–6	Auto-Align Layers, 360
shadows, 86	bit depth, 23
Manipulating layers, 119	Brush Tool, 253
Manual fix, Photomerge, 370	color, 124
Maps see Bitmaps; Displacement maps; Gradient	definition, 412
maps	filters, 390
Marching ants, 412	image modes, 17, 299
see also 'Ants'	layer mask project, 299
Marquee Tools, 60, 130, 412	navigation and viewing, 10–13
Masks:	screen modes, 12, 159–61
channel masking, 145–6	selections, 133
definition, 123	shadows and blur project, 336
depth of field, 270	smooth tone technique, 285
effects projects, 383–6	switching between, 122–3
filter usage, 201	see also Blend modes
foreground, 276–9	Modified files, 70–2
Gradient maps, 263	Moiré, definition, 412
layers, 120, 127	Mollison, Chris:
Lens Blur filter, 189	images, 14, 114, 294–5, 297, 374, 406
Liquify filter, 180–1	web link, 419
Maximum/Minimum filters, 200	Monitors:
montage projects, 327–8	calibration, 100
project, 298–307	color conversions, 98–9
retouching projects, 230	positioning, 101
selections, 141–2, 144	printing recommendations, 108
sharpening techniques, 240, 243–6	resolution, 3, 30, 70
shortcuts, 300, 418	settings, 3–4
Smart Filters, 174	Monochromes, 112–13
smooth tone technique, 285–6	see also Black and White
stitching, 367–8	Montage projects, 297–331
switching modes, 122–3	see also Photomontage
see also Layer masks; Quick Masks Matting, 138	Mosaic filter, 195 Motherboard, definition, 412
Maximizing shadow and highlight detail, 108	Motion Blur filter, 404
Maximum aperture, definition, 412	Moving selections, 133
Maximum filter, 200, 255	Multi-black printers, 113
Media types see Paper	Multiple exposures, 90, 412
Median filter, 192, 193	Multiple Raw files, 91–2
Meehan, Anica, 375	Multiply blend mode, 156–8, 322
Megabytes, definition, 412	Multiply blend mode, 150 0, 322
Megapixels, definition, 412	Narrow color ranges, 223
Memory, 8	Navigation, 10–13, 417
cards, 412	Navigator palette, 10
efficient use, 9	Negatives, 412
scratch disks, 414	see also DNG format
units, 24	Neutral colors, 224, 237
video/virtual, 416	New Selection, 133
see also RAM	New Window, 13
Menu, 6	Neylon, Chris, 40, 170, 202, 419
Merge to HDR, 343, 344, 412	Nickel cadmium (NiCd), 412
Mesh, 358	Nickel metal hydride (NiMH), 412
Metallic silver, definition, 412	No Color Adjustment control, 105
Mezzotint filter, 195	Noise:

adding, 192, 236, 264, 384, 386	digital Polaroid transfer effect, 388, 390
definition, 412	for printing, 101, 106, 108, 111, 212, 241
reduction, 85, 192–4, 230	Pasting, xiv
Noise filters, 192–4, 230, 236	see also Copy and paste
depth of field, 271	Paths:
effects projects, 384, 386, 394	definition, 413
Gradient maps, 264	montage projects, 314-18, 333-4, 360-1
Non-destructive editing, 126, 413	saving, 317
Non-imaging, definition, 413	selections from, 147–51
Normal blend mode, 155	PCs, xiv, 2, 11, 27
NTSC Colors filter, 200	PDF, definition, 413
	Pegging, definition, 413
ODR see Output Device Resolution	Pen Tool, 147–51, 315–16
Offset filter, 200, 201	Per Channel option, 193
Opacity:	Perception of color, 22
blend modes, 155, 310, 402	Perspective:
definition, 413	Clone and Stamp, 233
effects projects, 382, 397	continuity, 332
filters, 176, 212, 390	correction, 190–1, 204–13
Gradient maps, 267	panorama project, 365, 366-7, 369
healing area, 285	Vanishing Point filter, 182, 184–5
layers, 119	Photo Filter, 224
montage projects, 331, 364	Photo multiplier tube see PMT
Opening Bridge program, 42	Photo-stacking, 50
Optimization:	Photographic quality see Continuous tone
definition, 413	Photomerge, 365–71, 413
histograms, 63, 102	Photomontages, 137
image quality, 56	see also Montage projects
tonality, 62	Photoshop CS3:
Option key, 149–51	color management, 105–6
Options bar, 7	Extended edition, 121, 194
Orientation for printing, 111	getting started, 5–7
Osman, Serap:	Smart Filters, 173–4
images, 15, 39, 115, 128, 129	Photoshop Document format see PSD format
web link, 419	Picture elements see Pixels
Out of gamut, definition, 413	Picture labelling, 51
Output bureaus see Professional printing	Piezoelectric, definition, 413
laboratories	Pincushion distortion, 190, 208
Output Device Resolution (ODR), 30, 33, 413	Pixelated images, definition, 413
Overlay blend modes, 162–3, 168, 229, 253, 276,	Pixels, 16
321	
321	definition, 413
Page Setup, 10	dimensions, 35
Paint Daubs filter, 186, 389	displacement, 351–2
	hot pixels, 274
Painting:	per inch, 31–2
depth of field effects, 272	resolution, 30–3
diffusion project, 386	selections, 131–2
layer masks, 127	sharpening images, 69
in Overlay mode, 321	smooth tone technique, 286
panorama project, 367–8	Planes of perspective see Perspective
sharpening techniques, 244	Plastic Wrap filter, 186
shortcuts, 418	PMT, definition, 413
see also Brush Tool	Polaroid image transfer effect, 387–91
Palette Knife filter, 389	Polygonal Lasso Tool, 131
Palettes, 7	Portable Document Format see PDF
Clone Source, 231–2, 239	Portrait makeover project, 396–400
color and light, 21	Posterization, 86, 376–80
Layers, 117, 118	ppi (pixels per inch), 31–2
Navigator, 10	Pre-press, definition, 413
Tools, 6, 7	Preferences, 8-10
Panorama project, 365–71	Preserve Details control, 192-3
Paper:	Presets, Gradient, 268

Previews, 136, 189, 240, 242	paper types, 241
Primary colors, 17, 21, 413	Refine Edge, 136
Print workflow, 5	sharpening images, 69, 196, 212
Printers/printing, 97–114	RAID, definition, 414
channels, 124	RAM (random access memory), 8, 414
color management, 103–4	Rasterized layers, 350, 356, 405
driver, 104	Raw format, 25–6, 75–96
duplicate images, 213	archiving files, 94
dye sublimation, 409	Bridge program, 52
lith prints, 392–6	multiple files, 91–2
monochromes, 112–13	processing files, 52, 91–2
overview, 108	sensors, 343
professional laboratories, 110–11	Smart Objects project, 273–5
Radius values, 241	see also Adobe Camera Raw
resampling, 38	Reconstruct Tool, 180–1
resolution, 30	Record sheets, 101
Processing:	Red copy channel, 253–4
multiple Raw files, 91–2	Red filter, 250
projects, 77–94	Red, Green and Blue see RGB images
Raw data, 77	Reduce Noise filter, 192–4
Processor speed, definition, 413	Reducing noise, 85, 192-4, 230
Professional printing laboratories, 110–11	Redundant array of independent disks see RAID
Profiles:	Refine Edge feature, 132, 135-6, 140-2, 306-7, 311
color profiles, 99, 111	Refining selections, 132, 135-6, 140-2
monitors, 3–4	Reflection effects, 288-9
Projects:	Reflectors, definition, 414
advanced retouching, 250–96	Refraction, definition, 414
montage, 297–374	Reintroducing color, 258
processing, 77–94	Removing:
retouching, 203–48, 250–96, 396–400	blemishes, 399-400
special effects, 376–406	blur types, 196
Proofing, 106, 108, 415	files in Bridge, 47
ProPhoto RGB, 79	panorama problems, 368, 369
Proportions, 35, 59, 408	red hair color, 398
PSD format, 26, 52, 213, 413	selections, 133
Pucker Tool, 181	Render filters, 195
Push Left Tool, 181	Repairing ghosting problems, 368
	Replace mode, Spot Healing Brush, 400
Quad Black ink system, 112–13	Replacing sky project, 326–31
Quality:	Reposition Only option, 365, 366, 369
Camera Raw, 76	Resampling, 35, 36–8, 414
edges, 304–5, 314	see also Sampling
editing, 126	Research, xiii
optimization, 56	Resizing, 70
printing, 102	see also Size
resolution, 31, 32	Resolution, 30–3
saving modified files, 71	definition, 414
Quick Masks, 120, 122, 141–2, 144	image size, 31, 35
definition, 413	interpolated, 411
depth of field, 270	monitors, 3, 30, 70
diffusion project, 383–4	for printing, 111
project, 299–30, 304, 306–7	smooth tone technique, 284
replacing sky project, 327	true, 415
shortcut, 257	Resources, xiii, 53
Quick Selection, 130, 132–3, 139–40, 299, 307, 413	Retouching:
Quick Thumbnails, 46	advanced techniques, 249–96
Quick Humbhalls, 40	projects, 203–48, 250–96, 396–400
Radial Blur filter, 341	RGB images, 17–18, 19, 21
Radial Gradient, 279	channel masking, 146
Radius:	channels, 124, 125
	color conversions, 98–9
Coursein Plus 354	definition, 414
Gaussian Blur, 354	delilition, TiT

Luminosity blend mode, 166	effects projects, 384
processing projects, 79	from paths, 147–51
Smart Objects project, 276	layers, 118
'Ringaround', 109	loading, 136, 138
Rollover, definition, 414	montage projects, 298–9, 303, 306–7, 314–18,
Rotate Image Tool, 369, 370	327
Rubber Stamp, definition, 414	moving, 133
Rudman, Tim, 392	refining, 132, 135–6, 140–2
Rulers, 13, 362	removing, 133
Halets, 13, 332	saving, 133, 136, 138, 301
Sabattier effects, 167	shortcuts, 417
Sampling:	Smart Objects project, 277
color, 20, 282	switching modes, 122–3
definition, 414	tools, 130–3, 147–51
layer mask project, 299	Selective color, 222
portrait makeover project, 398–400	Sensors, 30, 93–4, 342–3, 408
smooth tone technique, 282, 285	Settings, 8–10
see also Resampling	color, 5, 100, 103
Saturation, 19–20	gray point, 66
in ACR, 84	monitors, 3–4
adjustment layers, 221–3	Raw format, 91–2
blend modes, 164, 165, 313	target values, 65
definition, 414	Setup:
digital Polaroid transfer effect, 389	digital darkroom, 2
Displace and Liquify project, 357	Page Setup, 10
Gradient maps, 268	printing, 110
sharpening images, 212, 243, 246	Shadows, 64–5
smooth tone technique, 284	adjustment layers, 215–16, 225
see also Hue	creating, 340
Save As/Save a Copy, 414	'exposing right', 90
Save for Web & Devices command, 72	Gradient maps, 261–2, 266–7
Saving:	management, 86
cross-platform, 27	maximization, 108
file formats, 25	montage projects, 342–50, 359, 362–3
frequency, 56	Overlay blend modes, 162–3
images with layers, 122	project, 332–41
modified files, 70–2	retouching projects, 226–30, 280, 283–4, 287
multiple Raw files, 92	290
panoramas, 369	Sharpen filters, 196
paths, 317	subtle shadows, 339
selections, 123, 136, 138, 301	Shape-based selections, 130
	The second second is the second second in the second secon
Scaling images, 209, 299, 414	Shape layers, 121, 177
Scanning:	Shark's teeth pixels see Staircase pixels
digital capture, 58	Sharpen filters, 196
Polaroid images, 391	montage projects, 331, 350
resolution, 33	retouching projects, 211–13, 230, 240, 280, 285
sharpening techniques, 240	Sharpening images, 69, 85
Scratch disks, 9, 414	advanced techniques, 240–8, 284, 294
Screen, see also Monitors	customization, 196
Screen modes, 12, 159–61	definition, 414
Screen real estate/redRaws, 414	High Pass filter, 200
Screen viewing, 70, 240	projects, 211–13
see also Viewing	saturation, 212, 243, 246
Secondary colors, definition, 414	smooth tone technique, 284
Selections, 129–52	Shell, Craig, 326, 419
adding, 311	Shift Pixels Tool, 286
adjustment points, 83	Shortcuts, xiv, 2, 417–18
blending images, 309	adjustment points, 83
color settings, 100	adjustments, 418
customization, 133–4	blend modes, 155
definition, 123	cropping, 418
depth of field 270	file commands 417

fill color, 230	Snap to Image function, 367, 369
Invert, 257	Snapshot, definition, 415
layer masks, 127	Soft Light mode, 162–3
layers, 119, 418	Soft proofing, 106, 415
masks, 300, 418	Softening freckles, 396–7
navigation, 11, 417	Software:
painting, 418	calibration, 4
Quick Masks, 257	definition, 415
selections, 134, 417	Solarised effects, 167
Stamp Visible layer, 256, 282, 290, 362	Sovereign Hill Museum, Victoria, 91
Transform command, 210	Special effects, 375–406
Undo, 286	Specifications, image size, 34
viewing, 417	Specular highlights, 215, 225
Zoom, 300, 315	Spinning wheels, 341
Similar option, selections, 135	Spot Healing Brush, 68, 239, 356, 400
Single lens reflex see SLR cameras	sRGB color space, 79
Size:	Stacks, 50, 193–4, 415
Brush Tool, 300	Stained Glass filter, 199
color samples, 282	Stainsby, Daniel, 319, 419
documents, 35	Stair interpolation, 37
processing projects, 78	Staircase pixels, 16
see also File size; Image size; Resizing	Stamp filter, 198
Sketch filters, 198	Stamp Tool, 182–3, 231–9
Skills:	see also Clone Stamp Tool
acquisition and application, xii	Stamp Visible layer:
dRawing, 148–51, 314–18	effects projects, 380
learning approach, xiii	montage projects, 331, 362
Skin tone see Tone	retouching projects, 256, 282, 284–5, 290
5ky effects, 217, 263, 326–31, 401	Standard mode, Bridge, 49
see also Cloud effects	Step Backward, 56
Slicing, definition, 414	Stephens, Jennifer, 286
Sliders:	Stitching, 365–8, 370
adjustment layers, 215–18	Storage, xiv, 24
definition, 414	Straighten Tool, 78, 208
Gradient maps, 261, 267	Strength setting, Reduce Noise filter, 192–3
lens distortion, 209	Structured learning approach, xiii
Shadow/Highlight project, 227, 230	Styles, layers, 119
Sharpen filters, 196, 212	Stylize filters, 197
tonal adjustments, 82	Subjective analysis, definition, 415
Slow-Sync setting, 88	Subtle shadows, 339
SLR cameras, 87, 414	Subtracting from selections, 133, 134, 299
Smart Filters, 173–4	Subtractive color, 21, 415
advanced blending, 405	Supporting DVD, xiii, 208
definition, 415	Bridge program, 53
effects projects, 382, 384-6, 389-91	contents, x–xi
montage projects, 337–8	processing projects, 77-94
retouching projects, 227	sky library, 326
see also Smart Sharpen filters	Texturizer filter, 391
Smart Highlighting option, 179	Switching modes, 122–3
Smart Objects, 80	Synchronizing Raw settings, 91–2
background layers, 238	System software, definition, 415
definition, 415	
effects projects, 383–6, 391, 393–6	Tab key, 7, 12
filter use, 211	Tablets, 137
image stacks, 193–4	Tagged Image File Format see TIFF files
layers, 118, 121, 126, 335, 388	Tagging, definition, 415
montage projects, 349–50	Target values, 65
project, 273–80	Target White Point, 100
Smart Sharpen filters, 69, 196	Temperature of color, 3
projects, 211–12, 230, 240, 243–6, 285	Temperature of Color, 3 Test print, 102, 104, 107, 109
Smooth option, selections, 135	Text, editable, 121, 409
Smooth option, selections, 135 Smooth tone technique, 281–6	
ATTOOLIT LOTTE LECTIFIQUE, 201-0	Text layers, 117, 121, 177

Texture filters, 199, 390–1	montage projects, 299, 303, 328, 335, 362-3
Texture of images, 309, 394	retouching projects, 275, 287-8, 291
see also Grain	Vanishing Point filter, 185
Texturizer filter, 199, 390–1	Transparency, definition, 415
Thaw Mask Tool, 181	Tri-color, definition, 415
Thematic images, definition, 415	Tripods, 366, 371
Third party filters, 176, 177	True resolution, definition, 415
Threshold slider, 69, 196, 230	TTL meters, definition, 415
Threshold view, 215	Turbulence Tool, 181
Through-the-lens light meter see TTL meters	Tutorial web links, 419
Thumbnails, 43, 46, 67	Tweening, definition, 415
TIFF files, 26, 27, 52, 415	Twirl Clockwise Tool, 181
Time of day project, 287–95	Type layer, 401–2, 405
Tinting, 164–5, 393	Type layer, 101 2, 103
Tolerance, pixels, 132	UCR, definition, 415
Tone:	UI see User interface
12-bit capture, 86	Under color removal see UCR
adjustments, 61–5, 82–3, 89	Undo shortcut, 286
Black and White, 251	Uniform Blur, 189
blend modes, 164–5	Uniform resource locator see URL
continuous, 408	Unsharp Mask (USM) filter, 69, 196
definition, 415	definition, 415
effects projects, 380, 397, 398	projects, 230, 240, 242, 243–6, 285
Gradient maps, 259–68	URL, definition, 415
levels, 18, 61, 63	User interface (UI), 5
montage projects, 371	USM see Unsharp Mask filter
optimization, 62	Utsunomiya, Akane, 169
retouching projects, 226–30	
selections based on, 131	Vanishing Point:
smooth tone technique, 281–6	definition, 416
Tone Curve, 83	filter, 182–5, 231–9
Tools:	Vantage point continuity, 332
Black and White, 253, 255–7	Variations command, 67
blending projects, 313, 405	Vector graphics, 148, 177, 363, 416
Bridge program, 51–2	Verdon-Roe, Victoria, 75, 84, 96, 419
cleaning images, 68	Verticals, 207, 234, 247
Clone and Stamp, 231–9	Vibrance in ACR, 84
cropping, 60	Video cards, definition, 416
definitions, 408, 411, 412, 416	Video filters, 200
depth of field, 270	Video memory, definition, 416
effects projects, 397–8	Viewing:
filters, 178–81, 208	channels, 124
Gradient maps, 264	duplicate images, 213
layer masks, 300–1, 305	Internet image size, 70
montage projects, 321–3, 325, 329–30, 348, 353, 356–8, 361	layers, 118
navigation, 11	modes, 10–13
palette, 6, 7	options in Bridge, 44–5
panoramas, 369–70	shortcuts, 417
paths and selections, 315–16	see also Screen viewing
processing projects, 78	Vignetting, 190, 206, 237–8, 257, 331
retouching projects, 230, 276, 279, 289, 293	Virtual memory, definition, 416
screen modes, 12	Visualize, definition, 416
selections, 130–3, 147–51	visualize, activition, vio
shadows, 230, 338	Warm colors, 224
smooth tone technique, 282, 285–6	Warn option, 287–8, 363–4
Transfers:	Warp Tool, 358
Adobe Photo Downloader, 48–9	Weather effects, 294
Bridge program, 52	
digital Polaroid transfer effect, 387–91	Web links, 419
9	see also Internet
Transform command:	Web logs see Blogs
advanced blending, 401, 404–5	Wheel-spinning effect, 341 White as peutral color, 237
IBDS DISTORTION 7117 7111	White as neutral color 137

White balance, 81
White light, 17, 21
White point, 3, 4, 100, 225
Wide-angle lenses, 204, 247
Width, pixels, 131
Wind filter, 197
Windows:
image window, 7
New Window, 13
Windows-based PCs see PCs
Work Paths, 151, 317
Workflow, 5, 416
Workspace/Working Space, 5, 44–5, 100

Zip drive, definition, 416 Zone System, 343 Zoom layer, 303 Zoom Tool, 11, 85, 300, 315, 416

Photography and digital imaging titles available at bookstores and www.focalpress.com

ISBN: 9780240520568

ISBN: 9780240520353

ISBN: 9780240520629

ISBN: 9780240520506

ISBN: 9780240808949

ISBN: 9780240520285

ISBN: 9780240520650

ISBN: 9780240807522

ISBN: 9780240520612

ISBN: 9780240520490

ISBN: 9780240520575

ISBN: 9780240520667

ISBN: 9780240519821

ISBN: 9780240806693

ISBN: 9780240808154